Across the Threshold of India

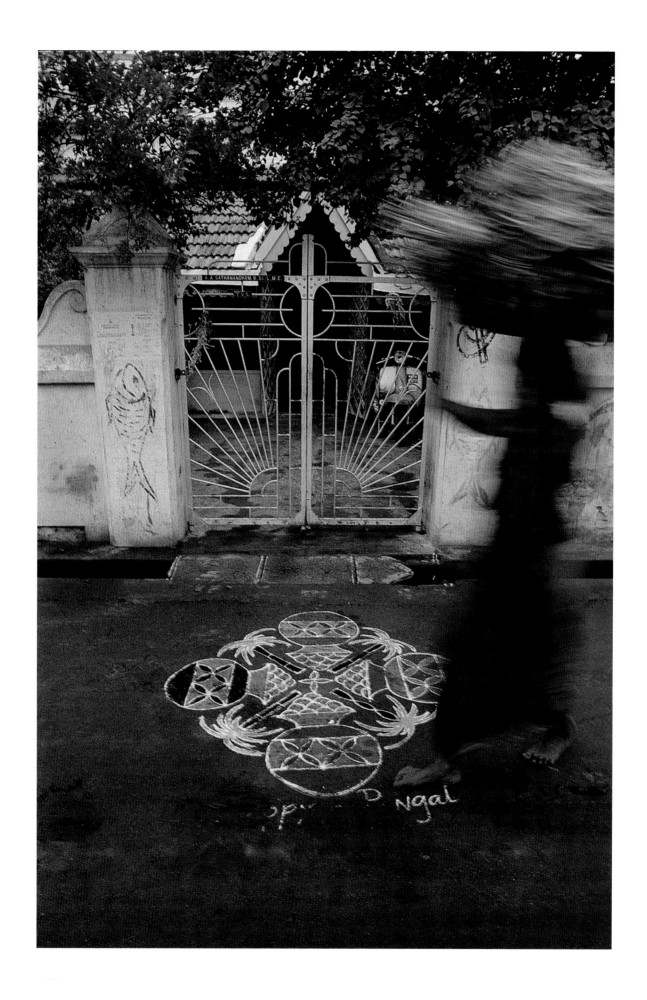

Plate A

Across the Threshold of India

ART, WOMEN, AND CULTURE

Photographs and text by
Martha A. Strawn

with introductions by Kapila Vatsyayan
and Mark H. Sloan

and a historical essay by William K. Mahony

George F. Thompson Publishing
in association with the Center for the Study of Place
and the Halsey Institute of Contemporary Art
at the College of Charleston

It happens before sunrise. A girl, freshly bathed,
the flowers of worship in her hair,
goes about the ritual of decorating her threshold
with traditional rice flour motifs.

They are bold graphic motifs
that come quite naturally to her
—lotus flowers and conch shells,
geometric patterns and peacocks and goddesses.
They well up in her imagination
and pour quietly from slender fingers onto a clean,
mud-caked floor.

You stop her and question her
— about meanings, origins, significances.
But she is innocent of any answer.
All she knows is that her mother taught her the art.
Meanwhile, of course,
the harvests will be kind,
the children of the household will grow up strong and dutiful,
Lakshmi will smile upon the family,
and there will be bliss in all the land.

—Anonymous (1976)

To my mother,
Marion Anna Gilmore Strawn

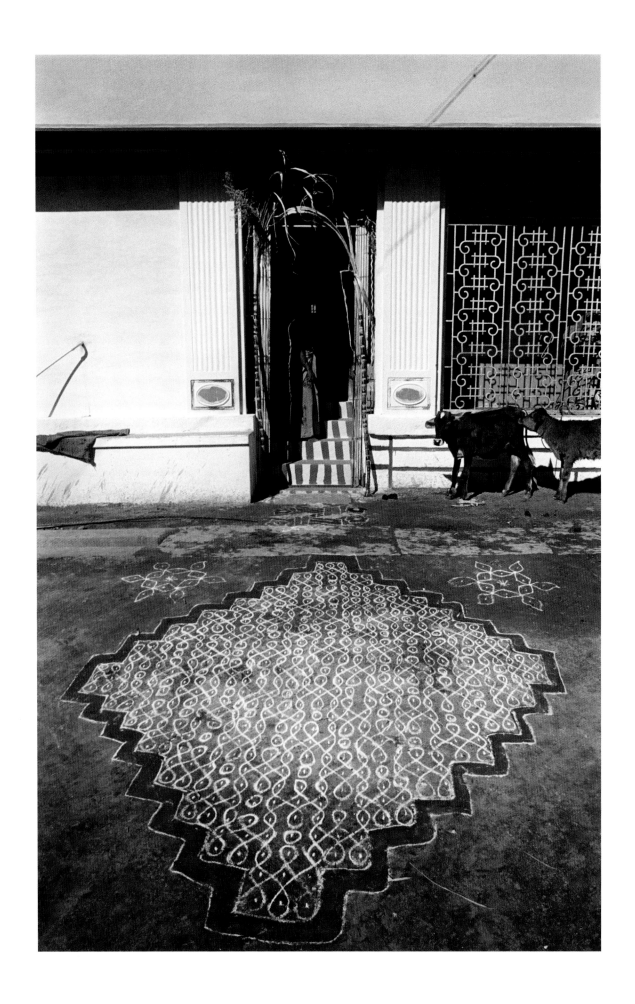

Plate B

CONTENTS

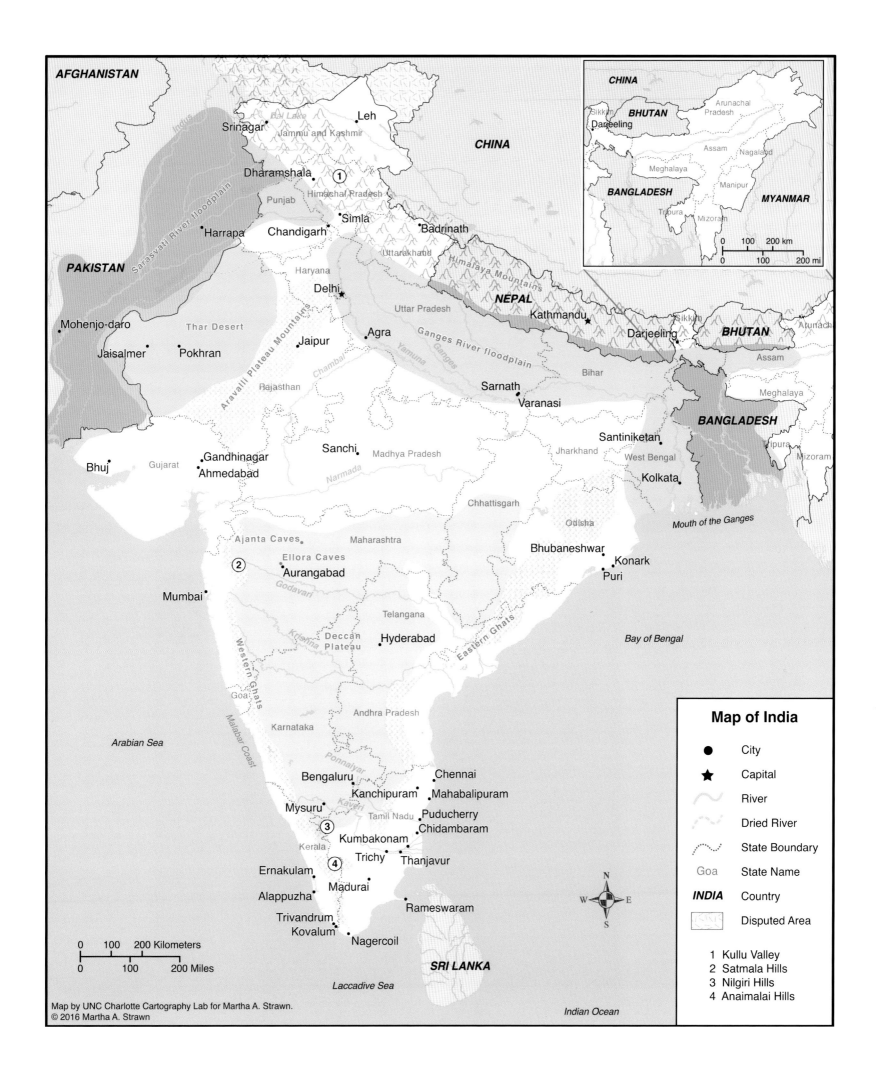

AFGHANISTAN

Leh

Srinagar

Dal Lake

Jammu and Kashmir

CHINA

Dharamshala ①

Himachal Pradesh

Punjab

Simla

Harrapa

Chandigarh

Badrinath

PAKISTAN

Haryana

Uttarakhand

Himalaya Mountains

NEPAL

Kathmandu

Mohenjo-daro

Delhi ★

Uttar Pradesh

Ganges River floodplain

Darjeeling

BHUTAN

Jaisalmer

Pokhran

Thar Desert

Jaipur

Agra

Yamuna

Ganges

Bihar

Assam

Sarasvati River floodplain

Aravalli Plateau Mountains

Chambal

Rajasthan

Sarnath

Varanasi

BANGLADESH

Bhuj

Gujarat

Gandhinagar

Ahmedabad

Sanchi

Madhya Pradesh

Narmada

Jharkhand

Santiniketan

West Bengal

Kolkata

Chhattisgarh

Odisha

Mouth of the Ganges

Ajanta Caves

Maharashtra

Bhubaneshwar

Konark

Ellora Caves

② Aurangabad

Godavari

Puri

Mumbai

Krishna

Deccan Plateau

Telangana

Hyderabad

Eastern Ghats

Bay of Bengal

Western Ghats

Arabian Sea

Goa

Andhra Pradesh

Karnataka

Malabar Coast

Ponnaiyar

Bengaluru

Chennai

Kanchipuram

Mahabalipuram

Mysuru

Kaveri

Puducherry

Tamil Nadu

Chidambaram

③ Kumbakonam

Kerala

Trichy

Thanjavur

Ernakulam

④

Madurai

Alappuzha

Trivandrum

Kovalum

Rameswaram

Nagercoil

SRI LANKA

Laccadive Sea

Indian Ocean

Map by UNC Charlotte Cartography Lab for Martha A. Strawn.
© 2016 Martha A. Strawn

0 100 200 Kilometers
0 100 200 Miles

Inset map:

CHINA

BHUTAN

Sikkim

Darjeeling

Arunachal Pradesh

Assam

Nagaland

BANGLADESH

Meghalaya

Manipur

Tripura

Mizoram

MYANMAR

0 100 200 km
0 100 200 mi

Legend:

Map of India

● City

★ Capital

〜 River

⋯ Dried River

⋯ State Boundary

Goa State Name

INDIA Country

▨ Disputed Area

1 Kullu Valley
2 Satmala Hills
3 Nilgiri Hills
4 Anaimalai Hills

N
W E
S

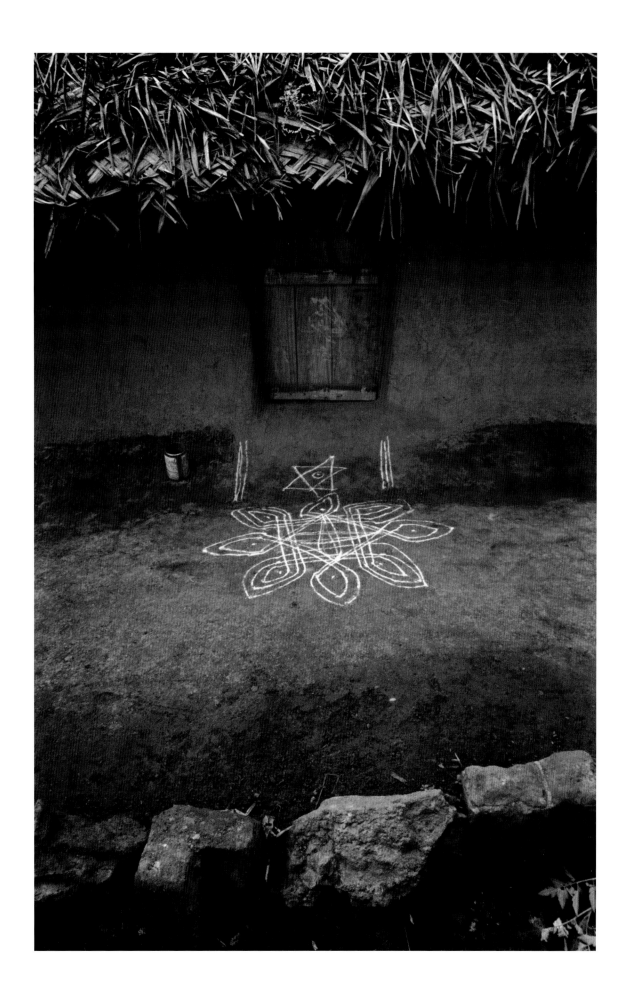

Plate C

MY JOURNEY ACROSS THE THRESHOLD OF INDIA began in 1977 with Sarasvati, the river and Indian goddess of the arts and knowledge. My fascination with the concept of rasa (aesthetics) and the vision of threshold diagrams gave rise to this work. At first, I was intrigued by the sensuous association between the flavors in Indian foods and the tastes in Indian art, and I was captivated by the physical existence of the diagrams in the streets and by their mysterious impressions. My understanding broadened over many decades, as I learned first-hand about threshold diagrams and their cultural context. My perceptions deepened as I watched the women make the diagrams and as I learned from Indian scholars and laypersons with whom I engaged. These critical interactions greatly affected the results of this project. Both my worldview and cosmic view were further enlarged, and, as my understanding of the complexity of the threshold diagrams grew, so did the complexity of the images I produced, mirroring my artistic development.

The concept of *threshold* is comprehensive in this work. The diagrams are liminal spaces, symbolic margins separating the secular from the sacred, the physical from the subtle.[1] I thus made the photographs to be liminal spaces, thresholds between one culture and another, one consciousness to another, and from one state of appreciation to another. In this sense, the photographs mirror the diagrams as thresholds.

Grounded in millennia of practice in the Indian subcontinent, threshold diagrams cycle forward in a spiral of time through women's mentoring of daughters, nieces, and granddaughters. In this instance, I have recycled the threshold diagrams in my photographs to share their aesthetic and their power beyond the geography of their origin. Their designs may feel familiar. They are the prototypes for design patterns we value in Indian tapestries, rugs, paintings, cloth, and architectural details. Such stylized patterns as flame, lotus, mango, six-pointed stars, water symbols, and numerous others all stem from the earliest practices of women who created the diagrams to make a space sacred in the temples, a simple yet profound function practiced with humility and grace. This artistic practice is a linkage through time primarily composed of universal symbols that legibly express metaphysical values. As such, they link the primordial vision of rural India with modern India, and through their designs they link the culture of India with other cultures globally.

When I began this project, little was written about nor visually recorded on the ancient practice of threshold diagrams in India, so I had few references to help me understand what I was experiencing in the field. As I developed associations with village women and Indian scholars, I gathered extensive notes. My two essays in the book reflect

my effort to organize my perceptions and to obtain provide myself a more authentic understanding and context for photographing the diagrams in their environment.

I eventually went to India to work on this project seven times during a thirty-seven-year span of time. During recurring field sessions, I often relied on an interpreter and cultural guide, so that I could interact with the women making the diagrams, unless I was in a more urban setting where the women spoke English. The dialogues I had with these women became a centrally important guide as this project developed. By revisiting many villages and neighborhoods, I was able to establish some on-going presence with the communities and the women artists and to note changes in how the women executed the practice as their lives changed. Though several Indian scholars made their published and unpublished research available, much most of my information came directly from the women executing this practice.

This book is designed to invoke the use of both visual and verbal literacies and to stimulate emotional and intellectual dialogue through the use of images and texts. The photographs in Portfolios I and II are called plates. They were made primarily with an aesthetic intent, but they also contain information. The photographs in Portfolio III are called figures (visual notes). They primarily present cultural information about Indian life and, as a section, visually relate their own story. Both the plates and figures are referenced throughout the various essays. As references, they form an interdisciplinary body of work I call *visual ecology*, a term I first used in my book, *Alligators, Prehistoric Presence in the American Landscape* (1997).[2] The use of the word "ecology," in this instance, refers to the larger concept represented by "deep ecology" or the larger worldview that life is an integrated whole. Such a view recognizes the inherent interconnectedness of all phenomena, natural and cultural. As Alan Watts (1915–1973) so eloquently stated in his posthumous book, *The Tao of Philosophy* (1995).

> We have been brought up to experience ourselves as isolated centers of awareness and action, placed in a world that is not us, that is foreign, alien, and is something other which we confront. Whereas, in fact, the way an ecologist describes human behavior is as an action. What you do is what the whole universe is doing at the place you call "here and now," and you are something the whole universe is doing in the same way that a wave is something that the whole ocean is doing.[3]

I view all cultural creations through the lens of a geographic sense of place as they cycle through time. This view will become evident in my two essays and the essay by

Bill Mahony, as we not only discuss how and why the traditional drawings are changing and, in some locales, fading, and also provide information that situates these diagrams in a comparative world context of making art.

To discover and live in the immediacy of an ancient practice of art, life, and religion has been a truly humbling yet remarkable gift. It is my hope that the "reading" experience of the photographs and text is satisfying, enjoyable, provocative, and, even, enlightening. As it has been for me, I hope it will be for others as well.

Plate D

Across the Threshold of India

Drawing A

It is the magic of mathematics, the rhythm which is
in the heart of all creation which moves in the atom
and, in its different measures, fashions gold and lead,
the rose and the thorn, the sun and the planets.
These are the dance steps of numbers in the arena
of time and space, which weave the maya, the patterns
of appearance, the incessant flow of change, that ever
is and is not. It is the rhythm that churns up images
from the vague and makes tangible what is elusive.
This is maya, this is the art in creation, and art
in literature, which is the magic of rhythm.

—Rabindranath Tagore (1961)

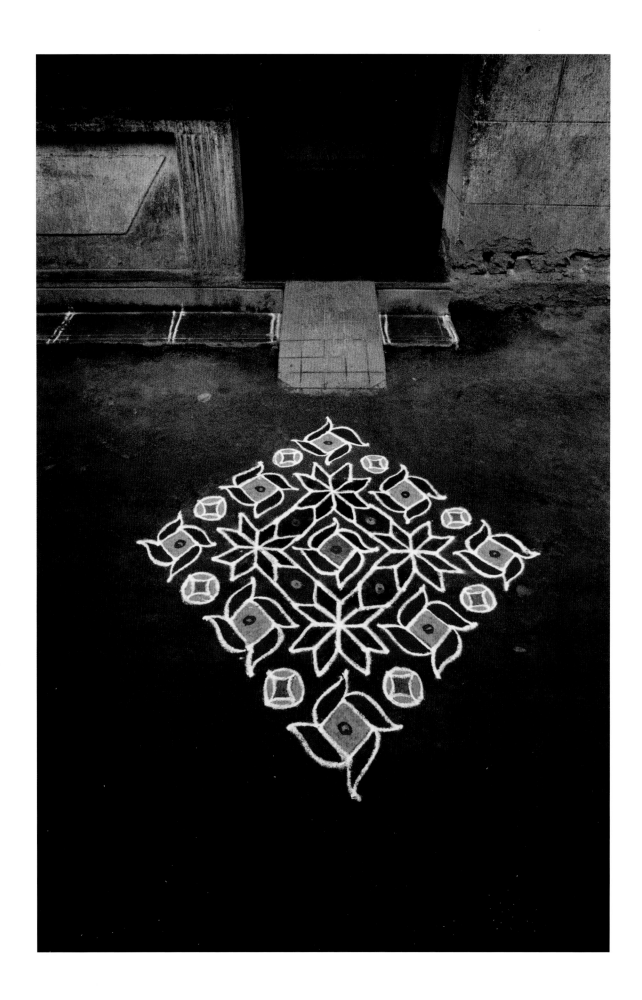

Plate E

The View from India

KAPILA VATSYAYAN

Some decades ago, I met Martha Strawn and saw her extraordinarily sensitive photographs on the "threshold drawings," or *kolams* as they are known in Tamil Nadu in South India. These fascinated me, because Strawn was not looking at these drawings as pure visual imagery: her engagement through these drawings and her photographs was at a deeper level — revealing an important aspect of the culture of India. This admiration for her work made me acquire some of her photographs for the Indira Gandhi National Centre for the Arts in New Delhi. Since that first meeting, Strawn has artistically and intellectually traveled a long way, for the threshold drawings were a beginning for her to cross many other thresholds of Indian culture.

The publication of *Across the THRESHOLD of India* is both a culmination and a pause in her journey. A perusal of her photographs and her narration makes it clear that, although *kolams*, or thresholds drawings, are her focus, she has extended her horizon to cover many other aspects of India. Fascinating, for example, is her account of a sense of place in Benares, or Varanasi, the modern name (pages 135–37).

This book is further evidence of Strawn's ability to go behind the visual image, as she identifies the context and focuses on the human instruments (largely women) who are the makers of these ordinary, but extraordinary, kolams. The photographs are an explicit visual statement of Strawn having internalized the myriad experiences she had of the life cycle — ranging from fertility initiation rites to a wedding, to birth, to passing away — while living and traveling in India during nearly four decades of exploration. And her intuitive eye creatively captures the vivid richness of Indian daily life — from riverscapes and streetscapes to shrines and the colorful spectrum of food stalls and fruit vendors — whatever catches her eye and, moreover, her conscience. The photographs pulsate with significance, making what seems ordinary into the extraordinary — just like the threshold drawings. She also very sensitively gives an account of the placement of these kolams as indicators of a bridge or passage between the profane and the sacred. This indeed is a threshold.

With remarkable clarity, Strawn mentions the numerous techniques of making these designs. Some can be made by a continuous movement of the hand and the dripping of the liquid from a cloth. Some can be made through demarcating dots, which are then connected in another pattern of unending lines. The dot, or *bindu*, is the highest form of abstraction, for it symbolizes the source of being, the center of the universe. The *bindu* has position only, representing the point where form touches form-

lessness. The drawings thus culminate in patterns that have a long history as signifiers, be it Sri Chakra (a magical form of great antiquity), the Naga (intertwined serpent deities), the swastika rangoli (an ancient charm of good fortune), or the many other symbols with primordial significance.

The concept of a threshold has received the attention of anthropologists, philosophers, and art historians alike. Victor Turner has described such space as "liminal," signifying a threshold.1 In curator Mark Sloan's essay that follows, he reminds us that, when Martha Strawn's exhibition, Threshold Diagrams, was first presented internationally in 1996 at the Halsey Institute of Contemporary Art at the College of Charleston in South Carolina, the relocation in place and time invoked a primordial consciousness and resonant chord among the local Indian community. His account of what happened in Charleston is fascinating. And, as Professor Mahony notes in his historical essay for this book, "the sanctity of the threshold has been honored in India since at least the time the first songs comprising the Rgveda (Rigveda) were first sung. . . . Actual textual references to these floor designs appear in works composed as early as 2,000 years ago."2

Convincingly, Martha Strawn assigns these threshold drawings the appellation of visual ecology. In her words, "Threshold diagrams are profound, because they represent an ancient practice performed with deep purpose. They are mysterious, because Indian knowledge of this practice has largely been forgotten. They are magical, because they serve symbolic functions that establish power by transforming one kind of space into another. They are practical, because making the diagram has a positive impact on the daily lives of Indian families."3

Across the THRESHOLD of India is reflective of a long journey. As I began, I met Martha Strawn some decades ago. In between then and now, she seems to have disappeared into liminal space. Now, what an absolute pleasure to see this magnificent book. What perseverance, dedication, and commitment! I have no doubt that *Across the THRESHOLD of India* will be received across the world with admiration for her perspicacity and her depth.

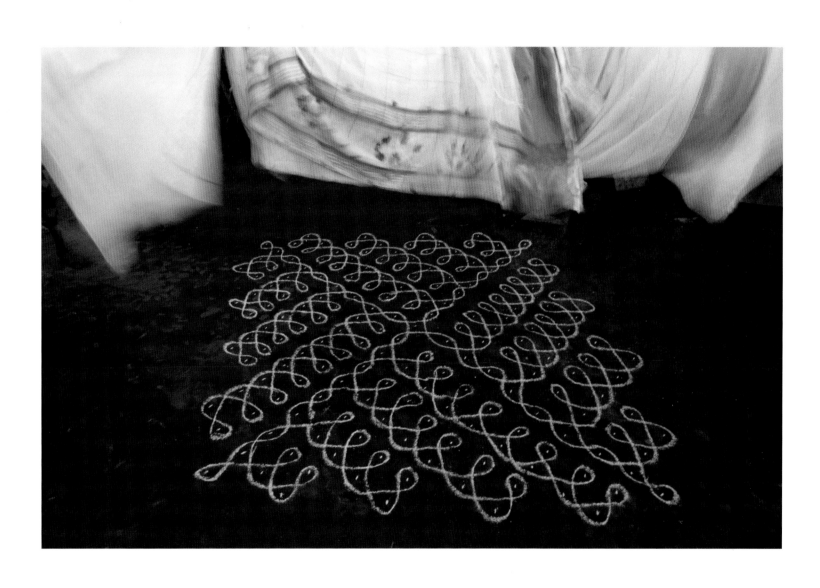

Plate F

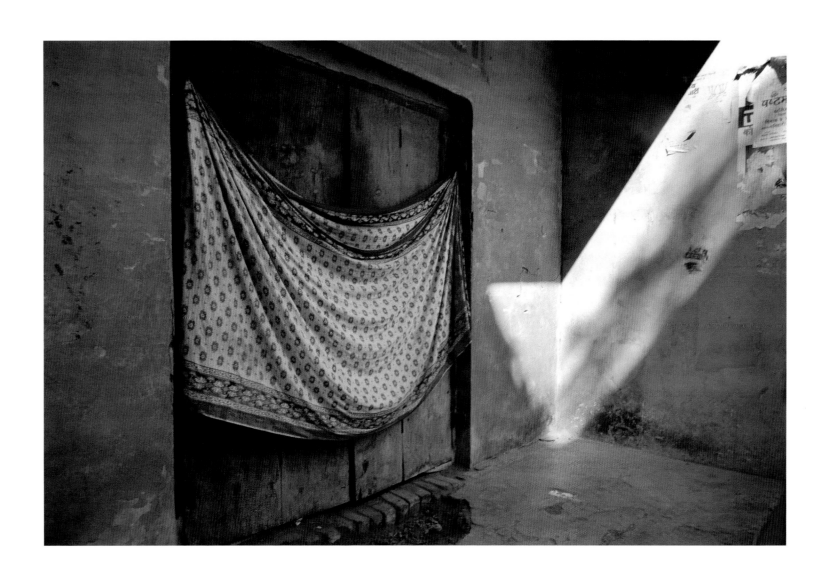

Plate G

Sanctified Spaces

MARK H. SLOAN

In the fall of 1996, Martha A. Strawn's exhibition, *Threshold Diagrams*, premiered at the Halsey Institute of Contemporary Art at the College of Charleston in South Carolina. In preparation, I contacted members of Charleston's Indian community six months ahead of time to seek their input and possible involvement. Not only did they enthusiastically embrace the concept, but they agreed to provide Indian food and music for the opening reception and created threshold diagrams at every entrance not only to our building, but also to the galleries each day for the run of the exhibition. It was extraordinary. A very broad spectrum of the local community came out in large numbers to see this beautiful collection of photographs and to read about this little-known form of visual expression. In thirty years as a museum and gallery director, I have had no other exhibition strike such a resonant chord within the local community.

Presenting an exhibition such as this is a tricky proposition from a curatorial perspective, especially as pertaining to India, where "post-colonial" critique of the anthropological archive has become something of a cottage industry in academia. Questions of who gets to speak for whom and concerns about cultural hegemony tend to cloud perceptions about ethnographic projects such as this. Fortunately, Strawn's approach is light-handed and unobtrusive, and she operates from a position that honors the makers of *rangoli*, one name ascribed to the colorful and symbolic threshold drawings that sanctify the entrances to secular and sacred spaces. She is humbled by their artistry and has proven to be a dedicated student of their tradition. Her self-reflexivity and willingness to acknowledge her outsider status is, in fact, among the most remarkable aspects of this multi-faceted project.

Strawn's photographs, as well as the scholarship surrounding them, fascinated the women who helped with the daily *rangoli* at the gallery. One, in particular, had learned *rangoli* from her mother and grandmother, yet she was unaware of the rich cultural tradition from which it springs — and she was not alone. The exhibition opened up a new line of questioning for those women and unlocked a vast storehouse of information about a practice that is, at once, both common and esoteric. This is a case of a culture discovering its own fascinating ancestry.

In a similar vein, in Charleston and other coastal towns in the American South, residents often paint the porch ceilings of their homes a light, robin's egg tone, available by the name haint blue from Benjamin Moore, Sherwin Williams, and most major paint brands. Haint blue dates back to the time of slavery; but if you were to ask a resident

why they paint their porch ceiling that color, most will say it is for good luck, without knowing what a haint is. According to African folk wisdom, haints are unsorted souls who are believed to hover restlessly between the world of the living and the world of the dead. Legend has it that haints are afraid of water, so the Gullah people on the nearby Sea Islands began painting the trim of their houses in this shade of blue to confuse the haints and keep them out. The superstition now continues in a more muted form manifested in porch ceiling paint, yet the historical origins are unknown to most people practicing this tradition today. Thus, we can see how both the Gullah's use of haint-blue paint and the Hindu heritage of threshold diagrams are examples of forgotten knowledge in contemporary culture.

With the *Threshold Diagrams* project, Strawn follows in a long tradition of ethnographic photography, although she has long branded her practice as visual ecology, in respect to the world that surrounds and defines us. More than a tool for indexical inscription, photography has been described as both a window and a mirror. In this case, Strawn's photographs offer a window into a world unfamiliar to most outside of India and a mirror to a culture whose traditions extend back millennia. Her work as a long-time participant observer in India is fueled by a genuine curiosity about its culture, and it is grounded in her desire to document and preserve a changing and, in some places, fading tradition, as modern India becomes more urban.

Strawn's photographs contain equal parts aesthetic pleasure and cultural meaning. As a photographer, her work has always been characterized by a gift for rendering the subtleties of light. She masterfully composes images that exploit the transformative qualities of light on surfaces. The aesthetic beauty of these images ensures that the meanings they carry will be relevant and appreciated well into the future. Indeed, the artist's eye is at the heart of this project, but Strawn has gone to great lengths to incorporate the most up-to-date information and scholarship to create a rich context for appreciating her photographic art. This project is both show and tell at its finest.

Photography enjoys the unique attribute of being able to freeze time. Strawn's collection, presented in this impressive book, offers a comprehensive overview of the history and practice of threshold diagrams in India. Here, these frozen images offer a glimpse into the past as they animate new conversations and considerations today. This overlooked tradition has finally found its chronicler in Martha A. Strawn, and civilization is the richer for it.

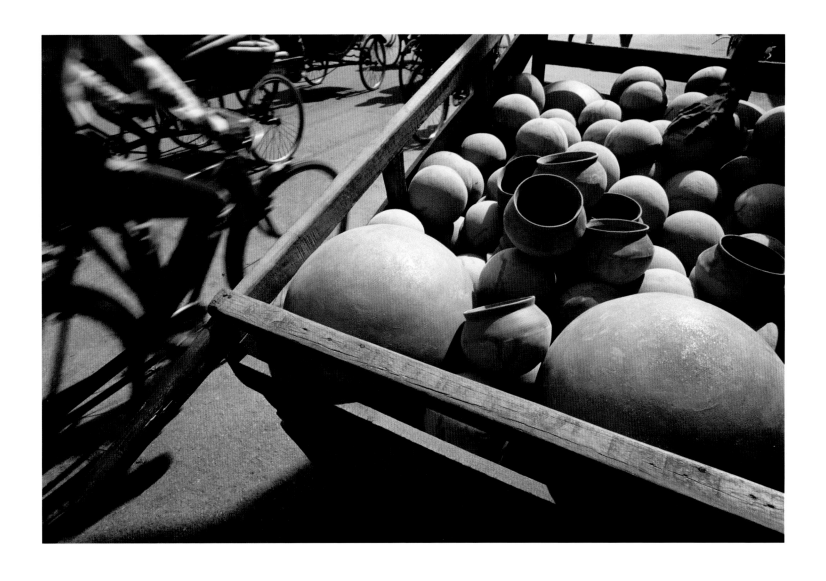

The Silver Gelatin Prints

Photography is about looking around,
which is a prerequisite for actually seeing.
It operates in that place between art and life,
where I like to work, and where I am joined by
a great many other women artists whose focus
has been "work" and "home" in the broadest
sense — that is, experience, familiar but
unexplored aspects of daily life.

—Lucy R. Lippard (2015)

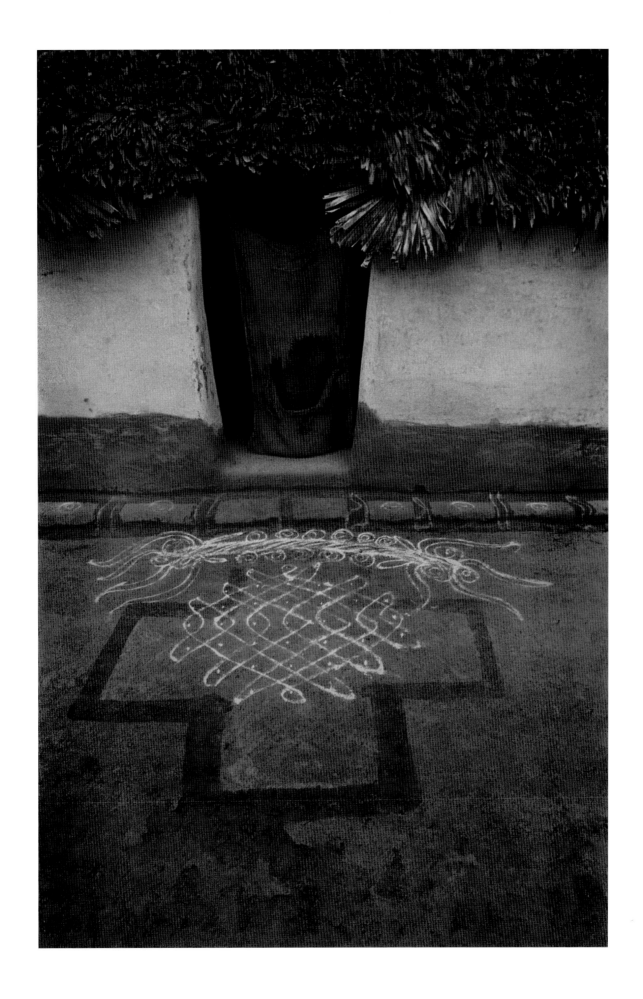

Plate 1

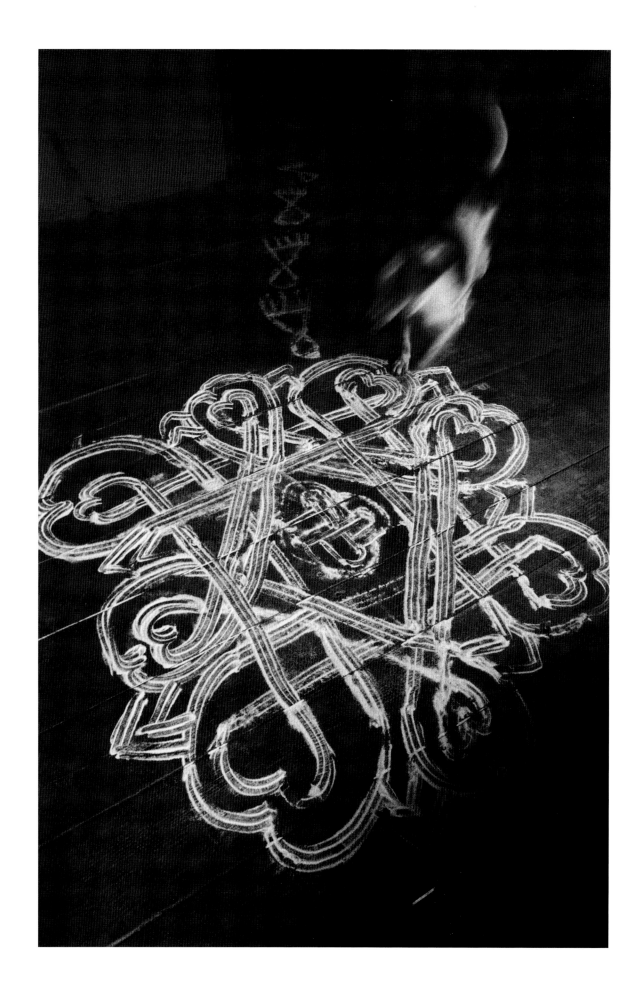

Plate 2

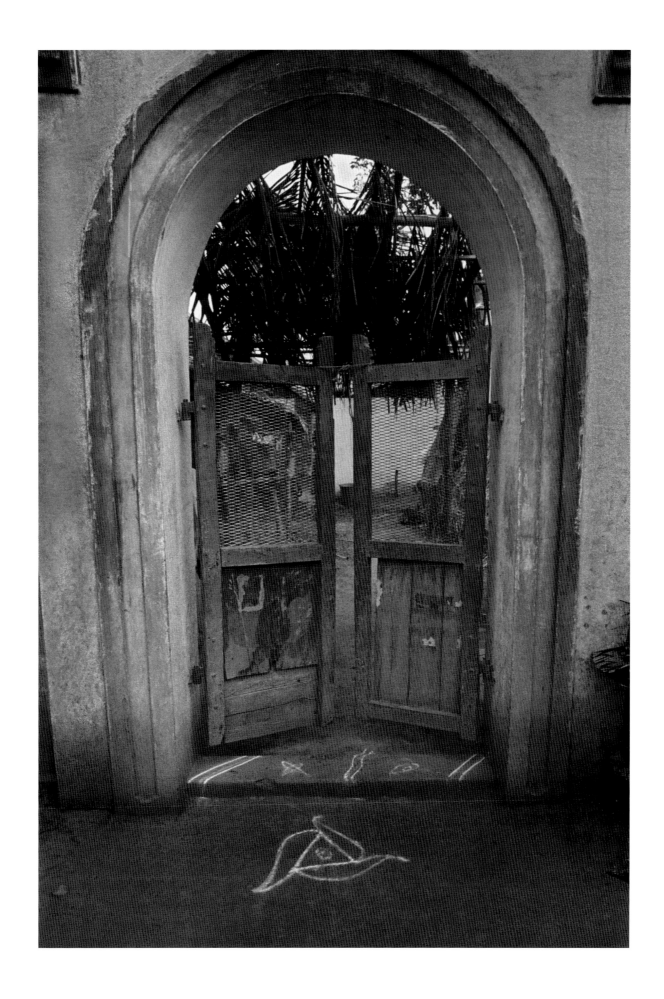

Plate 3

Plate 4

Plate 5

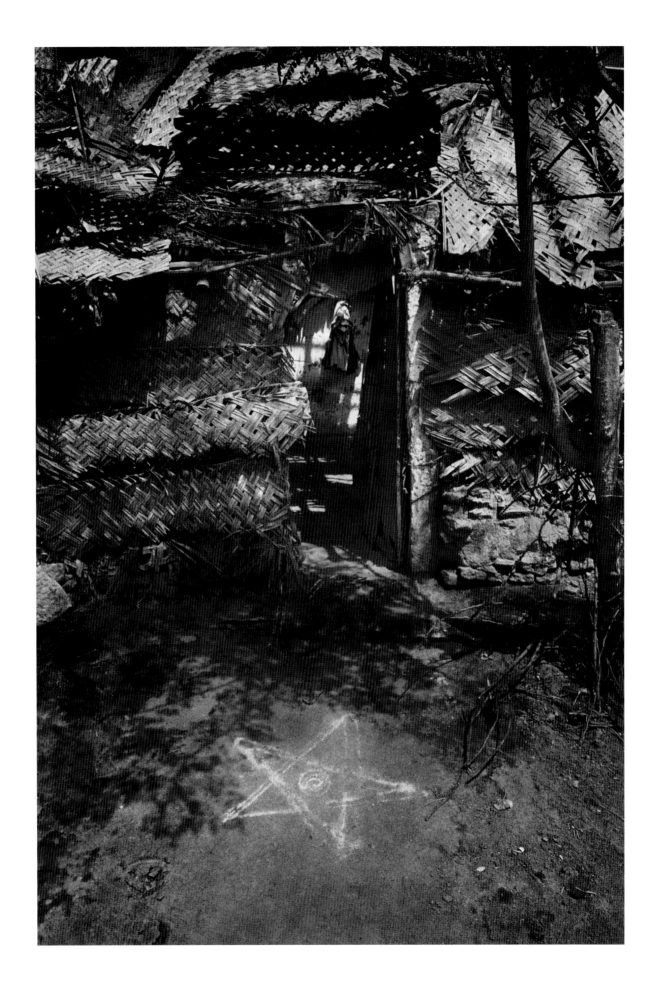

Plate 6

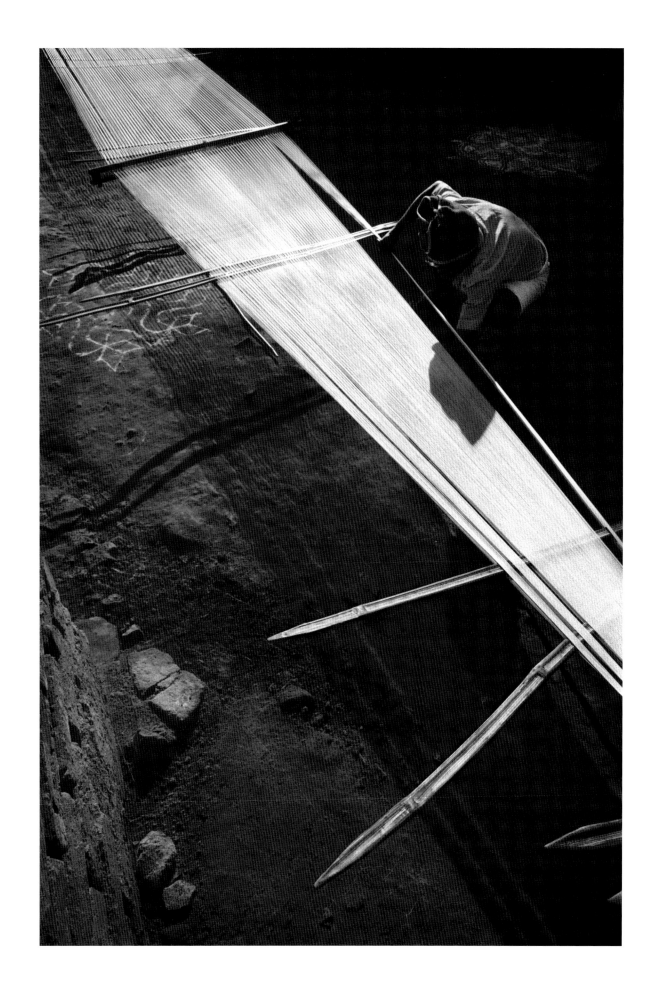

Plate 7

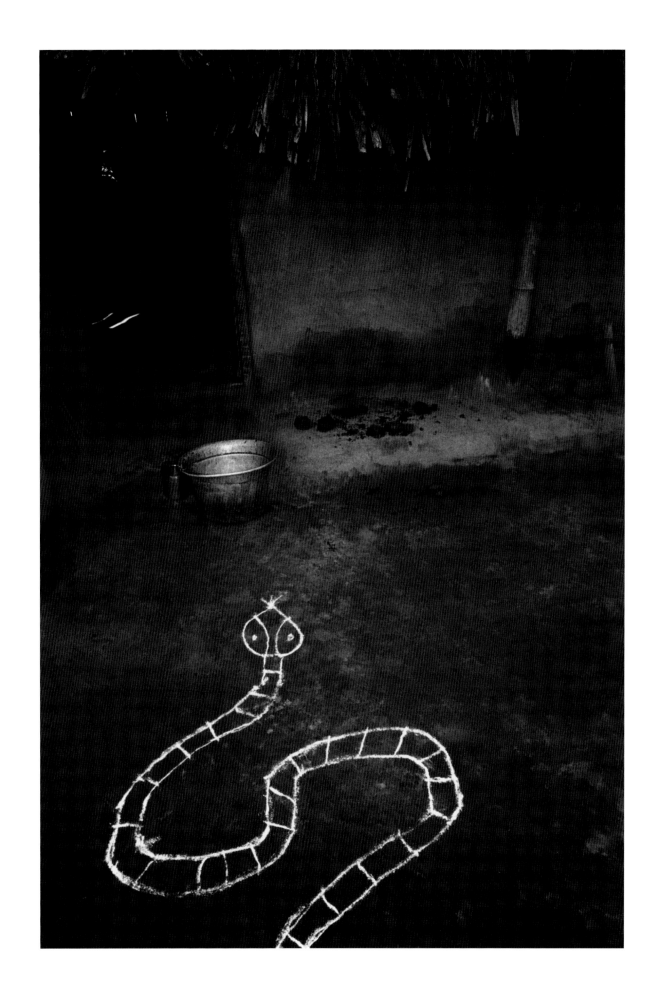

Plate 8

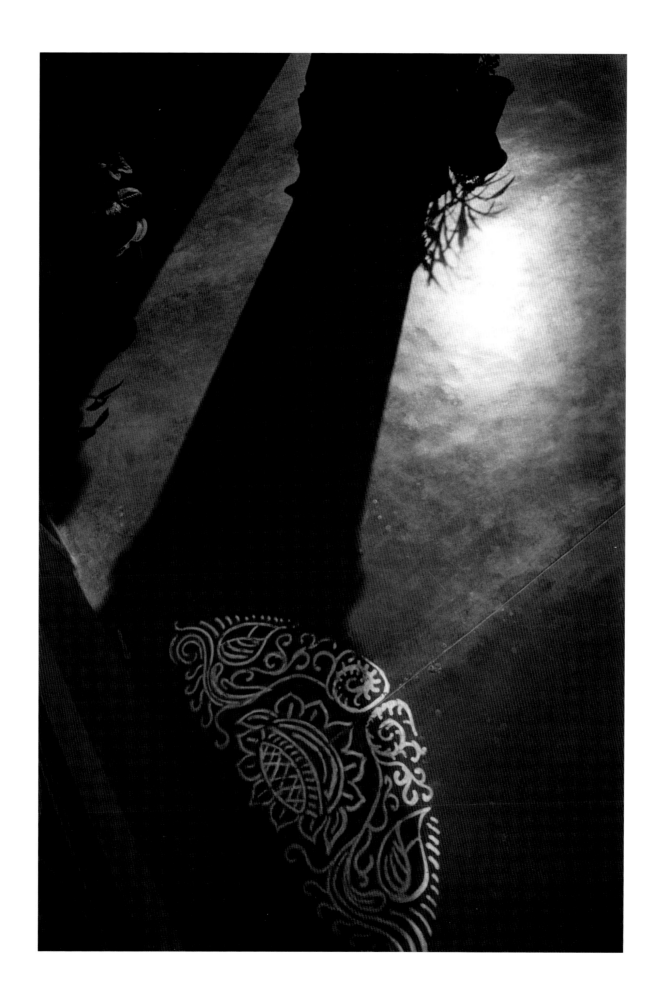

Plate 9

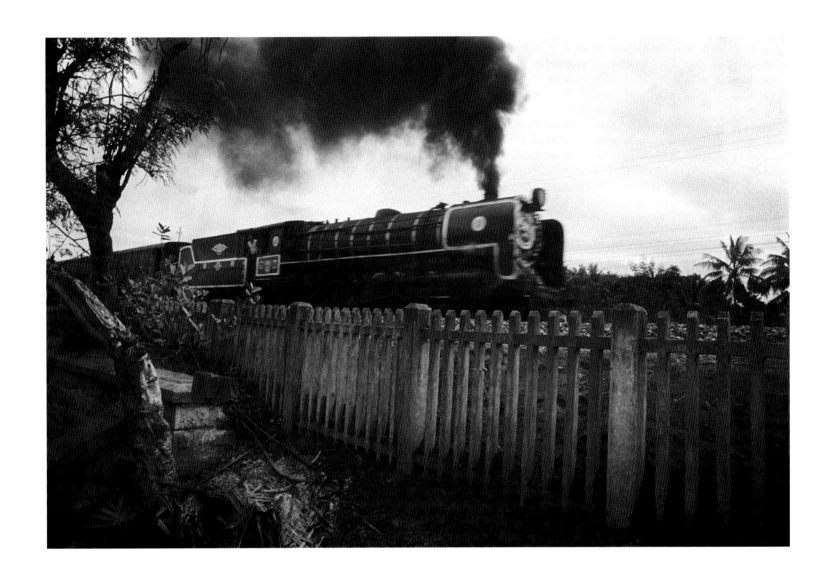

Plate 10

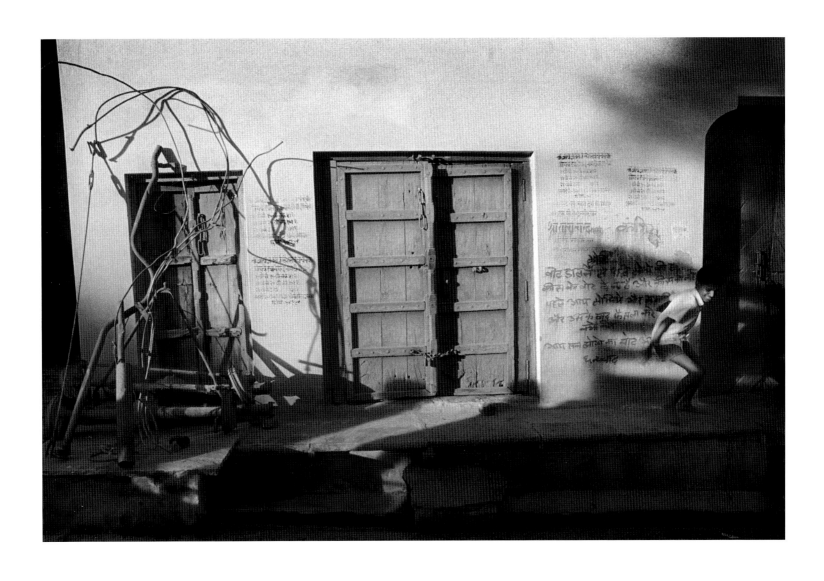

Plate 11

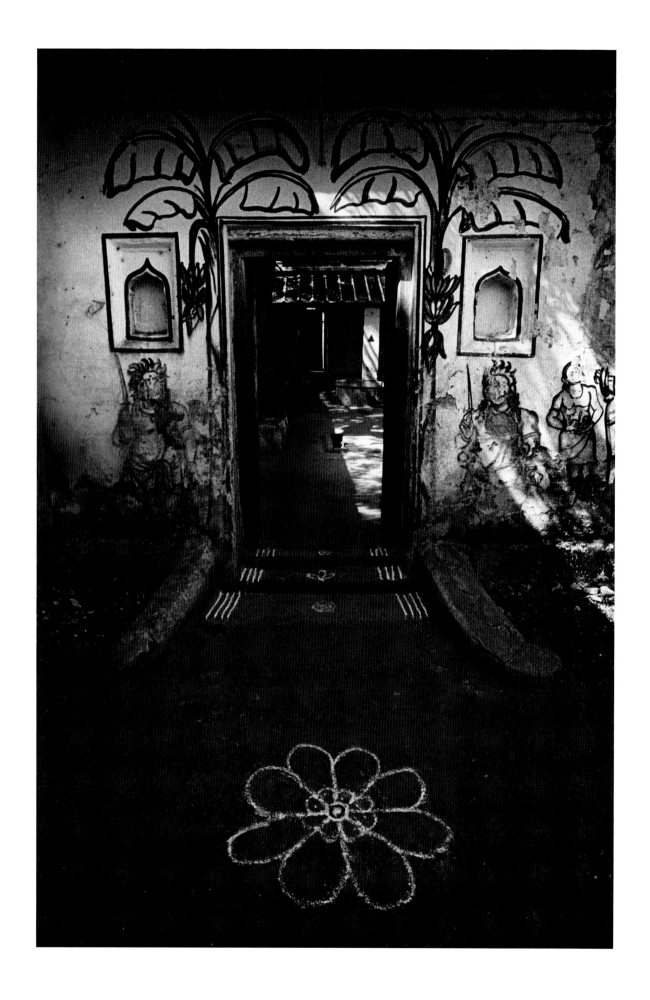

Plate 12

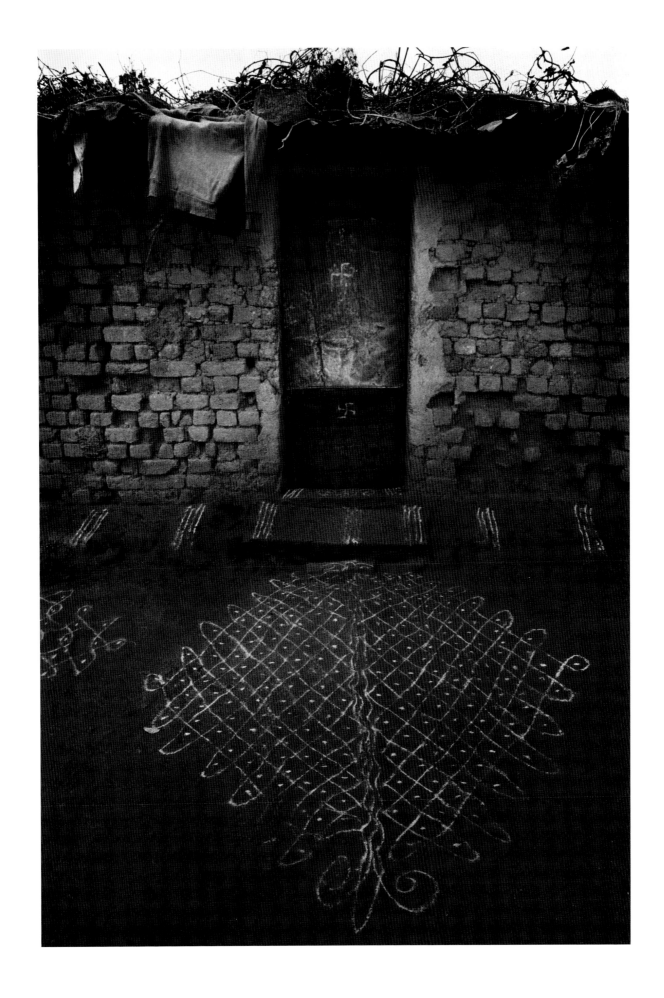

Plate 13

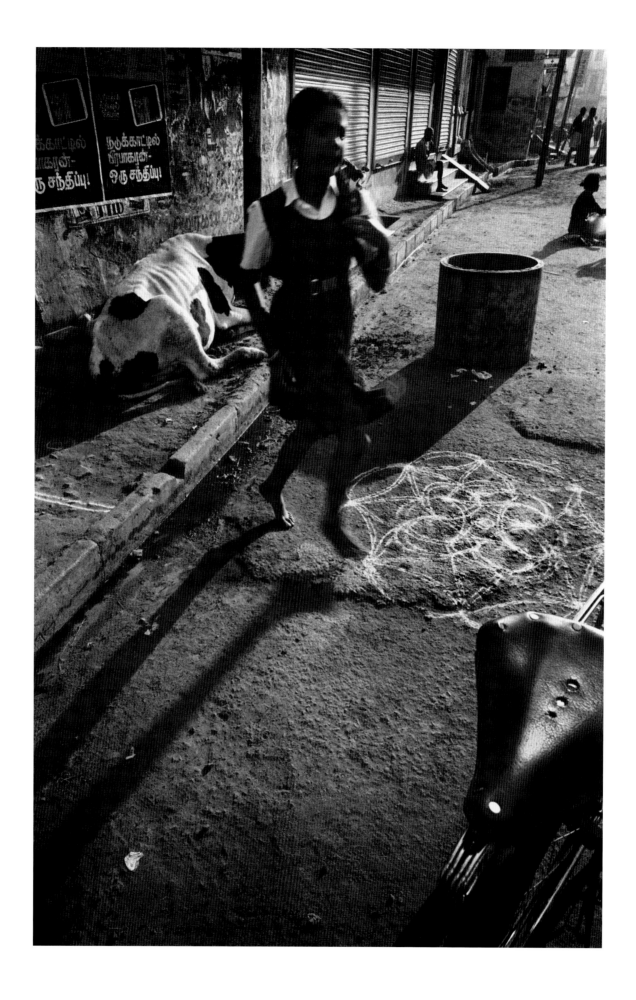

Plate 14

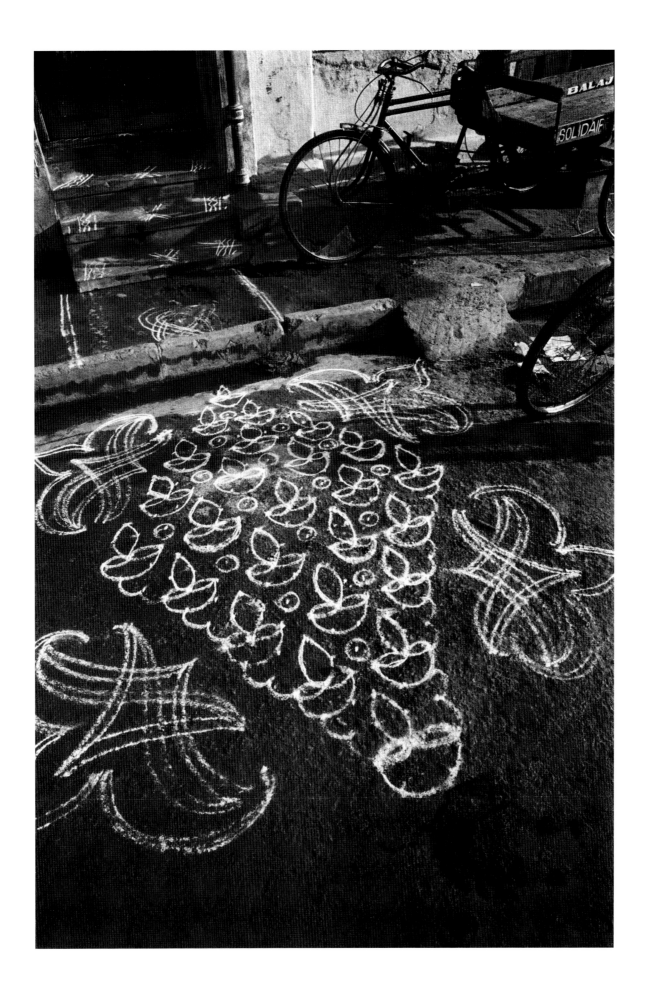

Plate 15

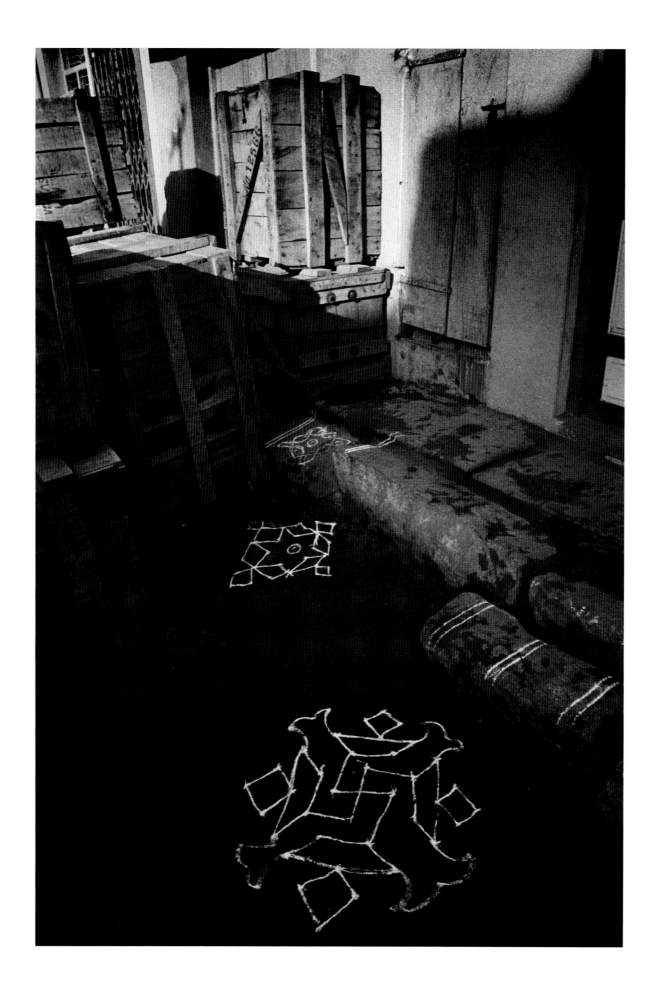

Plate 16

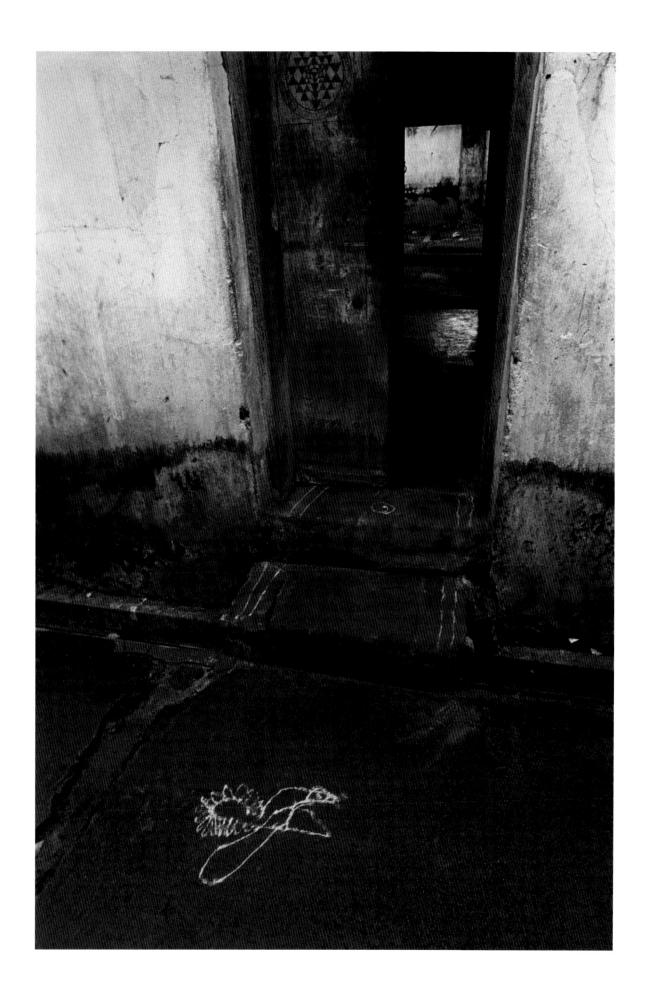

Plate 17

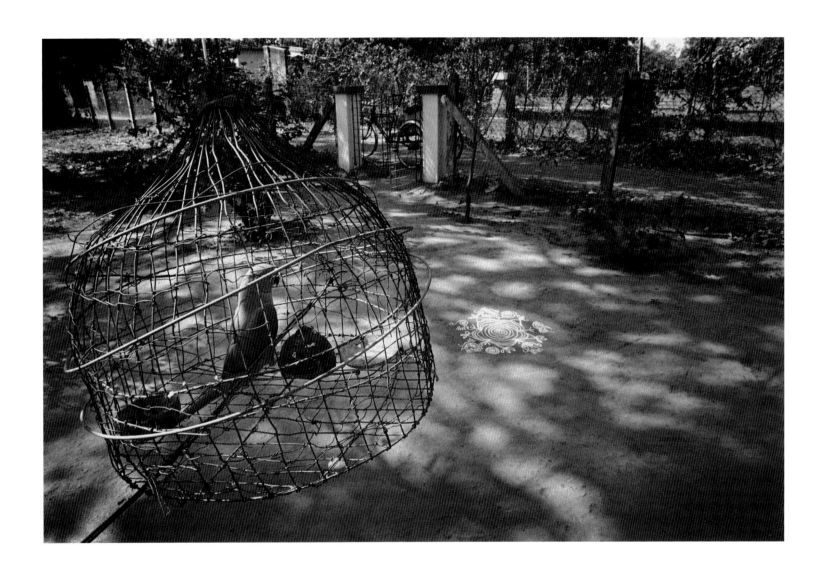

Plate 18

Plate 19

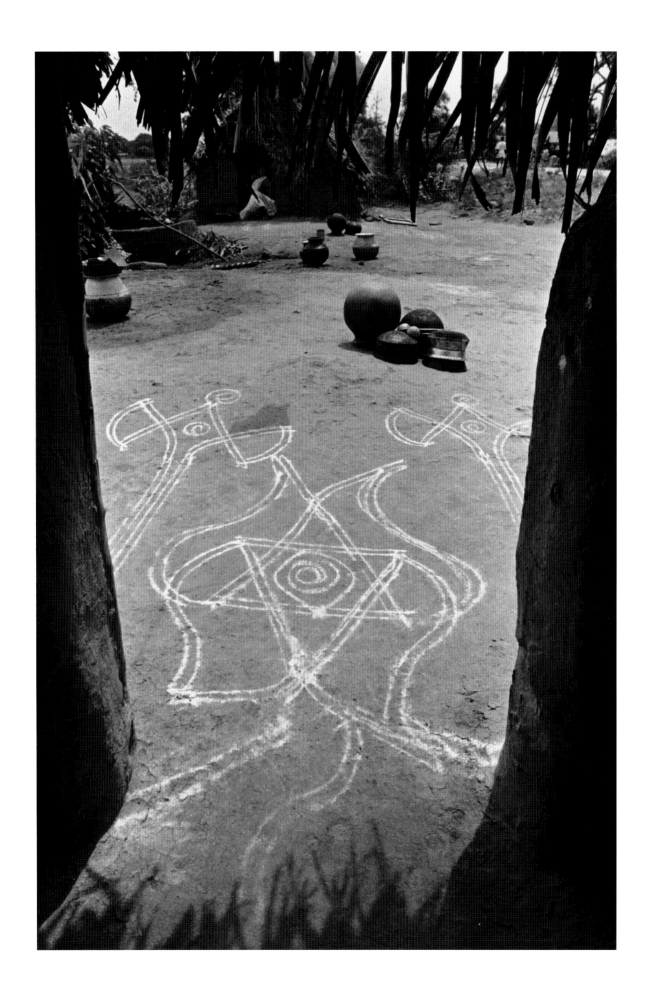

Plate 20

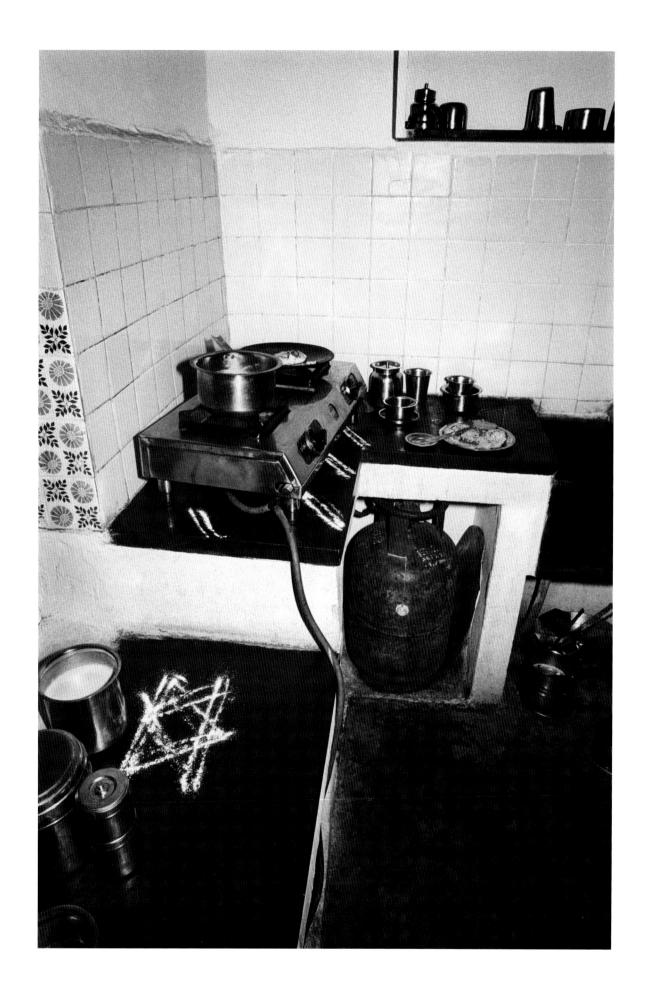

Plate 21

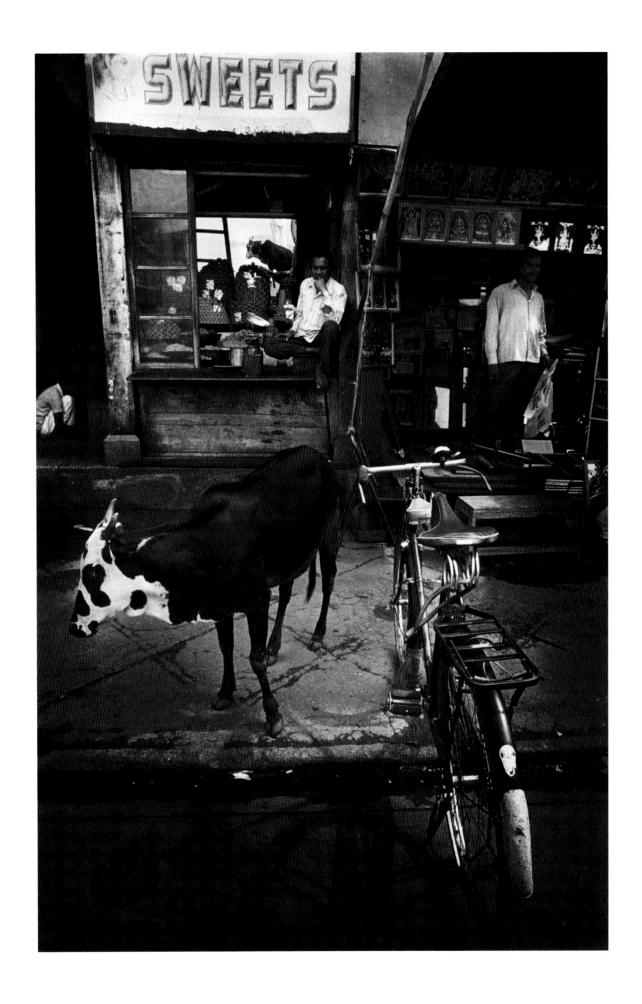

Plate 22

Plate 23

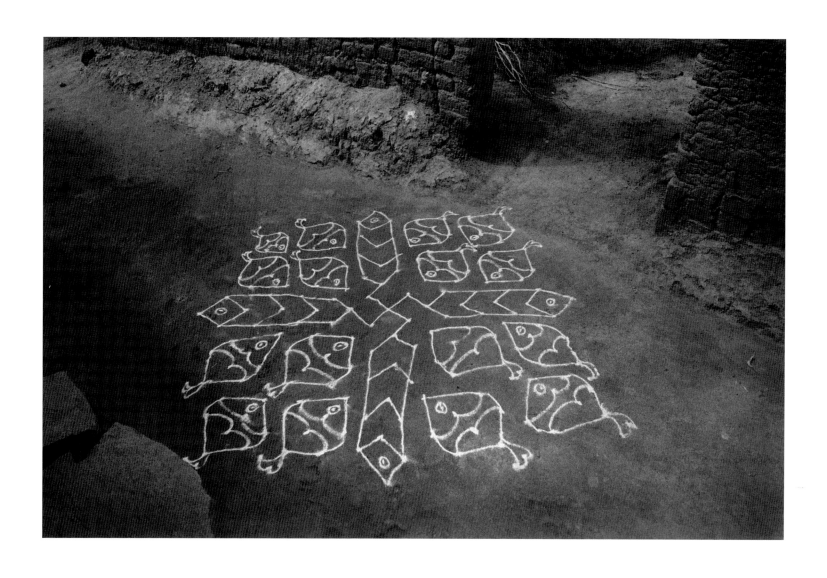

Plate 24

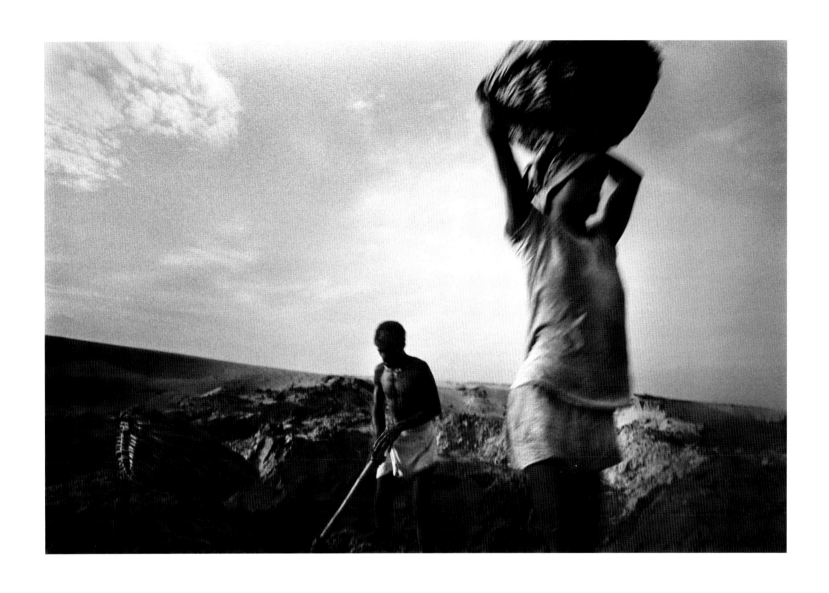

Plate 25

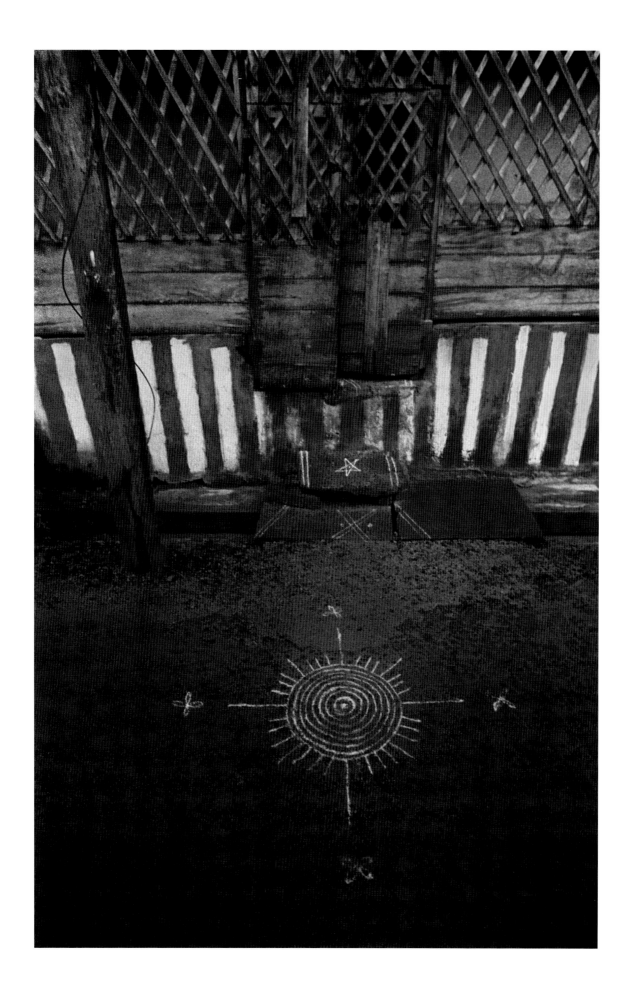

Plate 26

Plate 27

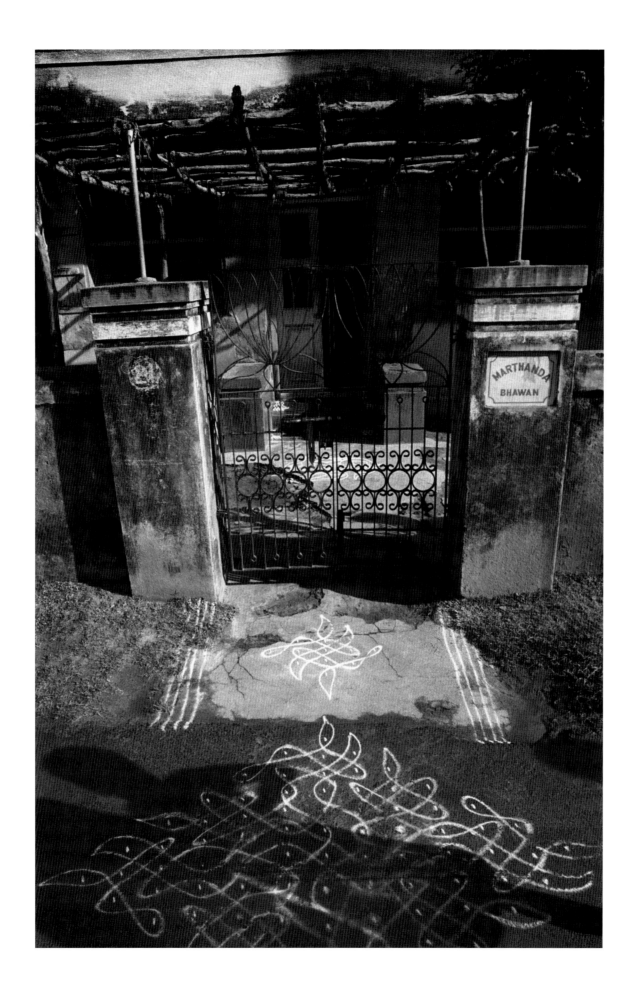

Plate 28

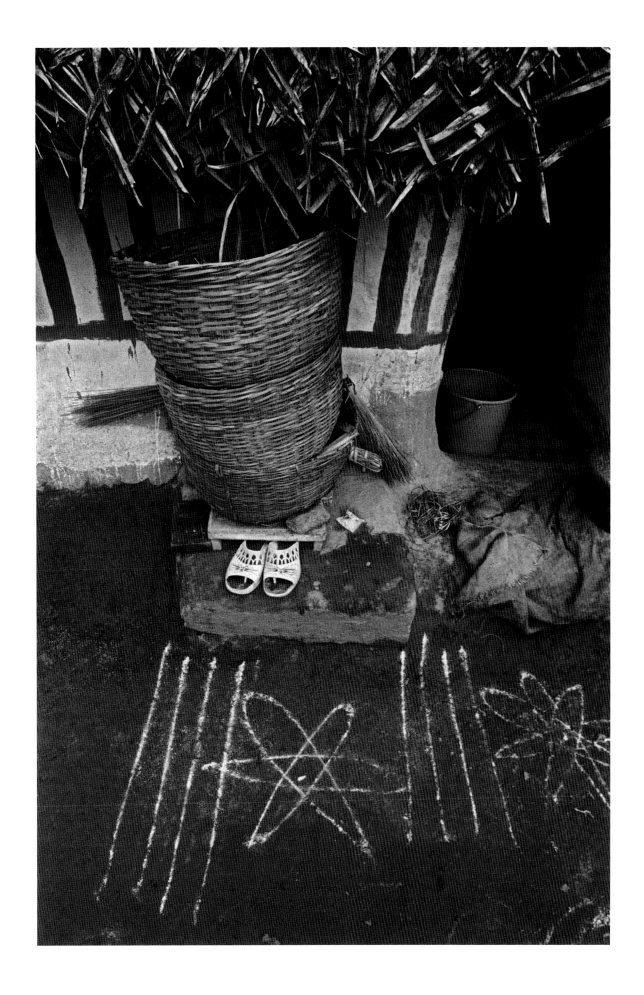

Plate 29

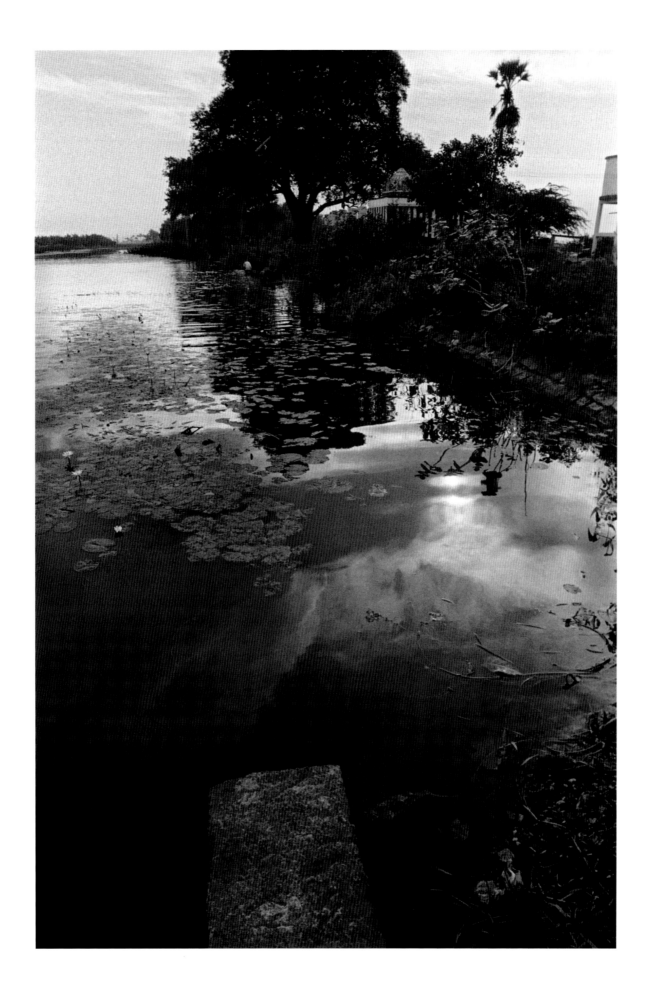

Plate 30

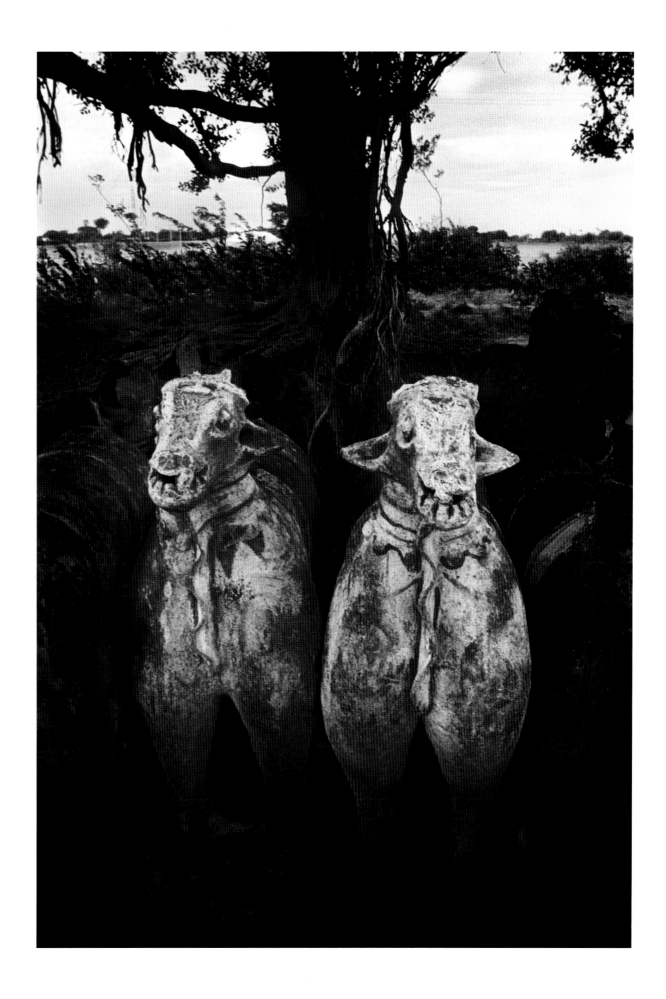

Plate 31

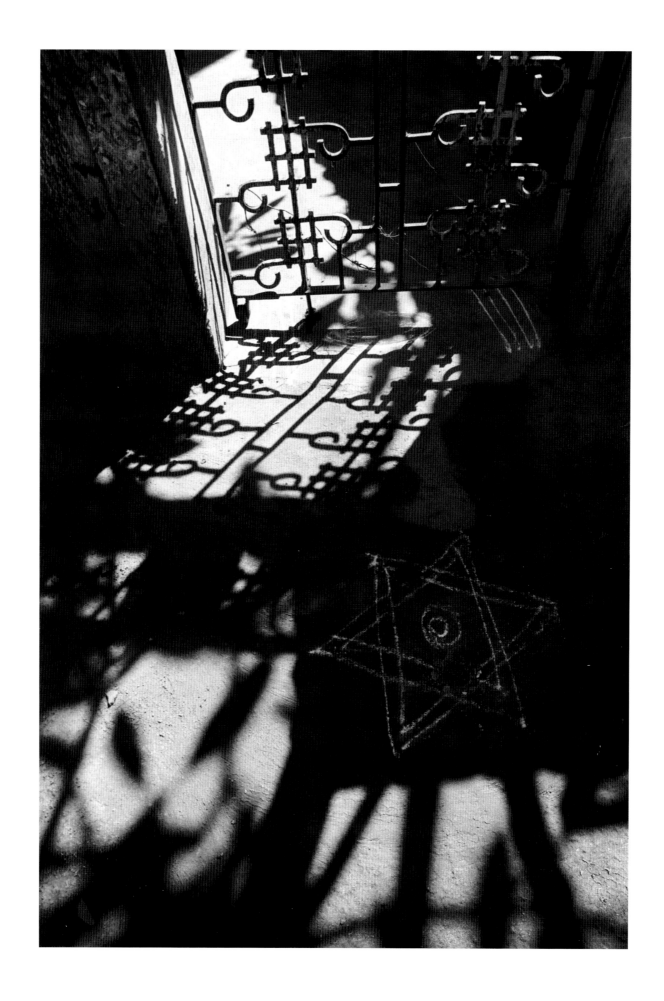

Plate 32

PORTFOLIO II

The Chromogenic Prints

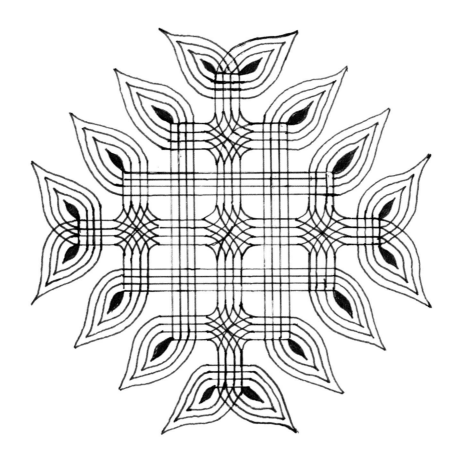

Drawing C

In both the arts and sciences the programmed brain seeks elegance, which is the parsimonious and evocative description of pattern to make sense out of a confusion of detail.

—Edward O. Wilson (1998)

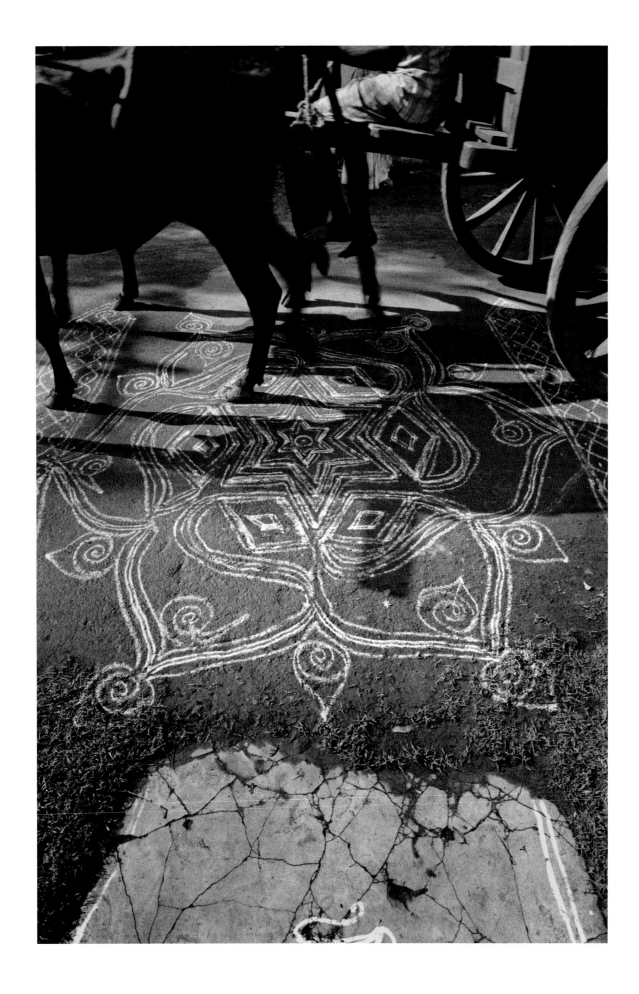

Plate 33

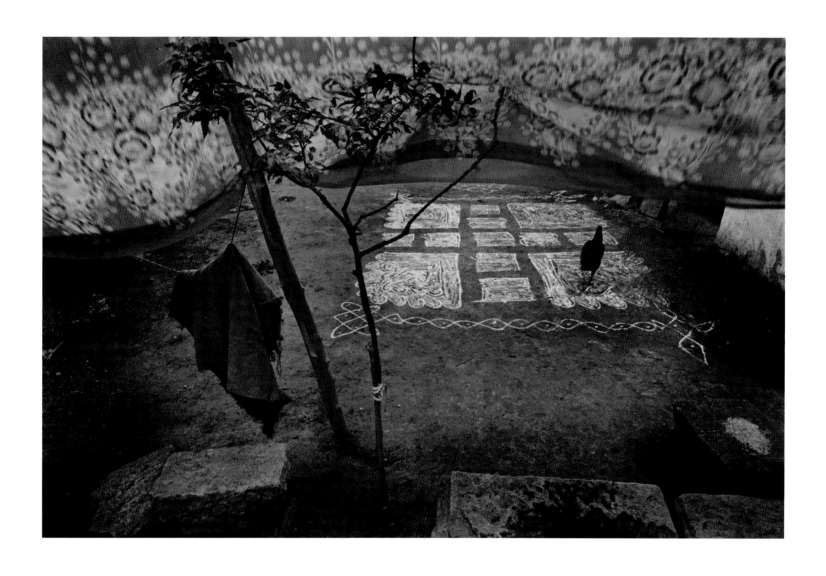

Plate 34

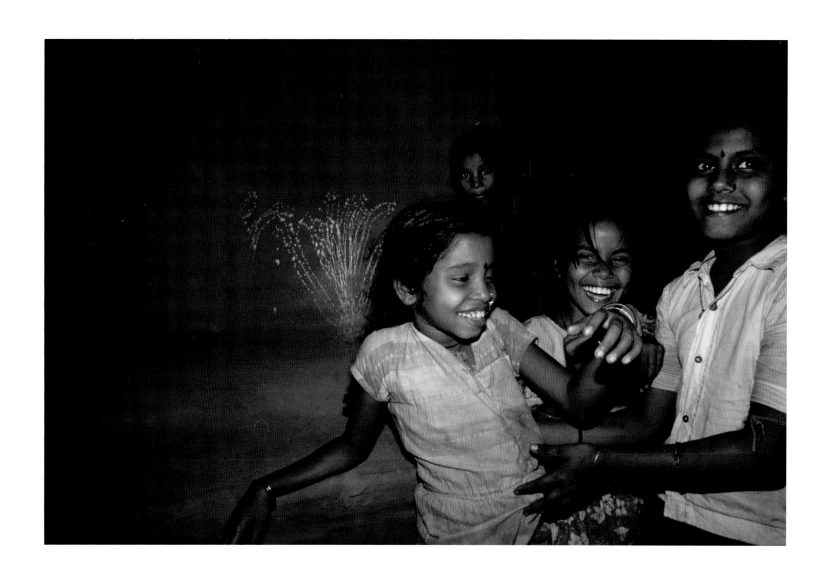

Plate 35

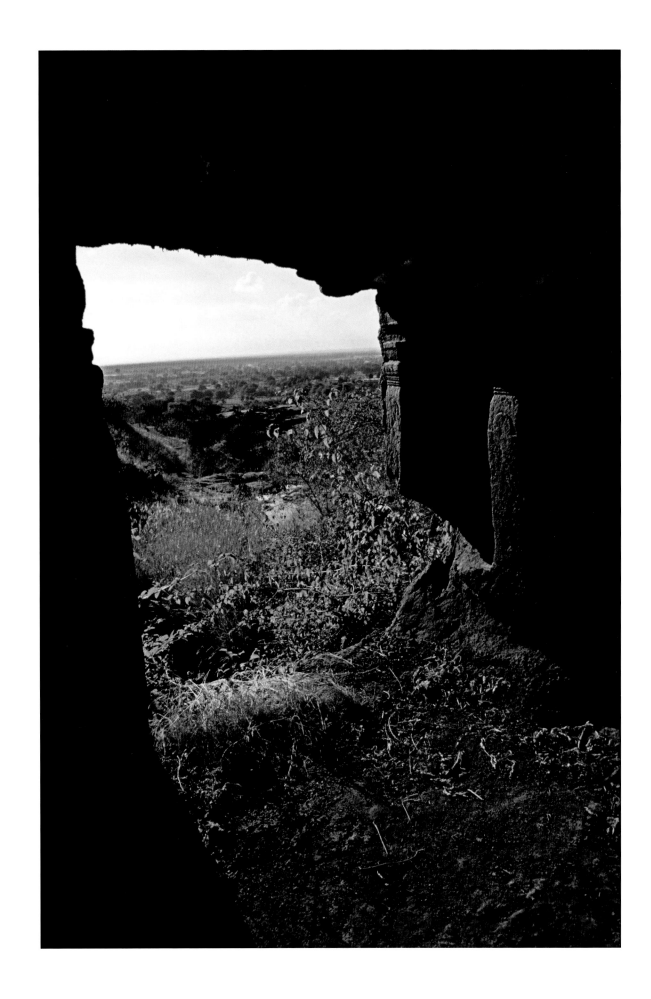

Plate 36

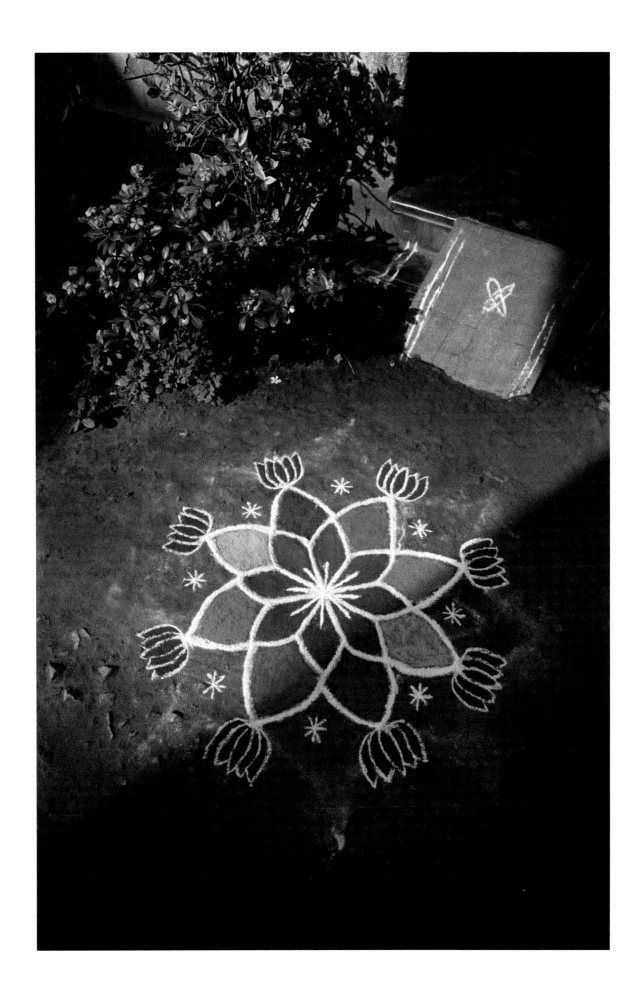

Plate 37

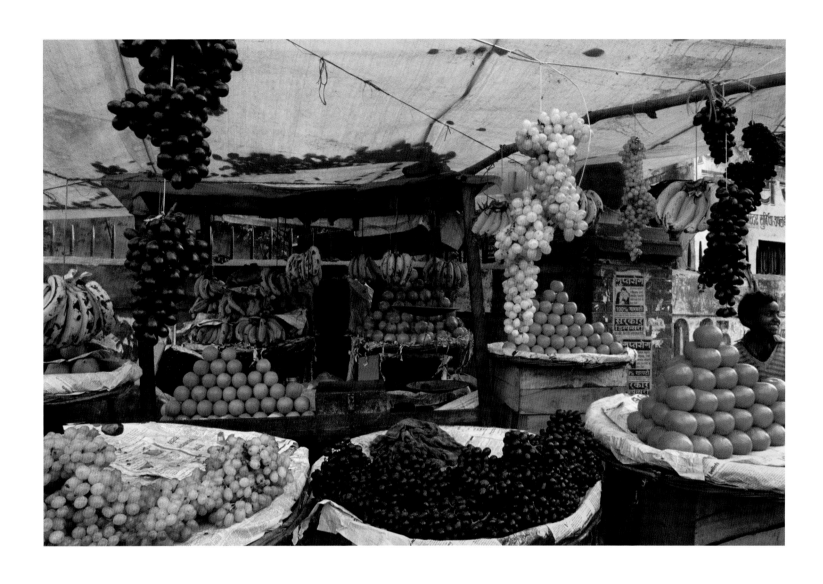

Plate 38

Plate 39

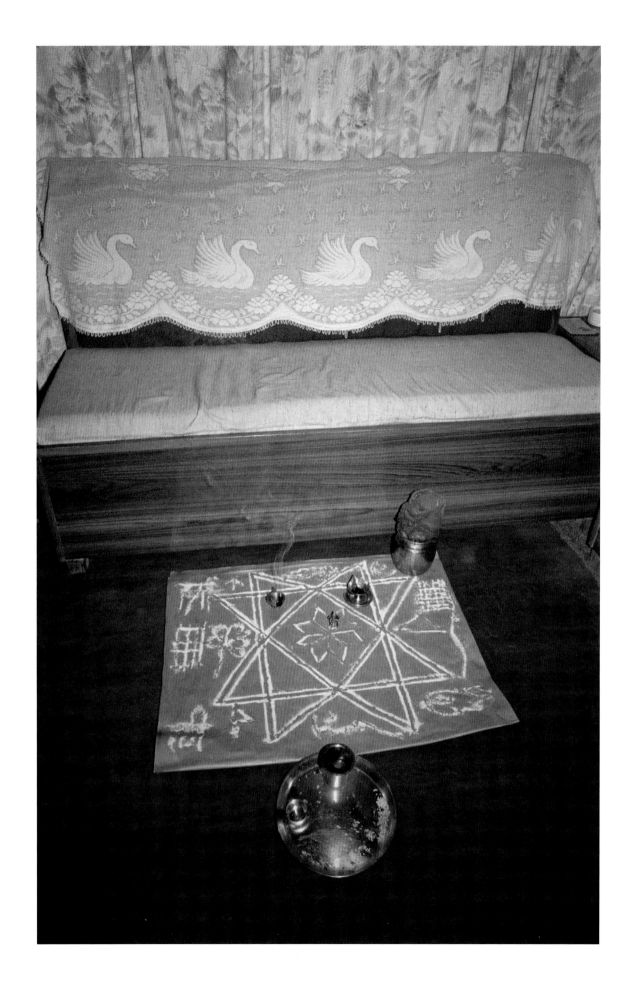

Plate 40

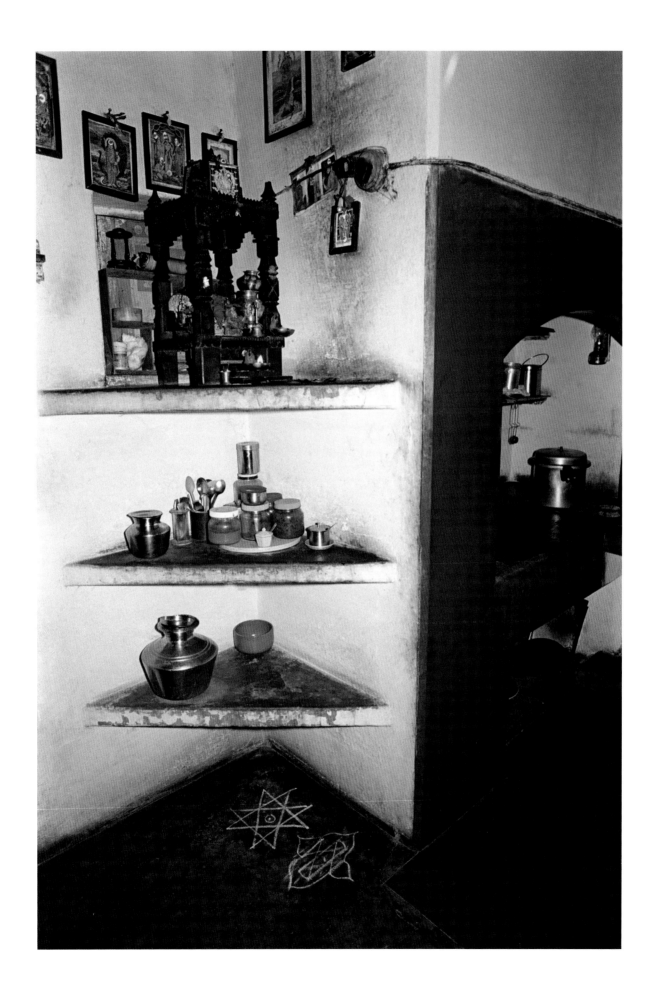

Plate 41

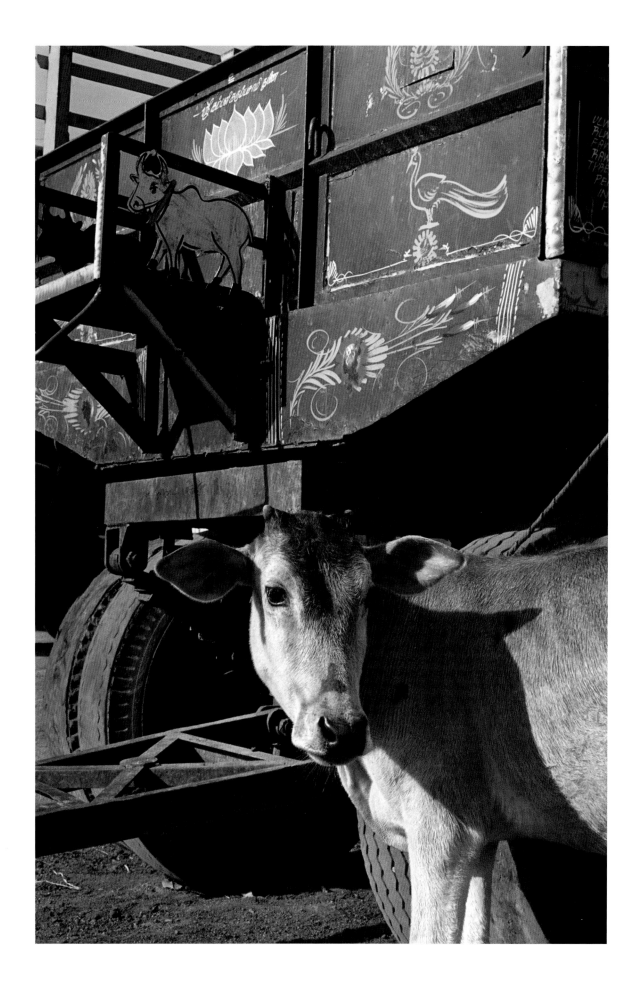

Plate 42

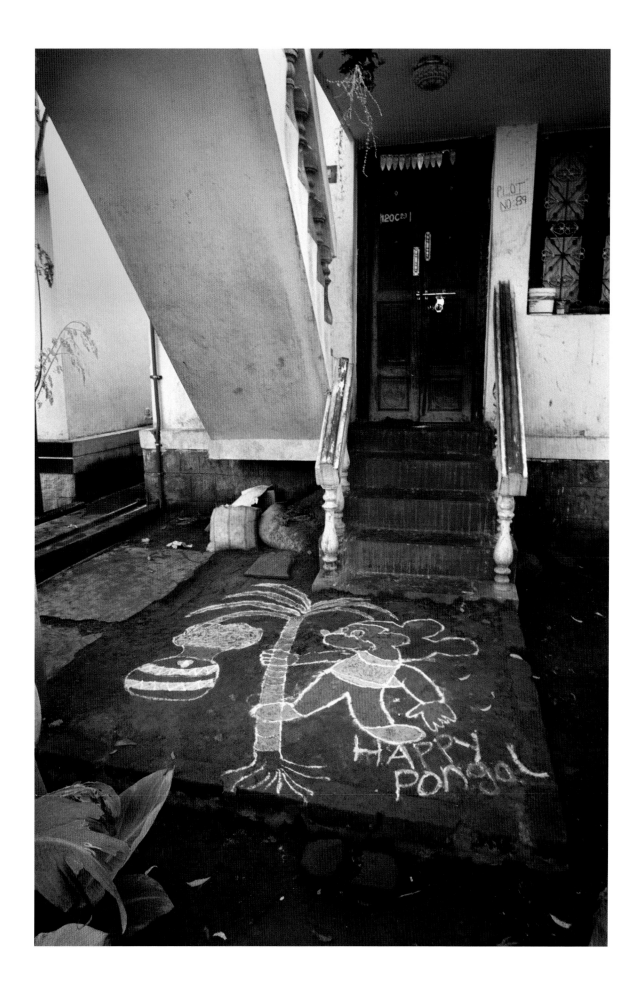

Plate 43

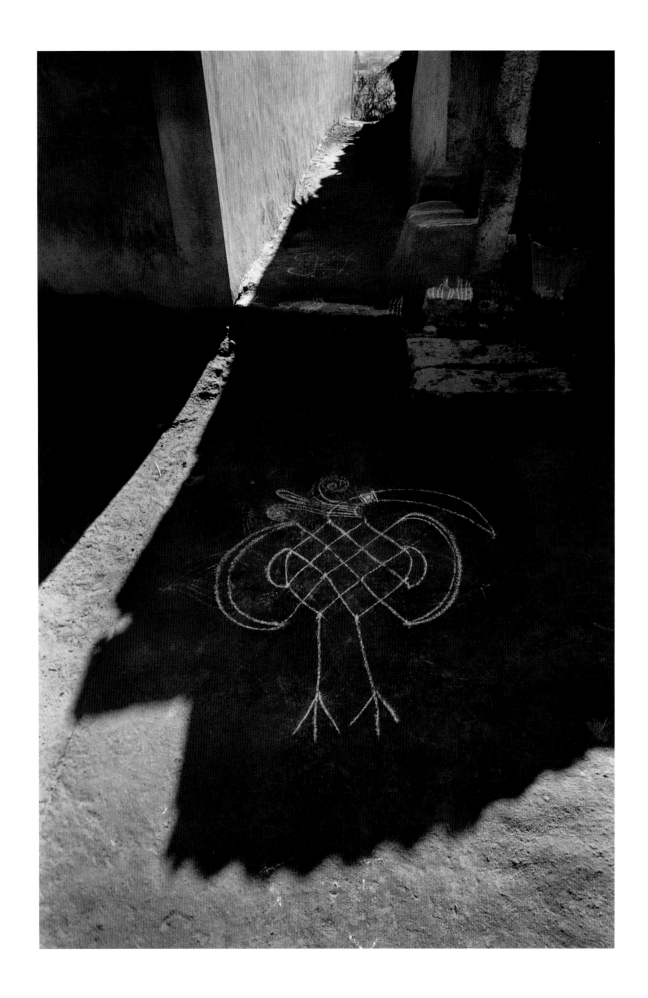

Plate 44

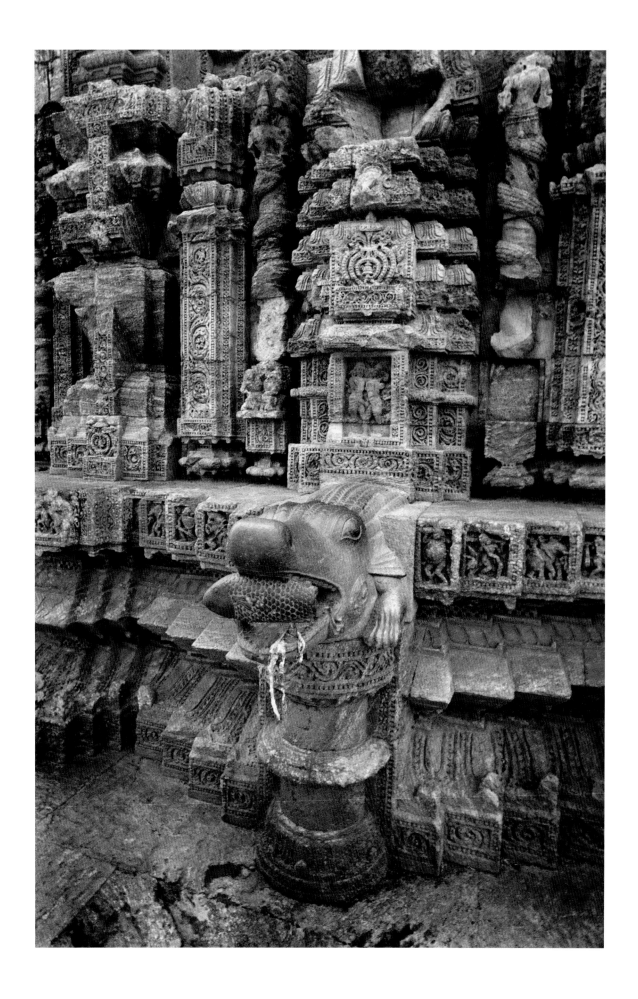

Plate 45

Plate 46

Plate 47

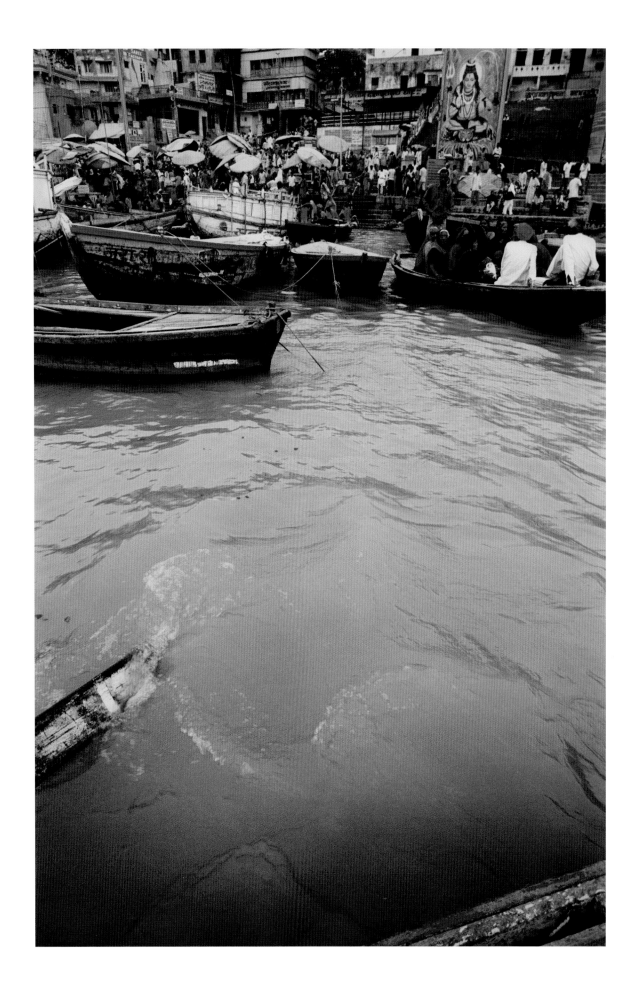

Plate 48

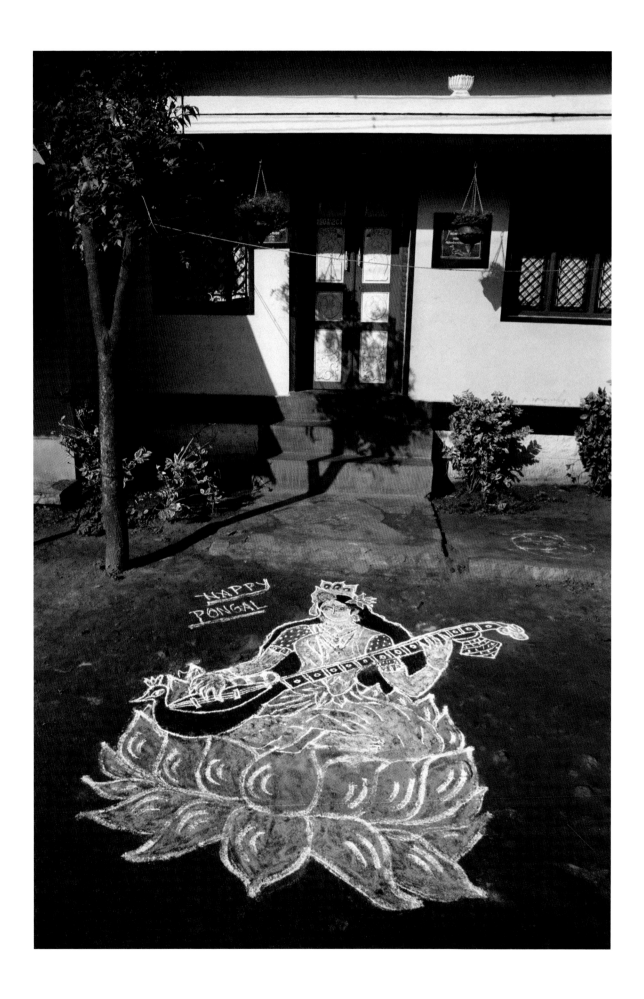

Plate 49

Plate 50

Plate 51

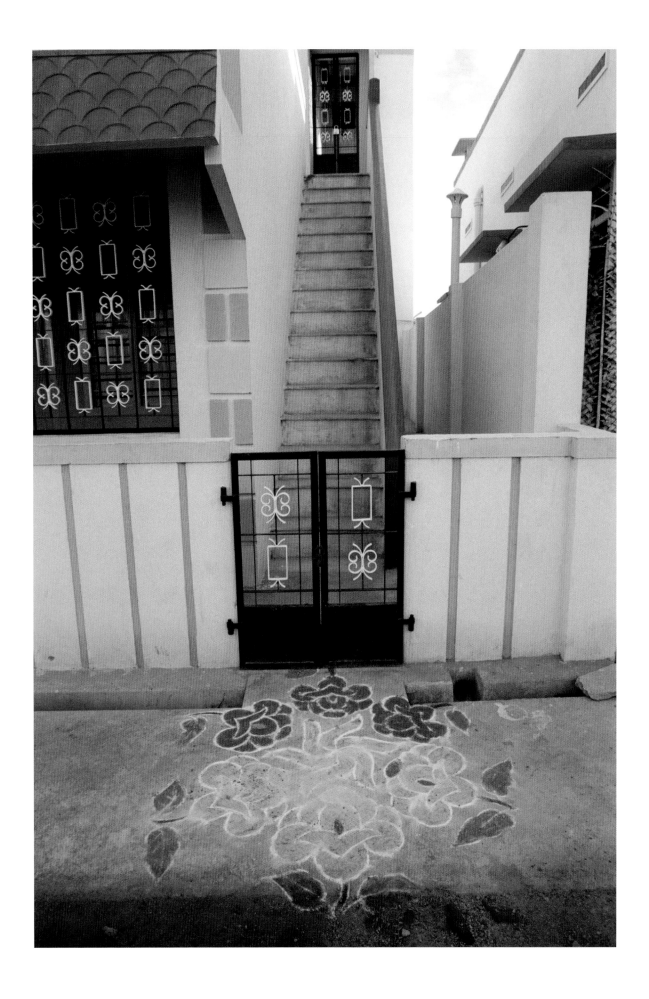

Plate 52

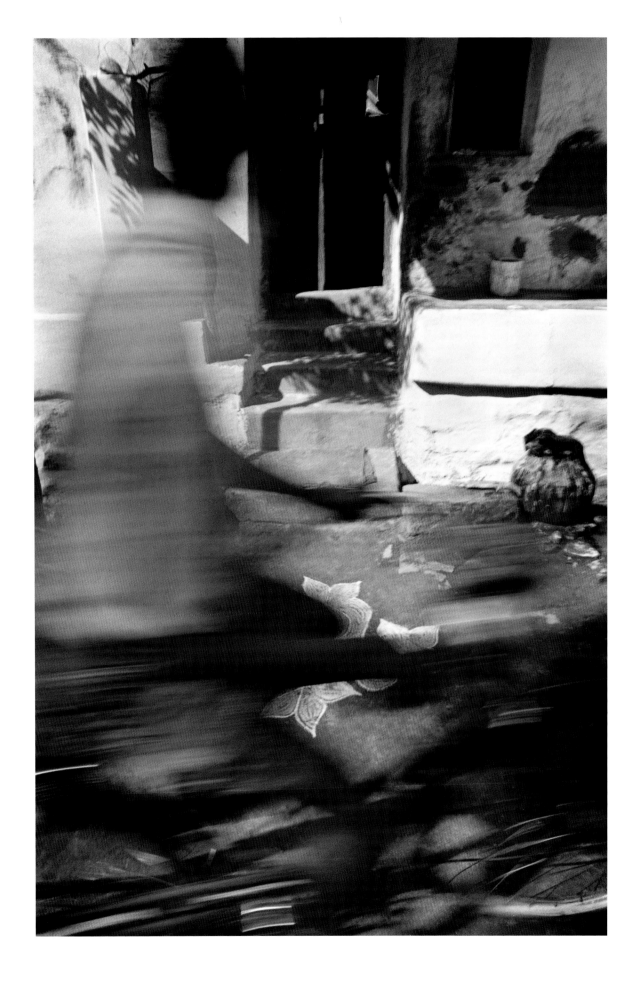

Plate 53

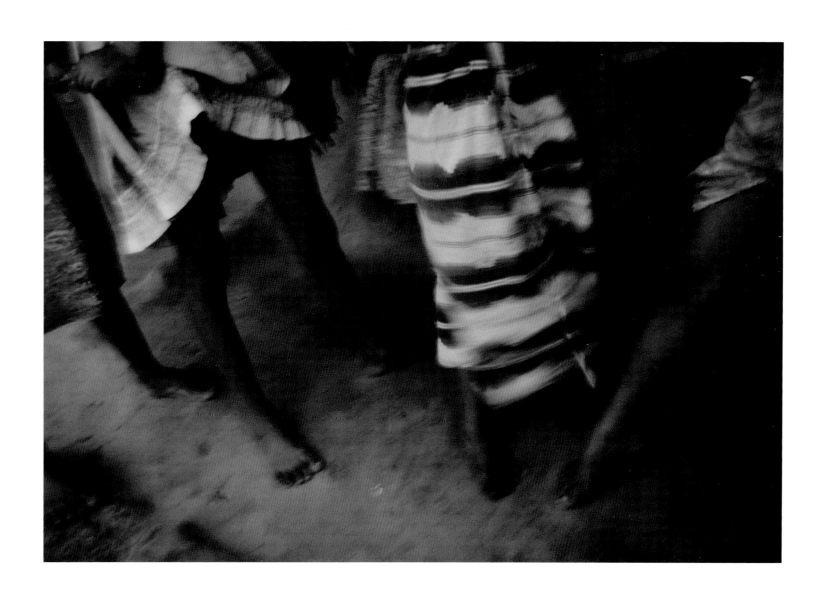

Plate 54

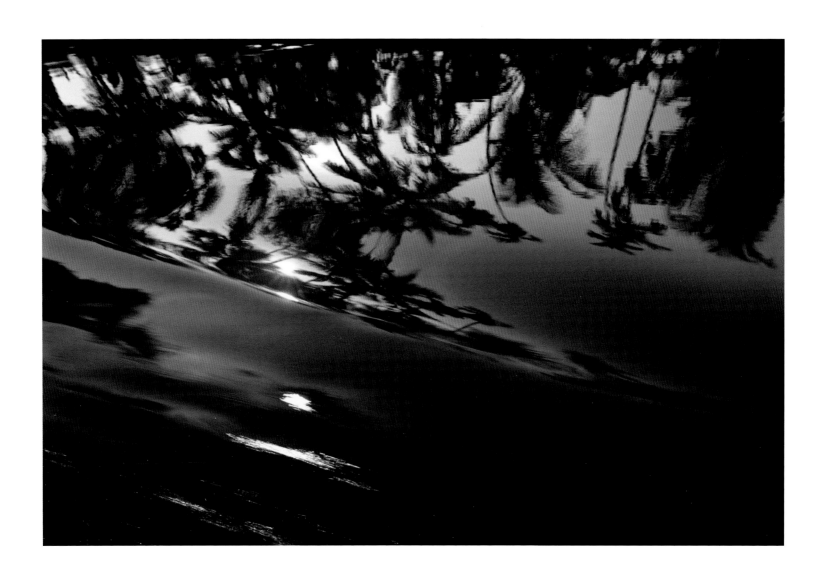

Plate 55

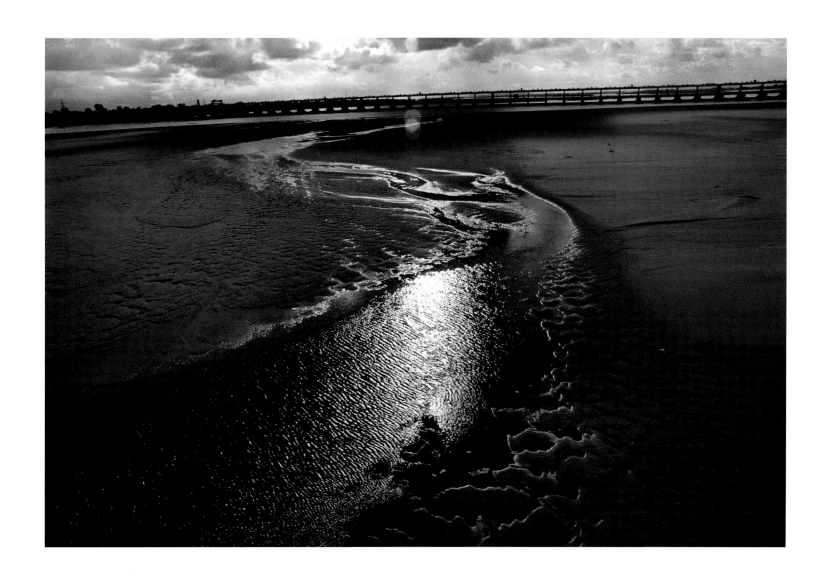

Plate 56

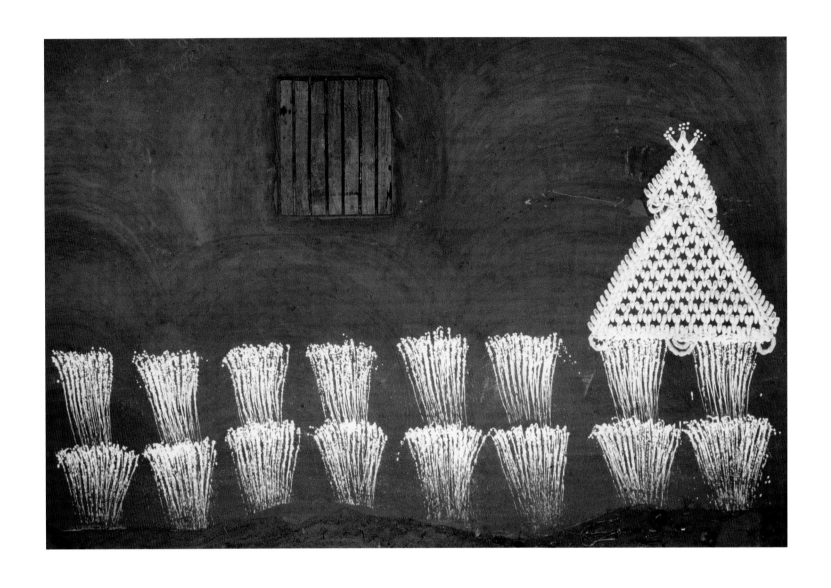

Plate 57

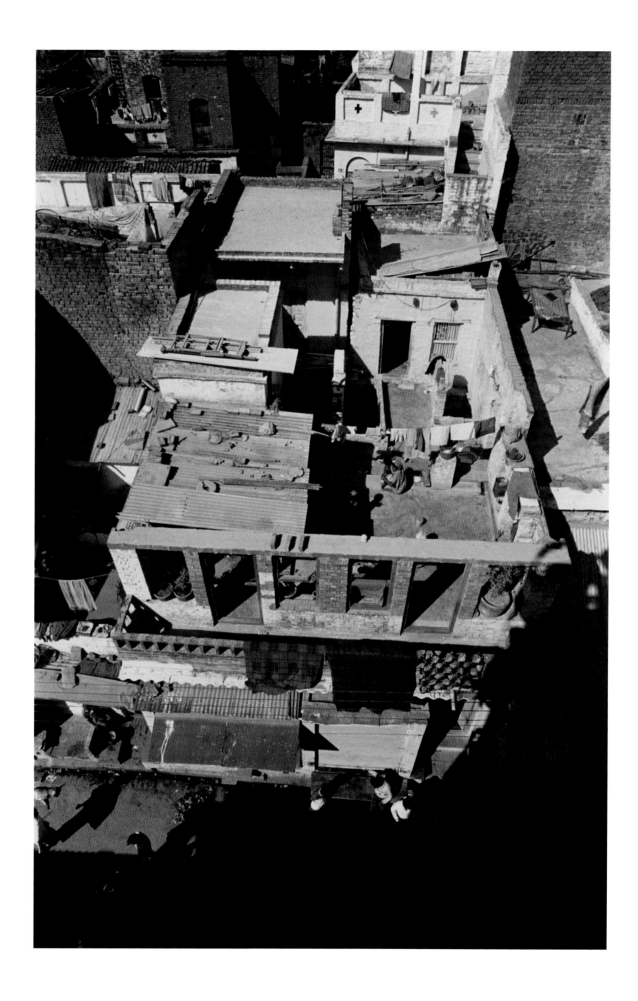

Plate 58

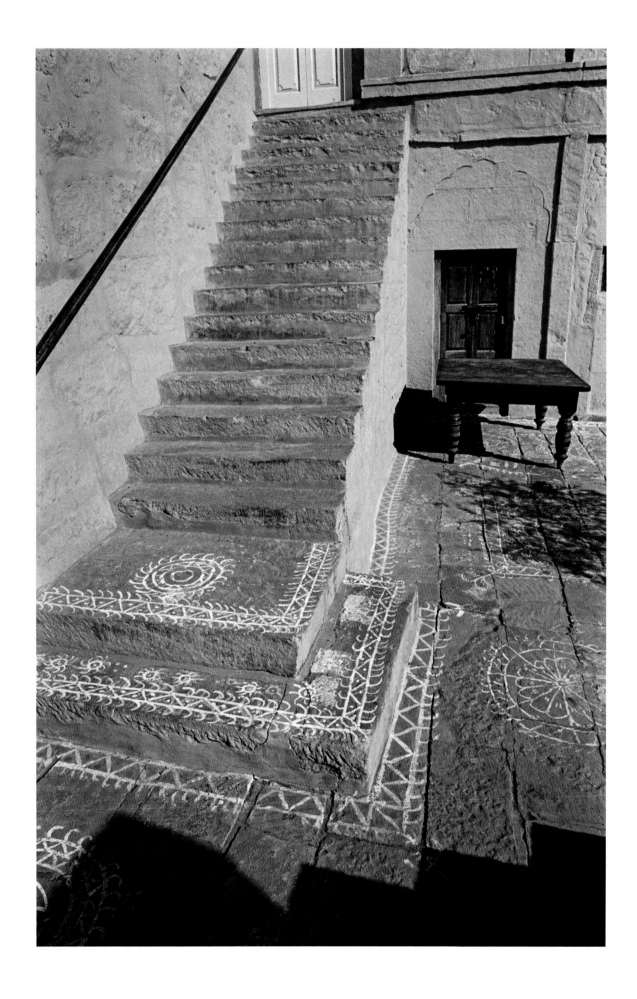

Plate 59

Plate 60

Plate 61

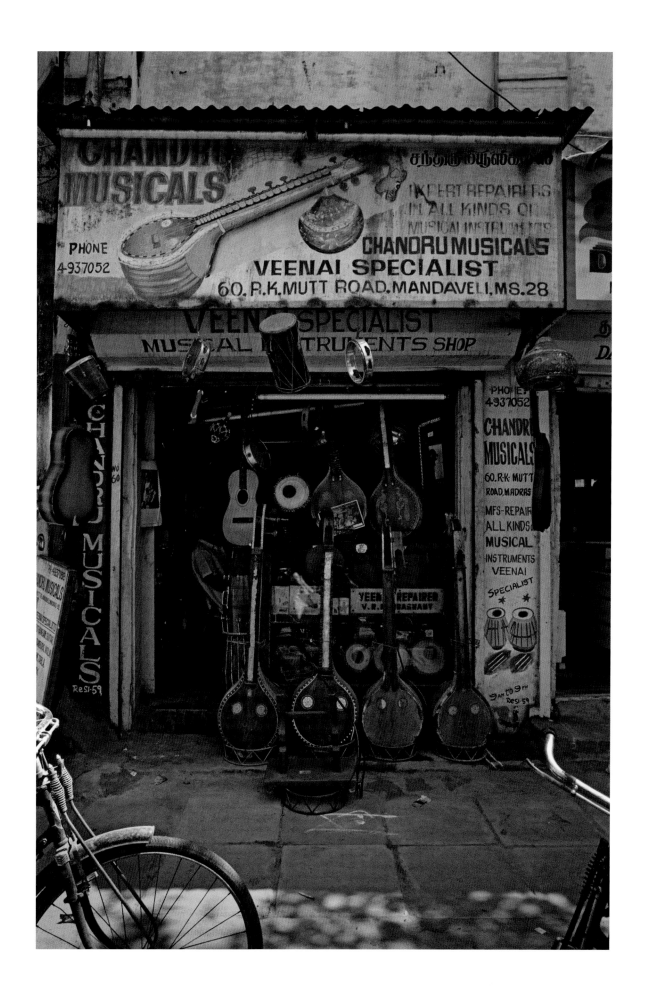

Plate 62

Plate 63

Plate 64

Plate 65

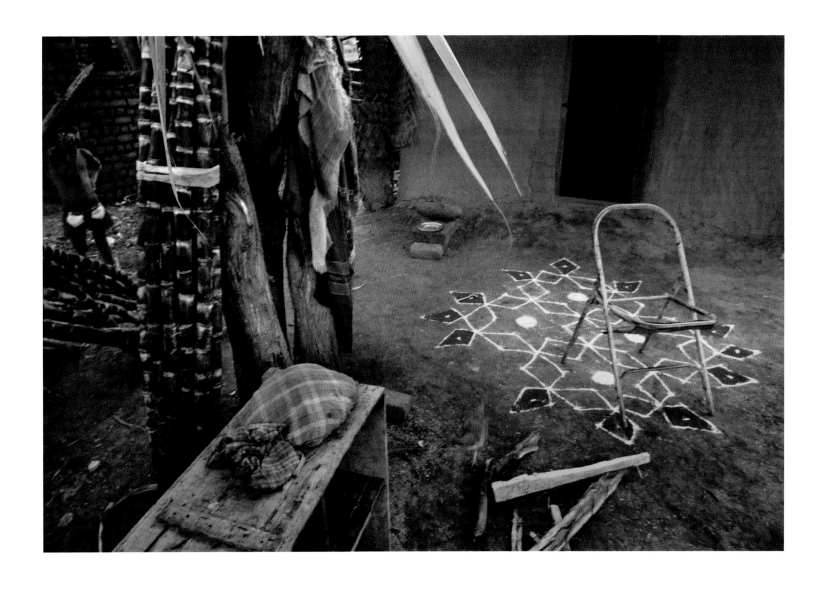

Plate 66

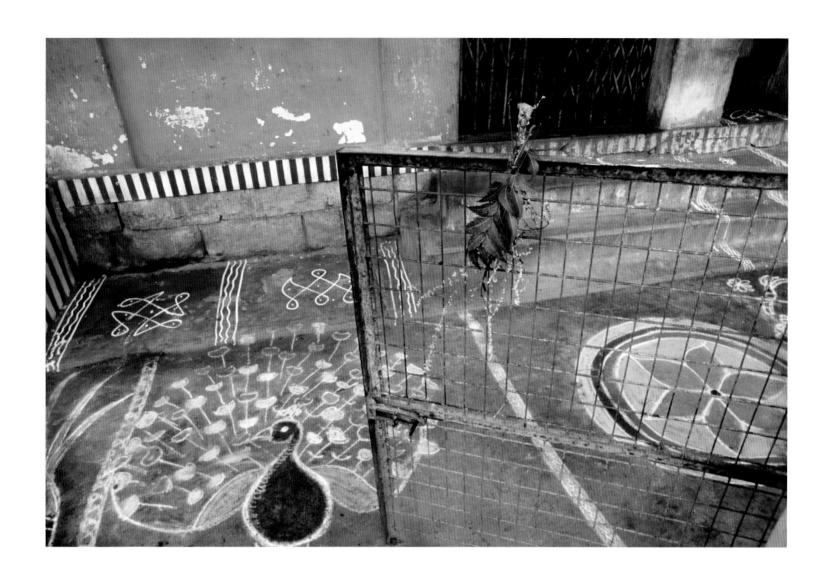

Plate 67

Plate 68

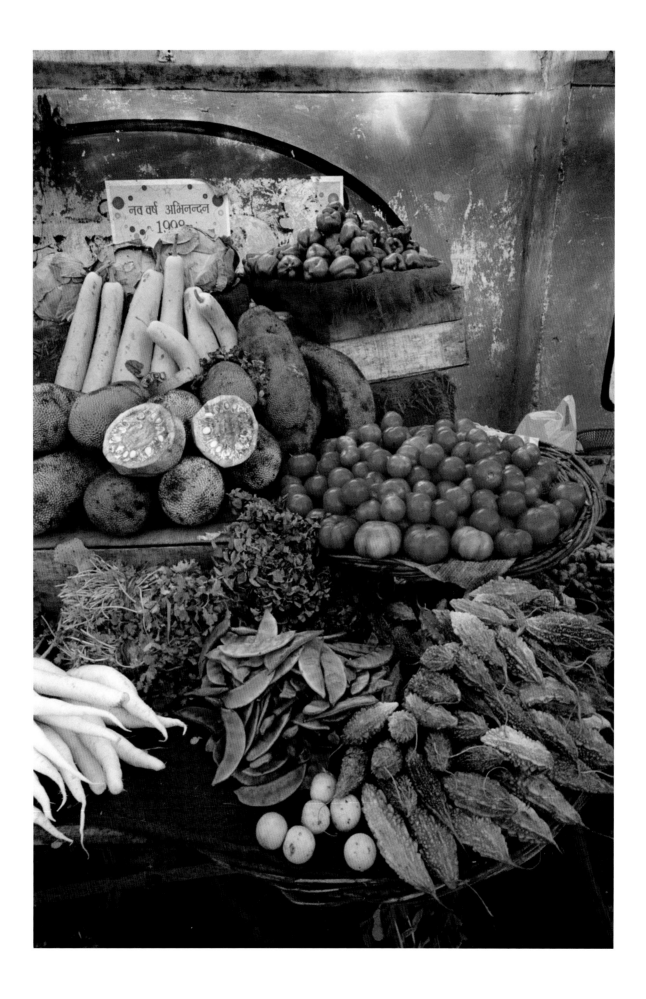

Plate 69

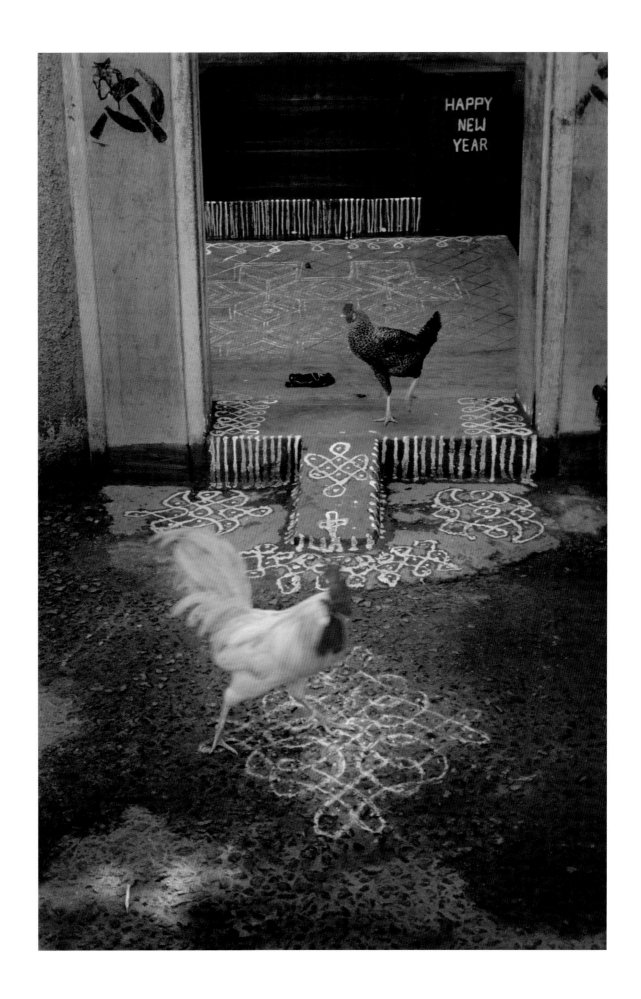

Plate 70

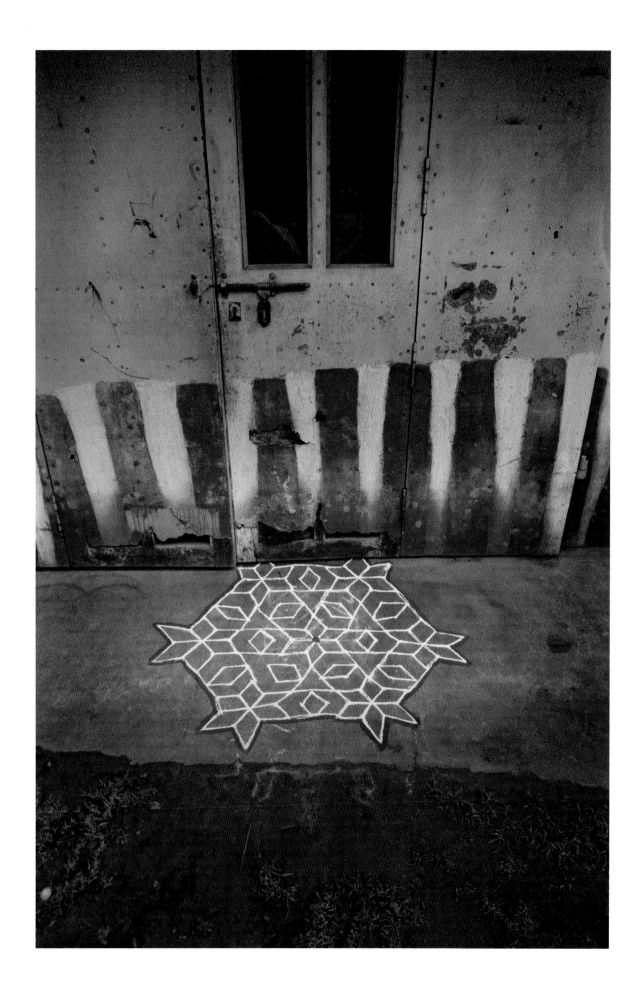

Plate 71

Plate 72

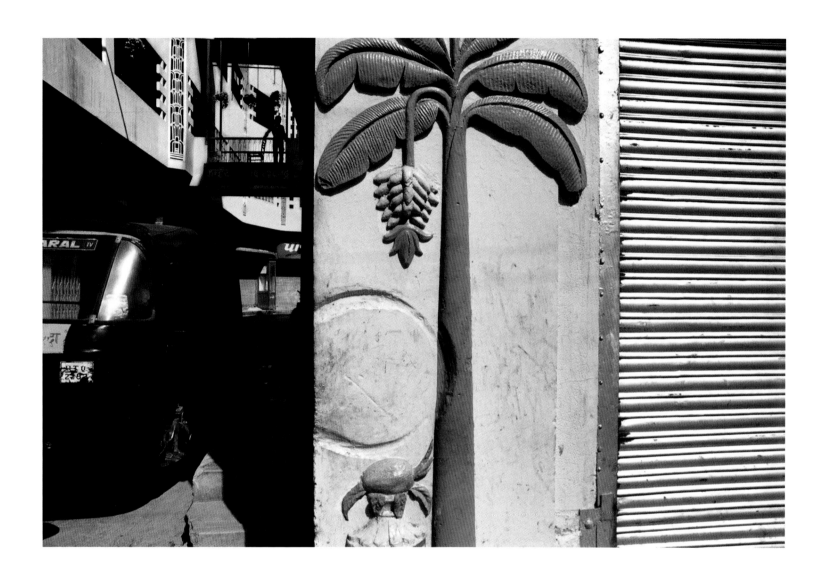

Plate 73

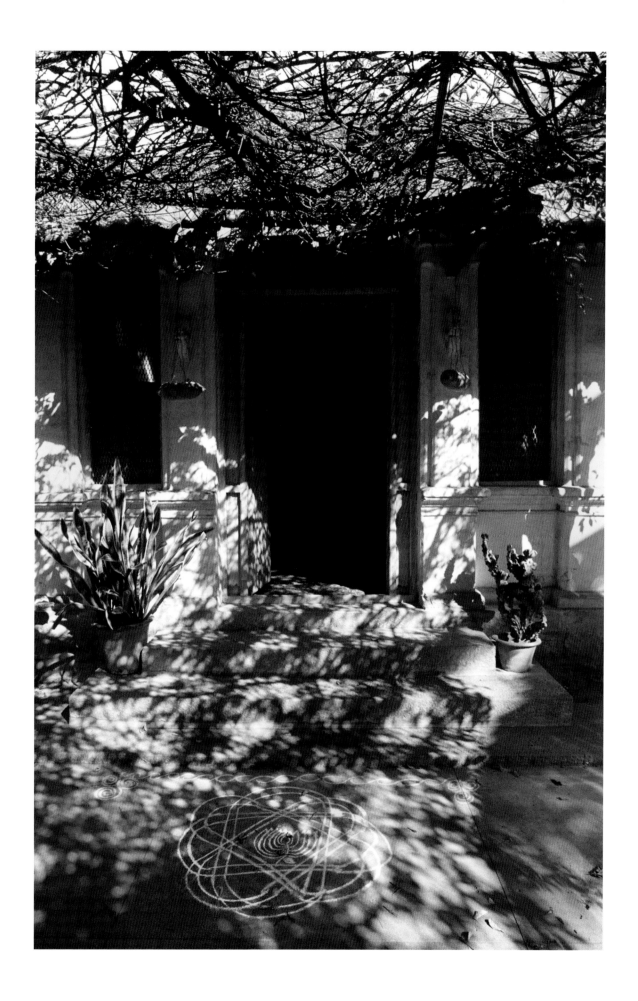

Plate 74

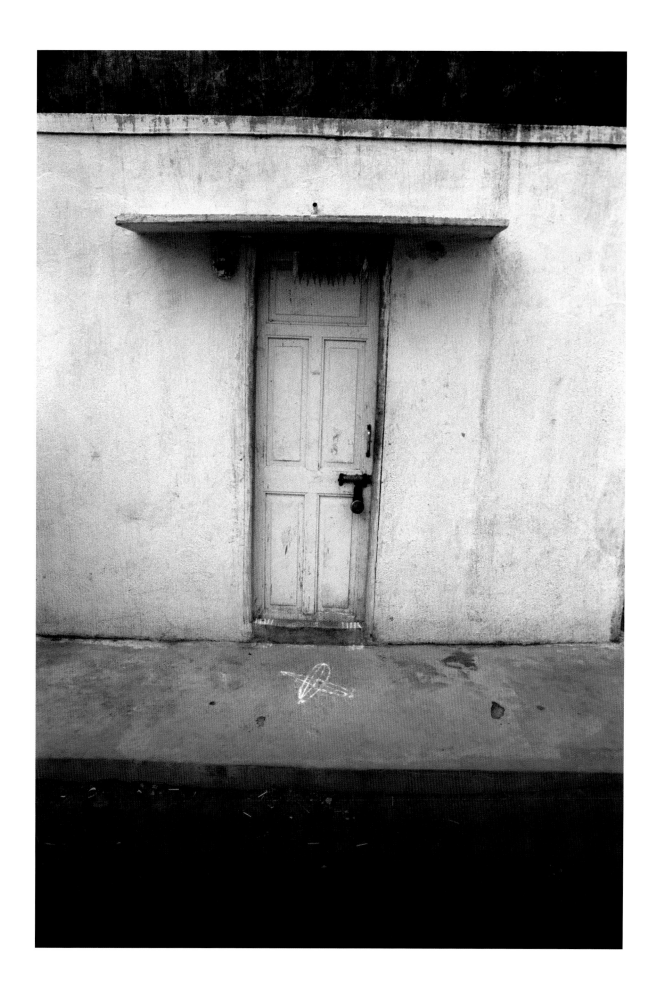

Plate 75

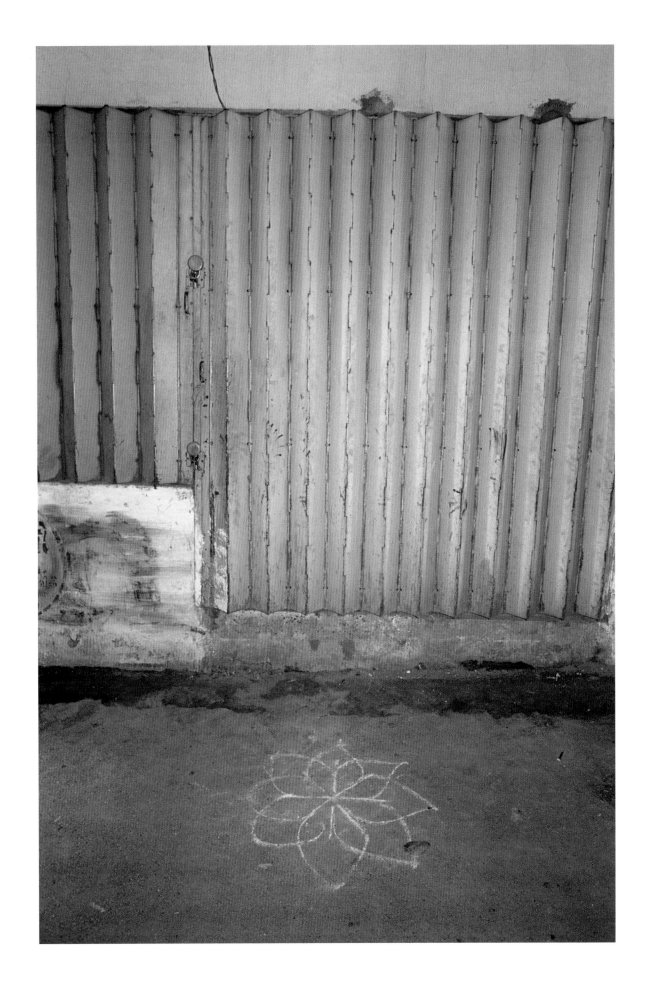

Plate 76

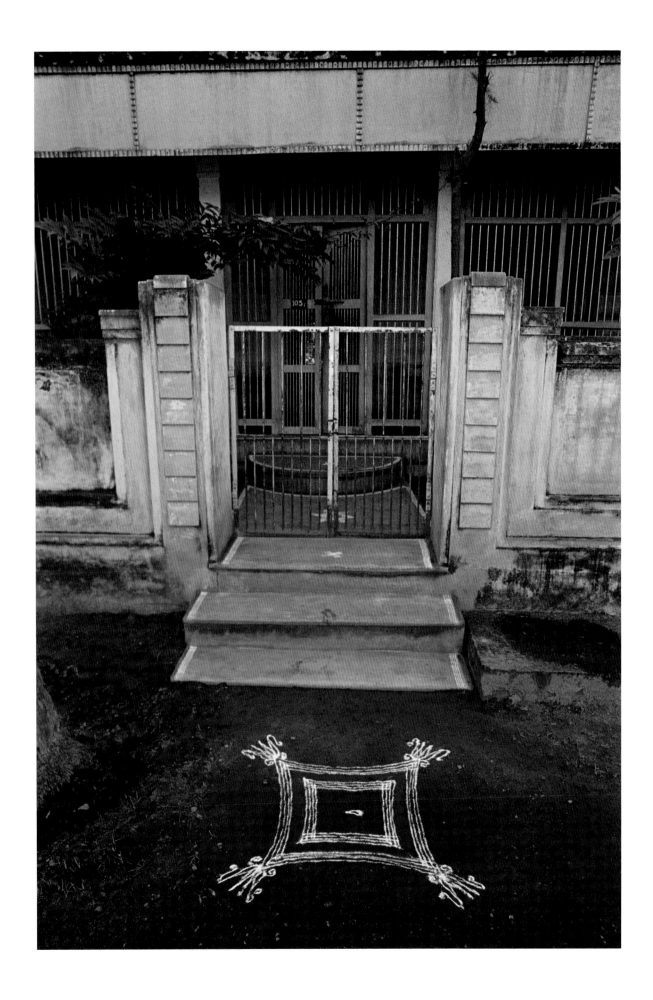

Plate 77

Plate 78

Plate 79

Plate 80

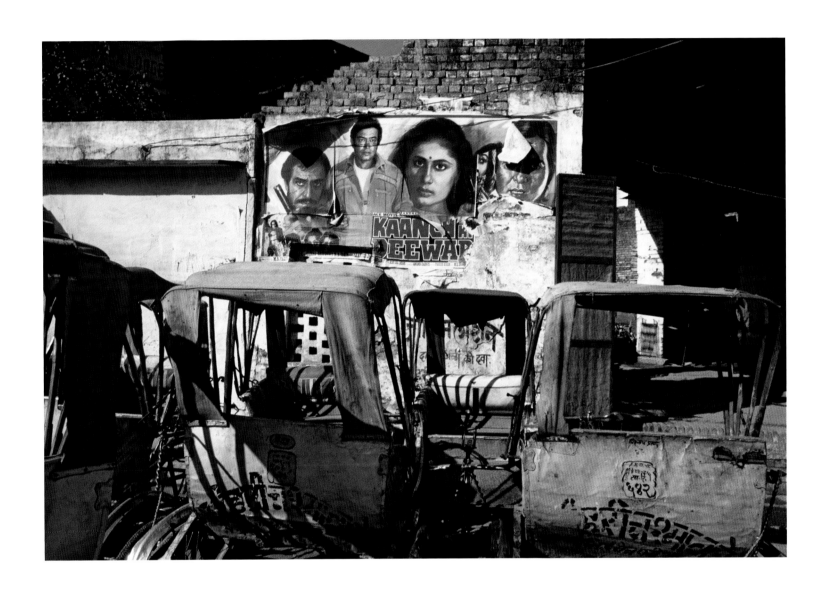

Plate 81

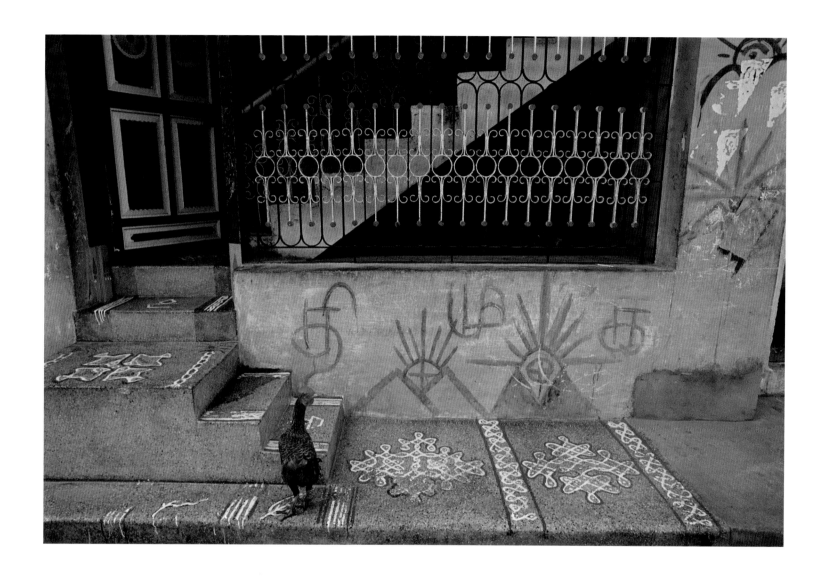

Plate 82

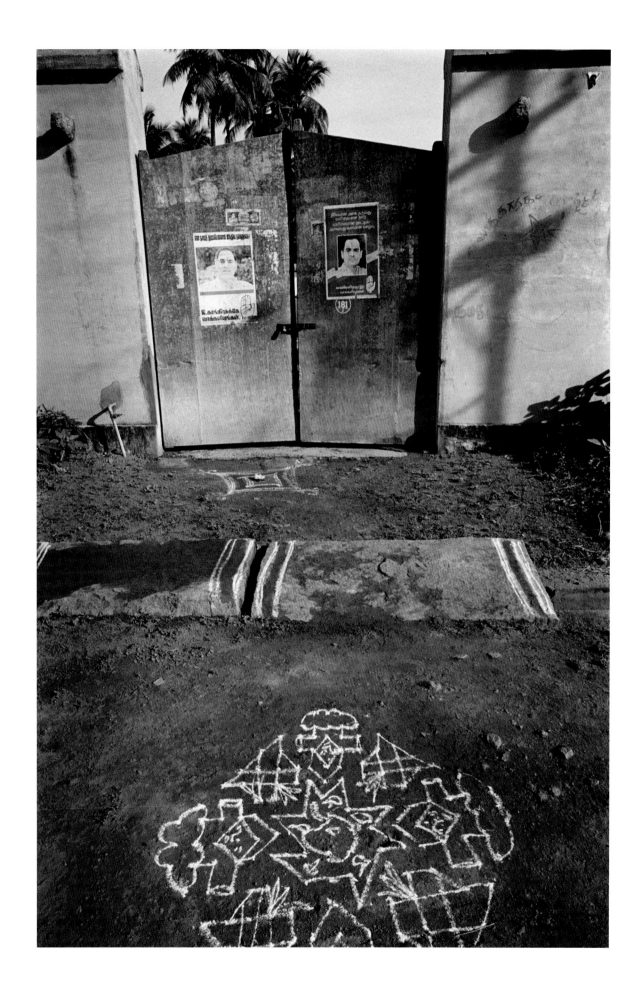

Plate 83

Plate 84

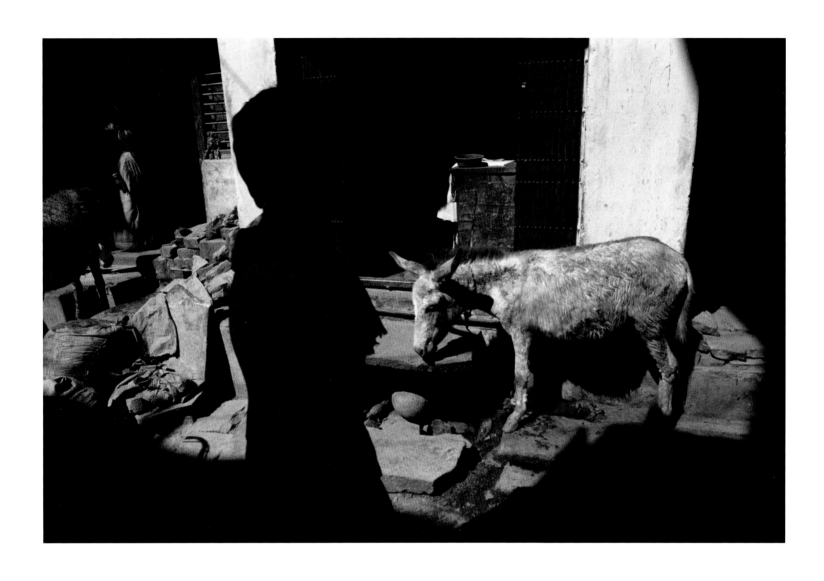

Plate 85

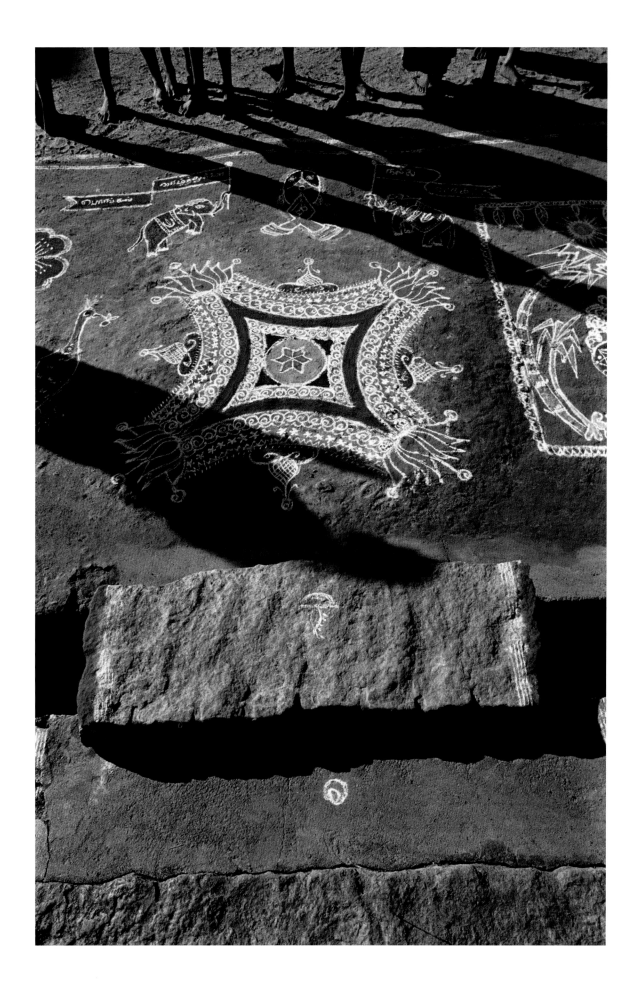

Plate 86

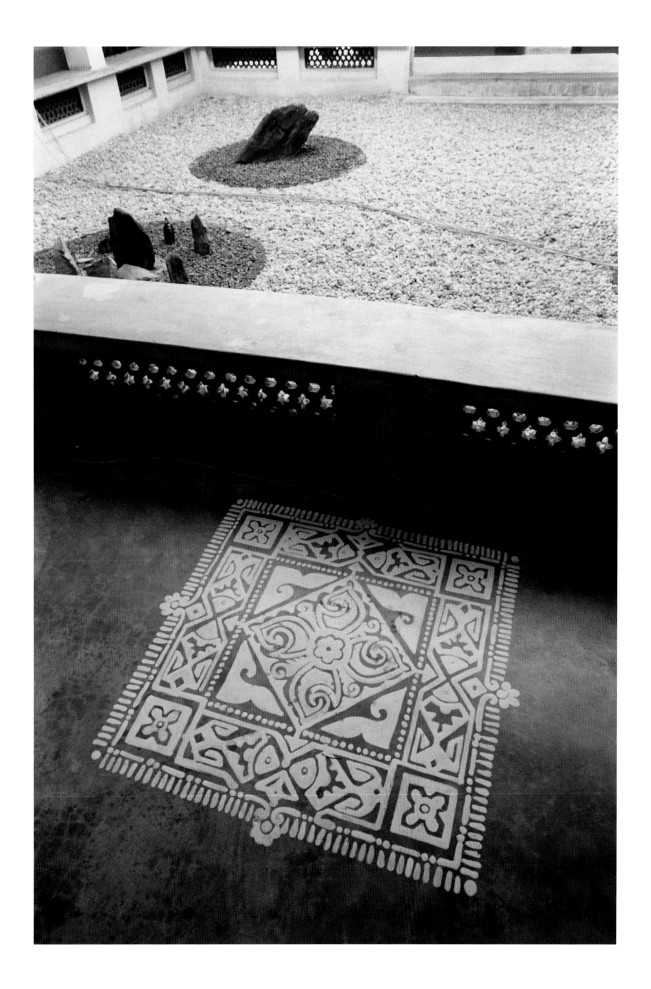

Plate 87

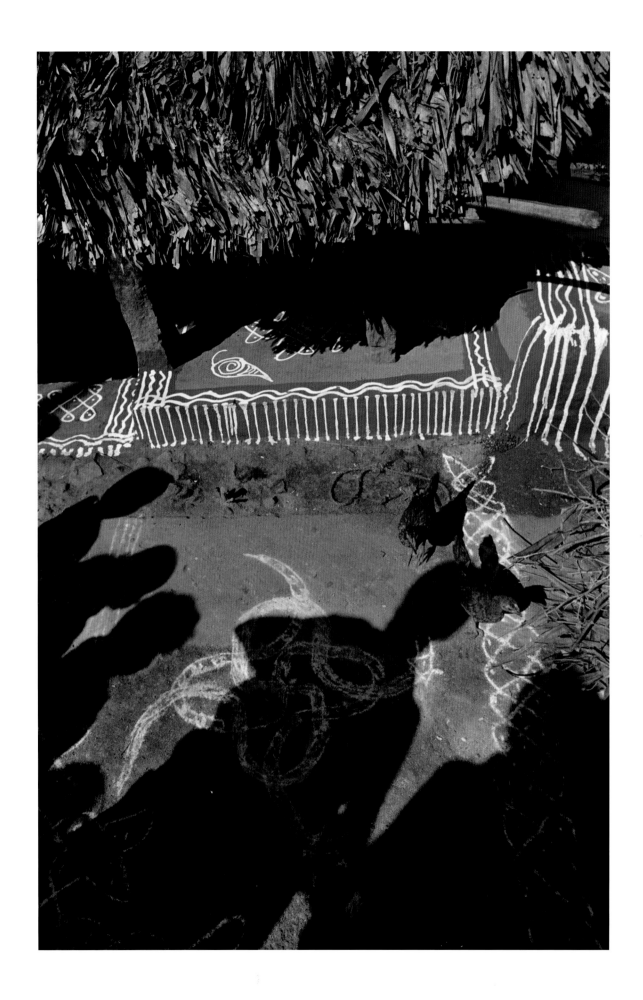

Plate 88

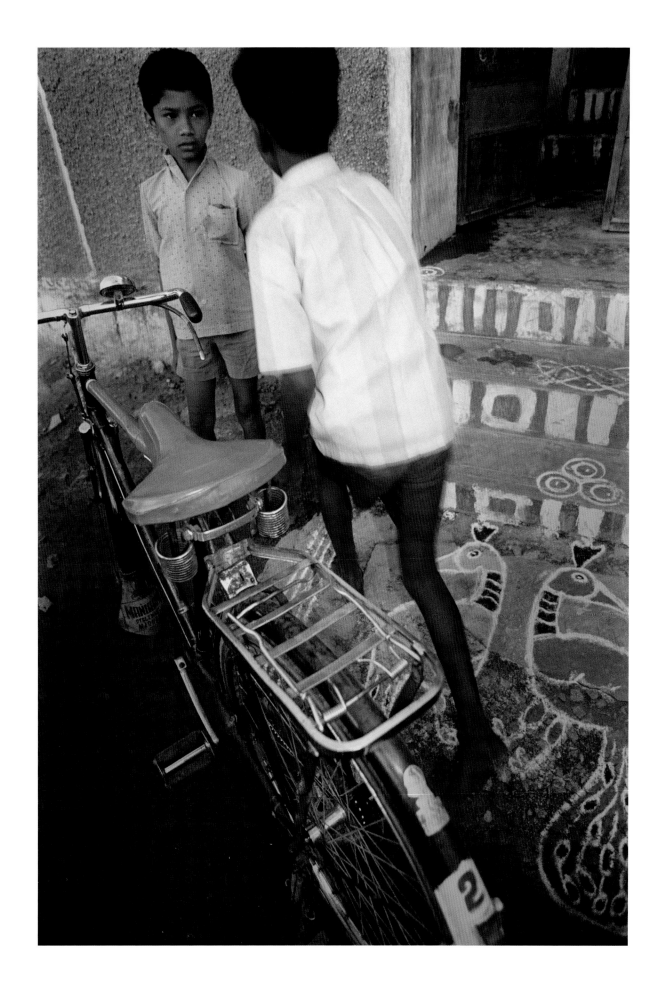

Plate 89

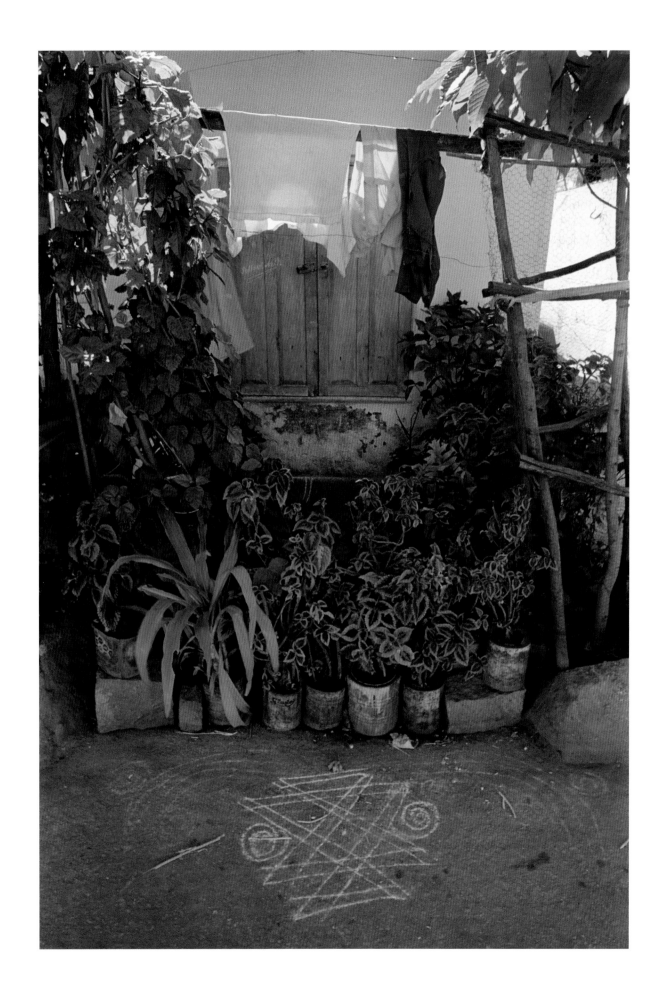

Plate 90

Plate 91

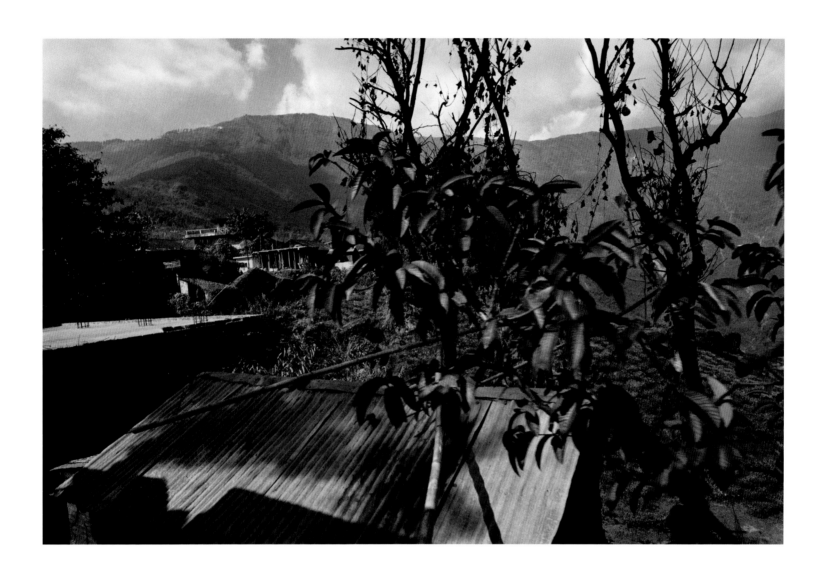

Plate 92

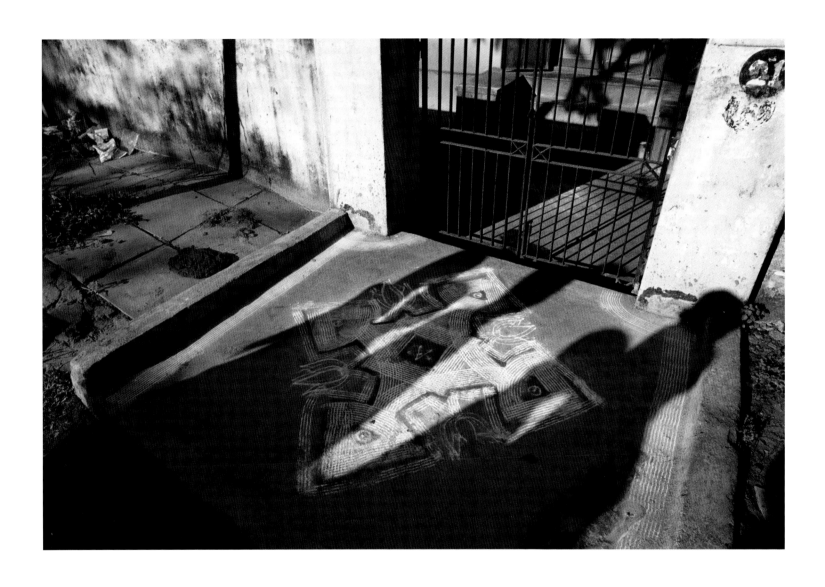

Plate 93

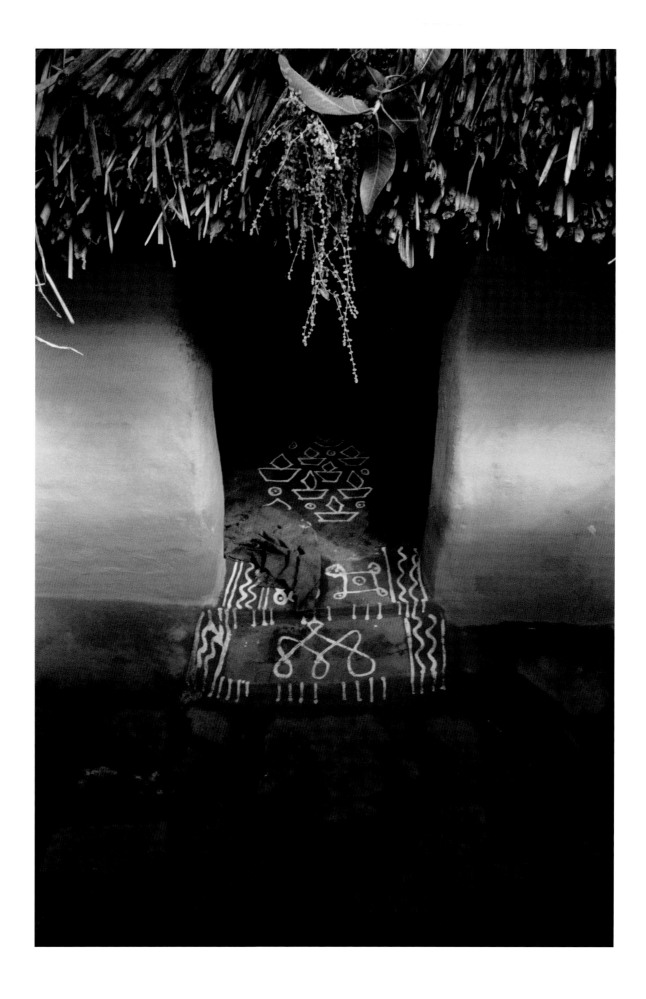

Plate 94

The permanence of the impermanent
is the flower of the soul.

—William T. Latham (2015)

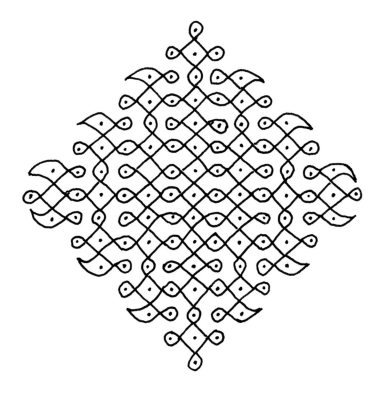

Drawing D

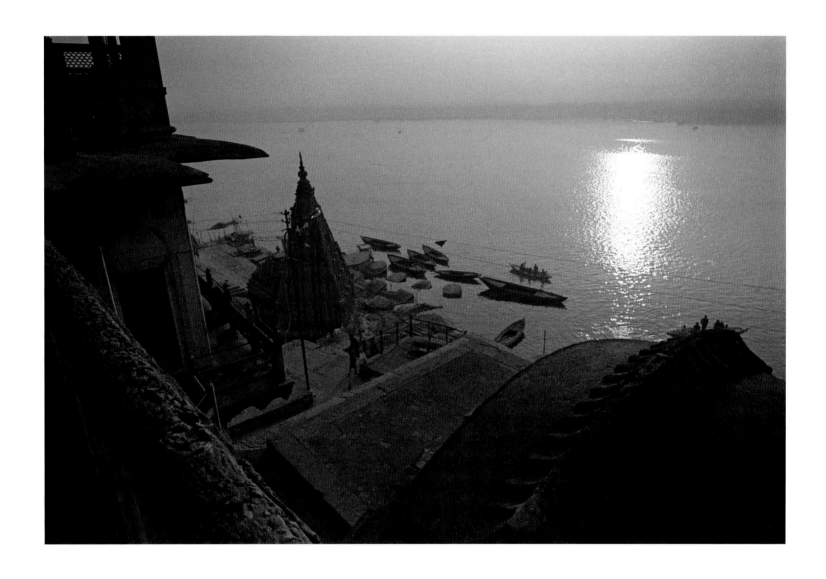

Plate I

Sarasvati, the Muse

MARTHA A. STRAWN

Art is an attempt to bring down within the vision of ordinary mortals some
of the Divine Beauty of which the artist catches glimpses, strives to trans-
late these into colours, sounds, forms words, by creating pictures, melodies,
sculptures, poems and other literature. . . . Beauty diversified into the arts
is the true refiner and uplifter of humanity. It is the instrument of culture,
the broadener of the heart, the purifying fire which burns all prejudices, all
pettiness, all coarseness. Without it, true democracy is impossible, equality of
social intercourse an empty dream. . . . Art is the international language. . . .
Art will permeate the whole atmosphere of the New Civilisation which is on
the threshold.[1]

—Dr. Annie Besant (undated)

A Sense of Place

Varanasi, also called Benaras or Banares, is the oldest living city in the world. For
more than 2,000 years, this city along the Ganges River has been a center of learn-
ing and civilization. When I first was there for a month in 1977, there was little use
of electricity, except in large hotels located out of the city center in an area called
the Cantonment. Oil lamps lit the city, flickering in the narrow streets and alleyways
around the famous Golden Temple, dedicated to Shiva as Lord of the Universe. Since
then, electricity has become prevalent throughout the city.

Tiny shops line the alley that leads to the temple. These shops glitter with shiny
items, stacked and hung in rows, arranged in patterns, densely organized in small
spaces. People fill the alleys day and night, going to and from the temple, stopping to
shop, then moving onward among others and the occasional sacred cow. The smell of
incense, perfume oils, and spices emanate from stalls. Toys beep, hoot, and whistle as
shopkeepers try to get the attention of passers-by.

These alleys are full of life and dense with sound, color, and smells. An intensity
permeates these spaces. The atmosphere feels as if all the humanity of the past two
millennia thrives in this area, which lines the west bank of the Ganges, while the great
sand banks form open space on the eastern side. Boats criss-cross the river, carrying
sand for construction from the eastern bank to the opposite shore (see Plates 25 and

47). Moving up and down the river, boats carry tourists at sunrise as the light hits the ancient cityscape broadside, revealing crumbling structures and pilgrims, bathing their sins away in the holy waters (Plate 49).

The city is defined along the river by more than 100 *ghats* (steps) which descend into the water (Plate 46). These ghats are used for bathing, washing clothes, ablutions, prayer, and, in two ghats, cremation. Pilgrims come from all over India—in fact, from all over the world—to cleanse themselves in this water. Many come to die in this holiest of places either by their own volition or carried by relatives. The streets around Varanasi twist and turn, creating maze-like pathways that lead to myriad tiny courtyards surrounded by several-story buildings. Many of these buildings are religious retreats, where pilgrims and travelers may stay for only a few rupees. Light cuts through narrow passages, striking shafts along walls and highlighting the bright colors in billowing folds of cloth that hang to dry in the heart of the city (Plate G). The wider streets are filled with rickshaws, people moving about, and animals and carts loaded with wares and foodstuffs. This city is seething with life and death, mystery and mysticism, intense intellectualism and highly developed aesthetics of art and music, raw humanity and brilliant activity. I know of no other place in the world like Varanasi.

The city's streets shine brightly from lights carried on the heads of men in a procession. The men appear to be strung together by great ropes of electric cords connected to a generator on a rolling cart at the rear of the procession. My senses are caught in the rhythmic beating of drums and horns blasting out rich, amber tones amidst an array of ringing bells, frolicking shouts, and laughter. In front of me women and children, adorned in brightly colored cottons and silks, walk alongside the procession, which swells with humanity and gaiety as it proceeds. I am surrounded and engaged in the celebration of Sarasvati, goddess of the arts and literature, learning, and speech (Plates 49 and 63; VN 10). Sarasvati is a manifestation of the Devi, or the Goddess as feminine, as are Kali, Durga, Lakshmi, and Parvati. A representation of Sarasvati is adorned with flowers and carried on a palette through the city to the ghats where she will be bathed before retiring her image for another year.[2] Her figure is identified by the vina, a musical instrument that she carries across her body, as well as the whiteness of her skin, the swan that serves her, and the lotus upon which she sits. A book, a rosary, and a water pot are also traditionally seen in her possession. Her appearance, white like snow and the moon, suggests purity and transcendence. Her vehicle, the swan, is a symbol of spiritual transcendence and perfection in Hinduism.[3] The procession passes shrines set up temporarily to honor the values this goddess represents: Sarasvati has no temples dedicated to her, since her essence is understood as permeating life in all places. Under the procession and in front of these elegantly decorated shrines

are threshold diagrams, making the spaces sacred. Just as in the permanent temples, these diagrams are essential in the liturgy of Hinduism.

During my seven journeys to India, I participated several times in the Pongal Festival in and nearby Madurai in Tamil Nadu, South India (Plate 43; VN 38), at which people celebrate the harvest and New Year's Day. The motivation for my return was primarily the development of a project called *THRESHOLD* about the diagrams women make in areas of transition, such as the spaces defining the doorways between the interior and exterior of a home (VNs 1 and 2) or business (VNs 59 and 62) and the spaces indicating the doorway into a sanctuary (VNs 8 and 11). *Threshold* also refers to the space between the physical body and the subtle being, and it may be symbolized in sound or visual symbols. Anthropologists such as Victor Turner describe such spaces as *liminal,* taken from the word, *limen,* signifying "threshold" in Latin.[4] These spaces are the transition states between two stable conditions of being. This project has particular meaning, because it involves two disciplines that are primary interests of mine: arts and aesthetics and the strength and history of the feminine in culture. I am particularly interested in the relationships between these two.

It is pre-dawn, and I am riding in a car through the silent streets of Madurai, Tamil Nadu, on my way to a small village outside the city. The dark emptiness of the streets is relieved by a woman sweeping the threshold area of her home (VN 31). Putting aside her broom, she picks up a stainless steel pot and splashes water over the stone and earthen surface of her walkway (VN 32). Further along the way, a small roadside shrine is brightly lit. We stop and are generously greeted. The ground in front of the shrine is newly wet and covered with colorful drawings celebrating the Pongal Festival in Tamil Nadu (VN 22). We continue on the road into the countryside as the dawn breaks and the sun emerges through the mist, a golden ball illuminating bullocks being washed in the waterways beside the road. Men and boys scrub animals, splashing water and working up lather in the process of preparing the bullocks for the auspicious harvest days ahead (VNs 18 and 19). A young bullock, tied to a palm tree, is standing on the roadside, munching on tender grasses. His horns are brightly painted vermillion and green, his hide is decorated with colorful spots, and he sports yellow turmeric paste on his hooves. The waters behind him sparkle and shine as men and bullocks bathe. The air is warm. There is a small fire beneath a canopy extending in front of the shrine (VN 16). The new year is beginning, signified by the Pongal Festival so elaborately adorned with colorful threshold diagrams.

I came to India once again for this. I came, as an artist and visual ecologist, for a sense of the place: to soak in the sensuous quality of the culture; to assimilate the

sharp contrasts and subtleties of life in the streets, temple complexes, rural areas, and homes; to savor the colors, odors, flavors, and sounds that stimulate my imagination; to engage in dialogue among citizens and visitors in bookstores, sweetshops, and restaurants and on buses and trains. India is a meeting place for diverse attitudes and ideas, philosophies, and cultural expressions. The average literate citizen in India is very well informed. The visual, performing, and literary arts are critically important in Indian life, consistently reflecting the soul of the culture in the course of doing business, practicing the sciences and mathematics, and in consideration of health and political issues. A breadth and depth of thought and a visceral response to ideas and aesthetics in all disciplines is characteristic of Indian culture. I can feel the wisdom of the thousands of years of civilization in small and large acts and transactions.

Visual Ecology

Visual ecology is a term I use to identify an approach I used in my book, *Alligators, Prehistoric Presence in the American Landscape*, in which I integrated animals and people and their arts, and the geography that shaped their mutual environment in a body of work primarily expressed and documented through the visual arts, supplemented with text.[5] Once again, I am applying the term *visual ecology* to this body of work. This time the application is used in the human sciences rather than the biological sciences. Here, it applies to the integration of Indian feminine energy in physical and spiritual forms, to the practice of making the traditional art form of threshold diagrams, to the significance of these diagrams, and to the geography that changed and shaped the culture that produced them.

This work was first researched visually. Afterward, further ideas and images were developed from textual, experiential, and collaborative research to create this book. The geographic character of a place is a fundamental driving force in the development of a culture. Whether that culture is biologically, artistically, or philosophically identified, geography forms the basis of its defining environment. As I worked throughout India during my seven trips since 1977, I photographed and absorbed the surroundings. These geographic and cultural experiences inform my understanding of the threshold diagrams.

The tools I use are social and visual practices that I associate with visual ecology. I learn about a place partially by making pictures, and I engaged that place by talking and interacting with people in a variety of situations, by eating their foods, and by watching. I look for personal habits that may begin to define cultural traits. I make note of the people, animals, transportation systems, water systems, lighting systems, commercial endeavors, construction techniques, weather, rituals, trash consumption, food

consumption, the arts and crafts, and anything else that reflects interaction in that environment so different from mine. I enjoy fresh experiences, the integration of another social system unfamiliar to me, and the variety of values this practice reveals.

GEOGRAPHY

As I worked in diverse areas of India, the landscapes and cultures changed, each reflecting its unique geographic nature. (For geographical references refer to the map on page 11.) Kerala is tropical with lush, quiet waterways that are highways for life there (Plate 55). This area is defined by the Nilgiri Hills, which divide the Western Ghats from the Eastern Ghats. In the Eastern Ghats—lands that step down toward the Indian Ocean—there are two main rivers, the Godavari and Krishna. Both spring up and flow seaward across the southern Deccan Plateau. South of the southernmost Krishna River are the cities of Chennai (formerly Madras) and, farther south, Madurai. They are located in the state of Tamil Nadu, home of Dravidian art and culture, characterized by ornate temples featuring soaring towers known as *gopurams*. Traveling through Tamil Nadu is like "temple hopping" while I visit Chidambaram, Kanchipuram, Madurai, Rameswaran, Tanjore, Tiruchirappalli (Trichy, for short), and the earlier shrines at Mahabalipuram. Each of these places is rich in artistic and social heritage. Approaching these temple towns over flatlands, divided into sections by rice fields, is thrilling because of the contrast between the land and the temple's architecture created by this culture. Roads into the towns cut a palm-lined swath through the fields. In the distance across the wetlands, ornate and elegant gopurams rise in grandeur, dwarfing even the tallest trees nearby. As the roadway becomes more populated, decorated lorries, cows, cars, bicycles, scooters, motor rickshaws, and bullock carts merge with pedestrians into a flow toward the town center, which is typically around the temple. Like a river with merging streams, the volume of humanity swells and surges into a whirling pool of life at the temple's gates. In Madurai, the Meenakshi Temple area is crowded with market stalls, selling cloth goods, foods, utensils, *puja* (Hindu act of worship) items, hardware, and other religious and household items.[6] The sounds of horns, bells, motors, and hawking voices permeate the atmosphere, as is the custom around many other Hindu temples throughout India.

The atmosphere in a *living temple,* one actively in use, is noisy by comparison to the quiet reverie of the inactive temples and monasteries such as those at Ellora and Ajanta. These cave temples are in the Central Deccan Plateau, northeast of Mumbai (Bombay) and a little northwest of Aurangabad. The twenty-nine Buddhist caves at Ajanta are cut into a steep rockface in the curve of a gorge. These cave temples and monasteries, dating from 200 BCE (Before the Common Era) to 650 CE (Common Era), are known

for their wall paintings. The cave temples at Ellora are known for their sculpture. Thirty-four caves comprise the Ellora site: twelve Buddhist caves (ca. 600–800 CE), seventeen Hindu caves (ca. 600–900), and five Jain caves (ca. 800–1000), all of which are cut into a steep hillside running north and south. The largest and most dynamic of the caves at Ellora are the Hindu rock-cut temples. Their scale is immense, especially the Kailasa Temple, which was carved out of solid rock, and is open to the sky, having been cut from the top down. Twice the size of the Parthenon (447–432 BCE) in Athens, Greece, the Kailasa Temple refers to Shiva's Himalayan home.

As I climbed around these remarkable structures and when crawling into the monks' cells or standing dwarfed next to a carved row of elephants, I reflected on the landscape beyond (Plate 36). Gazing outward, I imagined living and working out from the heart of the Earth. I wondered about the lives of the earliest people who first began to carve out their dwellings and sanctuaries. The geographic terrain inspired the creators of these places to such a pitch that work continued to evolve over a 1,200-year period. The geography formed the backdrop for development of religious beliefs and cultural transitions, forever shaping the character of the place and, perhaps, affecting beliefs today.

During my field research, I looked for threshold diagrams northwest of Ajunta and Ellora in Rajasthan, westward as far as the Thar Desert. Delhi was hot in mid-afternoon, and the bus I boarded had no air conditioning. I took a front seat next to the window for the air. Traveling out of Delhi across the Aravalli Plateau was pleasant once we cleared the dung-smoke and scooter-smog of the city. The lands and villages sped by as the sun dropped below the horizon. The night cooled briefly until the bus descended from the height of the plateau. Then, *wham,* like a gigantic searing wave, the hot air slapped my face and enveloped my body. I stuck my head out the window to see if the engine was burning, but it was only the hot desert heat that struck me again. Soon, an arm reached over and slammed my window shut in chorus with the other windows throughout the bus. I felt panic hit as I considered the lengthy journey ahead in this hot, closed box hurtling down the highway. Again, a helping hand offered a bottled soda, passing drinks to passengers to diminish the alarm. This is summer in the Indian Thar desert—searing hot, even at night.

In the next days, while traveling by camel, camping on the sands of the desert, and watching the sun rise and fall across that great stretch of arid barren landscape, I felt the exotic nature of this westernmost part of India. The ride was unfamiliar and somewhat uncomfortable, but the experience was unforgettable. For miles the camels loped across sands that were relieved only by an occasional scrub tree or barren-looking bush. Every now and then, we stopped to rest and draw water from a pipe in an oasis. We visited a deserted town and temple complex, the sun bearing down as we explored

the ruins. Back on my camel, Kaloo, I felt mesmerized by the undulating gate of the animal beneath me and the plaintive sound of the camel driver wailing a desert song across the sands.

Our port was Jaisalmer. We entered through a great gate and trekked upward through the city's walls. This fascinating, medieval-looking city in the desert reminds me of an Arabian Nights tale. Small, winding streets intertwine, and hawkers gather in town squares where people meet. Centuries-old buildings are made of cut blocks of a rich-yellow sandstone, so the city radiates a golden glow at sunset. The buildings seem miniature in scale, as if made for make-believe or shrunken by the sun. Many buildings are three or four stories high, but they are a diminutive three or four stories. My hotel featured a roof cafe where occupants dined, sipped tea, and talked while watching the city around and desert beyond. Gazing outward from the rooftop felt like sitting high on a beach looking over an ocean. In the desert, camels are like ships, and the sun sets brilliantly on the horizon while the moon rises dramatically against a pitch-black sky. For out in the Thar Desert, on the edge of the Indian Pakistani border, there are no extraneous lights. The remote position of this city, its exotic structure and appearance, make it a memorable experience for the traveler (Plate 79).

India, like the United States of America, has a varied geographic terrain and, as a result, is composed of many diverse cultures. Far different from the Thar Desert environment is the Himalayan habitat. The north of India is bordered by a long sweep of the highest mountains on Earth. The Himalayas consist of several smaller ranges separated by deep valleys, such as the Kulu Valley in Himachal Pradesh. Most of my journeys northward into these mountains were on trains (Plate 10). Travel by train in India is sometimes challenging and usually rewarding, especially in second class. Second class is not as comfortable as first. The seats are hard, and six people are crowded into a section, which transforms at night into six beds. These beds are slabs of wood thinly padded and covered with plastic. Once released from the back wall, they fall forward, hung at a ninety-degree angle by chains. There is no air conditioning and little heat. This is where humanity, however, displays its full generosity, curiosity, and connectedness. Travelers meet, talk, and share experiences and life styles across cultures. Whether American or Australian, French or Indian, Japanese or Russian, people in second-class trains in India tend to communicate and be generous with each other.

From Delhi, I took a train to Simla, Himachal Pradesh, on one occasion and to Leh, Ladakh, on another. From Calcutta (Kolkata), I took a train to Darjeeling (Plate 92) and a train-bus-jeep combination to Kathmandu, Nepal. Each of these trips etched my memory. Leh is one of the highest inhabited cities in the world at 11,500 feet (3,505 meters) in elevation. Altitude sickness is a danger for visitors. Death may result if travelers are not attentive to their bodies' response to the altitude. Once I accli-

mated, Simla and its environs so high in the sky, provided the perfect background for studying threshold diagrams and, specifically, the astrological associations with those diagrams for which I sought verification. In Simla, as in other Himalayan cities such as Srinagar in the Dal Lake region, westward, and Darjeeling, eastward, I felt elevated by geographic references. I also found a learned Hindu priest who translated the astrologically based *nav graha* (nine planets) diagrams for my enlightenment (Plate 40).

On another journey, I descended via bus from Katmandu, Nepal, in the Himalayas to the vast Ganges Plain of Uttar Pradesh. The trip was long, hot, and crowded. We frequently shared the narrow, unevenly surfaced roads with cows and bullock carts that lumbered along. Brightly decorated lorries, loaded so high they appeared to be teetering on their tires, careened toward the bus at irregular intervals, passing precariously close. All this time I held my breath, hoping we would not collide. As we rolled and bumped onward, I looked out the window into the hazy, sweltering sunlight that flooded the plains, enveloping huts, trees, roadside shrines, animals, and people in a smokey glow. Occasionally, we stopped at roadside cafés, usually near a village. On these stops, most passengers got off to stretch and to drink *chai*, hot tea boiled with milk, sugar, and spices, or Fanta (Coca-Cola's brand in the Far East) and other sodas. These cafes also served *poories*, puffed fried breads, accompanied by a scoop of potato *masala* served on a swatch of banana leaf, or *chana masala,* chickpeas in a rich, brown-curry gravy. For the lighter appetite they had *idlies*, steamed rice-batter cakes served with coconut chutney and masala powder mixed with sesame oil. These treats are standard roadside fare and serve as a delightful substitute for the less imaginative hamburger, hot dog, or pizza slice served along U.S. highways (Plate 64).

I regularly carry a small stalk of miniature bananas when traveling in India. They are easy to peel and delicious to eat. India is home to nineteen varieties of these fruits, each with its own distinctive flavor. Another tasty traveling snack is the groundnut, another name for peanut. The variety commonly available in India is similar to the small sweet Valencia peanut found in the United States. Indians shell and lightly roast groundnuts in sand, which evenly disperses the heat. The sand is sifted from the roasted nuts, which are scooped into a cone of recycled newspaper, tied with string, and delivered in exchange for a few rupees. I love these delectable snacks, but none is as good as the *masala dosa,* commonly referred to as a *dosa*. Found around Calcutta (Kolkata), in the Bengali Market in Delhi, and throughout South India, the *masala dosa* reigns supreme in my preferences among Indian fare. This large but thin rice/lentil batter crêpe is rolled around potato *masala* and served with coconut chutney and a vegetable stew called *sambar*. A *masala dosa* followed by a large glass of freshly squeezed pomegranate juice is an ambrosial combination.

Once back in the bus, stretched and satiated, we resumed our journey once again toward Varanasi. The great and most sacred Ganges River cuts through the plains, which suffer dramatic floods during the monsoon season. This holy river of Hinduism emerges from the Himalayas and flows across these plains through Varanasi, eventually emptying into the Bay of Bengal. The Pilgrims Trail follows along this same pathway, along the river, over the roads, through the fields to Varanasi with its ghats leading into the holy Ganges River. In this area, the primary source of subsistence is farming, leaving many people impoverished as a result of repeated flooding and overcrowded conditions. Thousands flock to this holy city to be cleansed of their sins, to study at Banaras Hindu University, to learn from a spiritual guru, to apprentice with a music master, or to die in this most auspicious place.

These "place" experiences informed my sense of how and why the women make the threshold drawings as they do. The feeling and knowledge of the places with their homes, markets, and temples in cities, villages, and rural landscapes provide the context for understanding what the diagrams mean in Indian culture and where they continue to be made as they are.

IMAGE MAKING

During my first trip to India in 1977, I saw the power of the threshold diagrams in the street below my bus window. I jumped from my seat and asked the bus driver to stop while I photographed the drawings and their environments. Intuitively, I knew this material was important.

At that time I was new to India, and everything was different. I had been there for about six weeks, working as a photographer with a group of artists and scholars studying Indian art and religion. Twelve of us represented the disciplines of filmmaking, weaving, religion, philosophy, writing, sculpture, painting, Asian art history, and photography. We had been studying the art of India through traditional approaches, including the consideration of temple art and architecture, miniature paintings, and cave paintings. My personal interests lay in art and food, as they reflect the people and their particular physical, psychological, and religious approaches to life.

Each of my experiences in India has been very different from the others. My reasons for first going with the group were to engage with a culture new and different to me, especially when our focus was to be on cultural experience, art, the making of images, and issues of human spirit. What I learned was exciting and fascinating and sometimes unfathomable, but it excluded something essential. I was unsure of what I expected to encounter. India must have practices representative of vast quantities

of unfamiliar knowledge, but I was not getting a sense of them. My encounters were limited mostly to academic information or to areas of contemporary life colored by intrusions of Western influence. Wanting more, I searched for a more intimate connection with the culture.

In 1977, when I encountered the first five drawings in front of five houses, located in a residential area in the vicinity of Mysuru (Mysore), I was aware that each drawing was significantly different from the others. All were made from some white powdery substance, and most were in a fugitive state, having been walked upon. After that initial exposure to these magical drawings, I hunted for them. I found only one more during 1977, and it was in the same vicinity.

Back in the United States, I reviewed the negatives and recognized the strange yet strong presence of those photographs that contained threshold diagrams. The power and stark beauty of the diagrams captured my attention (Plates 1 and 3). I wondered about the women who drew them and the artistic, religious, practical, and magical elements associated with making them. The diagrams affected me deeply. My creativity was stimulated, and I wanted to learn more and to make pictures that reflected the depth of the subject.

By this time, I was intrigued and highly motivated to find out more about the drawings and their significance. As a photographer, I decided to do visual and scholarly research in India to resolve my questions. I wanted to enhance my visual perimeters and to make a satisfying series of images that would relate to my thoughts and feelings about the existence of these drawings within the Indian culture. On a superficial level, research was easy, because many Hindu Indian women practice making threshold diagrams, and most Hindu Indian men like talking about them. But beyond a basic knowledge of what the diagrams mean on a contemporary conscious level, little material was readily available on the subject. Over a thirty-year period, I gathered information in India and elsewhere in libraries and in interviews.

Aesthetic Approaches

Light is key in the creation of photographs. Light is the expressive medium not the camera, film, or paper. And, when I travel, my awareness of light heightens, affecting my perception and the photographs I make.

India is a blazing array of lights and colors. Deep, secret crevices of space in the architectural fabric of the cities are relieved by sunlight streaming from above to etch streaks across walls or down allies, glistening on wet stones and on water streaming between walls and walkways. Sunlight glances across a drying sari in a courtyard. It bounces across narrow passageways, reflecting colors from one surface to another.

Overlaying hues of color, like the layers of time, are visible in the contemporary Indian culture. I feel the depth and intensity of the history and mysteries pulsing through the streets. I can see the richness of humanity in small, thatched hut villages, around temple-centered marketplaces in cities, in fields worked by bullocks and tractors, on packed buses and trains with their hawking food venders at every stop, and near a myriad of small, quiet shrines that are located on town and city streets or isolated in rural areas along dusty roads or in the middle of fields. The presence of people is everywhere, etched into detail by the light.

Photographically, my aesthetic problem was to make strong visual images that engage and reflect the feeling of magic in these diagrams, to represent the mysticism prevalent in the Hindu culture, and to exemplify the power of the feminine existing historically and contemporarily in that same culture. Each goal had to be accomplished while showing the subject matter in its greatly limited environment, an entranceway of some sort. I worked to express the position the diagrams hold within their culture and to have the images reflect the activities and environmental variety inherent in Indian life.

The aesthetics of my work are established through a developing body of knowledge that continuously alters my perception and my interpretation. Intimacy is critical in my working process. Photography is language that I use in a combined intellectual and sensuous manner. My aesthetic priority is to make visually appealing and engaging pictures that portray information and feeling. By choice of subject I indicate what is significant to me; by choice of form and style I reveal my own nature and attitude toward the subject. A comprehensive photographic experience includes initial thoughts and imaginings kindled within by the opportunity, the social context, the physical environment, the items on which the photograph focuses, the atmosphere perceived, and my reactions as an image-maker. Also encompassed are the interactive effects of using the camera in the experience, the selection of photographic materials, my interaction with the images through the printing process, and my decisions regarding presentation of the work, whether in an exhibition or book form.

My general artistic problem is to communicate my comprehensive experience. I work to make visual statements that can be "read" for their information on two levels: factual and interpretative. I also want the images to be felt sensuously and emotionally. Realizing the responsibility to communicate interactively with the viewer, I intend to inform with as much integrity as possible, giving as accurate an impression as I can. I hope to engage the viewer's interests and to involve her or him thoroughly in my interpretation of the experience.

My initial approach to photography in India was to experience a quiet, interior association with the mystery of the culture and, eventually, the threshold drawings. I chose the medium of black-and-white materials, because they reflect the philosophical back-

ground of the practice of making the diagrams and elicit the core feelings of mystery and magic of the diagrams that have been a great part of their lure. The sense of deep, intense mystery contained in the creation of a sacred space and the graphics used in its visual execution harken back to the myths and knowledge relating to the mother goddess.

On one level, these associations with mystical and philosophical knowledge are more attuned to my use of black-and-white photography. At least abstraction more appropriately reflects my interpretation of this subject (Plate 1). I felt, however, that I was limiting the representation by using only the black-and-white medium. It seemed incomplete. As I learned more about the subject, my perceptions and interpretative aesthetic changed.

Colors are used luxuriously in India—in clothes, tapestries, rugs, body decoration, architectural embellishment, art work, food, and ritual practices. I consider such lively and dominant use of colors to be "color sensual," a term I coined to describe the sensuous nature of a place or situation revealed by effective use of color.

The people of India, both men and women, rejoice in the dramatic use of colors. Like visual jewels, colors embellish everyday life and festive occasions. It is not unusual in the rural areas to see a women working in a rice field wrapped in a colorful sari, adorned with a nose ring, and wearing ankle bracelets, toe rings, marriage necklace, earrings, and wrist bangles. She may have jasmine blossoms in her hair and a dot of red *kumkum* on her forehead, signifying marriage. She might even have red (*henna*) designs on her feet and hands, called *mehandi*.[7] Adornment is important in India, whether its purpose is symbolic or simply decorative.

When choosing chromogenic media (color) or silver print media, my decisions are based on the nature of the subject. My photographic background is composed of equal experience in black-and-white and color media. Their aesthetics are very different. I use black-and-white media for more abstractly felt subjects, to emphasize their philosophical, theoretical, formal, and stoic qualities (Plate 3). I use color for more specifically felt subjects, to emphasize the social, realistic, or celebratory aspects within the content of my pictures (Plate 94). I use both to achieve feelings of intense intimacy (Plates 6 and 91) or to create a feeling of media distance (Plates 11 and 58), depending on how I handle the vision and the materials. My interpretation of the subject matter determines the choice of medium.

Three prominent Indologists specializing in the arts of India influenced my work. In years prior to my research on threshold diagrams, Ananda K. Coomaraswamy, Pupul Jayakar, and Stella Kramrich with great foresight recognized the importance of this art and considered it another fine-art form. Each valued the diagrams as being equally significant to other arts of India, such as painting, sculpture and architecture, though none of them focused their aesthetic research or writing specifically on the diagrams. From

the writings of each and during a meeting with Stella Kramrich at the Philadelphia Museum of Art in the 1980s, I found my own observations and concepts regarding the significance of the diagrams substantiated.[8]

As an artist and student of both Western and Eastern arts and art history, I continually consider the differences and similarities between the two cultural approaches to art. Acknowledging the difference between the European concept of a Western aesthetic and that of the East Indian aesthetic alters the sense of value the artistic practice of threshold diagrams merits. Whereas most Western art emphasizes the creative identity of the maker as part of the value of the art, much of Eastern art, including East Indian art, emphasizes the inner concerns and values of a maker but not their personal identity. Understanding Eastern art means considering all of the purposes in the art as well as the processes by which these purposes were achieved. The artist serves as a skilled and devoted servant to the process of creating a harmoniously integrated manifestation of the artist's conceptions. Without knowledge of the artist's conceptions, valuing the art which results is a hollow exercise. Conversely, experiencing an art object in its original site, such as a figure in a temple as opposed to one in a museum, greatly adds to our ability to understand and appreciate more fully its aesthetic and symbolic qualities. In its original context, the figure may be experienced much the same way the artist felt during the creative process instead of isolated out of life. Full association between all art forms and life is fundamental in the Eastern approach to art.[9]

My work has led me to realize the aesthetic evolution of making threshold diagrams. Once a spontaneous art form based on the desire to alter personal existence, the practice often became one based on the motivation to create a formally designed decoration. If evolution stops here, the practice will become decadent and eventually die. Through informed efforts by individuals and formally organized groups, however, aesthetic training to reconnect the process with indigenous meaning has begun. The results of these efforts are not yet known; but, as this work reveals, textually and visually, several factors play significant roles in the outcome.

Describing the diagrams, as I do in my essay, "Mazes, Mysticism, and the Female Principles" (pages 195–239), is complex, especially in the areas of stylistic description, choice of language, and art historical reference. I always seek words and descriptions that are not loaded with derogatory cultural and academic interpretations. My information was drawn from both academic and non-academic sources, especially firsthand experience. I also tried to keep arts and science lingo out of my descriptions and to use common language and vocabulary carefully. Words such as "primitive" and "sophistication" carry cultural overtones of judgment that I do not intend. Also, in describing the diagrams I chose descriptive language such as "ingenuous" and "ingenious" in an effort to translate the experiences faithfully. *Ingenuous* is defined as "(1) free from

reserve, restraint, or dissimulation; (2) artless, innocent." It means frank, candid, free, open, sincere, honest, generous, natural, simple, guileless, unsuspicious, unreserved, straightforward, blunt, and unaffected. *Ingenious* is defined as "(1) characterized by cleverness or originality of invention or construction: an ingenious machine; (2) cleverly inventive; resourceful: an ingenious engineer." It means bright, gifted, able, resourceful, adroit.

Both *ingenuous* and *ingenious* apply to threshold diagrams, but they are distinct from each other and should not be confused or thought of as synonyms.[10] Because the diagrams may well hail from thousands of years of practice based on deep-seated belief systems, I want to imply the importance of their complex heritage and tradition. I also want to acknowledge the beauty embodied in those fresh, direct, uncontrived, and spontaneous creative acts as opposed to the studied, contrived qualities inherent in the more evolved decorations and art forms frequently made in contemporary times. I, therefore, use *ingenious* and additional vocabulary that stresses directness and spontaneity when appropriate.

INFLUENCES

Inquiry about threshold diagrams involves the study of changing forms and actions, changing from process-based to product-based practices. These changes in ritual are a function of cultural changes. As Indian society changes from being primarily agricultural to one in which women are moving into industrial and technological roles, it affects many of the ritualized practices, including the threshold diagrams. I address this transition later in my essay, "Mazes, Mysticism and the Female Principle" (pages 195–239).

The Female Principle in Hindu religious tradition forms the basic context for the threshold diagrams. A division of interpretation exists regarding the hierarchical structure of the godhead(s). One viewpoint espouses a pantheon of gods and another of goddesses which, together, form the Hindu religious tradition.[11] In this case, the powers and roles of the gods and goddesses vary within their respective pantheons. Often the individual gods and goddesses are coupled, representing a balance of male and female energy for the particular cosmic roles associated with each pair. Their coupling also infers a subservient position for the consort (wife) of the god. While the goddesses represent Hindu concepts about sexual roles and relationships, they also express Hindu thought about sexual identity that appears contrary to social expectations. These are the roles in which the goddesses represent power, action, and cruel behavior in favor of cosmic order. Within this viewpoint, the goddesses are astounding and unusual. Their characteristics may be described as either masculine or unconventional.

Another viewpoint asserts that all deities (gods *and* goddesses) were brought forth as different manifestations of an underlying feminine principle or an overarching great goddess.[12] Though some scholars argue that the Vedic literature does not refer to such a feminine power, others assert that it does.[13] Furthermore, with increased understanding of the Vedic Sanskrit, many words previously thought to refer to gods are now translated as goddesses, making the numerous references nearly equal.[14] Many scholars also acknowledge that the pre-Vedic cultures recognized and worshiped a strong female deity. My interpretations are based on the latter position. The existence of an overarching female principle seems likely, considering a breadth of references and resources.[15]

My interpretation of the diagrams varied according to influences that included related knowledge and experiences about Hinduism, the social interaction between the secular and the sacred, the mythology of the goddesses and gods, the role of numerology and astrology, the integration of magic and mysticism, the derivation from yantras and mandalas, the form and structure of the diagrams, the function of the diagrams, Indian cultural perception of time, and female creativity. Each one of these influences affected the way I thought and felt about the threshold diagrams, and my visual responses varied with the changes.

Knowledge of Hinduism is important, because the threshold drawings are practiced only by people living within the influence of Hindu religion, manners, or customs. Hinduism is a name that describes the beliefs of a group of people who are diverse but similar enough to be categorized by "foreigners" (persons not from India) into a singular religious framework. The name "Hindu" comes from the sacred river Indus or Sindhu. Various theories account for the name. Some say its source was the ancient Persians and the Central Asians, who first used the term for the people and territory of northwestern India. Some say it came with Muslim invaders, who with that name designated a religion inclusive of Hinduism, Buddhism, and Jainism during the early part of the second millennium CE. The British, during the early part of the nineteenth century, so described the complex grouping of people of the South Asian subcontinent.[16] Ultimately, Hindu refers to a socio-religious group defined, according to Indian scholar Brian K. Smith as ". . . the religion of those humans who create, perpetuate, and transform traditions with legitimizing reference to the authority of the Veda."[17]

Intense social interaction accompanies the religious activities of contemporary Hindu culture, including its festivals, which are related to auspicious occasions.[18] Play and reverential activity are united harmoniously, joyously, and colorfully at festivals such as the Teppam at Mylapur Kapaleeswarar Temple in Chennai. Teppam literally means "float." During this festival, the temple's deity is removed from the temple, seated on a decorated float, and taken around the temple's tank (a large pool of water

with steps leading from the surface edges down into the bottom of the pool). This rit-ual takes place at night when the entire area is decorated with many flickering lights. The streets surrounding the square tank are filled with people of all ages celebrating. Brightly colored toys, bangles, flowers, sweets, and savories are among the endless array of items for sale at small stalls along the tank's edge facing the street. Music fills the air and mixes with the sounds of traffic. In rhythmic repetition, bells "jing" on rick-shaws precariously making their way through crowds of vehicles. Horns blow as cars, scooters, and buses warn pedestrians in the crowded streets of their presence. The steps descending into the water on the four sides of the tank are lined with devotees celebrating the rebirth of the deity. A priest's chants accompany the illuminated float as it moves around the tank three, five, or seven times. The atmosphere is light-hearted: human and god-encompassing in a glittering, colorful, and participatory context. All generations come to play as they venerate the deity and celebrate the occasion.

The intermix of secular and sacred is a characteristic of Hindu society. I have used color media to reflect the Indian cultural celebration of existence, composed of a series of revolving rituals associated with auspicious occasions, and black-and-white media to reflect the more philosophical and mystical elements characteristic of the culture.

Numerous manifestations of the gods and goddesses are found in the diagrams. To interpret the symbols sensitively, I had to understand the Hindu pantheon of gods and goddesses. Like the Greek and Roman deities, they are confusing until you realize that a single god-force is represented by various personalities. The Hindu Supreme Being represented in multiple god and goddess identities makes "god" understandable so that many different persons can find an association.[19]

Another example of greater knowledge changing my visual sensibilities is substan-tiating the association of numerology and astrology with the threshold drawings. The dot patterns that form the basic structure upon which many of the designs are built were established initially on a set of numbers directly related to the science of numerol-ogy. The signs and symbols used in many of the drawings are manifestations of a belief in the power of astrological doctrines. Originally, the threshold drawings were consciously designed in an orderly manner on the basis of numerology and astrology as it functioned as an act of magic (VN 30).[20] Magic, as defined by Evelyn Underhill in her book, *Mysti-cism*, means when "the will unites with the intellect in an impassioned desire for super-sensible knowledge" for the purpose of deliberately exalting the will, "until it transcends its usual limitations and obtains for the self or group of selves something which it or they did not previously possess. It is an individualistic and acquisitive science: in all its forms an activity of the intellect, seeking Reality for its own purposes, or for those of humanity at large."[21] The threshold diagrams are magical because part of their function

is to gain something that one wants such as good health, good luck in financial transactions, protection for the domicile or business, or a fruitful harvest.

As I interviewed Indian women and men about the threshold diagrams, I asked, "Are these drawings part of a religious practice?" The answer was always, "No." I inquired about what function the drawings serve in daily life. The function, I was told, was to make a secular space sacred (which seemed contrary to their being labeled a nonreligious practice), to insure good fortune or good luck, and to protect. I asked the Indian women to describe their feelings while drawing the diagrams. Their answers ranged from "meditative" to "competitive," depending upon when the diagrams are made. If they are made regularly in a home as part of the ongoing lifestyle of the woman's daily existence, then the answer was more likely "meditative." If the diagrams are made primarily on auspicious occasions or irregularly in the woman's daily life, the feeling description ranged from "fun, creative feeling" to "competitive with the neighbors or with other recognized *rangoli* (common reference to threshold diagrams) practitioners." From my observations, all of these descriptions are accurate.

Whether or not to consider the threshold diagrams as part of religious activity has been a dilemma. If they define "sacred space" but are not part of a religious process, then what are they? As I studied the socio-religious context of the diagrams, they continued to be magical in their appearance, and they were made in a ritualistic manner. So I considered the difference between a religious ritual and a magic ritual. By comparing magic and mysticism and using mysticism as analogous to the spiritual elements of the Hindu religion, I began to distinguish the nature of threshold rituals and their relationship to the philosophical, cultural, and religious histories of India.

I once again referred to Evelyn Underhill's book, *Mysticism*, for a comparative definition of mysticism. She writes: "The fundamental difference between the two is this: magic wants to get, mysticism wants to give . . . Both magic and mysticism in their full development bring the whole mental machinery, conscious and unconscious, to bear on their undertaking: both claim that they give their initiates powers unknown to ordinary men."[22]

Mysticism is a heartfelt activity, non-ego oriented, seeking to give oneself over through the instinct of love, surrendered to the ultimate Reality. "Mysticism is the science of union with the Absolute," Underhill claims.[23] Accordingly, magic and mysticism represent opposite ends of the spectrum of the transcendental consciousness of humanity. And the great religions—that is, Hinduism and related rituals and practices—lie within the ends of the spectrum.[24]

Interestingly, the threshold diagrams appear to be perfect symbols for the dualism present in transcendental consciousness. Whereas the diagrams represent magic

in their functions to insure good fortune and to protect, they also represent mysticism by functioning as *yantras* (mystical diagrams) and *mandalas* (ritual symbols) and making a space sacred. Even when the diagrams are primarily decorative, they are derived from *yantras* and *mandalas*. Their dual purpose is a reflection of the unity inherent in the Hindu philosophy and mythology, which underlies and defines the religion.

THE IMAGES

Consider a diagram in front of a rural house in Karnataka (Plate 13), another made by a *pandit* (holy man) inside a home in Himachal Pradesh (Plate 40), and a third made in Tamil Nadu (Plate 27). All three illustrate duality; each differs from the others in form and content. The image made in Karnataka incorporates a drawing set up on a numbered set of dots, each dot symbolizing the source, the raw potential.[25] The design is dependent on the uniform connection of these points, which is an unending line symbolizing the unbroken, perfect whole or the constantly renewing cosmic cycle. This kind of diagram, called a *pulli kolam*, will entrap evil unendingly. Lively and intricate in execution, it is reminiscent of an energetic spider having spun a web to catch prey. On the door of the house, above the threshold ground diagram is the same as a reverse swastika, which symbolizes energy moving out into the four directions of the universe, a symbol of setting the cosmic cycle in motion.[26]

The image from Himachael Pradesh is a *navgraha* threshold diagram executed on a paper surface to keep from messing up the floor inside the house (Plate 40). *Navgraha* means nine astrological signs symbolizing the original nine planets. The image in the diagram is composed of an abstracted eight petal lotus containing a sun symbol, Surya, in the center. Around the outside of the lotus, beginning at the top right and reading clockwise, other graphic symbols appear: Venus, Moon, Mars, Rahu, Saturn, Ketu, Jupiter, Mercury.[27] Outside the ring of planetary signs are other symbols, representing fertility (snake), the cosmic force (swastika), mother goddess (sixteen-part grid), and so on. Use of astrological references in this diagram is apparent. According to Ajit Mookerjee:

> Throughout India, from time immemorial, an idiom of simple forms has provided the language of inward searching—a vocabulary of signs to express the human relationship with the universe. . . . Cosmogonic diagrams chart a pathway of evolution which is retraced by the psyche during ritual worship—a return to the source. Planetary diagrams determine the correct timing for the performance of the ritual. . . . For the ritual artist, the making of a work of art is a way of living by which the principles of cosmic order are experienced and communicated.[28]

Astrological imagery is usual in diagrams for *navgrahas pujas*, annual birth prayers which chart the course of well being for the coming year on the basis of astrological forecasts.

The diagram from Tamil Nadu is a departure (Plate 27). Made for the *shrada* ceremony (the dead), which is an inauspicious occasion, this diagram differs in several ways. Cowdung is used to render the ground image instead of rice or calcium carbonate, which are used only for auspicious occasions. The location of the space made sacred, not at the entrance to the home, is in some other more interior place. It functions as a sign that the space is made sacred in preparation for the death *puja*, which a priest performs. Direction and shape determine the structure of the diagram. The diagram faces east, composed of a circle placed on the left (south side) and a square on the right (north side).

The priest performs the ceremony from the center of the diagram, sitting on a small, wooden bench placed directly behind the circular and square symbols. A brass plate containing offerings to Yama, King of the Dead, a brass cup with a cobra-shaped spoon in it, *gingily* (sesame) seeds, *tulsi* leaves, and dried grass are special items and materials used during the *puja*. Black *gingily* seeds are placed on the diagram as an offering to invoke the ancestors. The ceremony is performed annually on the anniversary of the death of a close relative. At the end of the ceremony, the family serves a meal on banana leaves. A setting is laid for the dead from which nothing is eaten. When a person dies, it is presumed that her or his last wishes are for the well-being of those left behind, especially the children. By symbolically feeding the dead during this ritual meal, the survivors act out a form of prayer to assure peace for the soul of the dead.

The threshold aspect of this diagram used in the *shrada* ceremony is symbolic, referring to the sacred crossing point of the soul from the sense-perceptual world of the body and the earth to the spiritual world beyond sensual limitations.[29] The purpose of the *shrada* ceremony is to assure the soul's continued peacefulness through propitiation of Yama. The ritual acknowledges that death is only a passage of the soul; the soul never dies at the death of the body, for the soul is timeless and unending. As Ajit Mookerji writes, "The rituals of death point to life's unity, with a vision of eternal reality, Brahman."[30]

The threshold diagrams are unified in their function and different in their execution and styles, depending upon in what region they occur. They create sacred spaces on the ground in threshold areas of houses (VNs 2, 6, and 7), businesses (VN 59), or religious sites (VNs 8 and 9). Their purpose is to trap inside the mazes of the diagrams bad spirits, evil, or ill will that might accompany either a traveler from the establishment or a visitor to the establishment. Such entrapment prohibits bad luck from traveling beyond the borders of the diagram in any direction, thereby protecting the travelers, the establishments, and those inside.

Threshold diagrams are similarly positioned and have an identifiable character. They occur in entrance areas on a ground plane and exist as graphic, symbolic representations defining sacred space.[31] These are limiting aspects when photographing them. Variety of expression in my images depends heavily upon the changing contexts of the diagrams. My interpretation is based on the multifaceted and layered knowledge gathered about their geographic occurrence, the multi-cultural influences (within India) that have affected the styles and materials of application, and the effects of developments and practices of different historical time periods occurring contemporaneously. The styles of Indian threshold diagrams change as Indian society changes. Continuing changes warrant ongoing inquiry such as, "What is the nature of the changes?" "What might have precipitated them?"

A case can be made that the less modernized and urbanized the cultural area, the more sophisticated and vital are the threshold diagrams. At this time in history, conscious concern for aesthetics and decoration smothers the unconscious or forgotten knowledge, the foundation of the most complex and visually sophisticated diagrams. In remote villages in the south and north, in areas that have had less outside influence, relatively speaking, the diagrams are intricate, vitally rendered in a technical manner that appears sensitive and at times quite delicate (Plates C, 1, and 88). They are decorative and beautiful, but they *feel* as if they are about something much more profound than mere decoration. These diagrams are magical and mysterious in their complexity and in their simplicity. They reflect the larger tradition.

VISUAL NOTES

Drawing E

If anything, I see myself as a "witness."
I'd also be pleased if you'd call me an
"interpreter." I try to hear and see
the message of a place and pass it on,
into that other language, the universal
one of images.

—Wim Wenders (undated)

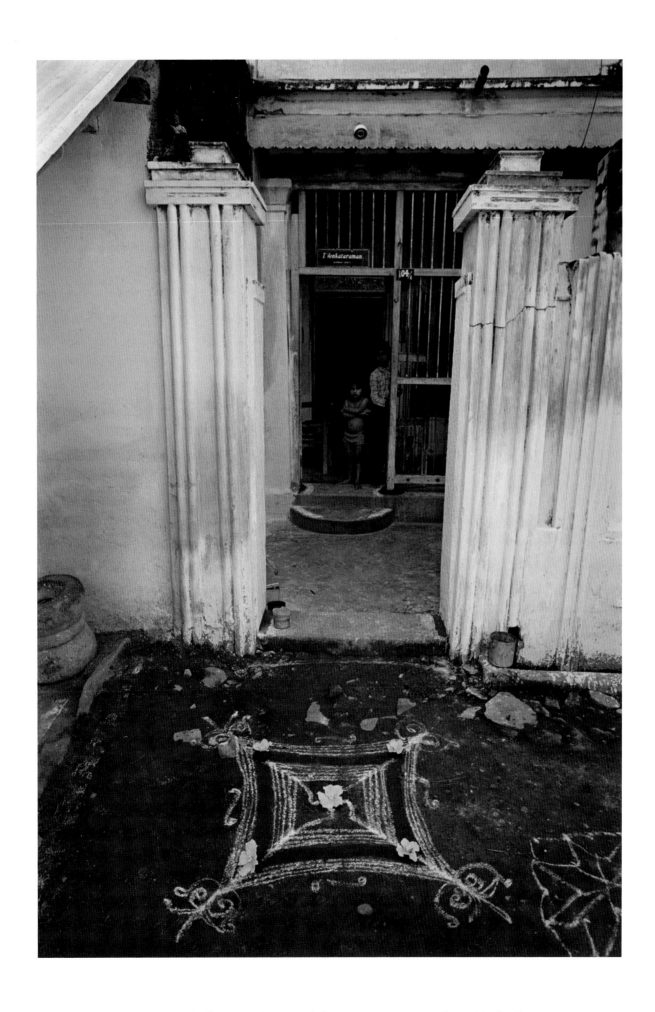

Visual Note 1. Pumpkin flowers on a diagram made for an auspicious occasion in Chennai, Tamil Nadu, 1990.

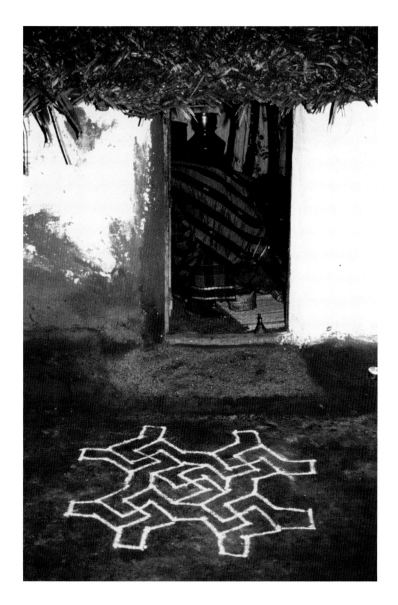

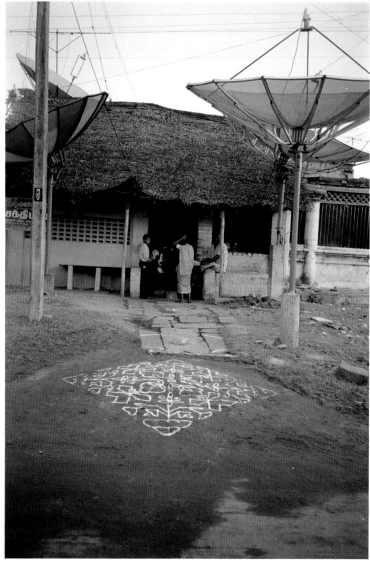

LEFT: *Visual Note 2. Kottu-kolam (line pattern) in a village south of Chennai, Tamil Nadu, 1986.*

RIGHT: *Visual Note 3. Sripraumbudur, a village near Kanchipuram, Tamil Nadu, 1986.*

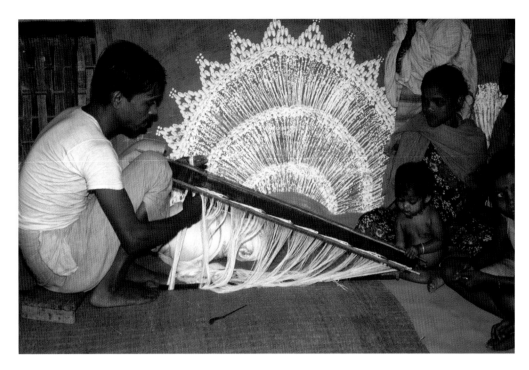

LEFT: *Visual Note 4. Wall drawing, Bhirapatrepur, Orissa, 1986.*
RIGHT: *Visual Note 5. Wall drawings, Chiloda, a village near Jodhpur, Rajasthan, 1990.*

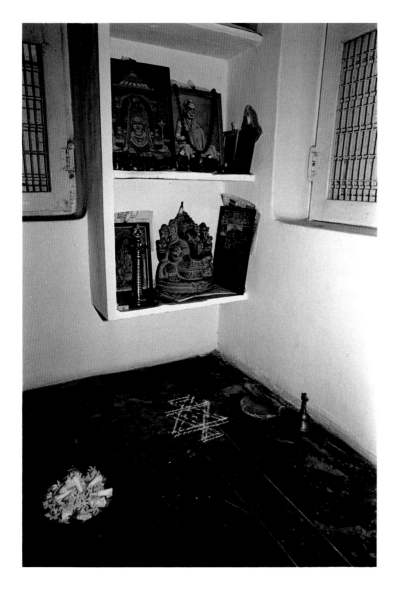

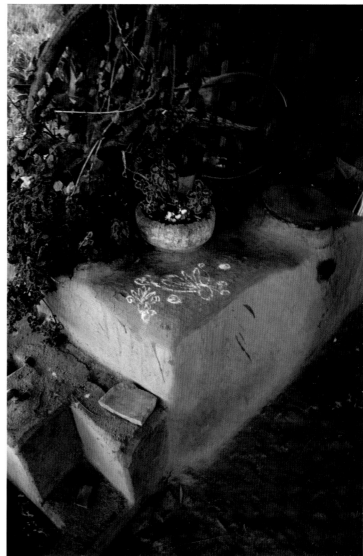

LEFT: *Visual Note 6. Chandru's puja room, Chennai, Tamil Nadu, 1990.*
RIGHT: *Visual Note 7. Rangoli in a garden in a village on the road between Ajanta and Aurangabad, 1990.*

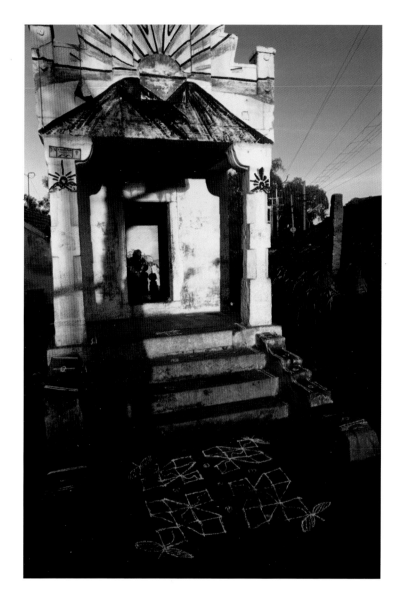

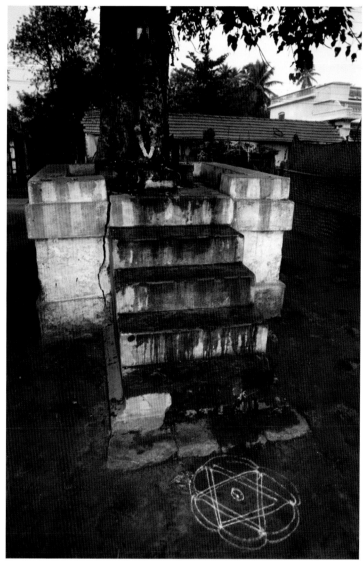

LEFT: *Visual Note 8. Village shrine near Madurai, Tamil Nadu, 1986.*
RIGHT: *Visual Note 9. Tree shrine, with Sri Chakra (double triangle) in a lotus diagram, in a village near Madurai, Tamil Nadu, 1986.*

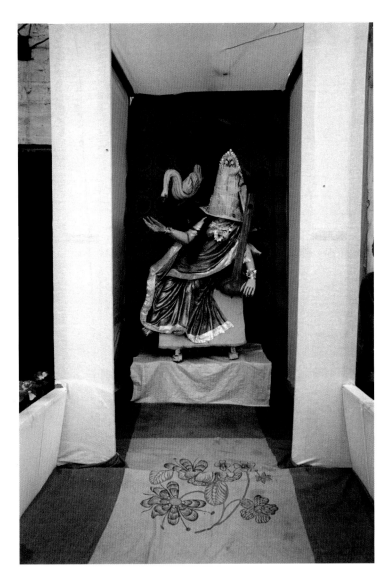

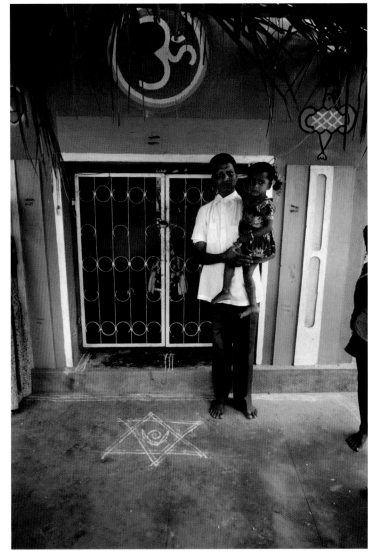

LEFT: *Visual Note 10. Shrine to Sarasvati during a festival in Varanasi, Uttar Pradesh, 1998.*
RIGHT: *Visual Note 11. Father and daughter at a roadside shrine with a Sri Chakra diagram in a village near Chennai, Tamil Nadu, 1985.*

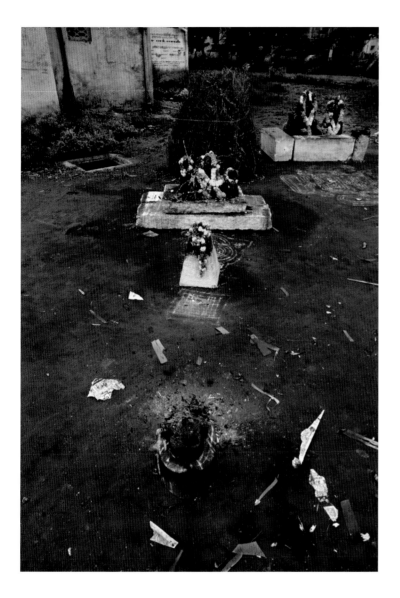 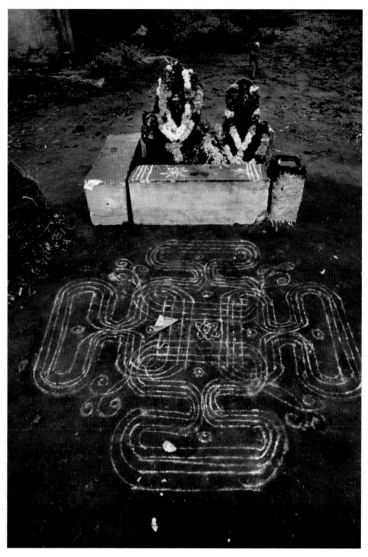

LEFT: *Visual Note 12. Shrine in a city street in Madurai, Tamil Nadu, 1990.*

RIGHT: *Visual Note 13. Shrine in a city street in Madurai, Tamil Nadu, 1990.*

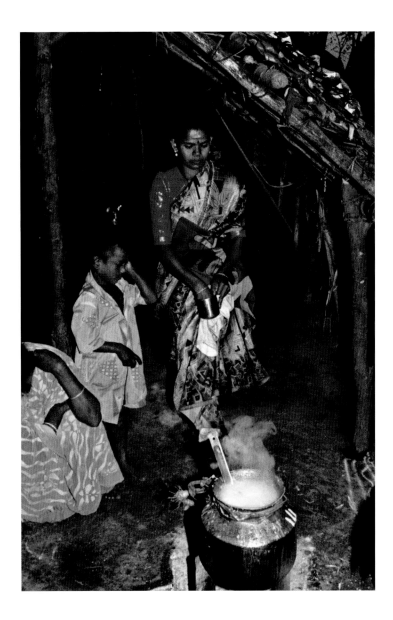
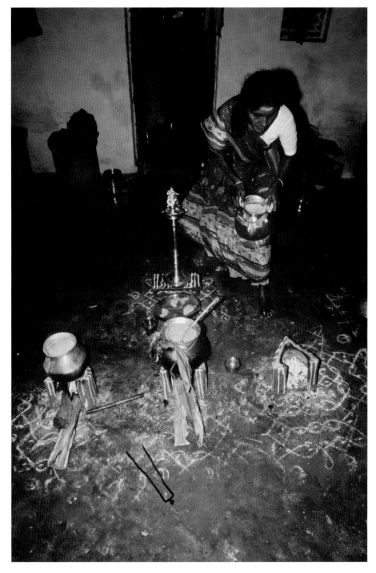

LEFT: *Visual Note 14. Boiling pongal, a popular rice dish, at daybreak under a full moon, village near Madurai, Tamil Nadu, 1998.*

RIGHT: *Visual Note 15. Preparations for pongal in Kancharampettai village near Madurai, Tamil Nadu, 1986.*

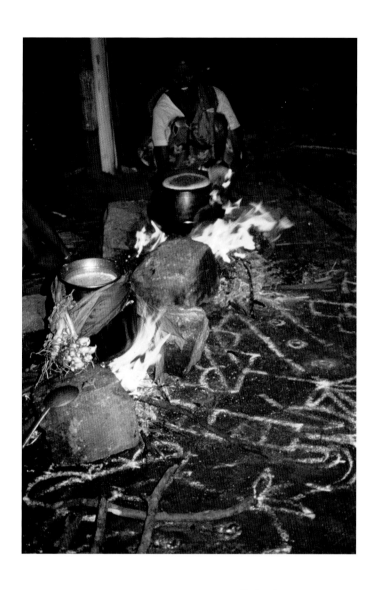

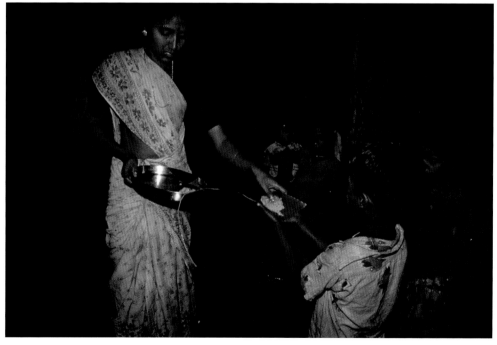

LEFT: *Visual Note 16. Boiling pongal pots on fires built on top of threshold diagrams and graced with turmeric and banana leaves, representing wealth and good fortune, streetside in Madurai, Tamil Nadu, 1998.*

RIGHT: *Visual Note 17. Pongal being served to children during a Pongal festival, Madurai, Tamil Nadu, 1986.*

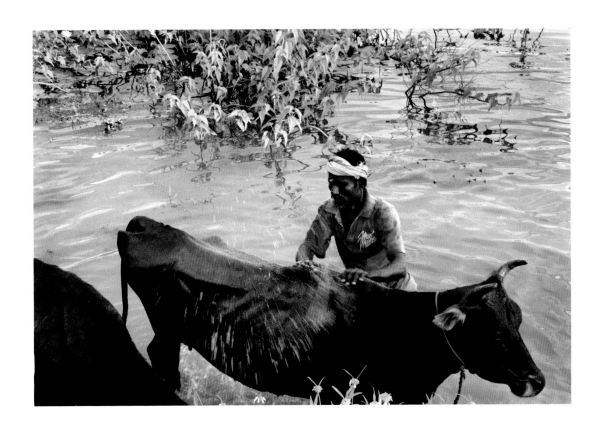

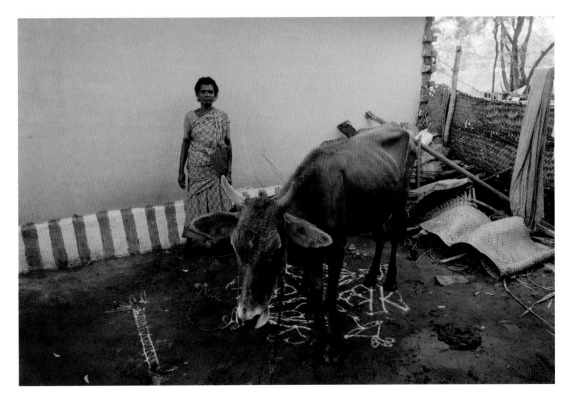

TOP: *Visual Note 18. Washing bulls near Madurai, Tamil Nadu, 1998.*

BOTTOM: *Visual Note 19. Bull decorated with turmeric paste and colorful spots in a village near Madurai, Tamil Nadu, 1998.*

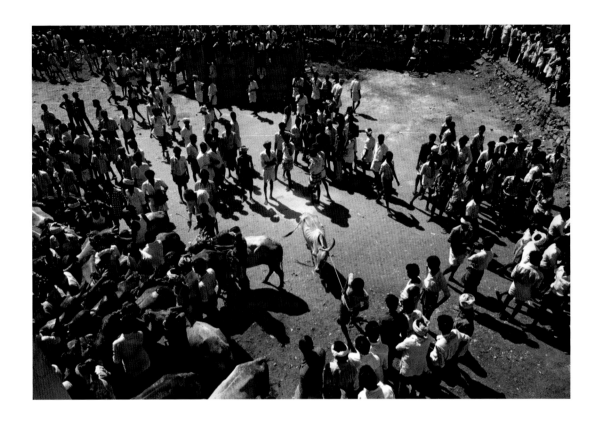

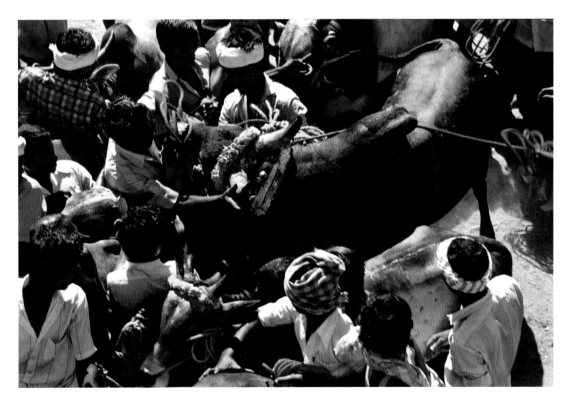

TOP: *Visual Note 20. Annual running of the bulls at Jallikattu in Alanganallur, a village near Madurai, Tamil Nadu, 1986.*
BOTTOM: *Visual Note 21. Bull decorated for Jallikattu in Alanganallur, near Madurai, Tamil Nadu, 1986.*

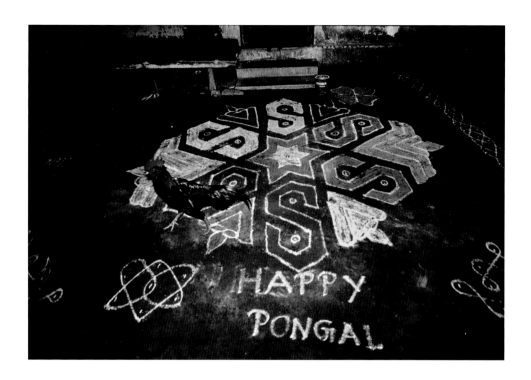

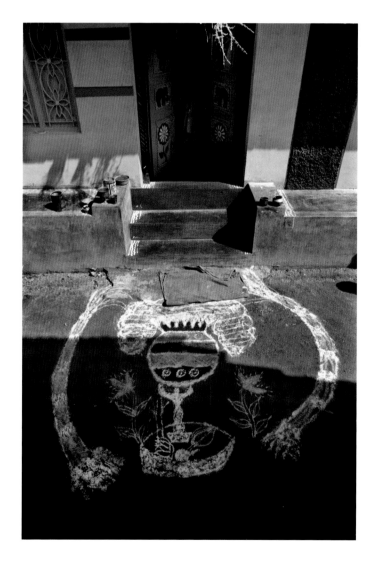

LEFT: *Visual Note 22. Stylized contemporary and auspicious diagrams made for the Pongal festival near Chennai, Tamil Nadu, 1986.*
RIGHT: *Visual Note 23. Representational Pongal diagram, showing bowls of colors used to construct the diagram in Srirangam, Tamil Nadu, 1986.*

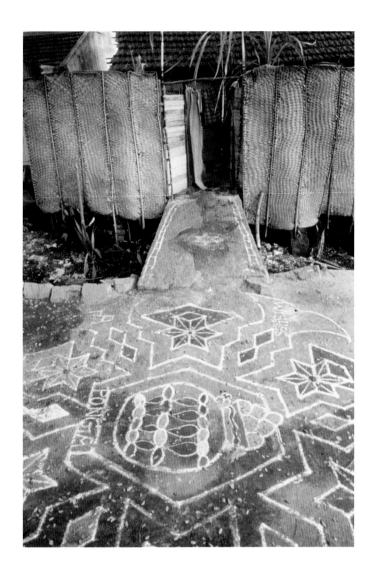

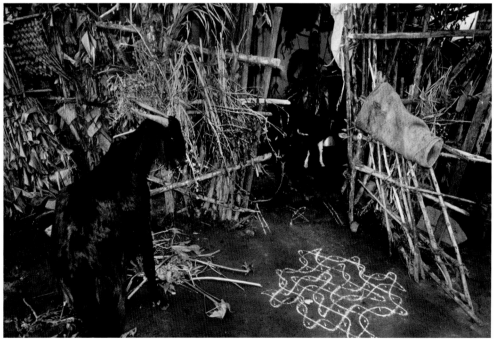

LEFT: *Visual Note 24. Pongal diagrams in Srirangan, Tamil Nadu, 1986.*

RIGHT: *Visual Note 25. Goats by grass fences with a diagram in the threshold in a village near Madurai, Tamil Nadu, 1998.*

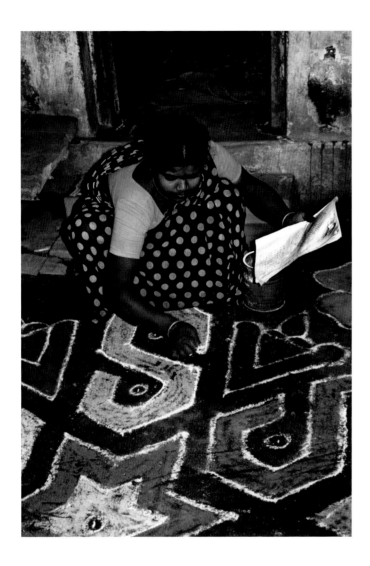

ஜோதி
எளிய கோலங்கள்

LEFT: *Visual Note 26. A woman with a diagram practice sheet and rice flour bowl in a village near Madurai, Tamil Nadu, 1990.*

RIGHT: *Visual Note 27. Commercial rangoli or kolam pattern books, 1986.*

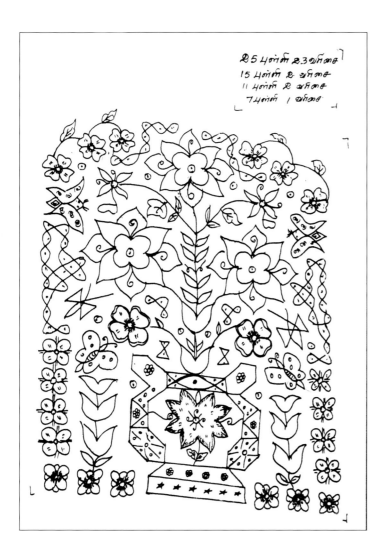

LEFT: *Visual Note 28. Page from a commercial rangoli pattern book, 1986.*

RIGHT: *Visual Note 29. Rangoli or kolam powders, 1986.*

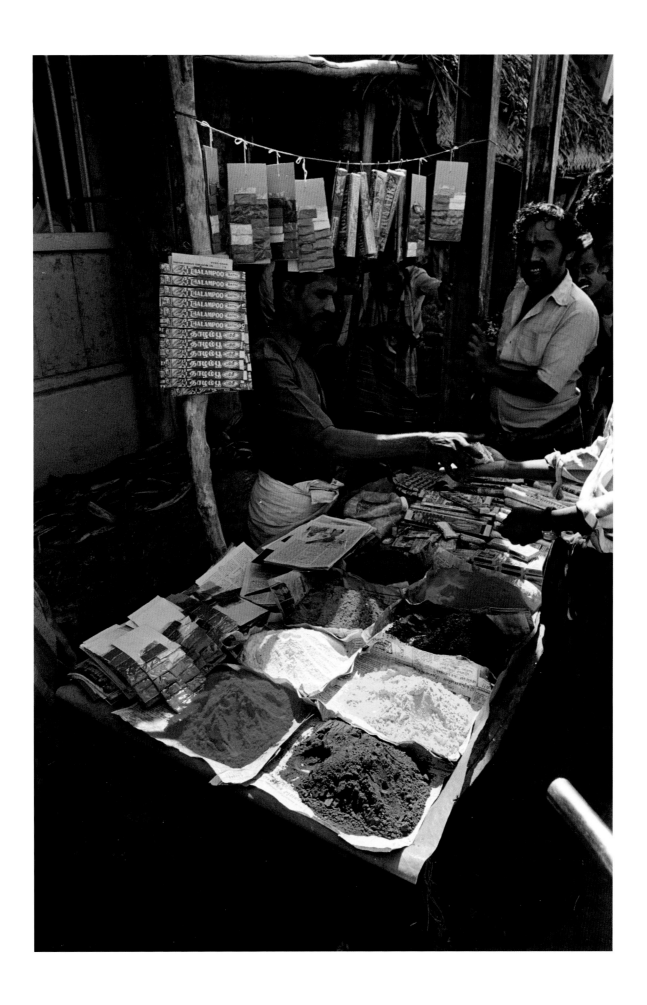

Visual Note 30. Kolam powder stall outside Kapaleeswarar Temple in Malapore, Chennai, Tamil Nadu, 2003.

Whatness is concerned with content.
In the solemnity of every hour life returns.
Whereness is concerned with linkages.
The legato of one squirrel holds a forest together.

—Frederick Sommer (1972)

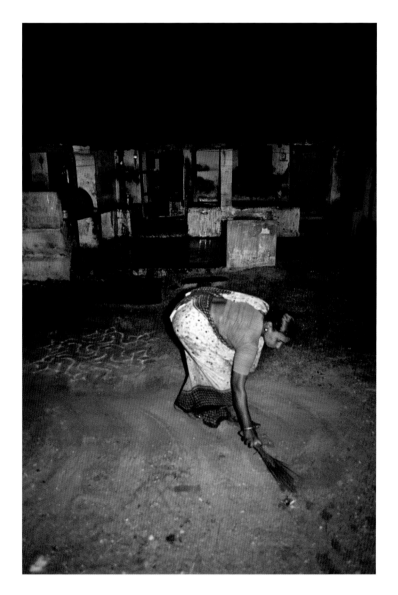
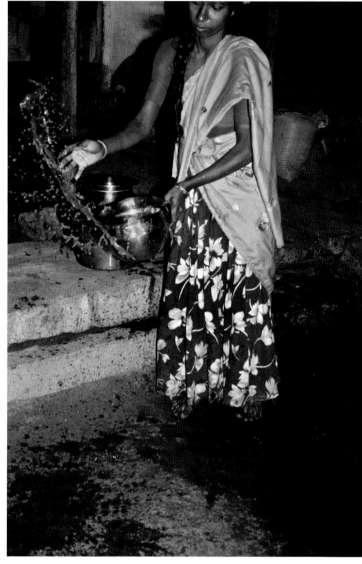

LEFT: *Visual Note 31. Sweeping the ground before dawn in a village near Madurai, Tamil Nadu, 1986.*
RIGHT: *Visual Note 32. Tossing cow dung water to dampen dirt in a village near Madurai, Tamil Nadu, 1986.*

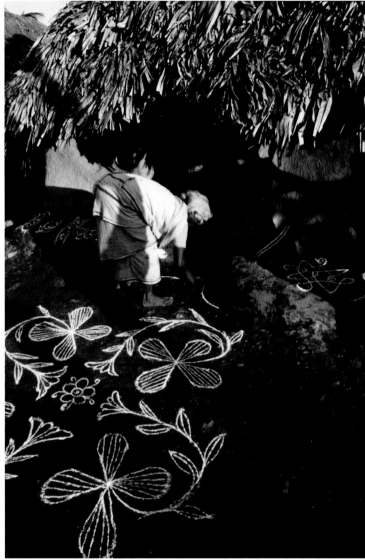

LEFT: *Visual Note 33. Beginning of a kattu-kolam (linear design), with dry application, near Madurai, Tamil Nadu, 1990.*

RIGHT: *Visual Note 34. Dry application of white rice flour, near Chennai, Tamil Nadu, 1990.*

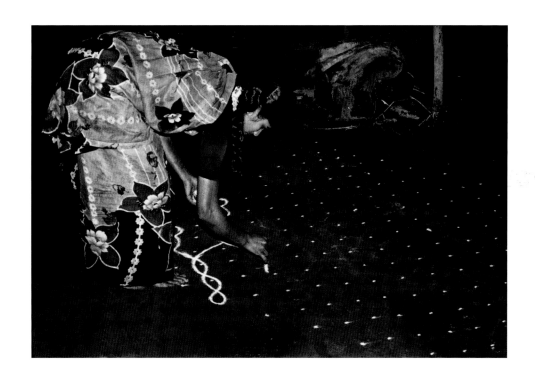

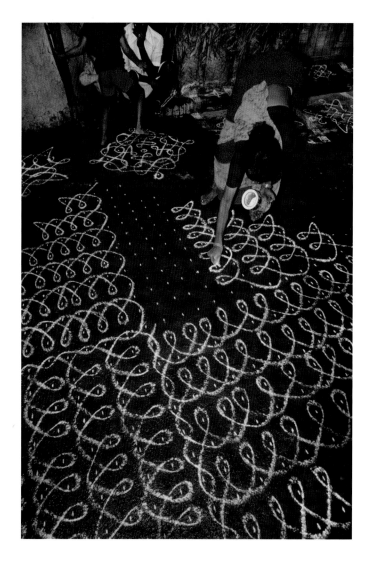

LEFT: *Visual Note 35. Beginning of a pulli-kolum, with dry application, in Chennai, Tamil Nadu, 1986.*

RIGHT: *Visual Note 36. Completion of a pulli-kolam, with dry application, in Chennai, Tamil Nadu, 1986.*

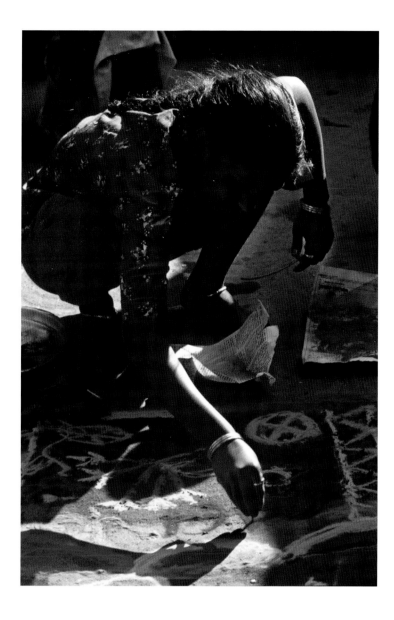 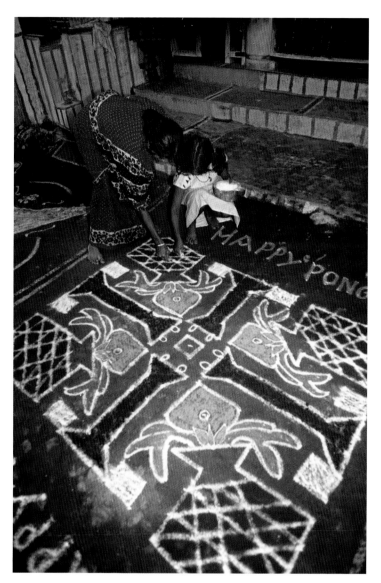

LEFT: *Visual Note 37. Dry application of colors for auspicious occasions in a village near Ahmedabad (Ahmadabad), Gujarat, 1990.*

RIGHT: *Visual Note 38. Mother and child making a diagram for Pongal in a village near Madurai, Tamil Nadu, 1998.*

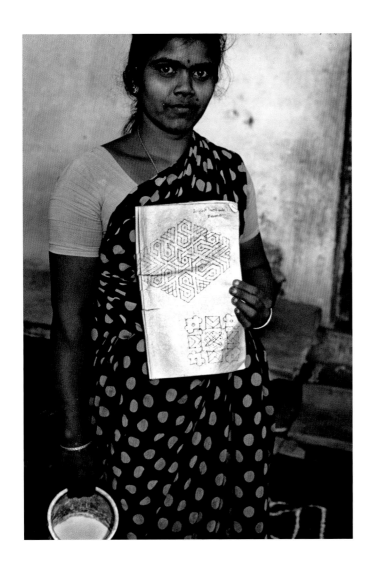

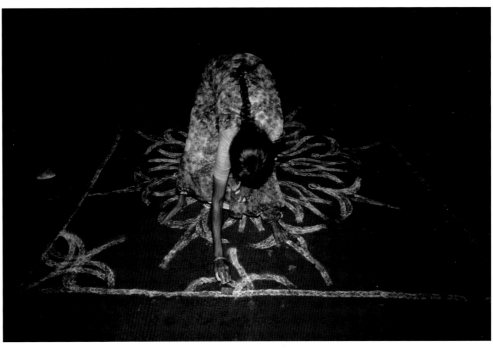

LEFT: *Visual Note 39. Woman with a diagram practice sheet and rice flour bowl in a village near Madurai, Tamil Nadu, 1990.*

RIGHT: *Visual Note 40. Rolling stencil, with dry application, in a village near Chennai, Tamil Nadu, 1990.*

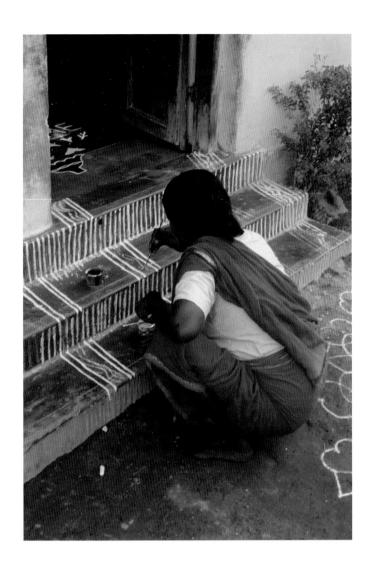

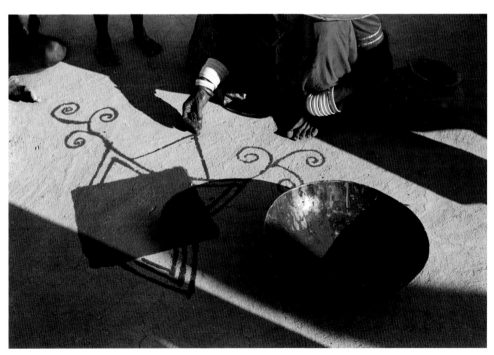

LEFT: *Visual Note 41. Wet application with brush on concrete steps in Madurai, Tamil Nadu, 1986.*

RIGHT: *Visual Note 42. Wet free-hand application of a kattu-kolam, using a small cloth as a wick to dribble chalk and water mixture onto a flat surface, in Khuri, a village near Jodhpur, Rajasthan, 1990.*

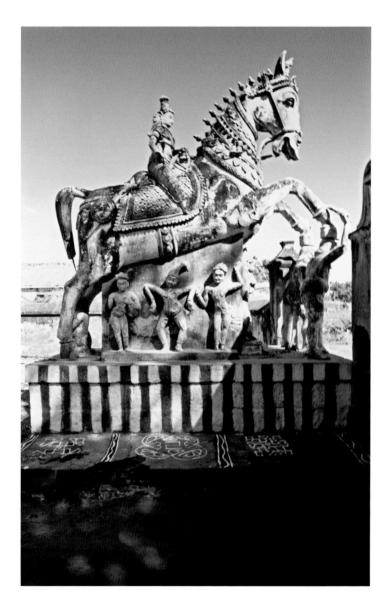

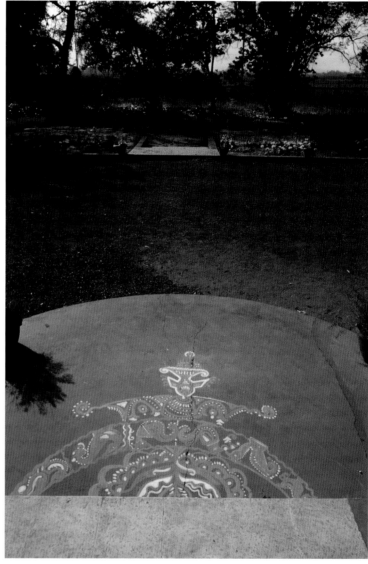

LEFT: *Visual Note 43. Wet application of a diagram at an auspicious place, a shine in a village in South India, 1990.*

RIGHT: *Visual Note 44. Wet application of a diagram in Shantiniketan, West Bengal, 1990.*

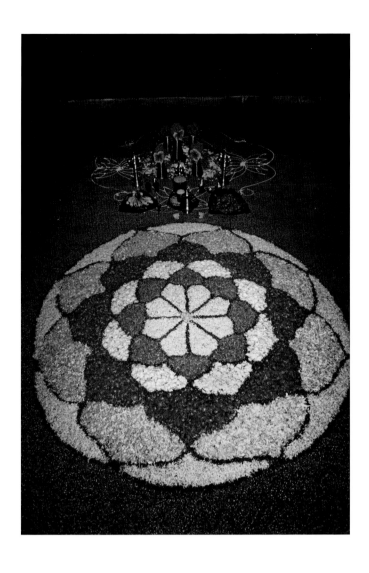

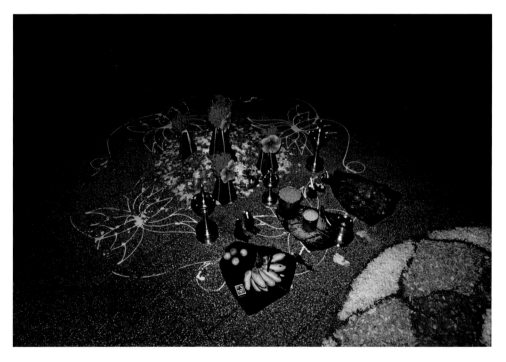

LEFT: *Visual Note 45. Athapuvidal, a threshold diagram made of fresh flower petals, in Trivandrum, Kerala, 1986.*
RIGHT: *Visual Note 46. Shrine created with symbols of the gods seated on a lotus diagram, in conjunction with a flower petal diagram made to honor King Mahabali, in Kerala, 1986.*

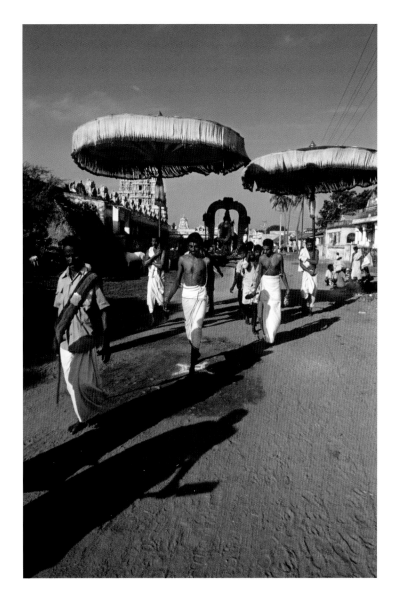

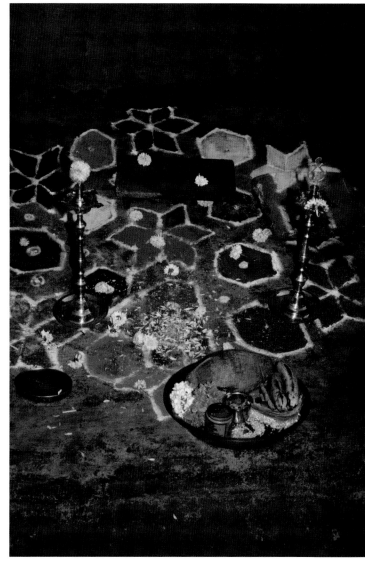

LEFT: *Visual Note 47. Typical religious procession in a street around a temple complex in South India, 1990.*

RIGHT: *Visual Note 48. Shrine for the gods, featuring a female initiation ceremony diagram, R. A. Puram area in Chennai, Tamil Nadu, 1990.*

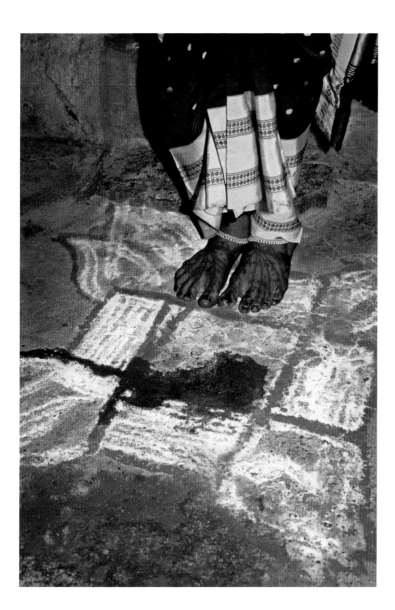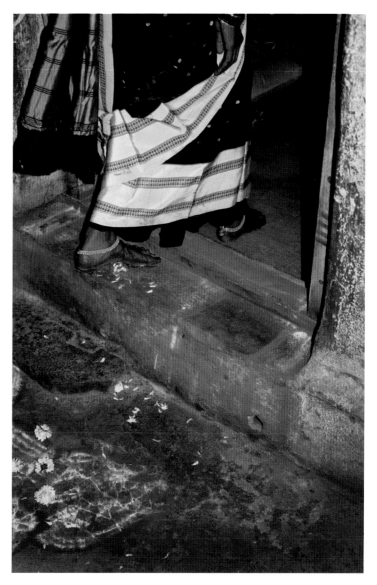

LEFT: *Visual Note 49. Fertility rite, featuring a female initiation ceremony diagram, R. A. Puram area in Chennai, Tamil Nadu, 1990.*

RIGHT: *Visual Note 50. Crossing the threshold into adulthood, featuring a female initiation ceremony diagram, R. A. Puram area in Chennai, Tamil Nadu, 1990.*

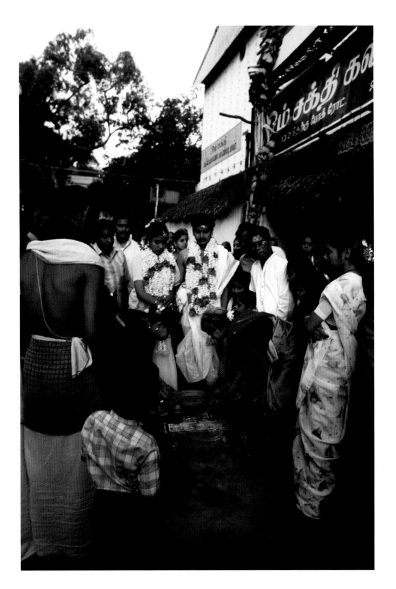
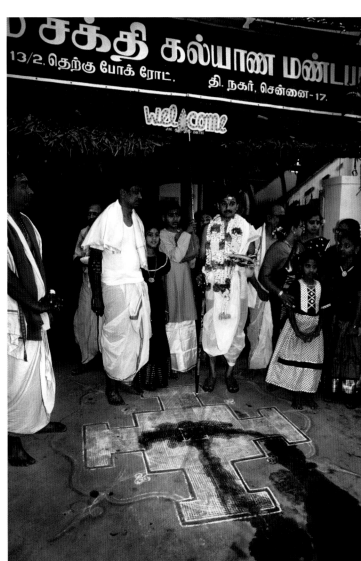

LEFT: *Visual Note 51. Marriage ceremony diagram in Chennai, Tamil Nadu, 1990.*

RIGHT: *Visual Note 52. Marriage ceremony diagram in Chennai, Tamil Nadu, 1990.*

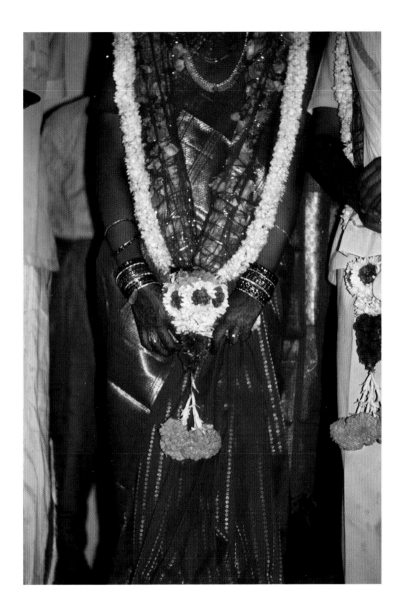

LEFT: *Visual Note 53. Marriage sari provided by the groom's family in Chennai, Tamil Nadu, 1990.*

RIGHT: *Visual Note 54. Preparation for a marriage feast in Chennai, Tamil Nadu, 1990.*

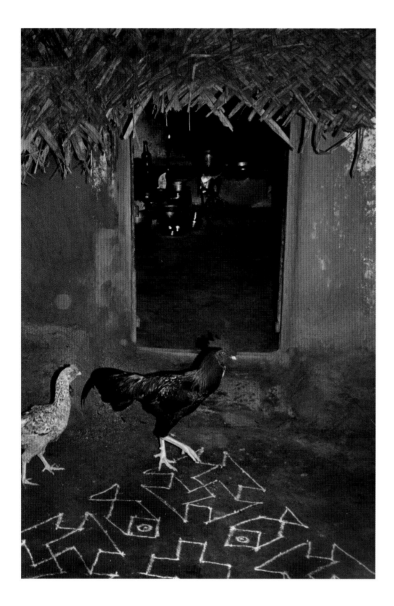

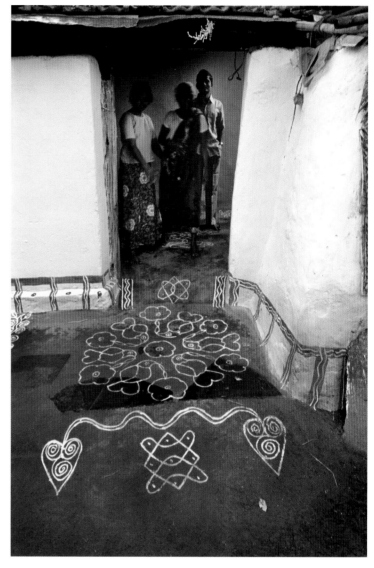

LEFT: *Visual Note 55. Prosperity diagram at the threshold of a home, with a view of the interior hearth and oil lamp, in a village near Madurai, Tamil Nadu, 2004.*

RIGHT: *Visual Note 56. Drawings and symbols of prosperity, fertility, health, and well-being at the threshold of a home in a village near Madurai, 1997.*

LEFT: *Visual Note 57. Sri Chakra diagram in Anandhi's garden threshold in Chennai, Tamil Nadu, 1990.*

RIGHT: *Visual Note 58. Puja (prayer) area at a home in Simla, Himachal Pradesh, 1990.*

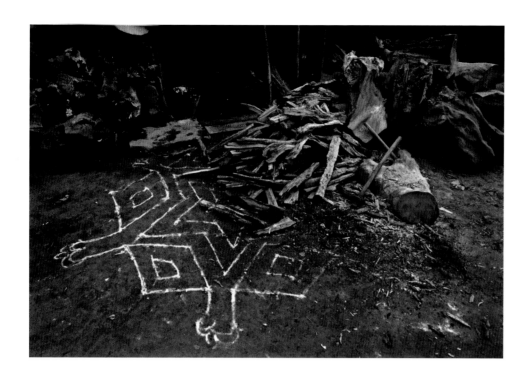

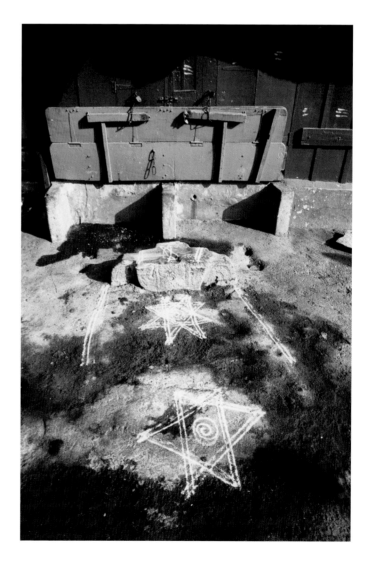

LEFT: *Visual Note 59. Wood is split for the burning ghats in Varanasi, Uttar Pradesh, 1986.*

RIGHT: *Visual Note 60. Sri Chakra, a cosmic cycle or eight-pointed star, and atomic symbol diagrams in front of a business on the road to Sririangam, Tamil Nadu, 2004.*

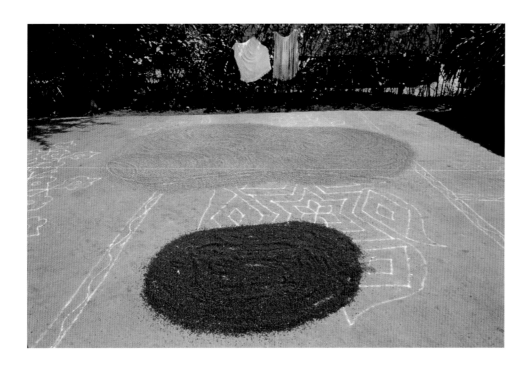

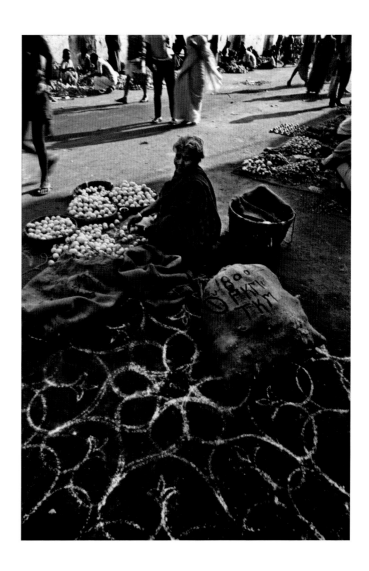

LEFT: *Visual Note 61. Lentils drying in a courtyard in Singaperumalkoil, a village near Chennai, Tamil Nadu, 1986.*

RIGHT: *Visual Note 62. Woman street vendor in Chidambaram, Tamil Nadu, 1986.*

In perfect rhythm, the art form becomes like the stars
which in their seeming stillness are never still, like
a motionless flame that is nothing but movement.
A great picture is always speaking. . . . That is art.
It has the magic wand which gives undying reality
to all things it touches, and relates them to
the personal being in us.

—Rabindranath Tagore (1961)

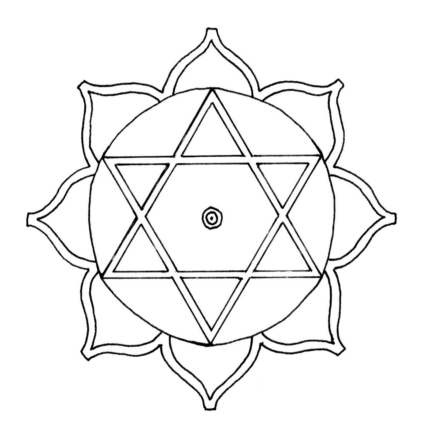

Mazes, Mysticism, and the Female Principle in Indian Life

MARTHA A. STRAWN

The Diagrams

The threshold floor diagrams, as traditional art forms of India, are profound, because they are an ancient practice performed with deep purpose. They are mysterious, because the Indian knowledge of this practice has largely been forgotten. They are magical, because they serve symbolic functions that establish power by transforming one kind of space into another. They are practical, because making the diagrams has a positive impact on the daily lives of Indian families.

These diagrams touch upon areas as diverse as religion, visual anthropology, art history and criticism, women's studies, psychology, mythology and symbolism, Indian cultural studies, Indian arts, and Indian classical literature. Their recorded roots go back to the beginning of Hindu history, and their practice continues today. While these diagrams are still being made, the form and nature of the practice changes as the culture changes. The phenomena of the profound may become forgotten knowledge as the pleasures of making designs primarily for the decorative arts (patterned space, made for adornment) becomes increasingly popular. In the more abstract and naively executed diagrams, which appear more sophisticated in design, connections to a larger meaning become most obvious and feel most powerful (Plate C).

While floor diagrams are made traditionally by women, the rare exception is the priest or monk who occasionally makes a floor diagram in an altar area. The diagrams, once down, change a secular space into a sacred space that is to be traversed by people, animals, and the spirits.

The women of India are responsible for maintaining a large part of the metaphysical and physical continuance of the threshold concept that has been inherent in Indian culture for thousands of years in which Indian women have wielded significant power. In both prominent and less-noticeable positions, they have maintained functions of control in arenas that make a difference. One example is the role women played maintaining the Indian way of life in the context of British domination. When Indian men began receiving English educations unrelated to the indigenous Indian life and thought, the women became largely responsible for the children's inheritance of Indian modes of thought and feeling, acculturation, spiritual training, and philosophy of life in the Indian tradition. Another of those arenas is the sphere of magical-religious ritual, not used as a mere bag of tricks but as a life-protecting force and performed as a meditative act.[1]

Early in the morning, just before sunrise, the woman sweeps the threshold area (VN 31), washes it with cow dung mixed with water (VN 32). After she completes these preparations, she may execute the diagram dry, using powder that is rolled from the forefinger by the thumb, drawing from a store of powder in the palm of her hand (VNs 34, 35, and, 36); or she may execute the diagram wet, using a powder and water substance dribbled through her fingers as she squeezes a small rag held in the palm of her hand (VN 42).

Traditionally, five colors (white, red, yellow, black, and green) are used in the sacred diagrams (VNs 29 and 38).[2] The colors of the diagrams vary according to the amount of traditional influence remaining and according to the character of "auspiciousness" of the day on which the diagram is made (Plate 37; VNs 48, 49, and 52). Auspicious days include anniversaries, birthdays, religious occasions, and significant rites of passage such as initiation or marriage. Excluding the use of flower petals during the *Thiruo-nam* festival in Kerala (VN 45), the powder used for dry and wet drawings varies by the geographic region where the diagrams are made and by the colors used. Most are made of rice flour or calcium carbonate (chalk) chunks ground into powder. Occasionally, calcium carbonate chunks are used like chalk sticks to draw on a hard surface such as clay tiles or cement. The use of chunks or sticks to draw on a hard surface probably developed with the occurrence of constructed floors (as opposed to earthen floors) or as a technique for wall drawing (VN 5).

Across India, no one name is used to refer to threshold diagrams. The names vary according to the state or region in which they are found. Some of the names used regionally are: *kolam* (dry form), *makkolam* (wet form), *pulli kolam* (all-white diagrams designed around dots and based on a system of tantric order) in Tamil Nadu; *athapuvidal* (flower petals) in Kerala; *alpona* in Bengal; *rangavalli* and *rangoli* in Bengal, Maharshtra, and Gugarat; *sathya* in Gugarat; *aripana* in Bihar and Uttar Pradesh; *cauk purna*, *cauka*, and *chowk* (empty square space) in Uttar Pradesh; *jhetti* or *jhunti* in Orissa; *mandana* in Rajasthan; and *apna* in Himachal Pradesh.[3] These variations more specifically describe the process or form used in making the diagrams. Variations in form establish stylistic differences in rendering, design, and expression that occur among the geographic regions.[4] Several factors influence their rendering, including: location of the diagrams, the variety of materials used, and variances in line quality.

First, because the location of the diagrams varies from placement on a horizontal plane to placement on a vertical plane, the visual perspectives and application techniques change to accommodate the nature of the surface plane. When applied to a horizontal plane, both dry and wet materials can be used. The dry powder is sprinkled (VN 37) or rolled (Plate 2; VN 40). The wet solution is dribbled or painted with a finger or

brush. When applied to a vertical surface, only wet materials are used. These wet materials are flipped in strokes onto the wall, dabbed with the fingertips or painted with a brush (Plate 57; VN 41). The vertical surfaces are usually walls, interior or exterior. The horizontal surfaces are primarily floors (the ground or surfaced floors), although streets, benches, or platforms are also used (VN 7).

Second, various drawing materials are used, varying from region to region. Most common are rice and chalk powders applied in either dry or wet forms. When colors are desired, flower, leaf, and root powders as well as ash and colored chalk are employed. Other variations include flower petals, cow dung, and, occasionally, paint. The physical nature of the substance with which the diagram is drawn affects the visual result. A dry rice-flour drawing looks more ethereal than rice flour applied in wet form to the same floor surface. Also, the characteristics of the surface on which the substance is applied can alter the visual effect of the diagram to the extent that the usable substances are limited. For instance, dry powder cannot be used to make a drawing on a vertical clay wall!

Third, line quality is influenced by the maker's level of inspiration, the skill of application, the technique of application, and the material used. Technique depends on the material used and the surface plane on which the diagram is applied.

Motivated by the desire to save time and to increase decorative skills, modern influences have resulted in several changes in the means of application. Rolling cylinders punched with patterns of holes release powder as they are rolled, functioning in a way similar to a player piano cartridge winding out the rhythm of a tune. Another quick application technique is the recently developed "stick-on" diagram. In this age of decals, Indian women have acquired the ultimate speed, making a daily diagram by snapping off the plastic backing and slapping down the diagram. Creativity aside, this technique provides a means of retaining the magical concept behind the diagrams as the Indian culture moves further into the harried technological age where application skills and appreciation of daily arts are endangered.

Each design differs from the others basically in color and construction. Color is determined by the purpose and timing of the practice. If the diagram is made daily and the day is not auspicious, then white is used (Plate 88). Made from rice flour or chalk, the white color, symbolizing purity, is the primary color used. Its symbolic reference to purity emphasizes the position of importance this quality holds in the Hindu culture.[5] Red is used with white in diagrams made on auspicious days (Plate 71). Red connotes energy and refers to blood, the source of all life. Symbolic of Surya, the life-force, yellow is made from turmeric. Black is symbolic of the void, emptiness, or, perhaps, death. It is made from burnt cereal ash. In some areas, black is not used for fear of inviting ill effects. Green is symbolic of continuity of existence—that is, cyclic

rejuvenation (VN 22). It is made from the leaves of the bilva tree. Blue made from indigo may also be included in the color palette. Blue is used to symbolize water (Plate 86; VN 22). Contemporary use of chalk to create the diagrams has added orange and violet to the color palette (Plate 37; VN 48). More colors are used on festival days.[6]

The diagrams differ first in structure to project various symbolic intentions. They are spoken of as "writings," because they employ hieroglyphic, pictographic symbols that referred to magical and alchemical origins.[7] The second area of design differences is in construction. Generally, the diagrams may be described as dot-structured, line-structured, or iconographic. The dot, or *bindu*, is the highest form of abstraction. The bindu symbolizes the source of being, the center of the universe. It has position only, representing the point where form touches formlessness, where male and female are unified, and where there is no beginning and no end. Many sacred diagrams are drawn on a dot structure. The *sarvatobhadra mandala* is regarded as the source of all *yantras* and *mandalas*, (geometrical sacred images which are made as graphic mirrors of supernatural essences).[8] Also, this mandala (circle) is a symbol of the energy of the virgin goddess and the explosive energy of the rising sun made manifest through abstract form. The *sarvatobhadra mandala* is structured on dots placed in a formal arrangement of two triangles, one with its apex pointing toward the sky, the other toward the earth (Plate 32; VN 57).[9] As Pupul Jayakar writes, "The expression of these two, great energy forms are integral to all *mandala* and *Vrata* (religious vow and associated practice) pictographs."[10]

The line structure frequently creates a labyrinth within which the evil forces are trapped, prohibiting them from following a family member of the maker into the world during the day or from entering the home and bringing in ill circumstances to the people who reside there. The line diagrams are made of continuous lines, that is, the lines have no beginning and no ending. They represent the cyclical nature of time, birth, and rebirth—the constantly renewing cosmic cycle (Plate B).

The iconographic design structure presents identifiable forms, rendered in the abstract or as representations, which symbolize various gods and goddesses, objects of reverence, ideas, and images, suggesting mythic experiences. The diagram may contain only one primary symbol such as a bird, symbolizing fertility [Plate 44], or the diagram may be composed of several symbols such as the *Athapuvidal*, symbolizing the welcoming mat for the King Mahabali during Onam (VN 45).

Expressive or, more precisely, stylistic differences appear in the diagrams by region. Both rendering and design differences affect expression. For instance, rice flour has a finer consistency than chalk powder. Rice flour is used almost exclusively in Tamil Nadu, while chalk powder is used in Gujarat. Both the availability of materials and regional custom govern these choices. Rice flour tends to render a lighter, more

delicate drawing than chalk. The drawings I saw in Tamil Nadu, for example, are more delicate in appearance than those I saw in Gujarat.

Inspiration is pivotal to the style and level of creative expression in the diagrams. Metaphysical or artistic concerns motivate the artist. When the primary emphasis in the drawing process is to create a sacred space (that is, motivation is metaphysical), the drawings appear more vitally rendered (Plate 41); when the primary emphasis in the drawing process is to create a formally designed decorative image (that is, motivation is artistic), the drawings appear less vitally rendered (Plate 43). This difference suggests that women who are inspired by a conscious or unconscious internal knowledge of the critical function and power of the diagrams they are making reflect that inspiration in the drawing process. If this is true, then metaphysical motivation can be said to result in more vital line quality and designs that are more ingenious, if not more complex. Complexity, however, appears to be more related to the skill level and time pressures of the maker than to the nature of inspiration or, even more, to whether the diagram is done as a daily drawing or for an auspicious occasion. Diagrams done for auspicious occasions are frequently much larger, more colorful, and sometimes more intricate in design. Examples of larger and more complex diagrams are those executed for harvest festivals, initiations, or marriages (VNs 23, 24, 48, and 52). Most of the diagram renderings can be described as falling within a stylistic range, from ingenious vitality to contrived formality. The more consciously formal or decorative the designs, the less the overall aesthetic projects liveliness and the feeling of meaning. I believe this correlation is related to the pivotal role of inspiration in the drawing process. This is not to say that a consciously designed diagram cannot be vital or lively in feeling, as if spontaneously created; rather, it suggests that primary motivation, like spiritual hunger, in the creation process has the greatest influence on the outcome of the drawings.

The *kolam* in Tamil Nadu and the *rangavalli* in Karnataka are some of the most ingenious and lively floor diagrams presently drawn (Plates 1, 13, and 70). As described by S. Shankaranarayanan, "The tamil name for *mandala* is *kolam*, guise, as it contains in disguise the Divine Power."[11] Similarly styled diagrams are drawn daily in Kerala. Another form drawn seasonally in Kerala is called *athapuvidal* (VNs 45 and 46). They are made of flower petals and symbolize carpets of welcoming for King Mahabali during the Onam festival. The athapuvidal is a floor diagram differing from the diagrams in all other Indian states, because it is created with flower petals. In contemporary practice, the most prized petal diagrams are the least vitally expressive. They are, however, very carefully and perfectly executed like the formal patterns in a finely woven oriental carpet.

The people in Orissa seldom execute floor diagrams. On the walls they make threshold drawings, which are usually abstract and simply designed, highly decorative in appearance, and often very colorful (Plates 57 and 65; VN 4). Wall drawings are

also found in other states such as Rajasthan, where both floor diagrams and wall drawings are made (VN 5). Most of the renderings in Rajasthan are applied to surfaces using a wet form of chalk that makes them heavier in line quality and more decorative in appearance.[12]

The *alpona* diagrams of Bengal, especially around Calcutta and Santiniketan, apparently has changed in style as a consequence of the influence of Rabindrinath Tagore's school, Santiniketan. Here, the diagrams are defined as a valuable source of subject matter to be modernized by the "artist" in a conscious effort to make "art." The alpona are done primarily in wet form and are found on both floor and wall surfaces. Stylistically, alpona do not have the vitality of those diagrams made less self-consciously. The intent of these contemporary patterns is significantly more decorative than the intent of more traditional forms (Plate 9; VN 44).[13]

In Himachal Pradesh, the simple white powder drawings are similar to those still prevalent in Tamil Nadu. Also, a wet form is applied to floor surfaces or to cloths that are hung behind an altar for a *puja*, or prayer, ritual (VN 58). The *puja* drawings that will remain on the floor are sometimes done in dry form. Traditionally, puja diagrams are made with white, red, yellow, and occasionally green powder or paste. Both men and women create the puja drawings. In other areas of India, where women usually make diagrams for the homes and men make them for the temples, exceptions occur. Women make diagrams for specific areas in the temples, and men make special home puja diagrams. Most men who make diagrams are *pandits* (priests or religious specialists). Content, which is characterized by astrological and numerological references using symbols and symbolic placement, influences the style of the puja diagrams. The line quality of the diagrams I observed was not very delicate, which suggests that concern for content may overshadow concern for form. An example of a puja drawing customarily made by a pandit is the *navagraha puja* diagram (Plate 40).[14]

To comprehend the character of the Hindu culture and the place of the threshold drawings in it, the significance of natural phenomena on the spiritual and physical lives of the Indian people must be understood. The combination of abstract mystical theory and meditation with strict observance of astrological predictions made by the study of the sun, moon, constellations, and other heavenly bodies forms the basic metaphysical response system for most Indians. The belief in and observance of various omens and superstitions that were nurtured during earlier historical times is still an essential part of daily life.

Three fundamental concepts are central in both ancient and contemporary Indian culture: the rebirth cycle, fertility and time itself. All are cyclic in nature, perhaps arising from the archaic observations of the waxing and waning of the moon—presumably,

the earliest cyclical event observed by humans. According to Srimiti Archana in *The Language of Symbols*:

> Various rituals (Indian) were enacted accordingly, either on full moon or new moon days. Even today, most of the auspicious rites are performed during full moon days (Poornima). The rites of the dead are performed on new moon days (Amavasya)—the day of the spirits or ancestors. The death and rebirth of the moon are identified with natural death and rebirth processes.[15]

The Indian people still use both solar and lunar calendars as well as a working almanac rooted in astronomy, algebra, and number theory.[16] Historically, Hindus believe their lives are governed by the heavenly bodies. Therefore, both astrologers and priests guide the actions in people's lives. The astrologer prepares a life history or horoscope chart cast for the individual. The priest interprets this life history for the individual in prayer.[17] In my experience, the priest related the information after the prayer was completed. Because the remuneration for each service is low, especially in the hilly or more remote areas, astrologer and priest are often one person who performs both services.[18]

Aesthetic differences in the drawings may be related to the degree that myths and religious practices remain, individually or communally, a vital part of the lives of the people who make the drawings. Their drawings through the effects of an inspired state of being, reflect that vitality as well as an intense feeling of meaning.

RITES AND RITUALS

The threshold diagrams represent an Indian woman's act of assuming power in concert with the forces that govern the well-being of her life and the lives of those around her. On three occasions, I observed and participated in the *Pongal* celebrations in Madurai, Tamil Nadu, and the outlying communities located relatively close to the city. Madurai and its nearby villages are composed mainly of Hindus. The city, one of the seven sacred cities of India, has a long history as a Hindu religious center, and it is the site of the Meenakshi temple. In that area, making threshold diagrams has continued consistently, which made my study there especially valuable.

Pongal occurs at the end of *Margazhi*, the month of the dying sun. *Bhogi pandigai*, the last day of Margazhi, precedes a new growth cycle. This festival day is dedicated to Indra, who bestows rain for the crops. On this day just before Pongal, the houses are cleaned out, and all unwanted things are gathered and burned. This ritual prepares the house for the first day of *Thai*, the next Tamil month. Thai is dedicated to the worship

of the sun god, Surya. Traditionally, Pongal takes place over three days called *Thaithirumal Pongal* (Tamil). On the first day, *Thai Pongal*, or *Perum Pongal* (Great Pongal), the people worship Surya. The second day of Pongal, called *Vettu Pongal* (Tamil), is spent honoring the home and worshiping Surya. The third day, named *Mattu* (or *Maatu*) *Pongal* (Tamil) or Bull Pongal, is a day for honoring the bulls. Some interpretations of Pongal include a final inauspicious day of relaxation called *Kaanum*, or *Kanyapongal*. On this day, people play and visit family members. Also on this day, preparations of rice and curd are left on banana leaves for insects and small animals such as ants, birds, and squirrels. This practice is symbolic of the importance of sharing the family's harvested prosperity with a universal family of living beings.[19]

The *Thaithirumal Pongal* festival celebrates a healthy, productive herd and a bountiful harvest. In early days, the people of India were mainly agrarian. They depended on cattle for much of their existence, and they used a barter system in which wealth was assessed by the heads of cattle and the quantities of grain one possessed. Present-day practices are similar, and the rituals remain the same. If the year has been good, the people feel secure. Two harvest periods occur every year in most of India, in October and in January. Pongal comes at the end of the larger winter harvest and is celebrated to give thanks for the harvest as well as to bring good fortune for the season to come.[20] During the fall, the temperatures are moderate and conditions are better for growth than during the extremely hot summers that precede the fall harvest.

During Pongal, very large and colorful diagrams are made in all varieties of threshold areas: in front of shrines and temples, at entrances to homes and businesses, and at entrances to courtyards or other communal gathering places. Being in an Indian village under a full moon, while watching women make these mysterious and magical drawings, is nearly indescribable because of their beauty and multi-leveled complexity. Arriving under a moonlit sky, I was able to see the morning dawn in concert with the Pongal rituals. The diagrams are started very early to be completed before sunrise (VN 14). Also before sunrise, a fire is built in the center of the diagram, and three pots of milk are put on to boil (VN 15). One is for sweet *pongal* (similar to rice pudding) and the other two are for savory *pongal*. Around this fire, women place offerings on plantain leaves in the forms of sacred objects and farm products such as small, earthen or metal oil lamps, turmeric, bananas, coconuts, sugarcane, and vegetables (VN 16). Five offerings are usually made: one each for the sun, fire, Indra (or house deity), the sacred lamp for prosperity, and Ganesha, the elephant-headed god known as the Remover of Obstacles, who is represented by a cone of turmeric.[21]

The central pot of sweet pongal, or "sakarai," is made of hand-pounded rice, "jaggery" (similar to dark brown sugar), "ghee" (clarified butter), spices, and a few almonds and raisins added to milk. This mixture cooks on the fire until a sweet pongal is ready

to eat. When the milk boils and flows over, the children excitedly gather around and shout, "Happy Pongal!" The women roll their tongues, making sounds to ward off evil spirits.[22] Then, spoonsful of the pongal are served on leaves and handed out to the children and the others present (VN 17). The flowing-over of the milk symbolizes prosperity and joy. "Pongal" means to flow out, and this entire ritual is based on celebrating bountifulness. In concert with bountifulness on Thai Pongal, the landlords give presents, usually clothes, to their workers: new dhoti-kurta for the men and new saris for the women.[23]

Vettu Pongal takes place on the second day of Thaithirumal Pongal, the day the home and Surya are worshiped. The focus of the celebration is to initiate children into worship. The ritual involves presenting the children with a small, clay house, similar to a doll house in Western cultures, containing miniature vessels and decorated with magical drawings made of lime. In a scale closer to their own size, the children are taught how to honor the home and to make offerings to the sun god.[24]

The third day is Mattu Pongal, celebrated only by people who own cattle, to honor the animals. Cattle, cows, and bullocks, enjoy (or tolerate!) acknowledgment of their contribution to material prosperity. Appreciation takes the form of washing and decorating the animals, taking them to the temple of the presiding village deity, treating them with the first serving of sweet pongal when it is served, and worshiping them. Until early afternoon on Mattu Pongal, you can see men scrubbing cattle in fields with buckets of water or in lakes (VN 18). You also see people decorating cattle with colored dots and a single line drawn continuously from the head to the tail. These colored markings probably symbolize continuous protection. "Kumkum" and sandalwood pastes are put on the cows' foreheads, and the horns are painted with bright colors and adorned with equally colorful tassels (Plate 42; VN 19). When all is done, the cattle are very festive looking creatures. The festivities on Mattu Pongal include a sport called *jallikattu,* much like the "running of the bulls" at Pamplona, Spain. Some refer to it as the "bull chasing."

When I attended jallikattu in a village just out of Madurai, huge crowds of people filled stands made of bamboo and other odd pieces of wood rising high into the air on either side of a rather narrow passage. Others hung from every available protrusion. Looking across from my own perch, I saw a wall of packed and jumbled people cheering and waiting excitedly for each event. At one end of the narrow passage a gate opened to release a grandly decorated bull. As it bolted out into and down the crowd-packed passageway, young men ran after it in a great state of excitement, shouting and waving their arms (VNs 20 and 21).

The notion of jallikattu is that a strong bull will be chased by youths who seek to tame it. This sport has heroic origins. Forest people, called Aayars, required young men

who wanted to marry their daughters to succeed in formalized bull-taming games.[25] The consequences of contemporary jallikattu are not so serious. Today, the sport is a colorful, wild, and raucous celebration enjoyed by participants and spectators.

In the afternoon, after jallikattu is over, families return to their homes to celebrate the end of the three days of Pongal. Once again, threshold diagrams grace the entrance to the home, and a fire is made. As the sun drops lower in the sky, the three pongal pots are prepared, and offerings are placed around the fire on plantain leaves. When the pongal boils over again and again, the children repeatedly shout "Happy Pongal!" An offering ritual to the animals is performed by the father, and this male head of the household, toiler of the fields and tender of the animals, serves pongal to the animals. Afterwards, the family eats a meal of savory and sweet pongals, fruit, and tea or coffee.[26] With the setting sun on Thaithirumal Pongal, the new year begins, graced by acts of reverence and colorful festivities.

These three days of ritual celebrations occur at the turn of the year, separating the old year from the new and dividing the most inauspicious month from the month dedicated to Surya. Therefore, Pongal serves as a threshold, trapping the evil energy and prohibiting it from going forward into the new year. That enormous, highly colorful, and extraordinary numbers of threshold diagrams highlight the ritual celebrations during Pongal makes perfect sense. Working by the light of the full moon early in the morning on Thai Pongal, women prepare the ground and consecrate it with the large, ornate diagrams in every conceivable threshold area (Plate 52; VN 23). These Pongal diagrams demonstrate the womens' skill in ways daily diagrams do not. At Pongal, women are more competitive in making the drawings, a little like striving for the best Christmas decorations in the neighborhood. In any case, the results are awe inspiring. For block after block, in the cities, towns, and villages, brilliantly colored, intricately made, symbolic diagrams cover the streets. It truly is a magical time (Plate 67).

For practicing Hindus, the rites and rituals associated with their beliefs usually incorporate the use of threshold diagrams. To invoke power and to communicate nonverbal meaning, Indian aboriginals made *mandalas,* symbolizing wholeness and the outer visualization of cosmic energy. According to Pupul Jayakar in *The Earth Mother*:

Mandalas were born of ancient man's perceptions of the cosmos and of the magical processes of birth, death and existence—imponderables that could only be explained or revealed non-verbally through geometry and the magical abstractions of mathematical form.

The primeval urge for the auspicious and for protection against the unknown and the malevolent had demanded from the earliest times the tools

of mandalas and yantras. The yantra was the concrete form of the mantra and could be used both for protective and for evil purposes.

The contours of the yantras and the mandalas are determined by the need to give visual form to the magical spell and to concretize the exploding energy of the ritual gestures. The magical diagrams created by the ritual act, when awakened and made operative by incantation and ritual gesture, could create, enclose, protect and destroy energy. Certain elements were common to all forms of mandala diagrams. These hieroglyphs of Tantra and magical ritual, the Vrata and Utsava mandalas, more commonly known as "aripans," "alpana," "sathia," "chawka," shared a common need for symmetry. The circle, the triangle, the square, the hexagon and pattern evolved from these simple structures, formed the basic elements of all magical drawings. Another common feature in the mandalas was the gateway, the opening that surrounded enclosed energy-charged space. These doorways were guarded by sound forms, mantras, and by invisible "ksetrapalas" and "dvarapalas," guardians of gateways and spaces. The entry into the heart of the diagram, into the sanctity and security of the mandala was through the mantra and mudra spell and magical gesture, revealed to the initiate.[27]

The use of magical drawings still occurs in numerous forms. The diagrams are drawn on surfaces, on walls, on pieces of paper or cloth. They are also stamped or engraved in metal or clay objects and made in food form. The threshold diagrams presented in this book are representative of a much larger practice. In each form, the diagram represents the makers' acts of assuming power in concert with the forces that govern the well-being of their lives and the lives of those around them.

Pongal, the annual Tamil harvest festival, presents a classic example of women exercising their control by making the diagrams. The festival symbolizes death and rebirth. Threshold diagrams are integrated into the ritual, essentially and comprehensively. While white, or white and red, diagrams are made year-round in most areas of South India (Plates 33, 62, 70, and 93), once a year (in mid-January) the Pongal festival features massive varieties of extraordinary threshold diagrams throughout the streets of the cities as well as in the more rural communities and villages in Tamil Nadu (Plates 34, 49, and 86).

Other diagrams made during harvest festivals are the *athapuvidal* of Kerala, with their unique flower petal composition (VNs 45 and 46). Their mythic reference is to the story of King Mahabali, also referred to as Bali, ancient ruler of Kerala.[28]

Onam is another harvest festival, held when many flowers are in bloom and the people are rich from the harvest. A saying goes, "Even if you have many riches and

money, you have to celebrate Onam to show Mahabali that you are still just as happy as when he was ruling." In celebration, the houses are decorated elaborately. Onam is characterized by the availability of sumptuous varieties of vegetarian food, the re-enactment of the golden reign of King Mahabali in lively songs and dances, and snake boat races held to the rhythmic sounds of traditional boat songs in the palm-fringed backwaters of Kerala.[29] Part of the ritual of Onam echoes Kerala's feudal society, which bases activities on the household structure. During Onam, the serfs present gifts of their labor to the landlords, and the landlords bestow gifts upon the serfs. Within a family, the eldest members give new clothes to the rest of the household.[30]

The athapuvidal is the major visual manifestation of Onam. Petals of many colors, sizes, and shapes make brilliant and intricate threshold diagrams that function symbolically as welcoming carpets for the returning king during his annual visit. The diagrams are quite large and ornate. Their styles range from abstract to realistic or figurative. The myth of Mahabali is symbolized repeatedly in the graphic representations. Among the sacred objects used are the *Thrikkakara Appan* (a terracotta piece made by local potters), a lighted oil lamp, and offerings of bananas and coconut.[31] These items are placed on a rice-flour diagram usually located at the head of the petal diagram (VNs 45 and 46). The complete creation is very complicated and rendered formally in a ritualistic manner. The diagrams are created and maintained for the ten days of Onam.[32] With their central themes of death/rebirth and the Mahabali myth, the diagrams made for this festival are unique in India. Their uniqueness is in the prescribed visual articulation of the myths and in the physical composition of the flower petal diagrams. These characteristics are derived, respectively, from the creation of these elaborate welcoming carpets as symbolic manifestations of the myth and from Kerala's tropical nature, with its abundance of flowers and lush vegetation.

The Creative Process

My first impressions of the diagrams in Mysuru (Mysore) in 1977 were that they were magical, mysterious, symbolic, vitally rendered and lively in their expression—curious finds in a very different culture (Plates 1 and 3).[33] As I continued to explore the phenomenon of threshold diagrams in a variety of circumstances, my first impressions remained intact, but the description expanded: the diagrams were powerful, complicated, decorative products of the makers' needs to be both meditative and competitive. They were integral to the lives of many Hindu women and their families, connected to the theories of numerology and astrology, embodiments of power and especially the symbolic of the power of women.

Women as Artists

Yantras and mandalas in the form of threshold diagrams symbolize women's perceptions of the nature of existence. Death/rebirth and fertility are cyclic processes traditionally at the heart of women's motivation to perform the acts of the various threshold rituals throughout India. The acts associated with the drawing process and the visual manifestations of the ritual involved portray a sense of power.

Both the diagrams and the act of making them are powerful forms of self-assertion. By doing the diagrams, women train their minds, spirits, and bodies in a sophisticated symbolic language that is communicated visually. They use discipline to learn a complex system of design and to develop an intricate set of application skills. For instance, women develop the ability to draw the same graphic pattern on both the left and the right side of a form, without distortion. Normally, such a freehand practice is difficult, but, in India, one frequently observes evidence of this trained capacity (VN 34). The body movements required to prepare the space and to draw the diagrams are a daily form of physical exercise, performed in a meditative manner similar to yogic practice, *t'ai chi chuan*, and other physical/mental arts associated with a philosophy.

To establish a personal connection with the threshold diagrams, I had to acquire a sense of why and how women transferred the crucial on-goingness of this activity. How was it taught and learned repeatedly over a vast history? What caused its survival in a world increasingly burdened with constraints on time? What are the reasons behind the existing variations? What are the pressures both for and against continuing the practice? What elements used in this primitive ritual are beneficial to the contemporary Indian culture? I needed answers to those questions as I proceeded with my visual work.

How, I wondered, did my experiences and intentions as a woman and an artist relate to those of the makers of the threshold diagrams? Women's attitudes concerning their own social/sexual state of being within India unfolded slowly. My misconception was that Indian women are dominated by the threat of blatant male acts of violence (such as bride burning) and socially dictated female acts of violence against themselves (such as *sati*, a widow throwing herself on the cremation fire of her dead husband). It seemed incongruous to me that such a society permitted a woman, Indira Gandhi, to become prime minister or placed numerous women in governmental positions of major authority.

The Female Principle

The key to approaching and understanding the position of women in India today is rooted in assimilating information about India's cultural history with its Vedic descriptions and associated myths and rituals. The ancient people indigenous to the Indian sub-

continent were hunter-gatherers. Their culture was based on the earth and its fertility. Some assert they lived in a matriarchal society, which revered women because of their exclusive association with procreation. The *Grama Devatas* (the village mothers), the Earth Mother, *Amma* (the Mother), and *Sakti* are names associated with the archetypal sacred female, Divine Mother, or cosmic feminine energy.[34]

According to Heinrich Zimmer, the first appearance of the Goddess (also referred to as the goddess, even as there are many manifestations) in a recorded form occurs in a myth reported in *The Text of the Wondrous Essence of the Goddess (devi-mahatmya)*, taken from the *Markandeya Purana*, which is "the most famous of the many myth-collections describing the character and deeds of the Goddess." Zimmer recounts this myth thusly:

> She is described as an unconquerable, sublime warrior-maid, who came into being out of the combined wraths of all the gods gathered in council. The occasion of the miracle was one of those dark moments for the gods, when a demon-tyrant was threatening to undo the world. This time, not even Vishnu or Shiva could avail. The titan was a colossal monster named Mahisha, in the shape of a prodigious water-buffalo bull.
>
> The Gods, under the leadership of Brahma, had taken refuge in Vishnu and Shiva. They had described the case of the victorious demon and implored the assistance of the twofold All-Highest. Vishnu and Shiva swelled with wrath. The other divinities also, swelling with the power of their indignation, stood about. And immediately, their intense powers poured forth in fire from their mouths. Vishnu, Shiva, and all the gods sent forth their energies, each according to his nature, in the form of sheets and streams of flame. These fires all rushed together, combining in a flaming cloud which grew and grew, and meanwhile gradually condensed. Eventually it assumed the shape of the Goddess. She was provided with eighteen arms.
>
> Upon beholding this most auspicious personification of the supreme energy of the universe, this miraculous amalgamation of all of their powers, the gods rejoiced, and they paid her worship as their general hope. In her, "The Fairest Maid of the Three Towns" (*tripura-sundari*), the perennial, primal Female, all the particularized and limited forces of their various personalities were powerfully integrated. Such an overwhelming totalization signified omnipotence. By a gesture of perfect surrender and fully willed self-abdication they had returned their energies to the primeval Shakti, the One Force, the fountain head, whence originally all had stemmed. And the result was now a great renewal unfolded into a system of strictly differentiated spheres and forces, Life Energy was parceled out into a multitude of individuated man-

ifestations. But these now had lost their force. The mother of them all, Life Energy itself as the primeval maternal principle, had reabsorbed them, eaten them back into the universal womb. She now was ready to go forth in the fullness of her being.[35]

A rich body of myth and ritual perpetuates the power of the female in India. Magic was and remains a key element in the culture, forming the basis of many rituals through use of symbolic gestures, sounds, and images that summon desired results.[36] Historically, huge cultural changes occurred when the overall societal profile evolved into a primarily patriarchal system in contrast to the earlier matriarchal societies of indigenous Indian civilizations. The idea that this change was initiated when the patriarchal Aryans invaded, conquered, and intermingled with the indigenous people of India is based on the Aryan Invasion Theory. Strong arguments now challenge the accuracy of that theory.[37] On the basis of the Aryan Invasion Theory, it might be said that huge cultural changes occurred when the patriarchal Aryans met and merged with the matriarchal indigenous people of India. Further, a logical supposition is that, in light of an invasion, the early Indian myths and epics indicate the power of the invaded to absorb and influence the traditions and practices of the invaders, since the strength of the sacred female remained strong in the integrated society's rituals and religion.

The newer theory is that civilization migrations occurred because of natural geological and climatic changes. These changes forced the highly evolved Indus-Sarasvati civilization located in the area around the Sarasvati River, which eventually dried up, to migrate eastward toward the Ganges River. Embodied in this theory is continuity of the indigenous peoples' beliefs and practices. Though the culture changed as it moved and evolved in response to geographic and cultural shifts, the historical precedents remained ingrained in later cultural manifestations.[38] For instance, again it might be said that powerful indigenous Mother rites, based on fertility and regeneration, were suppressed as the ancient tribal groups blended with others to form an amalgam and the power of the sacred female survived in secret women's rites and fertility rituals.[39]

In the context of the Aryan Invasion Theory, it might be said that one technique used by the Aryans to "purify" the archaic people and to initiate them into the Aryan culture was to require participation in the *Vrata Stoma* ceremony. Another concept, however, suggests that the Vrata Stoma ceremony evolved as the civilization did. In either case, this ceremony became the *Vratas* (rituals, homeopathic magic, and alchemy), constituting the ritual-bound base affecting all of Hindu household life. Vrata rituals were and still are essential for women. As the primary participants enacting the Vrata rituals, women connect to esoteric knowledge and remembrances of a time when women were the priestesses and seers guarding the mysteries.[40]

Finally, from the Aryan/indigenous marriage, or from the migration and evolution of the Indus-Sarasvati civilization, into a Vedic/Indus-Sarasvati civilization, two approaches to controlling one's circumstances evolved: the Vedic and the non-Vedic. The Vedic peoples believed in sacrifice, ritual, and worshiping the gods. Non-Vedic peoples used magic and alchemy and Vrata and tantric rituals, which were open to the women, who were non-Brahmin, Sudra, and the tribal. They thought they had the ability to affect change, and their rites and rituals were used for that purpose. Both approaches were and are practiced throughout India, in urban and rural areas, co-mingling.[41] A form of these practices, the threshold diagrams, has been made throughout India. Each region has both characteristics common to all regions and characteristics particular to its identity. Regional characteristics have created stylistic variations about similar concepts, since people in all regions have made diagrams for similar purposes.

When magic and alchemy of the non-Vedic practices integrated with the rituals and worship of goddesses and gods of the Vedic practices, a form evolved that harkens back to the primary power of the Goddess. Contemporary women draw magical diagrams in temples, at shrines, and in front of homes, consecrating the sacred space of the threshold, and they believe they can control the influence that affects the space (VNs 1, 8, 10, and 11).

Within the cultural history of Hindu beliefs, the goddess is perceived and worshiped in two ways. The Goddess is seen in the three consorts to the three male manifestations of the Supreme Being, and she is seen as autonomous in the goddess Sakti, or Mahadevi, who is identical with the Supreme Being, the source of cosmic Life Energy, the One Force, the fountainhead, the Mother.[42] The Supreme Being is the Prime Cause of everything.[43] This Being has no identifiable characteristics to which mere humans may relate empathetically. The Supreme Being often is portrayed with three descriptive aspects: the creator, the preserver, and the destroyer, personified in a trinity of gods: Brahma, Vishnu, and Shiva. Because the complementary joining of the male with the female is a basic premise that symbolizes unity or wholeness in Hindu philosophy, three female principles have been identified as their consorts: Sarasvati (the goddess of all creative arts), Lakshmi (the goddess of wealth or prosperity), and Parvati (the goddess of protection and destruction). Their qualities complement those of the three aspects of the gods. As consorts, they reflect the patriarchal ideal of what a wife should be: the preserver, nurturer, and lover for the husband and the family. Even if the myths contain other qualities of these consorts, the culture censors all except those desired by the patriarchy. As Rehana Ghadially writes, "In a patriarchal culture, what we get is a masculinist definition of ideals and images of women."[44]

When the goddess is autonomous, the situation is different. According to Shakunthala Jagannathan; Sakti is the symbol of cosmic energy in its dynamic form: the "World Mother, who is the power and energy by which the Great God creates, preserves, and destroys the world."[45] Sakti (literally, energy or power) has many forms, including Parvati (the consort of Shiva), Kamakshi or Rajarajeshwari (the Great Mother or the Divine Essence), Durga (the ego and arrogance that each human has to subdue), and Kali (her angry form and the personification of Time). In all her forms, Sakti has eight arms, each of which holds a different symbol or weapon and moves in a separate direction from the others. Sakti has two important aspects: the Divine Mother, worshiped mainly in the home, and the goddess of terror, usually worshiped in public or in secret practices and rituals. Blood is usually shed in sacrifices to Sakti.[46]

With the manifestation of Sarasvati as one of the three primary consorts, a strong projection of power emanates. As one of the few important goddesses in the *Vedas* who remain significant in later Hinduism, Sarasvati is the earliest example in the Indian tradition of a goddess associated with a river, the Sarasvati River. She predates later river goddess associations with the Ganga and Jamnu rivers. The Sarasvati River (now a dry river basin) is said to originate in heaven and to provide an ever-flowing stream of celestial grace, which purifies and fertilizes the earth. In Indian tradition, including Hinduism, Jainism, and Buddhism, crossing a river symbolizes moving from the world of ignorance or bondage to the world of knowing or freedom. Crossing the river entails crossing the threshold between these spaces and changing from one state of perception to another. The waters of the river purify and carry the pilgrim forth, reborn into an enlightened existence. Sarasvati's identity, therefore, is associated with both earthly and heavenly attributes, giving her character a transcendent dimension.[47]

In later Hinduism, Sarasvati is less directly associated with a river but with the life-giving nature of all water: clouds, rain, rivers, ponds, streams, and such. More significant in later Hinduism is her association with creative sound most often referred to as "speech." The whole creative process is contained in the sound of *Om*, the sound that created the universe, the sacred syllable, representing the sacred word, personified as the Goddess Sarasvati (Plates 49 and 63). Because speech is a coherent sound, which is a vehicle for carrying ideas, wisdom, and culture to others in communication, Sarasvati is identified with thought and intellect, communication, knowledge and learning, inspiring and embodying both the arts and sciences in human culture. The more abstract comprehension of the significance of the goddess as a symbol of cosmic creativity, transcendent in nature, encompasses the larger scope of Sarasvati's attributes. The goddess represents a long history of the development of the Vedic civilization as it evolved into present-day Indian culture in its depth and rich diversity. The attributes

of Sarasvati that support this evolution are her associations as a universal goddess whose functions extend to the creation of the worlds. Referred to as "mother of the world . . . whose form is power or sakti, and whose forms contains all forms within her," this goddess of culture is equated with the highest powers of the cosmos.[48]

When the manifestation is Kali, the images of the Goddess are black. Her mouth is red, symbolizing blood, and she has fanglike teeth. She is scantily clad, wearing a strand of skulls around her neck. Kali is a horrible, demon-destroying female image. She is a threatening, powerful manifestation: the goddess of all natural phenomena that cause feelings of terror. Worship of Kali requires animal sacrifice, which, according to scholars, has included human sacrifice.[49] Reference to human sacrifice in early religious practices of indigenous Indians conveys the notion of giving the "all," as a unified whole.[50] The "all" refers to the ultimate giving possible by a people: the complete connection with the Supreme Being.[51] Some scholars assert that human sacrifice is associated with the worship of the Goddess in all cultures;[52] others refute this idea, indicating scholarly disagreement on this subject.[53] Whether human sacrifice occurred is not the point. The fact that the myths and legends include human sacrifice as part of Indian cultural history influences the contemporary Indians' feelings of heritage. That heritage is based on potent female power. The knowledge affecting present Indian culture asserts that indigenous matriarchal Indian cultures were spiritually maintained by priestesses, who exacted male sacrifices for the satisfaction of the Goddess, Earth Mother.[54] By propitiating the Earth Goddess with pieces of human flesh buried in the fields, the worshipers acted to ensure a bountiful harvest and good health.[55] Women as priestesses and seers nurtured such beliefs and controlled the rituals.[56] These women were not oppressed and powerless. The female was the representative of the supernatural force that affected all life.

Things have changed. Many Indian women are oppressed. Their oppression is an accustomed one. Accustomed to hierarchical structures in the community and in the family, the women exist in expected circumstances maintained by a combination of custom, functionality, and religious belief, although many of the circumstances are limiting or abusive. A relationship between equality and individual freedom is a concept alien to Indian society, and Indian women's experience differs from Western women's experience of oppression.[57] Western women's anger is partially a product of frustration resulting from unexpected inequality. The countries of Western Europe and North America claim equality as a fundamental political ideology. Women, however, do not enjoy a parity with men, financially or otherwise, and, when there is an expectation of equality, experiences of inequity breed frustration, anger, and hostility. Direct anger and exasperation are expressed by women in the West. The widely described feelings of women in India are sorrow, discouragement, and suppressed anger. Indian women are mirrors of emotion.

The position of Indian women is, perhaps, unique in the world. Since the beginning of India's (and Pakistan's) independence from Great Britain, and with the adoption of a democratic system of governance on August 15, 1947, the constitution granted women full equal rights. The constitution states that women and the former untouchable castes and tribals who are recognized as "weaker sections" of the population must be assisted so that they can function as equals in society.[58] These legal provisions were established largely because of social reforms initiated by men for reasons based as much on political expediency as on social consciousness.[59] Nonetheless, the statements of Indian government officials are consistent in recognizing the obligations the constitution imposes and that the revisions congruent with the changing times provide for the health, education, employment, and welfare of women in each of India's Five-Year Plans. In the first through the fifth plans, the emphasis was on providing women with "welfare" and "protection." In a step forward, the sixth Five-Year Plan put a new emphasis on involving women as "partners in development."[60]

Besides having constitutional rights and being included in governmental plans, Indian women have legal and political guarantees that support the equality of the sexes, including property rights and provisions for divorce, employment, and health. The Directive Principles of the Constitution protect the principle of equal pay for equal work. Labor legislation ensures provisions for maternity leave, the government officially supports the use of contraceptives for birth control, and abortion is legal.[61] Given these legal safeguards and equal-opportunity provisions, Indian women have an immense, formalized base upon which to build a better existence. What women in India have not had are localized systems of implementation to make equality readily accessible. The bureaucracy is so complicated that, when a woman needs support to attain some aspect of a better existence, the bureaucratic mountain is usually too hard to climb. India lacks a satisfactory infrastructure that is directly accessible to women and that can make available the necessary psychological, physical, and political support that would encourage them to act in their own behalf. While women have legal and constitutional rights, these rights are effective only if they are exercised. To exercise them, Indian women need public support and a feeling of personal powerfulness.

Most women feel they have inadequate power to combat their oppressive circumstances. Those women who achieve positions of equality generally are either from wealthy, politically prominent, or more highly educated families or they have obtained an education and, therefore, feel a greater degree of empowerment. Their backgrounds give them both a more worldly perspective regarding the possibilities available to them and the motivation to work to improve their current situation.

For the rest, achieving this state of mind is difficult. Poverty sets limitations on women's choices. Illiteracy creates a further limitation, as does the inability to use the

law. Women uphold a value system of reverence for the father and devotion and service to the husband in the manner that one serves God; these practices are overwhelming deterrents. They are also faced with oppressive cultural hierarchies such as age, caste, and relationship by marriage. Marriage relationships are the source of a large degree of the personal abuse and self-imposed violence Indian women suffer. The antagonists in the family are often the other women. As Rehana Ghadially asserts, "Most women in India experience family violence as the cruelty of the mother-in-law or the husband's sisters."[62] It is, in fact, the husband or his younger brother who functions as the married woman's greatest ally.[63] Also, the mythology, as it is presented in the Hindu concept of *pativrata*, reinforces their value system and romanticizes it through legend, folklore, folk song and rituals. *Pativrata* "connotes a wife who has accepted service and devotion to the husband, and his family, as her ultimate religion and duty."[64] Indian mythology serves the patriarchal system well. In fact, the position of women is romanticized by that the mythology. Can the myths and legends be reinterpreted to reflect the experiences of women to give them support and strength? Some reinterpretation is already happening. According to Nancy Martin-Kershaw, women are creating their tradition. She cites as an example:

> . . . every Indian woman knows that Sita, in the Ramayana epic, is the ideal
> wife, submitting to Rama in all things. Yet, how many women know that Sita
> was a master of archery? Sita also ultimately grows tired of Rama's continual
> testing of her fidelity to him during her capture by the demon king Ravana.
> Finally, she is the woman who says that she has had enough and returns to her
> mother, the earth, where Rama no longer can control her.[65]

Another reinterpretation is found in Pupul Jayakar's book, *The Earth Mother*, which provides a description of the background and evolution of the culture through the ritual arts of rural India as they developed from its early matriarchal society. In the context of India, Jayakar describes the association of women with nature, the character and strength of the female principle, the effectiveness of the women who have acted out of their own power through time, the symbolism that evolved and persists today, and the particular forms or ritual arts that have been created. Stella Kramrisch, in her foreword to *The Earth Mother*, wrote:

> The goddess herself also is subject to change. The terrible Mothers may
> change their nature and change from devourers into protectors. But what-
> ever her manifestations in anthropomorphic-zoomorphic shapes, her yantra
> remains the same, the Sri Chakra.[66]

Sri Chakra is the geometrical projection of paramount power, a mandala, a symbol of the Supreme Being (Plates 21, 32 and 62; VNs 11, 57, and 60).[67] Women in contemporary Indian society have a powerful cultural heritage. Jayakar's book is a treatise documenting and explaining the power of that heritage and offering an example of a woman's self-empowerment.

Women's empowerment manifests itself in the business of survival in daily life, in the community, in magical and religious rituals, in health care, in politics, and in the arts and literature. Significantly, out of Indian cultural history comes a continuous line of women making threshold diagrams. Retaining the power they had openly in pre-Vedic times, women have continuously exercised their association with nature and magic. As the indigenous cultures submerged, so did the power of women, but threads of this power remain. Running through the metaphysical existence of the culture is a continuous practice of creating sacred spaces in threshold areas. The rituals are female-maintained, providing women with a link to the past as they continually re-enact the gestures and render the symbols that have held significant meaning throughout time.

Initiation and Marriage

Anandhi, my friend and cultural guide from Chennai (Madras), took me to a female initiation in Madras. We entered through a gate into a small walled courtyard just off the street. On the left was a duplex house with two front doors facing to the right. In front of us was a walkway to a common cooking room. To our right was an open area with a well at the far end near the cooking room. A high cement wall defined the right dimension of the courtyard. Two families lived inside, and the daughter who lived in the duplex farthest from the street was to be initiated. The light was on a slant in the sky, glinting across the girl, as she stood dressed for the first time in a richly colored sari, adorned with flowers, her feet decorated with *mehandi* designs (henna decoratively patterned drawings on the hands or feet), silver ankle bracelets, and toe rings. Her mother guided her to a small wooden stool placed in the center of a threshold diagram located outside the house in the open area (VNs 48 and 49). Once she was seated, an intimate group of female family and friends witnessed her initiation, placing offerings in a plate in front of her seat on the diagram, where two small oil lamps burned. The young woman was lovely, unsure of her actions but glowing in her excitement, as she was guided from the altar-like space to the decorated threshold of the house. As she stepped across the threshold, sari swirling around her ankles, jewelry jingling and sparkling in the sun, she was reborn into a new life (VN 50).

The coming-of-age or initiation ceremony occurs at a young woman's first menses. Held at dawn, it is an awakening and a passage of the girl child into a new identity and role identified as "woman."[68] The customary mythic semblance is that the girl becomes

a mature woman, ripe in her fertility to bear children, able to maintain the household, and ready to serve a man. The religious theory, however, is much broader. The girl child is maturing into a woman representative of the powerful female principle. As Srimiti Archana writes, "She alone, like the earth, was able to bring forth and invoke the life-generating forces, and was installed and deified as the primordial Mother Goddess."[69] Within the symbolism of Tantric Cosmic Unity, her movement into the mature female position of a goddess positions her as equal to the mature male position of god.[70] For both females and males, the initiation is an experience of symbolic death and rebirth, a threshold crossing into a new life.[71]

The marriage ceremony shows the same dichotomy. Marriage, the most auspicious occasion, is the beginning of the cycle of regeneration, because from marriage comes birth, making possible the continuing passages—rebirth and death. Each of the ceremonies I attended, was a series of formal, festive, and extensive rituals celebrated amid the rhythmic sounds of horns blowing, cymbals clashing, and bells ringing; bountiful displays of flowers in garland and loose forms; and sumptuous gastronomical creations of curries, savories, and sweets. Elaborate and expansive threshold diagrams played a critical role in all parts of the process, including those in front of the bridegroom's home on the morning of the day he goes to get the bride, those throughout the marriage hall on the day of the marriage, and those in front of the couple's home on the morning following the consecration of the marriage. On the day the bridegroom leaves his home to take part in the marriage, an elaborate diagram adorned with banana-leaf pillars standing on either side is drawn at the threshold of his front gate, providing a positive point of departure and announcing his intentions to all passersby. At the marriage hall, diagrams are drawn in front, throughout the entryway, on the marriage platform inside, along the edges of the rooms that hold the wedding gifts and those used as the changing rooms for the bride and groom.

As everyone crowded around the couple outside the marriage hall, they stood in the middle of an immense and intricate white drawing and performed rituals prior to entering the hall (VN 51). The rituals were accentuated by periodic drum rolls and blasts from a horn. During the ceremony, a plate of red liquid, *aarti,* was poured onto the drawing (VN 52).

Once inside the hall, we sat in chairs facing a large low platform, as though we were an audience attending a play. The wedding party, including the bride and groom, their parents, and several priests, sat in a semi-circle around an area marked by a diagram and numerous ritualistic objects. The marriage ritual was long and tedious, with many of the guests milling around while the ceremony continued. The priests performed a variety of rituals for the bride and groom while, with only a few exceptions, they sat passively. One of the major actions was the changing of the sari. At

first, the bride wore a wedding sari provided by her family. As part of the ceremony, the groom's mother gave the bride a new sari. Accepting the sari, the bride left the platform, retired to the changing room, and returned in a grand procession dressed in the sari that was the gift of the groom's mother. This event symbolized her identification with the new family system (VN 53). Finally, the couple's union was sealed when the priests directed them to take seven steps around the sacred fire. The groom led the bride, reciting:

> Take thou one step for the acquirement of force; take thou two steps for strength; take thou three steps for the increase of wealth; take thou four steps for well being; take thou five steps for offspring; take thou six steps for the season; take thou seven steps as a friend; be faithfully devoted to me; may we obtain many sons; may they attain to a good old age.[72]

Afterward, a great feast of vegetable curries, mounds of rice, *puris*, gunda pepper, savory lime, and mango pickles was served on banana leaves. The dining hall had several rows of long tables with guests seated only along one side. On the other side men served steaming buckets of *sambar* (a spicy vegetable stew) and *rasam* (a "pepper water" thin soup), walking up and down the tables to keep the guests satisfied. Dessert was a sweet rice pudding with nuts (VN 54).

In marriage, the woman, by the custom of *pativrata* (husband vowing), leaves the association with her family and her dedication to her father to join the family of her husband to serve and revere him as a god. The marriage ritual is theoretically much broader. In one place, the groom touches the bride's feet, which are placed on the *ammi* stone (used for grinding in the household) and says, "You are coming into my house as Lakshmi. I will respect you as I would respect and honor you as the goddess Lakshmi deserves."[73] In verse and activity, the ritual joins the couple as equals into a unified "whole." The bride and groom are analogous to the god and goddess, uniting their forces to form "perfect continuity and equilibrium"[74] as represented in the models of Sarasvati/Shiva, Lakshmi/Vishnu, and Parvati/Brahma. Neither male nor female is hierarchically above nor below the other. Both are balancing forces to each other and independently purposeful in their existence.

The marriage hall diagrams consecrate the space where these various rituals take place. The diagrams at the homesites also announce significant events. The morning after the sexual consummation of the marriage, a white diagram is drawn in front of the house by older women in the family. Since most couples live in the homes of the husband's parents, it is usually the mother-in-law, her mother, her sister, or the sister of the husband who makes the diagram. Upon notice of the consummation of the

marriage, a splash of red powder mixed with water is dashed across the diagram, signifying the blood of fertility (red) imposing its presence and joining with the sacred space of purity (white).[75] Another transformation is marked at the threshold: Is this a sign of purity transforming into impurity or purity into fertility? Is this a symbol of a balanced "Cosmic Whole," the impure with the pure? The answer varies, depending on whether the symbolism is interpreted from the matriarchal or patriarchal point of view. Whatever else it is, it is a sign of change.

Customs guide the way a society implements its theoretical or philosophical structure. If social pressures to alter a society exist, customs can be altered, using cultural myths and rituals as tools to effect change: reinvent the myth, and change the cultural attitude, and the focus of the related ritual will change as well.

The initiation and marriage ceremonies are fundamental rituals that offer a potential for change that could be positive for women. Both ceremonies are representative of a religious philosophy based on "cosmic unity" and the "harmonized whole."[76] Although the customary interpretation establishes a hierarchical order placing women below men, the religious theory equates the sexes, symbolically uniting them into a "harmonized whole." Both are threshold ceremonies that take place in space made sacred by ground yantras.

The Power of the Female
India's cultural history is grounded in the primary power of the female principle, and women have retained essential practices affecting Indian life. There are at least four ways for women to move forward.

First, women can reinterpret the mythology and identify with the strength, individuality, and vitality of the consort goddesses, empowering themselves and improving their situation. Even more effectively, women can identify with the primary power of the autonomous goddess. Through association with her, they can identify with the creative and the destructive powers embodied in the female principle and recognize the full range of women's sexual equality.

Second, women can break the subservient bonds of pativrata by redefining the prevalent marital relationship to one of equality.

Third, women can use a wider perspective to honor and re-associate with their creative abilities. Women can enlarge their perspective of creative production to encompass everything, from rural products to technological research.[77] Further developing their self-image as producers would make women feel more able to improve their economic and social status, thereby empowering them to make changes in their quality of life.

Fourth, women can re-evaluate the significance of the control they exert in the rituals of daily life and in the rituals on auspicious occasions. They can realize their power in the magical and mystical practices such as the threshold diagrams. Such practices provoke essential feelings of psychological and spiritual stability, which underlie the business, political, cultural, and domestic sectors of Indian society. The power residing in performing these drawing rituals is fundamentally influential. If Indian women realize their own potential strength and exercise it, they have the opportunity to create a society that can be a model for other cultures and a salvation for themselves.

The Practice of Drawing

Historically, the information and technical skills involved in making threshold diagrams are transferred when older women in the home teach the young girls at the age of about four to five years. Teaching occurs on two levels: assimilation and directed learning. On the first level, the little girl observes and assimilates information about the technique as she stoops alongside her older sister, her mother, her aunt, or her grandmother while the older person makes the daily drawing (VN 38). Her observation happens regularly; the model is consistently available to be absorbed without the child making much conscious effort to learn. On the second level, in a more conscious learning process, the child keeps a notebook in which she practices making designs. She learns the complexities of constructing the diagrams within a system composed of traditional values of design, symbolic representations, regional influence, and personal practice and interpretation. Having seen several notebooks in the cities, villages, and rural areas where I worked, I observed that the designs become increasingly intricate as the girls grow older and become experienced in making the diagrams. The correlation is not surprising, and, collectively, the notebooks can serve as marvelous records of a learning process.[78]

Each of the practice books I saw reminded me of something akin to the combining of a personal, visual journal with the piano practice notebook I kept and used as a child. Notebooks, however, are much harder to come by in India than they are in the United States. Only wealthier women of society can afford them. Thus, traditionally, poorer women practice by drawing the designs in the dirt with sticks or on small slates with chalk. In both cases, the young women make drawings, using a "rubout" and redo technique to improve. Eventually, as they rub out the completed diagrams daily, making room for others to be drawn, they may reflect and strive to improve yesterday's drawing today as part of their mature working process.[79]

Perhaps related to pride of status is the degree of pride displayed by numerous women who have shown me their notebooks from childhood. The real source of this

pride is in their growth demonstrated visually in the notebooks. Like many who use a personal journal, they see their own development within these books, and these visual journals can be shared more easily than a written journal as women hold them up to be photographed, or sit, sharing their skills and their meditative associations while turning pages for our joint perusal (VNs 26 and 39).[80]

Recently, women also have attempted to extend their skills by using publications that are analogous to the "how-to" books one might purchase at an arts and crafts shop. In India, these books, called "Rangoli" books, are sold in shops near Hindu temples and in some bookstores (VNs 27 and 28). Books on ritual diagrams contain line and dot patterns for various designs and directions for drawing them. The positive side of the publication of these pattern books is that they reinforce the continuance of the practice. They also provide a published record of some of the patterns in existence during their era. The negative side is that the pattern books tend to promote formulaic patterns that women make according to printed instructions as opposed to creating their own visual interpretations within the boundaries of the prescribed ritual for any given time.

The ramifications of the effects of using these pattern books are much greater than one might initially presume. The generation of Rangoli books has created a body of material that functions as a set of patterns for contemporary diagrams rather than as instruction for an on-going process. Teaching by practice, the experience is transferred from mother to daughter, aunt to niece, and grandmother to granddaughter, thereby acting out a personal and cultural belief system. These beliefs, when transferred by practice, are visually reflected in the diagrams, which are part of a larger ideology. With the use of pattern books, eventually all drawings could become stylized to reflect the patterns in the books, and, in their desire to "master" the book patterns, women could lose their impetus to create their own designs. Young girls might think that copying from the books is more sophisticated than learning from the rich oral and practiced tradition passed from their mothers and other women in the family. A move away from the personal transferal of knowledge about the diagrams would potentially diminish the metaphysical dimensions associated with the practice. In the minds of most women I interviewed, using the pattern books has lessened the association of the diagrams with their rich past.[81] As Franz Boas states, "Pattern books appear only at a time when the folk art is decadent."[82] None too soon, the research, involvement, and documentation by women such as Pupul Jayakar and Srimati Archana ensures that the knowledge associated with these diagrams is not forgotten.

Time
I went to Orissa with my friend Anandhi. Orissa is the Indian state least affected by the technological age. Neither Anandhi nor I had been to Orissa before. Neither of us

spoke Oriya, the state language, and little else was spoken outside of the populated areas. Consequently, our verbal communication was limited.

We went to Bhubaneshwar, the capital, to get information and directions for locating accessible rural communities where sacred drawing might be practiced, and we boarded a bus headed east toward Puri. In the early afternoon, we reached a roadside village located about six miles (ten kilometers) from a rural arts community recommended to us. Without knowing how we would get there or exactly where the community was, we let the bus leave without us, feeling somewhat stranded as we watched it go. I suggested that we hitch a ride to the arts community on a bullock cart, the only apparent transportation off the main road. Anandhi looked at me incredulously. The villagers watched curiously as we went in search of a person who could speak a language we could understand. I located a driver with an empty cart who was headed out on the only road into the jungle from the village, and, with the help of a shopkeeper who spoke English and Hindi, we negotiated a ride.

The venture was one of the more remarkable experiences of my life. The cart was primitive, with two wooden wheels about four feet tall connected by an axle. Resting on the axle were three large bamboo poles tied together and to the axle, forming a long yoke that extended to the bullock. The driver sat on the front end of the bamboo poles where they were thickest. The load was balanced between the wheels, spreading beyond the diameter of the wheels in both directions. On this trip, Anandhi and I were the load. The ride was uncomfortable, but it was exciting and interesting as we passed thatched mud homes nestled along a turquoise river winding through golden sand and lined with palms and palmettos. The vegetation grew increasingly dense as we rolled deeper into the jungle (Plate 80).

We arrived at the village of artists and craftspersons in midafternoon and began to communicate through an intricate process of using gestural, visual, and double-translated verbal languages (Oriya to Hindi to English, and vice versa). The village was laid out around a central square comprised of a large communal building and a walled spacious yard. The mud walls of the houses were decorated with wall drawings (Plates 35 and 65). Painters, mask- and scroll-makers, playing card craftspersons, and others lived and worked at operating cottage industries. This contemporary artists' and artisans' village is analogous to the guild communities in the West. The community is an association for its members' mutual aid and the promotion of their common interests. We worked there, observing, interacting, and photographing until dusk, when we climbed onto another bullock cart to return to the main road to catch the evening bus.

On the journey back, in the quiet on the edge of night, the wooden wheels creaked and bumped on the narrow dirt road. A villager had hung an oil lamp on the bamboo poles at the back of the cart. As the lamp swung, its light flickered, casting a

constantly moving light on the surfaces of large leaves that lined the jungle road. Huge shadows appeared and dissolved, accentuating the already dramatic atmosphere. The night was gentle. We talked in low tones, careful not to disturb the muted quality in the air. I realized that people throughout India had traveled for centuries in this manner; the experience was from another era—we were riding through the past in this contemporary primal place.

As I savored the gentle primitiveness of the ride, somewhere in the distance the whistle from a train's steam engine sounded. Shortly afterwards, a jet plane flew overhead. I was conscious that, within a short time span, I had taken a jet plane from the United States to India, a steam-driven train from Tamil Nadu to Orissa, a bus to the nearby town, and a bullock cart to the rural community. Each form of transportation represented a different era of technological development. Their comparative speeds and the ramifications of these speeds on society hit home. At that instant, I understood the concept of "simultaneous time" and I realized the reality of "cyclic time," in which more than one era occurs in the same moment and events recur in a circular system. In this reality, one experiences events with elements that simultaneously have origins in more than one era. Of this concept Shahrukh Husain writes:

> As Mahakali, the mistress of time, Kali occupies both the time and space of the mortal dimension and a still point at the centre of infinity. Hindu cosmology describes a universe that undergoes a series of cycles, or ages. At the end of each age, all creation crumbles into Mahakali and returns to seed, from which the next age arises. According to the sacred text *Devibhagavata*, the Goddess at the end of time has no tangible form or quality and represents absolute Truth.[83]

Among the most profound experiences I had in India was learning to feel that expanded, abstract nature of time. Although I had read about various concepts of time, my previous reality was that time is only a means for determining what part of the day I am in, for relating the present to the past and the future, or for identifying a point at which I had scheduled an event. The time sequence of the stories comprising history meant little to me, except to establish what came earlier and what came later. Time was linear; it contained a forever past and a forever future. My life was a tiny segment on a continuous timeline. I would read about the Stone Age or the Iron Age and think: ". . . . way back then." I would watch a *Star Wars* movie and think about a forward space "up ahead." My present moment was the reality in contemporary time, shared with all others existing in that era.

Only two epochs had meaning to me: the Atomic and Information Ages, character-ized by the nuclear and technological effects on present culture. From my perspective, these ages of my life contain artifacts from other eras, but those eras were past and uninhabitable by humans existing in the present. So were the future eras uninhabitable. We fantasize about the future, time, and space. We share H. G. Wells's fantasy about time travel in his book, *The Time Machine* (1895), we stretch our imaginations far into the future with the idea of instantaneous, molecular space travel as Gene Roddenbury's *Star Trek*'s (TV series, 1966–1969) atomic transporter and in James Cameron's timeless linkages in *Avatar*'s (film, 2009) living forms.

Since my first visit to India, time has acquired another configuration. It feels entirely different, more than a two-dimensional concept of behind and beyond. I grasp a time that is multidimensional: the present is sandwiched between a behind and a beyond, running concurrently on either side. My perception is also that time is a system that circles back over itself, regularly repeating patterns of phenomena. In a present moment, I experience different eras simultaneously. Those who travel to other cultures, in which the eras of development differ from our own, are able to experience such a time phenomenon. Being in a place where the Chalcolithic Age is the present cultural age provides the stimulus for a changed perception.[84]

India exists in the realm of cyclic time. The Indian concept of time is entirely non-linear, except when required by interaction with the Western business world. Con-temporary Indian culture is a tapestry made of past eras actively coexisting with the present. In Rajasthan, elephants, scooters, cars, camels, and buses frequent the same city streets. In Varanasi, or Benaras, as many shopkeepers use oil lights as use electric lights. Recently, all over India, huge speakers have been mounted which broadcast loud, rasping versions of anciently designed sacred music. The music blankets life and emanates from the inherent magical and religious qualities derived from the earth. Farmers till the soil in the fields with modern tractors and bullock-drawn ploughs, while showing respect by working around animistic plots where statues of rural gods and goddesses stand under sacred trees (Plate 31). The values, rituals, practices, and technologies of differing eras exist simultaneously and are in accord with the materials and human impulses accessible in a particular time and place.

India, however, is in danger of losing its ability to retain her rich cultural heritage as the consuming technological culture integrates.[85] As Pupul Jayakar writes:

> The primal danger to the rural ethos is not the change of godhead, but is of the
> linear time-stream, integral to a technological culture, taking over rural India's
> cyclic sense of time, where the transitory and the eternal exist simultaneously

within a myth-richened perspective and where the past is constantly transformed and recreated in the immediacy of group ritual. A challenge is posed to the perception and approach of the artisan, a challenge not only of tool, technique and resources of power but of human values, attitudes and directions, a challenge to those attributes of the human situation that are integral to the creative process.

The danger to rural India lies in its accepting the values and norms of a technological culture and of a consumer-oriented society and, in doing so, losing communion with nature and its inexhaustible resources of energy. The danger is of losing the sense of mysterious sacredness of the earth . . .[86]

Dangers and Destiny

Threshold diagrams confront the same dangers as the rural ethos. The demands and influences of the technological, consumer-oriented society with its linear time structure undermine and squeeze out the motivation that supports continuing the diagrams. The nature of technology requires dependence on linear time. The cultural attitude created by a linear construct directs the society to establish priorities for, set and meet deadlines, make appointments, coordinate interrelated actions, establish timetables, and so on. It is a system facilitating efficiency, but it is alien to a nature-related existence. Nature operates on circular time. India's cyclic system emphasizes on-going existence through birth, death, and rebirth. Seasonal recurrences are charted according to a solar or luni-solar calendar. The sun, moon, planets, and stars are seen as deities influencing the daily life and the destiny of the people (Plate 26), which is why astrologers and *pandits* (Hindu holy men) are used to help people develop their spiritual paths.[87] These astrological bodies are also important representations in the diagrams.

Fertility is the other essential function in cyclic time. Seasonal reproduction is dependent upon fertility for regeneration and maintenance of crops and animals, including humans. The past matriarchal culture, mirrored in nature, is inherent in the Indian religious life, rituals, and customs, especially in the important harvest festivals and their associated rituals. If people lose their awareness of their nature-related existence, much of the rich heritage sustained today could vanish.

Another product of the technological, consumer-oriented culture is the production of the "how-to" books on the practice of designing and making threshold diagrams. I discussed earlier the detrimental effects of the production and distribution of these books. Their use is increasing, however, because, in the faster-paced world, fewer women take the time to do the drawings, and fewer and fewer have schedules that accommodate the daily drawing ritual. Even if women continue to practice the

ritual, their time is limited and insufficient for teaching their daughters as they were taught. A reasonable solution is to teach the young girl by modeling and then to get her a "how-to" book. If repeated from family to family, village to village, state to state, all across India, the larger profile of the cultural production will be affected. The aesthetic results will become standardized, reflecting the styles and patterns of the models demonstrated in the books. Originality will be overridden by efficiency as the effects of technological pressures push the practice toward decadence.

The third and, perhaps, most threatening danger to the continuance of the vital and intrinsic practice of making threshold diagrams is the disguised degradation of the drawing's position in the Indian culture. This degradation is softly veiled by the enthusiasm displayed in the patriarchal culture regarding the "primarily decorative practices," in which the women are involved. My understanding of the background and present context for making threshold diagrams is different from the academically classified description or categorization of the diagrams. I have been told repeatedly that the diagrams are not made within a religious context. I have learned that they are rituals that may be associated with magic. My understanding is that magic and mysticism are religiously associated activities that differ primarily in that the goal of magic is to gain something for oneself or for others, and the goal of mysticism is to give or relinquish oneself to unite with the Absolute.

Making threshold diagrams is both magical and mystical. These diagrams establish a sacred space. Creating them is intended as a meditative activity, though not always a consciously meditative act in practice. The primary goals are to bring good luck to the family and to symbolize feeding the creatures of the world. The former is a magical act to gain protection; the latter is a religious sacrificial act of giving for the well-being of others. The sacrifice is clearer when viewed in the context of the past. Historically, India suffered waves of intense famine. To put your precious rice flour on the ground as an offering when your family is starving was a substantial sacrifice. Offerings to a deity for propitiation or homage are religious acts. They acknowledge a power greater than that of humans—that is, the power of the creator(s), controller(s) of the universe—and the need to propitiate and pay homage to this power through symbolic gestures and offerings.

Deriding the importance of threshold diagrams concurs with the social oppression of women. Women relate differently to the concept of a goddess than to the concept of a male god. A goddess connotes their lives and their abilities, while a male god is the father or the lover, the mysterious Other. In either case, the association is to paternalistic characteristics, since the lover/husband is customarily deified by the wife, who is subservient.

Paternal societies keep men in godlike roles—that is, in control of their existence within the world and, to an extent, in control of their existence beyond this world.

Predominantly, Western and Eastern man's perception is that he is elevated above the rest of the animal kingdom, closer to God (control) through his ability to reason. As Marilyn French argues, to re-enforce this notion, men attempt to disassociate from nature.[88]

Woman is obviously associated with nature. She constantly reminds man of that association by her natural ability to menstruate, give birth, and lactate. In fact, women demonstrate an alliance with nature, a feeling of familiarity that man spent generations rejecting because he cannot control the many forces of nature.[89] The closer women identify with nature, the more both are unfathomable and potentially powerful and dreadful to the marginalized male onlooker.

So, what must men do? Suppress, control, and eradicate the feminine in themselves, in their male children, and in the "womanly" aspects of life. A long history of the rejection of feminine elements in man can be found all over the world.[90] However, the beliefs and practices indigenous to areas in the Indus valley are unified and, perhaps, even female-dominated. In much of Indian thought, the principle of unity of the male and the female portrays the ideological ideal representing the equality of both sexual identities. The customs and mythologies of the culture, however, have made a majority of women subservient and oppressed.

Men are more physically powerful. Power connotes control. Men do not want to lose their power—physical or psychic. They demonstrate fear in their tyranny of women. Is it fear of returning to the matriarchy? From the male perspective, to sustain a female goddess in a paternally dominated society is contrary to the good of the social order. To sustain major emphasis on female manifestations of a god with priestesses rather than male manifestations of God, or a unified principle with priests, was dangerous to the power balance while the culture moved from being maternalistic to paternalistic. Adulation of women as well as fear of women had to be addressed. In the temples, the priestesses were replaced by priests. The priestesses, having taken their sacred-space diagrams from the domestic homes to the godly homes (temples) during the matriarchy, returned to their domestic homes and took their magic diagrams with them during the patriarchy. By doing so, they retained an important element of spiritual control, not in the sense of power over but in power to maintain the integrity of their lives.[91]

The fourth and final danger to threshold diagrams is the consciousness of the women involved in their creation. If the women of India seize the power they have in their cultural heritage, their social structure, and the laws and provisions available to them, if they create support groups and systems within their local areas, and if they define for themselves what they feel is natural to their way of life and what gives them the dignity they deserve, then they can move toward realizing the strength of the feminine. They can look to an indigenous feminism, because they have a powerful

heritage to support them. An indigenous feminism is the strongest avenue they can follow, because it is natural. By reinterpreting and making use of their own mythology, modeling their own goddesses, and using laws, customs, and rituals already in place, women will decide what is best for them, rather than follow what the most Western cultures project upon them. The threshold diagrams are a metaphor for this process. If Indian women validate and celebrate the threshold diagram practice, consider how it may be used to enhance the empowerment of women in India, and consider how their empowerment will work for the overall good of the culture; altogether, they are acting to realize an improved destiny.

Artistry and Categorization

In India today, threshold diagrams satisfy three needs and purposes: the desire for ornamentation, the need for ritualistic, religious practice, and the need for social interaction and sustenance. Thus, the drawings may become more important as a solution to a cultural problem. But the possibility also exists that the threshold diagrams will become meaningless expressions of purely decorative value in the Indian culture. As an open-ended, expanding class of graphic expression, the threshold diagrams represent a historical sequence that can continue only when their originating source (a problem) is given greater scope by new needs. The diagrams have traditional and present/future functions within patriarchal India. Just as aboriginal Australian bark painting is an "open sequence," deserving new solutions in the twenty-first century, the aboriginally derived Indian threshold diagrams deserve the same, as George Kubler writes, "because their possibilities are still being expanded by living artists."[92]

The effect of Rabindranath Tagore's school, Santiniketan, was a positive step in the development of the practice. Having become stabilized—that is, set in their traditional form and execution—the diagrams in Bengal, and later elsewhere, changed under the influence of the teachings at Santiniketan (Plate 87; VN 44).[93] While the changes deleted much of the feeling of original purpose from the practice, making the diagrams decadent, they have since drawn attention to the diagrams' position in the culture. Their significance is being recognized and their continued practice is carefully encouraged. The Government of India, Ministry of Information and Broadcasting, published an article in 1960 entitled "Alpana," which describes, according to its subtitle, the diagrams' "Origin and Evolution, Decline of Traditional Forms, The Santiniketan Alpana, the Governmental Programme for Revival of the Art, the Synthesis of Old and New Forms and Notes on Basic Principles and Techniques of Execution." The article states:

> There is a real danger that we have to guard against when introducing modern types of Alpana in the villages. Modifications, innovations there must be.

Where stagnation has actually set in, new forms are necessary for revitalizing the stereotyped, archaic compositions. The women who have forgotten this art have to be introduced not only to the primitive art handed down by grandmother to mother, but also to the new types of decorations which are gaining popularity in the urban areas due to the influence of art schools. But we must seriously search for the right approach to the question of teaching new Alpana design. It should be an approach that will bring fresh life to the old art, and not supplant it by a new one.[94]

Interestingly, the government article is aimed at informing rural social workers who can affect community projects in villages and tribes. The article asserts the importance of an "acquaintance with this rich heritage of our village life will be of value, since the object of community development is to enrich and enliven rural life in the most comprehensive sense."[95]

As women recognize the additional value of making threshold diagrams in contemporary Indian society, they can use the new techniques in conjunction with the old to create revitalized forms of the diagrams. They can reinvest personal resourcefulness, mixing the new aspects of the practice with the old, changing the results while maintaining the integrity and the vitality of the ritual.

The threshold diagrams of India in their traditional forms are becoming a threatened, even endangered, species of magico-religious imagery, because they are being transformed from individual, internally conceived, and originally rendered diagrams to those that reflect more socially affected designs and are rendered using patterning techniques. Knowledge of these diagrams is also endangered, because they have been only marginally noted and documented. If the rate of change continues, the traditionally executed diagrams will be difficult to find. As a consequence, continued study of the indigenous practice will be nearly impossible, except through use of previously documented imagery and information.

The following four factors influence the current status of the diagrams as they are viewed in art historical contexts: the temporal nature of the diagrams, the surface plane on which they traditionally are drawn, the nature of their function, and women as their primary producers. These factors have appeared in limited research data and documentation, ultimately endangering our ability to preserve knowledge of this tradition. Within the context of Indian and Western scholarship, the combination of these factors contributes to the easy dismissal of the significance of the diagrams.

First, until relatively recently, permanence was required to qualify a creation as an art object. In consumer-oriented societies, most art objects are evaluated at least

partly on their permanence; therefore, because the threshold diagrams are not durable, the enduring qualities of their style have been overlooked. In fact, impermanence is an important feature of the diagrams, psychologically as well as symbolically, since creation and recreation of the elaborate designs teaches women the transience of life and creation.

Second, the surface plane or artistic "ground" of the diagrams is usually the floor, the earth, or the street. Our perception of the diagrams is psychologically devalued, because we must look down to see them, in contrast to looking up at an object we revere or consider dominant. Even our language reflects this attitude. We "look down on" something or someone we disrespect; we "look up to" something or someone we respect.

Third, part of the function of the threshold diagrams requires that people walk through or across them, which impairs and even destroys them. To walk upon an item, then, is associated with devaluation. The functional use of the diagrams, therefore, appears to render them less important than creations that are protected and maintained (Plates 53 and 89; VNs 47, 49, 55, and 59).

And, fourth, while the Indian threshold diagrams are produced primarily by women, in many cultures men are primarily identified as the artists or artisans. Historically, invention and the production of art are the chronicled domains of male creativity, whereas women's creativity has been traditionally associated with their reproductive ability and other creative roles associated with domesticity.[96] Even current histories of art continue to demonstrate a bias associated with maintaining patriarchal control of the arts through continuing exclusion of women's contributions to the field. That bias exists in the face of contemporary scholarship offering substantial data that supports the importance and proliferation of women's significant contributions in the arts in many cultures over a vast historical span.[97]

These four criteria reflect Western attitudes toward categorization of objects and information. This view applies equally to India, because of the great influence that Western scholarship has had on developing the historical literature of India, including the study of India's art. Consequently, references to, and images of, the diagrams are included in only a few of the many books on Indian art and Indian religions and culture.[98]

The accumulation and dissemination of knowledge about the diagrams may be affected by their "categorization" and lack of formal positioning and description in both scholarly and critical literature and in art historical writings. As previously stated, to those such as Kapila Vatsyayan, Mark H. Sloan, and William K. Mahony who know the diagrams are, at their core, magical-religious or sacred imagery, they are a form of art issuing from the indigenous sources of the Indian culture, which evolved to be known as Hindu customs and rituals. My research supports this observation.[99] Nonetheless, some consideration of the characteristic worldwide attributes of the diagrams is necessary in understanding the complex associations they have for Indian art, religion, and culture.

An underlying issue is whether threshold diagrams are categorized as "language" or "art" or are they a good example of a combined visual system satisfying the criteria for both categories? Franz Boas, in *Primitive Art*, and Anthony Forge, in "Schematisation and Meaning," indicate that the more unambiguously language-like a pictograph is, the less artistic it becomes. When meaning is conveyed through use of the ambiguous nature of symbolic abstraction, however, the experience evokes a more complex response on emotional and thoughtful levels.[100] The Indian threshold diagrams satisfy the criteria of both definitions, and Srimiti Archana's book, *The Language of Symbols: A Project on South Indian Ritual Decorations of a Semi-permanent Nature*, is a comprehensive resource on threshold diagrams, in which the author translates various forms of designs into specific meanings within a cultural context.[101]

Scholarly reference to the diagrams is as "writings" rather than as "art." Pupul Jayakar suggests that the reference to writings is evidence of their "archaic hieroglyphic origin."[102] Thus, the terms "hieroglyph" and "pictograph," are used to describe the threshold diagrams. They are similar in that they both refer to pictures or symbols drawn to communicate, as in a language. A "hieroglyph" represents a word, syllable, or sound. A "pictograph" represents an idea. Both mean "picture-writing." Other cultures use similar diagrams as "writings." American Indians of the United States produced petroglyphs (images cut into the rock) and pictographs (images drawn on rock surfaces) as well as temporary sand paintings. Cryptanalytic methods are used to decipher their meaning, purpose, and structure.[103] Also, anthropologists in the United States such as Polly Schaafsma are using their studies "To demonstrate the usefulness of rock art as a tool for widening the understanding of prehistoric cultural systems in the Southwest."[104]

Indian threshold diagrams are likewise similar to Australian aboriginal art, Haitian ritual diagrams called *veve*, and prehistoric European art. Anthony Forge asserts that "pictographic writing is the logical culmination of schematisation." He defines schematisation as abstraction constrained by unambiguous representation. And he states that schematisation is a process that leads to hieroglyphics and eventually to writing.[105] Forge also describes the difficulty of transcultural reading of visual languages. Pictographs may be made up of signs or symbols. Signs are cultural. To go into another culture means learning the references of that culture's signs. Signs are direct, unambiguous references; symbols are indirect and ambiguous. As visual languages move from unambiguous representation to ambiguous representation, they become more allusive or poetic. Forge asserts that symbols must operate in a created context that directs the reader's interpretation within a range of meaning.[106] Thus, the reader translates a sign and interprets a symbol. While Forge bases his comments on Australian aboriginal art and European prehistoric arts, his assertions hold true for Indian threshold diagrams.

The Indian diagrams mirror the Haitian ritual diagrams, or *veves*, in numerous aspects. Their similarities may be noted in the book, *Sacred Arts of Haitian Vodou*, which contains several essays by various authors that provide parallel characteristics for comparison. [107] The Haitian veves are cited as descended from at least two African cultures, those of the Kongo and Nigeria. Both are executed in threshold locations with the purpose of making a space sacred and, both are related to or intended to be cosmograms. While the Indian diagrams are drawn to represent a threshold between levels of perceptual existence, facilitating entry, the Haitian diagrams are different as Marilyn Houlberg asserts:

> [veves] are associated with transitional places such as thresholds and their magical powers are so strong that they can protect all at that most mystically dangerous place—the crossroads. The Marasa join Papa Legba [symbolic aged character who has the power to open the spiritual road] as the guardians of the crossroads where the world of above meets the world of below, where the world of the living intersects with the world of the dead.[108]

The rituals for which the veve are drawn are conducted in a similar pattern, that of a diagram being made upon which ritualized activities may take place, and then prepared foods are served to the participants. Also, production of the veve in another form than on the ground parallels the Indian diagrams. Tina Girouard asserts that the veve are also made in the form of Haitian *drapo Vodou,* or shimmering flags made of sequins, which "serve to elevate the spirit and focus meditation on the sacred." [109]

At the same time that the Indian diagrams convey meaning as a language in the form of sacred images, they are influenced by three factors that prevent, according to Heinrich Zimmer, "any arbitrary treatment or alteration of (their) repertoire of symbolic signs." The first is the "literary tradition of myths, in which a particular aspect of the divinity takes on an active role, preserves descriptions of its appearance." The second is the "tradition of artistic craftsmanship . . . [that] normally passes from father to son [mother to daughter]." The third is the "models that previous generations have handed down as standardized and obligatory representation of the deity."[110]

Artistic craftsmanship is based on development of technical skill. The manner in which the skill is developed and the level of its development determine that skill. Form is defined by choice of materials and type of application; that is, technical treatment. When similar forms recur, they are called typical forms, and forms vary aesthetically, according to their character. Style is identified by consistent craftsmanship developed in a particular manner.

The consistent use of several technical treatments to make the diagrams has resulted in the development of various typical forms such as in the wet (Plates 9 and 87) and dry (Plates B and 13) traditional drawn applications, in the stenciled or partially stenciled applications (Plate 86; VN 40), and in the flower petal "built" applications (VN 45). In the diagrams, styles exist primarily according to geographic location such as in Tamil Nadu (Plates B and 28), West Bengal (Plate 87), Rajasthan (Plate 59; VN 42), Kerala (Plate 45), and Himachal Pradesh (Plate 2; VN 58).

The diagrams function as symbols. In the creation of these symbols, imagination is evident, especially when comparisons of a particular style are made within a close timeframe and geographic range (Plates 33, 44, 70, 74, and 76). Note Plate 37, made according to the typical stencil/book patterns. This diagram is beautiful but relatively unimaginative in that similar renditions may be seen frequently. In Plates 74 and 76, the diagram, although using similar images and technical treatments, is uniquely presented.

Art affects us aesthetically in several ways, including perfection of form, association of form and ideas, response to pure essence of concept, and relationship between the object and its context. The threshold diagrams provide aesthetic appeal in each of these four ways. Often, when the technique is imperfect, imagination compensates, and the aesthetic results are pleasing (Plate 13). In this diagram, the lack of perfection of form is compensated for by the emotional feeling communicated in the contrast between its elegant simplicity and its immediate surroundings.

The analogies to other traditions of cultural pictographs are significant, because they illustrate the differing bodies of documented knowledge about each culture. We are able to assess, through comparative study, the perceived and recognized values held for each of the respective prehistorical arts. American Indian petroglyphs, Australian aboriginal art, prehistoric European art, Haitian veves, and Indian threshold diagrams have similar, necessary artistic components, including development of a relatively high technique, division of style, constant use of the same kind of materials, and the purpose of communicating with and influencing the lives of others (gods, persons, spirits, and so on). To reiterate, the art that has been least researched and documented among these markings is the threshold diagrams. Much work is needed to address fully the range of the diagrams in relation to society, religion, and art history within their respective Indian and world contexts.

A strong argument is that immediate research on the threshold diagrams is necessary in order to capture knowledge of the practice while it exists in its indigenous forms. Already, the availability of quick drawing techniques has changed the inherent value of the practice. Creativity and vitality are becoming harder to find, as drawing aids and patterns contribute to their decadence.[111] As a visually symbolic system drawn with ritualistic gestures, the value is to create physical signs representing the spiritual/

emotional investment of the initiated. The personal ceremony involved in the drawing ritual, followed by the social function enacted when persons traverse the sacred space, constitute a continuing performance, analogous to a contemporary "performance piece." As the performance is repeated, it transmits part of the Indian culture from generation to generation.[112] Also, as in many performance pieces, once the event is over, evidence of its occurrence remains in visual form. Technically, both skill development and style are transmitted. Style depends on advanced skill practiced widely enough to create typical forms. When the forms reach perfection, the objects may be judged to have aesthetic value. They have attained the status of art. Some may not be executed perfectly, but they may exact heightened feeling and have aesthetic value. Ultimately, they elicit a relationship between the object and the viewer/user. The heightened awareness, the essence the object conveys, is called an "aesthetic response" in the West and *rasa* in India.[113]

Rasa

The subject of *rasa* unlocked the door to my appreciation of and feeling for Indian visual and performing arts. Rasa is literally defined as sap, juice, essence (as in the essence of Being and the essence of emotion in the creative/aesthetic sense, for essence flows.) The term is applied to all forms of the arts: theater, dance, music, literature (particularly poetry), and the visual arts. It engages the nine emotive essences that may be evoked in any classical or traditional form and which bring awake a corresponding awareness in the audience; the Serene, Compassionate, Wonderful, Heroic, Odious, Furious, Terrible, Comic and Erotic, the essence of union.[114] Unity within oneself of the sensuous experience of stimuli from without to form a feeling of universal understanding is the holistic goal embodied in the concept of rasa. The Indian view of arts and aesthetics is governed by the traditional Indian cosmocentric vision. Unity of ones mortal existence with the comsic energy, as K. D. Tripathy writes, is a "journey from sensuous to supersensuous for an aesthete and a reverse process from unity to multiplicity for an artist in the creative expression."[115]

The late Dr. Prem Lata Sharma, then musicologist at Benaras Hindu University, introduced me to the concept of rasa in a lecture she gave in 1977 in Varanasi. I responded empathetically, feeling an understanding of the comprehensive content of her subject. In her inimitable way, she transmitted the essence of rasa, the sentiment of which is aesthetic experience.[116] The artistry of her presentation was in her delivery— the vitality and grace of her gestures, the modulated tones of her voice, her charismatic choice of words, and her use of analogy as a teaching tool. Her delivery was eloquent and reflective of the concept she was introducing. Her analogy was based on the preparation of food, reflecting that taste was the traditional perceptual reference to rasa. She

related sensual taste to aesthetic taste. Using one's sensibilities to prepare food with a complete awareness of the effects of the blending of flavors, textures, colors, and temperatures, the delicacies and strengths of the created cuisine, and the physical and mental effects of one's personal eating experience was equivalent to rasa.

In Indian cooking, grinding stones are used to pulverize numerous varieties of pulses (Plate 65). Chopping blades are used to cut vegetables and fruits such as yellow squash and bananas, white coconut and cauliflowers, green bitter gourds, spinach and okra, orange mango slices, purple beets and eggplants, and red tomatoes and capsicum (Plate 69). Mortars and pestles are used to powder and blend pungent spices such as cardamom, cumin, fenugreek, cloves, nutmeg, mace, cinnamon, saffron, and chilies (Plate 41). As Sharada Gopal asserts, "Spices and aromatics are the very heart of Indian cooking. Flowers, leaves, roots, bark, seeds and bulbs (the simplest of natural ingredients) are used in endless combinations to produce an infinite variety of flavours: sweet, sharp, hot, sour, spicy, aromatic, tart, mild, fragrant, or pungent."[117]

As spices and foodstuffs are added together in various quantities, according to their particular character, strength, and contrasting qualities, they blend with each other to create a balanced and subtle bouquet of flavors and aromas. The created new taste is savored on multiple levels by inhaling and exhaling over the palate while eating, allowing the flavors and aromas to intermingle inside one's head. Visually and tactually, colors and textures of the cuisine complement each other, culminating in a summary sensuous experience that resonates throughout one's being.

The heightened experience of tasting and savoring the flavors and sensations of food as it is eaten and becomes part the body is a self-intimate phenomenon stimulated by the food. Nourishment takes on transcendental qualities, as the partaker senses the relationship between feeding the body and feeding the soul through artistic appreciation of the aesthetics of cuisine. The Indians are very aware of the integratedness of body and soul, daily life and religion. Preparation of food stuffs involves prescribed rituals; certain foods actually have spiritual significance. Rice is considered an auspicious food in offerings, whereas gingily seeds are considered inauspicious. In Midnapur, women make *gaina bori*, which are ornamental or decorative. These food items are made of dal paste, which is "drawn" onto a poppy seed base, dried and fried (Plate 64). They are a form of *alpona*. These Indian *bori* are analogous to Western pretzels, which originated in Alsace and were, in ancient times, a poached dough, sprinkled with salt and cumin seeds and hardened in the oven. Pretzels were originally made in the shape of a ring encircling a cross; and they were linked to the cult of the sun.[118] This analogy demonstrates that ancient Western cultures have long integrated similar foods into their spiritual rituals. To experience the essence of an edible creation requires the same aesthetic sensibilities as experiencing other creations that can be physically, emotion-

ally, and mentally ingested and assimilated into one's own being. Dr. Sharma's taste analogy, relating the creation of food to the arts, was aptly and delightfully illustrative of rasa.

The Phenomena of Threshold Diagrams

Recently on a cold, star-filled night in January, under the full moon which signals Pongal season in India, two fellow artists were looking at the threshold photographs in my studio. Michael gave a long pause over an image (Plate 76) that I find pivotal in my understanding. He then said, "This is not my favorite. It does not have enough in the image for me to engage with it." My other friend, Heather, who was a research assistant with me in India in 1998, just smiled in appreciation for the photograph. The three of us talked briefly about the print and then moved on to the next picture.

As the Pongal moon sunk in the dawn sky, I woke with the contested image in my mind. It resounded with character for me. I wondered at the difference in our responses, since all of us were experienced in the interpretation of images. The picture is composed primarily of a large flat expanse of blue, corrugated metal which is a door. The blue door is in two sections, one shorter (left) and one taller (right), to fit the spaces being covered and which meet above the right corner of the ledge. The sections are fastened together by brass padlocks. Above the door is a strip of light blue on the painted wall surface, subtly mottled with delicate crack lines and pale-yellow stains. The surface is deeply pocked in two places near the center and right of center, revealing the dark-gray mortar beneath. Left of center, a two-strand, twisted wire drops from the top across the wall's surface, disappearing behind the door like an electric cord for a ceiling lamp that might be inside. The lower third of the print is a ground plane that is earthen-colored, brown. It is separated from the blue door on the left by a whitewashed square shape of a partially seen ledge. On the front of this white shape is drawn a blue and gray graphic that is only partly visible and streaked horizontally. From the right of the ledge, a cement step or sill extends to the right side of the print. A section of the street's surface below the ledge and sill forms the base of the image. In the center of this area is a delicately drawn lotus diagram.

When I first printed this image, I was initially confused. The picture looked up-side-down in either of its vertical placements. On closer inspection, the position of the diagram revealed the correct orientation of the image. The ambiguous nature of the picture came from the brass padlocks, which are subtle parts of the picture. The locks are turned up-side-down, probably the result of a prankster, but they are totally mind-altering in the close perspective of the picture, and this positioning makes orientation of the image ambiguous. As in the use of all mandalas, upon mediation on

the image, the threshold diagram causes enlightenment by giving orientation to the reader's worldview.

As I strung these thoughts together, I realized that this incident is a perfect analogy for the wisdom gained by studying threshold diagrams and their foundations in Indian culture. Heather and I understood this analogy emotionally and intellectually because of our acquired knowledge and cultural experiences. We were able to recognize the holistic meaning, because we were both in harmony with the image. Michael's different experiences in life itself gave him a completely different perspective.

My initial and subsequent experiences with the phenomena of threshold diagrams have been similarly sensual and transcendental. Making diagrams is practical. It establishes a discipline of routine exercise and meditation, requires consistent cleaning and decoration of the threshold space, and demands reinforcement of an awareness of the strength and power inherent in the female principle: it is ideal. Making and using the diagrams implies belief in one's own ability to affect supernatural forces and celebrates a spiritual belief system reflected in the ritualistic nature of the practice. The diagrams reflect the spiritual beliefs of the people who create them through both the abstract and symbolic images drawn by hand and the gestures and rituals performed. The recurring imagery and performance patterns indicate belief in the possibility of transcendence over ordinary experience. My aesthetic appreciation of the diagrams, expanded by my knowledge of and experience with them, is in response to their particular nature.

Their traditional structure as yantras and mandalas, visibly manifests universal vibrations; the corresponding sound form being *mantras*. In Tantric practice, the structure of the ideal vibration of a mantra is isomorphic (similar to; that is, same in appearance but with different ancestry) to the fundamental vibration of the universe. In achieving a most subtle form of a mantra, we aim to attain a form of abstract consciousness, and transcendence. Likewise, a visible form (yantra or mandala) meditated upon can create vibrations that have the potential to stimulate a state of transcendence.

The idea of visual art forms expressing spiritual development and engagement is not new. The abstract forms of the Indian yantras and mandalas are, perhaps, most closely comparable in their intent to the Western abstract art movement initiated just after the turn of the twentieth century by the Russian artist and writer, Wassily Kandinsky (1866–1944). Working in Munich, he published a book called *On the Spiritual in Art and Painting in Particular* (1912), which espoused changing art styles from relatively realistic portraiture, landscapes, and still lifes, of mythologic and religious themes, of genre images reflecting the poignancy of daily life, of nudes transforming desire into beauty.[119] Kandinsky's credo, according to Roger Lipsey, purported a new art based

on an "absolutely fresh sensitivity to line and color in themselves, to form as such rather than as description, and to space as such rather than as a setting for events. [He] intuited two universes in one—the visible universe of matter, space, and time, and an invisible universe of spiritual energies."[120]

The art historical precedent is significant. My passion is for my work and for interacting with the artistic processes of my contemporaries as we develop our creative abilities in photography, painting, ceramics, sculpture, and fractals in computer art. Each of us recognizes the power of integrating our personal knowledge in our work. And most rely heavily on daily creative practice for inner strength, harmonious existence, and even sanity.

Fractals are possibly a link between indigenous intuitive knowledge and contemporary, highly developed computer knowledge. The key idea in this linkage is structure. Fractals in nature are the signs of dynamic activity in growth or decay. French naturalist and mathematician, Benoit Mandelbrot (1924–2010), in 1967, developed the idea of fractal geometry. He defined fractals as broken, wrinkled, uneven tracks and marks in nature potentially repeated into infinity. Another biomathematician, Przemyslaw Prusinkiewicz (b. 1952) associated fractals with kolam structures when the computer was used to amplify the structural elements of nature ad infinitum.[121]

Gift and Rani Siromoney, working together at Madras Christian College, also made linkages between computer mathematical elements and structural elements of the kolam. The Siromoneys suggested that early kolam practice was based on structures created by recycling sequences of patterned symbols forming "necklace languages" that could be learned and passed down as any other language might be conveyed from one generation to the next.[122] As Gift Siromoney summarized (Plates A, F, and 13):

> There are many interesting and complicated designs made up of a single unending line where dots or pullis are used as a frame for drawing these designs. . . . The pulli pattern is used as a skeletal frame-work by which village women are able to memorize the design.[123]

Further connections between computer science and the arts, and religion may be noted in Steven R. Holtzman's *Digital Mantras*:

> Visual art, music, mathematics, mantra, numbers, and form are all investigations of structure. They may aim to discover structures that reflect the fundamental structures of the cosmos. But there may also be a mystical purpose, such as the objective of attaining a state of higher consciousness through this process of discovery.[124]

It seems to me that the role of numbers as abstract elements of structure for the threshold diagrams reflect the unconscious or, perhaps, conscious intentions of women making order out of chaos in a universally cosmic sense. This concept is supported again by Holtzman:

> The investigation of structure can be placed in the context of an ethical attitude. The Pythagoreans' purpose was to find spiritual ecstasy in the study of the divine dance of numbers. The goal of mantra is to achieve inarticulate, abstracted consciousness. Kandinsky's purpose in his art was to create spiritual vibrations in the viewer.
>
> Expression, whether in music, paint, or cyberspace, can be integrated with religion and science in a view that sees all of these as investigations of structure. With this view, there is no separation among art, religion, and science.[125]

Holtzman further asserts, under a section in *Digital Mantras* labeled "Technology is a Tool for the Investigation of Structure":

> Technology is a tool for investigating the cosmic truths found in structure . . . Fractal are effectively numerical expressions of visuals…as we approach the twenty-first century, we can return to an integrated view of art, science, and the mystical. We will find ourselves returning to the mystical traditions of the ancient Greeks and Indians. Using the new tools that will arrive, we will search for the perfect mantra. In developing new digital aesthetics, we have the opportunity to integrate technology, science, and the mystical to reveal *Brahman*.[126]

Our awareness of the importance of creative action in our lives puts us closer to feeling cosmic creativity. The fluid state of creativity, a heightened sense of awareness, is akin to or may even involve periods of transcendence. Is this what the Indian women know either consciously or unconsciously? Is this the value inherent in the threshold diagram practice, which historically retained the secrets of the practice as they were passed from mother to daughter for generations? And, is the value of the mathematical structure involved that it acts as an aid to achieving a transcendent state?

The cosmic relevance of the threshold diagrams, coupled with their enduring feminine heritage, is what fascinates me. Their aesthetic and feminine model in one of the oldest civilizations on Earth is a compelling precedent for cultures worldwide. That these threshold diagrams are formed with humility for holistic purposes, often on a

daily basis, is a testament to the inherent value of the practice in Hindu culture. In my mind's eye, I focus on this beautiful image:

Early on a misty morning in a remote village, a young woman is bent over, guiding a girl child's small hand as they, mother and daughter, together make a simple threshold diagram that symbolizes an element of the whole spiritual universe. The mother guides patiently. I can hear her soft sounds of encouraging instruction. This is the thread that binds the tradition. I am mesmerized by the intimacy of the inheritance, as I watch this historical process. Mother and daughter finish the diagram and go into their home. As the day brightens, people, dogs, bicycles and bullock carts traverse the streets across the diagram. The intensity of life is heard in heightened sounds as the town wakens.

Perhaps later, the diagram will be drawn again. Each time, a complex system of symbols is so simply and playfully transferred in practice. And each time I witness a threshold diagram being made, I am struck by the depth and beauty of this great inheritance.

Plate J

At the Threshold:
The Sanctification of Space in Traditional India

WILLIAM K. MAHONY

Included in the remarkable photographs by Martha Strawn are representations of threshold designs traditionally painted by women and girls of India in the quiet of the early morning darkness and, less frequently, at the setting of the evening sun. Holding small amounts of powder, which they let slip through their fingers or through the small hole at the bottom of their closed palms, the women draw these patterns at their doorways and gates, just as their foremothers have done for century after century, millennia after millennia, of Indian history. In the southern parts of India, the medium is usually rice powder; in the northern and western regions of India where rice is not as abundant, women use wheat, corn, or mineral powder. It is especially auspicious for a woman's household if she draws the design—or "writes" them, as the process is usually described—in front of an eastward-facing doorway so the rising sun can shine its first light over it and directly into the home. They typically consist of intricately geometrical, serpentine, or meandering lines, usually white, and often woven through each other or around small dots. Sometimes the space between these lines is filled with bright color. In many neighborhoods, women engage in friendly competition with each other to see who can draw the design that will elicit the most joy and admiration.

At one level, these designs serve a quite useful purpose: the rice attracts insects who might otherwise invade the food stored within the homes. Women who draw them, however, will sometimes imply that this act of giving aid to such bothersome creatures itself carries more than just practical significance, for it represents the notion that all life is valuable and worthy of respect and concern. By placing food at their entryways, the women not only help to purify their own homes, but also enact the view that all beings in the world play an integral part in the interrelated, smooth, and harmonic movements of the world as a whole and, accordingly, are to be honored with nourishment.

Girls usually learn to draw these designs at about age five and, as women, continue to do so for the rest of their lives. Learning and practicing the art is, for some, symbolic of their membership in the larger female community. Vijaya Nagarajan, a contemporary scholar, remembers her initial experiences of drawing these designs as a girl:

The making of the *kolam* involved pouring rice flour through the fingers with an even flow, almost as if you were pouring 'dry water' from the hand. As I tried to create the rice flour drawings, and the rice fell in uneven clumps that in no way resembled the beautiful carpet-like drawings that were in front of the neighboring houses, I felt a sense of embarrassment and shame. . . . As I became more adept at the *kolam*, I vaguely sensed that making a *kolam* was one of the signs of traditional Indian womanness.[1]

Regarding the social function of this art, another scholar, Eva Marie Gupta, has similarly concluded that the rites and rituals associated with drawing these designs provides "a fundamental social codex for the women according to which their whole life was structured and through which a sound basis for an equilibrium in a life in harmony and equality within the family and the village was given."[2] By painting these patterns on her threshold for all of her neighbors to enjoy, an artist engages in a creative activity that integrates the neighborhood or village as a whole. It also serves an important personal function: these designs are simply fun to draw, and enjoying one's own creativity is a rewarding way to begin the day.

To the observer, the most striking aspect of these designs is not so much their practical function as it is their visual effect. Those who have walked the narrow roads of village India, especially in the south and east and, to some extent, the back streets and alleys of modern urban centers, will remember fondly the experience of seeing these designs in front of almost every household. Glancing at Strawn's photographs as a whole, one senses in the threshold drawings not only a gentle simplicity, but also, in many, an almost paradoxical beguiling attractiveness yet quiet mystery. Look, to pick just two examples, at Plates 1 and 13. These designs, like most others reproduced in this book, are a bit playful, perhaps somewhat childlike, yet, viewed from another perspective, they are intricate and refined. The combination draws and holds our attention.

Instances of this art bloom like flowers with the rise of the morning sun, and, like flowers, they fade and disappear, yet to reappear again at the next dawn. Sometimes rather plain, sometimes quite complicated, they are alluring and, in their own ways, quite beautiful. Indian aesthetics have long appreciated the sense of fluidity and movement within an encompassing wholeness and integrity of existence. A sixteenth-century Indian philosopher summarized the nature of beauty (*saundarya*) in a few words that might well be shared by the women who create these designs: "The balanced and proper arrangement of each and every part leading to an easy combination of the whole; that is called *saundarya*."[3] For well over 2,000 years of recorded Indian thought, the physical and spiritual universes as a whole have been understood to be

a world of potential and actual beauty, an intricately interconnected artifice, a universal fabric, woven warp and weft on the intertwining "threads" (*gunas*) of lightness, darkness, and energy (*sattva*, *tamas*, and *rajas*). When all is well, these three strands exist in mutual and balanced harmony with each other and yet bring movement and thus support the flow of life. Like the patterns in these threshold designs, the cosmos as a whole is understood to wind in, around, and through itself. Each element of the universe, like each part of these designs, can be known by its connection to every other element, and by its occupation of its own distinct and unique place.

Beauty in India consists of more than symmetrical harmony and a feeling of balanced movement. It also allows for a sense of ambivalence. Similarly, these threshold designs both beckon us within and yet also ask us to stand clear of the doorway. Look, for instance, at Plates 28 or 90. On the one hand, these designs seem to ask us to enter into the world behind them. Their harmonious simplicity charms us. We feel welcome. Yet, on the other hand, their labyrinthine intricacy bewilders us, forcing us to step back in order to see them. Thus, in a way, the drawings protect the home from outsider's intrusion. We feel that the space behind them is private and that we should stay outside unless invited in.

There is something about these designs that seems almost ethereal, or celestial, or even atomic (see, for example, Plates 29 and 75), and yet they are grounded, quite literally, on the dark, hard, and solid soil in front of their artists' homes or, in urban settings, on concrete walkways. They are like constellations of the heavens brought to Earth. They may seem quite modern, even contemporary, and yet, in a way, they also seem primordial, as if the people of India have been drawing them since the beginning of time. While some drawings seem rather spontaneous and casual, most give form to an almost chthonic, magical sensibility lying deep within the creative imagination of those who produced them.

Women decorate their entryways during various religious festivals and on auspicious occasions marking such important family transitions as the birth of a baby, a child's first meal of rice, an adolescent's passage into adulthood, or a couple's marriage. The artists also draw these designs in alignment with the change of the seasons. Women in Tamil Nadu, for example, form draw these patterns, especially during the harvest festival Pongal, a celebration of the New Year, which takes place during the cool and pleasant month of January (see, for example, Plate 67 and VNs 22 and 24). This is a time of happiness and relaxation marked by the family's enjoyment of the warm, cooked, recently harvested rice (*pongal*) and of celebration of the universal regeneration that rice signifies. The New Year sees a rich flowering of these designs in front of almost every house. The only time in Tamil Nadu in which women tend not to draw them is during the dark lunar month immediately preceding the Pongal festival

and at those times their household has suffered a recent death or if one of the family is ill with a serious disease.

Women and girls who create these designs thereby align themselves with what is understood to be the underlying divine artfulness of the universe as a whole. Accordingly, emphasis is given to making them with care. Nagarajan, for example, tells us:

> I remember the feeling of the hands of my mother and my grandmother, curving lightly over my small right hand, gently guiding my trembling fingers. Rice flour was clenched in my fist. In trying to make sure not a bit of it spilled accidentally on the recently swept ground, I was feeling the awareness I always felt whenever I held rice in my hand. It was to be handled with the utmost delicacy and attentiveness. So often I had been told by elders in the household that even if a few grains of the precious rice were to fall on the ground in wastefulness, carelessness, or thoughtlessness, the goddess of rice, earth, and wealth, Lakshmi, from whom this bountiful rice flowed, would stop entering the threshold of our home. If neglected by the goddess Lakshmi, our family could become impoverished and hungry.[4]

These designs are called by a variety of names appropriate to their general shape and the technique used to draw them. The word *kolam* itself can generally be translated as "floor design," but it also includes such primary meanings as "beauty" and "gracefulness" as well as "form, shape" and "adornment, embellishment." All of these definitions connote harmony, proper appearance, and enhanced attractiveness. Secondary meanings include "line, current, watercourse" and "the planet Saturn," all of which suggest, in some way, the process of flowing movement or meandering (Saturn is the wandering planet). Other meanings include references to two animals, namely "bird" and "snake."[5] In southern India, the most common and probably the oldest method of writing a kolam entails placing a set of dots on the ground. The Tamil word for this kind of dot is *pulli*, so such a design is generally known as a *pulli-kolam*, or "dot-pattern" (see, for example, VNs 30 and 36). Other basic types named according to the way in which they are drawn include the "line-pattern" (*kottu-kolam*; see VNs 2 and 24), the "wiggling design" or "snake-like pattern" (*nelivu-kolam;* Plate 8 and VN 56), the "square-pattern (*catura-kolam;* Plate 34 and VN 3) the "circle-pattern" (*vatta-kolam*) and the "woven-pattern" (*pinnal-kolam;* Plate 93). Other, more descriptive terms include the "five-angled" (*aing-kolam*; Plate 6) "six-angled design" (*arukonam-kolam*; Plate 32 and VNs 9, 11, and 57), "blooming lotus" or "heaped up lotus" (*kuvi-tamarai;* Plates 12, 37, and 74), and "flowered lotus" or "complicated lotus (*sikkal-tamarai*).

Throughout India, these designs are most often drawn directly in front of the doorsill or entryway, but some are also drawn on walls, some on the floors within the house, and some outside of the house completely, such as on the spot where one approaches a sacred tree (see VN 9). Sometimes they are drawn at rather unexpected points of passage, such as on a stone that serves as a bridge across a sewage channel (Plates 83 and 86). They are drawn at temples and shrines (VNs 7, 11, and 12) as well as in homes where they serve to sanctify the household's private ceremonial room (Plate 41; VN 58) or as seats upon which the gods and goddesses are said to sit during the daily devotional rites (VNs 6, 12, and 13).

In the south of India, women tend to draw the designs with a wet paste; in other parts, notably western India, they are formed with dry powder. Some folk traditions include the use of animal figures as part of the pattern, the most common being birds and serpentine forms but also including fish, elephants, and butterflies. Images of the sun are common, and some drawings incorporate images of chariots, lamps, chords and swings. Perhaps the most ornate of these threshold designs are the *alpana* of Bengal, the *aripan* of Bihar, the *soma rakhna* of Uttar Pradesh, and the *apna* of Himachal Pradesh, where the artists incorporate alchemical symbols as well as stylized portraits of human and divine beings, mirror fragments, amulets, thread, and cloth. At times they include astrological symbols and are used in fortune-telling ceremonies. Some patterns are floral in appearance—the lotus, a pan-Indian symbol associated with the creation and maintenance of the universe, appears particularly frequently—while others, especially in the southern regions of India and which are perhaps the oldest and most traditional in style, are strictly geometrical and abstract, the most common shapes being the triangle, square and circle. One often sees within these drawings visual suggestions of the swastika (Plates 13 and 24; VN 1), which is an ancient symbol of auspicious sacred power associated with the creative energy of the sun and with the god Vishnu, who sustains the universe.[6] Some regional practices prohibit treading on the designs because their magical potency is too strong or valuable; others encourage it precisely because of their transformative power.

By the end of the day, the lines of these designs become blurred from the weight of the many feet that pass near them, and they disappear completely if it rains, the exception being the permanent ones drawn by the women of Bengal and other eastern regions. But nobody seems to mind. In fact, for the most part women are pleased to have the repeated chance to compare their artistic skill with that of their neighbors. More importantly, however, by gradually dissolving and disappearing through the day, these threshold designs embody the notion that time, even the special cyclical times of ritual, moves onwards. Life is dynamic, not static. Just as the sun continues

past its dawn towards its noontime heights and then to its fall into the west, so, too, does a woman and the members of her family move from birth through maturation, marriage, and the responsibilities of keeping a healthy household, into old age, and death. Traditional Indian thought holds that death then renews life: as the sun rises the next morning, so life begins again in a subsequent birth. Each stage is as important as the others, and none remains permanently. Like the sinuous and unbroken lines of the Indian threshold designs reproduced in Strawn's photographs, life flows from age to age, finally to come back—transformed—onto itself.

In this essay, I offer some thoughts on these threshold designs from my perspective as a student and teacher of religions in India. Gazing appreciatively at innumerable instances of this art over decades, I have come to feel that, while they have graced the doorways to India's homes as recently as this morning, they also reflect cultural continuations and combinations of a number of practices, ideas, and values that have enlivened Indian culture for millennia. In thinking about them, I have found it both interesting and illuminating to reflect on a number of texts from ancient and classical India that refer explicitly to these types of designs or express implicit themes that are similar to those embedded in this art. The artists who have drawn them through the generations are likely not to have been directly influenced by these texts. Neverthe-less, their artistry suggests themes and experiences of the world that have also found expression in India throughout the centuries. In some ways, these designs are similar both in form and function to the auspicious *yantras*, *mandalas*, *cakravyuhas*, and other geometrical or labyrinthine patterns that have appeared throughout the long history of India in a variety of settings—such as the performance of ritual drama, the con-structions of a temple, the practice of meditation, and the worship of the innumera-ble gods, goddesses, and divine or semi-divine forces that are seen to give life to the sacred universe. Throughout their history, the people of India have expressed their understanding of the world and have asserted their place in it through mythic narra-tive, theological discourse, and philosophical speculation. The artists who write these threshold designs express their worldviews, too, but they do so through nonverbal, visual means. By creating them, they sanctify the space delineated by the threshold.

SOME HISTORICAL OBSERVATIONS
Excavations in what is now Pakistan at Mahenjo-Daro on the Indus River and at Harrapa on the Ravi River have uncovered copper tablets made around 2000 BCE (Before the Common Era) that were most likely used for religious purposes and on

which artisans engraved meandering designs that are remarkably similar to those depicted in these photographs.[7] The discovery at these excavations of large granaries and irrigation canals has led many scholars to believe that what has come to be known as the Indus Valley Civilization that produced these plates centered primarily around agriculture, in general, and grain production, in particular. Not surprisingly, the abundance of other artifacts—such as buxom, curvaceous clay and terra-cotta figurines as well as cylinder seals adorned with lunar, plant and snake symbolism—gives ample evidence to suggest that the culture that produced these copper tablets placed much reverence in fertility, female powers, and goddesses as well as on the power of transformative or cyclical regeneration. These same themes have survived the many centuries and find expression in various ways as, for example, in traditional Indian threshold designs.

The sanctity of the threshold itself has been honored in India since at least the time the songs comprising the *Rig Veda* were first sung, perhaps around 1200 BCE, if not earlier. "O wide and all-embracing divine door," a Vedic prayer reads, "let the gods in, please, and give them easy access."[8] Another asks: "May the divine door that increases cosmic harmony be thrown open in order for us to perform, at this times and at this place, the sacred rite."[9]

Actual textual references to these floor designs appear in works composed as early as two thousand years ago.[10] The *Kama Sutra*, a first-century CE (Common Era) work attributed to Vatsyayana, lists the laying down of variegated lines made of rice and flowers as one of the sixty-four courtly arts.[11] Yashodhara's *Jayamangala*, a commentary on the *Kama Sutra*, notes that such drawings decorated the temples of the goddess Sarasvati (the divine patron of the arts) and of Kamadeva (the god of love).[12] The *Vishnudharmottara Purana*, which dates to the sixth century CE but which includes older material, describes how the sun god is to be worshiped by painting an eight-petalled lotus blossom on the ground.[13] The *Varangacharita*, a seventh-century CE Sanskrit work, refers to the use of five-colored powders, flowers, and rice-grains in drawing patterns the ground, especially in the context of the ritual offering of gifts of grain to divine spirits whose oblations (*bali*) typically were made by arranging the rice in a circle.[14] Someshvara's *Abhilasitarthachintamani* recognizes as one of the genres of painted art *dhulichitra*, which literally means "dust-painting" but which probably means "painting on the dirt."[15] By the twelfth century CE, Shri Kumara's *Shilparatna* was to make such a meaning explicit: *dhulichitra* was the same as *bhauma-chitra,* "painting on the ground."[16]

That such designs on the ground were used for ceremonial purposes is illustrated by references to them by such works as *Gadyachintamani*, an eleventh-century

CE work by Vadibhasimba, who describes a prince's entry into a hall that was "distinguished by line drawings done with auspicious powder."[17] At various points in his *Lilacharitra*, a thirteenth-century CE Marathi work, Mahindra Bhata describes the way in which spiritual leaders were welcomed by their devotees, who cleaned the yard in front of their houses with water and dried cow dung (*gomaya*, long used in India to purify the floor and walls of the home and temple) and then decorated the ground with *rangoli* designs.[18] The *Akashabhairavakalpa*, a set of ritual instructions written between the fifteenth and seventeenth centuries CE, frequently mentions the use of such drawings in religious rites. For example, according to that text, the floor around a temple's sacred fire altar was to be cleansed with cow dung and then decorated with *rangolis*.[19] Similarly, a ritual performed in honor of the traditional nine planets includes the construction of a "charming bower full of flowers . . . in the yard in front of the house [followed] by the smearing of [the ground] with cow dung and the drawing of *rangoli* in the shape of an auspicious square [*sarvatobhadra*]."[20] In a ceremony known as the Vastupuja, the consecration of the place in which a home was to be built, these designs were painted as a way to ward off any evil forces that may have lingered near the spot. Instructing the king in his royal obligations, the text notes that "[he] thinks of performing the ceremony of appeasing evil spirits while performing the consecration of the place. Having thought of this, he smears the right side of the ground with cow dung and draws *rangavalli* on it."[21]

The fact that these designs have a long and traditional history, or that the designs look very similar to each other throughout any particular region, or that the painting of such designs in nearly pan-Indian practice does not mean that the process by which they are drawn is rigidly formulaic. Each design is different and can reflect its artist's unique preferences. While in recent years, especially in urban areas, some women have begun pouring powder through mass-produced tin sheets punctured with holes, village and many city women still enjoy the process of making their own particular designs distinctive and uniquely attractive.

Feminine Sacrality and the Ritual Art

Although Indian society, for the most part, has long been patriarchal, Indian religious sensibilities have always been pervaded by a sense of feminine sacrality. The religious ideals and practices of the highly prosperous Indus Valley Civilization centered on the worship of the great Goddess, whose creative powers and fertile rhythms brought the seasonal alluvial flooding of the rivers that periodically nourishing the earth, which then gave birth each year to the life-sustaining grains in the fields. Reli-

gious sensibilities in India, aligned with an earth-oriented agricultural worldview, have long been complemented by traditions that have tended to praise generally masculine divinities of the sky, such as the Vedic tradition, but the Goddess appears in this latter pantheon as well, as indicated, for example, in these words of praise Vedic poet-priests sang to Ushas, the goddess of the Dawn:

Dawn arrives, shining—like a lady of light—
stirring all creatures to life. . . .
Dawn's light breaks the shadows.
Her face turned to all things across this wide world,
she rises in splendor, enwrapped in bright clothes.
Shining in golden colors, dressed with rays of light,
she guides forth the day like a cow leads her calves.[22]

For Vedic poets, the goddess Dawn embodied the return of life to a world of cold darkness and thus of goodness from evil:

As if aware
that her arms shine
from her morning bath,
she rises
so that we may see her.
Dawn, the daughter of Heaven,
has come to us
with light,
driving away
evil and darkness.[23]

The goddess of the dawn's light shined through the celestial doors at dawn and thus crossed the universal threshold between night and day. As another poet proclaimed.

Our eyes look on Dawn, the bright escort of happy sounds.
She has opened the splendidly colored doorways.
Stirring the whole world, she has shown us her riches.
Dawn has awakened every living creature. . . .
Bringing with her all blessings that sustain life,
Sending forth her radiance, she reveals herself. . . .

Arise! The breath of life again has reached us.
Darkness has passed and light approaches.
She leaves a path for the Sun to follow.
We have arrived where people prolong life.[24]

In India, the dawn has long been the most sacred time of the day, for this is a time of emergent light and life from the otherwise encompassing darkness. In general, sacred architecture is, therefore, oriented toward the east. Temple doorways, for example, are ideally constructed so that the rising sun illumines the entry's doorway. So, too, the sun and its light have long been regarded as holy. Religious symbolism in India, including symbolism found in these designs, often includes solar imagery. For example, women of Bengal draw images of the "great circle" (*mahamangala*) as part of their praise for the sun, while, during the month of Margoli (December–January)—a time of short days and long nights—the women of Tamil Nadu draw chariot designs (*ter-kolam*, *ratha-mandala*) in which images of the sun are drawn inside a chariot and then offered reverence. Such practices are old. According to Haradatta's commentary on the *Gautama Sutra*, a text from the first millennium CE, girls are to offer worship of the sun by painting solar images on the ground with colored powder in the morning and evening at that time of year when the rising sun is in the constellation Aries.[25]

Traditional religious sensibilities in India see the Goddess to be the source and embodiment of the sacred, universal power (*shakti* and other terms) that creates, nourishes, protects, cures, and brings all things in the world to their inherent completion. Sensing that this divine force is the effective source of all that exists, from the most physical of material substances such as dirt and vegetation to the most sublime emotional states of pure joy, sadness, and love, the people of traditional India have sought to align themselves with it and thus to be in harmony and balance with all of life and being as a whole.

As divine creator, nourisher, protector, and destroyer of evil, the Goddess has been known in traditional India by many names and has often been the object of prayer and petition, as we read in the following:

O Goddess who removes the suffering of your supplicants,
have mercy!
O mother of the whole world, be gracious!
. . . You are all women, and you are the world.
By you alone, as mother, is this world filled.
. . . O Mistress of the universe, whose nature is the world,
filled with all powers,

Save us from danger!

. . . Be gracious to those who are prostate before you,

O Goddess who removes the suffering of the world![26]

Various annual rituals mark the Goddess's important place in the world. The Navaratra ("nine-night") festival, for instance, honors nine forms of the Goddess and takes place during the first nine days of the lunar month of September-October. In general, celebrations of the Goddess often revolve around the longing for, and assistance in, the renewal of life. For example, the celebration of Divali (the "festival of lights") is directed primarily to Lakshmi, the goddess of prosperity, and takes place at the time of the autumnal equinox, just about the same time as the end of the monsoon season and the harvest of the crops. This celebration includes the telling of stories about underworld spirits who bring prosperity but must be shown the way from the darkness to the household by means of lighted lamps that glow in the windows and doorways. Divali often includes the worship of the god, Dharmaraja, the king of social and cosmic order, an image of the Vedic figure of Yama, the latter of whom is said to live with his twin sister, Yami, in the underworld, where he serves as the lord of the dead. At the beginning of the rainy season, girls and women tie small threads around their brothers' wrists as a way to protect them from evil forces. Then, during Divali, they invite their brothers across the threshold—which often will be decorated with a stylized lamp on the threshold floor—cut the threads, give them sweets, and hope for gifts in return.

There is some evidence to suggest that, in centuries past, sacrificial blood offerings have been given to various forms of the Goddess as a way to gain and keep her favor.[27] Hindu religious traditions, in general however, eschew ritual blood sacrifices. Instead of such violent ceremonial offerings, gifts to the deities came to take the form of flower petals, rice and other grains, fruit, clarified butter, and other presents that symbolize and embody the power of life. Similar elements also appear in a family's daily household (*grihya*) and life-cycle (*samskara*) ceremonies.

Pious Brahmin families typically perform grihya rites at sunrise and sunset every day. The evening ritual usually includes offerings of rice or other grain to Agni and Prajapati, respectively the god of life-giving fire and the divine Lord of all Creatures. Morning rites involve offerings of rice, clarified butter, curds, or other delicate foods to Prajapati and Surya, the latter being the god of the sun.[28] Those morning and evening ceremonies also include rice-offerings at the domestic doorway to the gods Pushan, the path-maker, Dhatar, the space-maker, Vidhatri, the distributor, and Maruts, who bring heavenly light and rain. Other domestic rituals include the various ceremonies performed at the birth and naming of a child, a young person's entry into the life of a student, and at a couple's marriage.

Brahmanical household rites have typically been performed by the male head of the family or by a local Brahmin priest employed by the family. Some traditions, however, allow a man's wife to take her husband's place in the evening and morning ceremonies as well as the various rice-offerings if he is unable to do so.[29] The wife usually took part in most of the other domestic ritual performances as well, usually in support of her husband's required ceremonial tasks. In general, though, women in Brahmin families could not consistently perform the traditional grihya or samskara ceremonies by themselves, and non-Brahmin women could not perform those rituals whatsoever.

This does not mean that women have had no ritual power. Women have long performed other rites not necessarily connected with the traditional grihya and samskara ceremonies. For example, throughout the centuries women have performed important rites known generally in Sanskrit as *vratas* (Hindi *vrat*, Bengali *brata*, and so on). In performing a vrata, a woman makes a voluntary decision to undertake a solemn vow, practices austerities, or devotes herself to meritorious acts as a way to protect her family, bring health to her home, or insure her household's continuing prosperity.

A woman who carries out such a vow quite often accompanies her practice with the painting of *rangoli*, *sona rakhna*, *apna*, *aripan*, *kolam*, and other designs. The dominance in such designs of images of the Goddess, particularly of Lakshmi, and of various fertility and regeneration symbols marks the conjunction of the woman's creative or restorative hopes with the universal Goddess's transformative powers. In a manner of speaking, women who create these designs become unofficial or noncanonical folk-priests, for, by writing them, women take part in a world in which their actions are understood to establish or maintain contact with divine forces and thus to have a direct influence on their family's health and welfare. The woman who forms such patterns draws on her own feminine connection with the generative and regenerative energies of the universe as a whole. As she draws these designs, she thereby aligns her actions with the power of the Goddess herself.

The Symbolic Importance of the Threshold

Of all the places they could be drawn, why are such designs placed at the threshold? There would be many ways to answer this question, for, since the beginning of time, the threshold has been a hallowed, sacred place understood to hold magical power or divine significance. To begin, however, we might remember one point that seems rather simple but carries much mythic and symbolic weight: a threshold faces two directions.

On the one side lies the warm and trusting familiarity of home. Here, people prepare their food, laugh and quarrel with their loved ones, give birth to and raise their children, take care of their sick and infirm and elderly. The world "inside" the threshold is finite, distinct, knowable. Here, there is light, order, safety. *Here*, one knows, is life.

In the other direction lies the impersonal, uncontrollable, and ultimately unknowable realm beyond the home. The "outside" stretches from the doorway into infinity. It has no edges, no boundaries, except the one at this threshold. It is easy to get lost in the unlimited vagueness. "Out there" is confusion, darkness, chaos, danger. *There*, one feels, is death.

Historians of religious symbolism have noted that, throughout history and in different cultures, people have tended to distinguish these two qualitatively different types of space in their experience of the world. Mircea Eliade (1907–1980), the Romanian scholar in comparative religions, for example, used the terms *sacred* and *profane* to describe the two.[30] Eliade's classification has its problems, but it is nevertheless helpful for our purposes to make use of these categories as we seek more understanding of the religious significance of the threshold diagrams. Eliade characterized the profane world as a world of *chaos*, in which people perform their actions without a sense of the larger significance of their lives. To live in chaos is to live without reference points, to see no structure, to know no firm and steady center: Life in chaos is like being lost in the dark or like drowning in an infinite ocean. Chaos is the world of fear, doubt, and uncertainty.

If profane space is chaos, then sacred space is the opposite: it is *cosmos*. Here, there is order and structure, and people perform the activities of their lives with a sense of meaning and, thus, of being oriented to the significance of life. The two worlds—the sacred and the profane or cosmos and chaos—are and must be separated, for, without this separation, the cosmos will be dissolved by chaos. And yet, despite this necessary demarcation of chaos from cosmos, there must be some way to move from one world to the other; otherwise, a person could never enter from a realm of meaninglessness into a world of significance and identity.

What is it that both separates and connects sacred and profane, cosmos and chaos? It is the threshold. To establish a threshold is, thereby, to proclaim: "*Here* is where we live"—which is really to say, "We are alive! We are alive in an otherwise unfathomable and potentially overpowering universe." It is to affirm: "Here there is meaning, here there is value, here we are real."

To establish a threshold is, therefore, to celebrate the creation of a meaningful world; and to cross that threshold is to live within that creation, to transform chaos

into cosmos. When viewed mythically, the threshold thus embodies the cosmogonic event itself. As the symbolic locus of creative and transforming power, it serves as the place where the original creators—the gods and goddesses themselves—make their home. Accordingly, to cross a threshold is symbolically equivalent to meeting a divine presence. At the threshold, light overcomes darkness, good overcomes evil, life overcomes death.

The threshold thus presents an appropriate place to acknowledge the power of Divinity. Evidence suggests that early domestic altars in a variety of cultures were, in fact, placed at the entry to the home. This was also the place in which gifts were offered to the gods and the gods' blessings were given to their worshippers. Throughout the worlds' cultures, the threshold came to symbolize the trust reached by those residing within the protected domain and those visiting from beyond. As one interpreter of threshold symbolism has said, "Crossing the threshold, or entering the door, of a house, is in itself an implied covenant with those who are within. He who goes in by the door must count himself, and must be recognized, as a guest, subject to the strictest laws of hospitality."[31] In India, religious mendicants, for example, were instructed never to gain entry into a home through a window, over a fence, or by other means other than a proper doorway. As a classical text on normative behavior says, "He should not enter a walled village or home except through a gate."[32] The threshold was the place of protection and safety, as well as of greeting and welcome, even of the gods themselves. Accordingly, another such text, dating to about the third century CE, notes that householders were to place offerings to the deities at the threshold.[33]

Some Symbolic Functions of these Threshold Designs

The designs drawn by contemporary women and girls attract the eye, in part because they are visually interesting, but they are more than this. They are mysterious and compelling, in part because they serve various symbolic functions that have found expression in various ways in India for millennia.

Creation and Establishment Symbolism

Indian thought has long regarded the physical and spiritual universe as a whole has been understood to be an intricately interconnected and smoothly turning artifice built on a balanced pattern of a cosmic order, in which all things and all actions have their proper place and in which all parts support and strengthen the whole in a flowing symbiosis. Ancient Indian poets saw the universe to be a work of art of sorts in

which all things are inextricably linked to each other in their cosmic harmony and balance. Understood in this way, the world is a cosmic weaving.

Imagery of the universe as a weaving of sorts persists throughout the history of Indian ideas. More than 3,000 years ago, poet-priests thought of the initial creation of the universe to be a result of divine artisans weaving the fabric of the cosmos together. A verse from one of the Vedic songs describes the creation of the world by Purusha (the primordial, divine Person) through an act of weaving: "The Person stretches the warp and extends the weft; the Person has spread it out upon this vault of the sky."[34] Students of the seventh century BCE trying to comprehend the nature of the universe asked, "On what are the worlds woven?"[35] Their teachers, at times, responded by using the metaphor of a spider's web to describe a world in which all multiplicity finds its expression within a more encompassing unity.[36]

It is a long way, in terms of time and sophistication, between the classical philosophers of India and the painters of these threshold designs. But, in a way, these well-formed, intricate, and fabric-like patterns that grace the entryways to Indian homes are representations of the physical and spiritual worlds in miniature. The patterns typically grow rhythmically away from their center and then return to that center again, just as the universe as a whole periodically expands from and contracts into its own timeless and spaceless center. These rhythms are the pulsations of life itself: birth, growth, death, re-absorption, rebirth—all of which take place within a sacred cosmos, which folds and unfolds over and within itself in an eternal transformation. By drawing these designs, the artists in their own way present an Indian philosophy in visual form and, in a sense, replicate, in their own thresholds, images of the perfect universe as a whole.

Age-old elements of traditional Indian thought include the vision of the world as an active and vital realm in which divine powers give life. Symbolic representations of those divine forces have often taken geometrical shape. The simplest but also symbolically most powerful of such shapes was the red or white dot. The dot is the *bija*, which means not only "plant seed" and "grain," but also "origin" and "source." The dot is also known as the *bindu*, referring here to a "drop" of the life-force. Since time immemorial, red has, in India, been the color of life-giving energy, and it is often associated with female divine powers. Similarly, white, the color of grain powder and sunlight, has embodied not only vital energy, but also purity and understanding, and it is often associated with male forces. There may also be some association with the colors of blood and semen, respectively. Accordingly, both red and white symbolize creative, living power as well as effective and generative wisdom—and thus fertility, health, and welfare.

Similarly, the downward-facing triangle is an age-old depiction of the womb and, therefore, of feminine creativity, and it is often associated with one of the many forms of the Goddess; the upward facing triangle is an abstract representation of male creative powers associated with the gods, particularly of Shiva (Plate 32). The visual superimposition of the downward- and upward-facing triangles, often surrounded by a circle, an image of wholeness, symbolizes and embodies the idea that the universe in its entirety consists of the balanced conflation of these creative feminine and masculine divine powers—and all complementary forces whatsoever—into one unified whole.

The use of such circular and interlocking geometrical shapes abstractly representing the sacred world in its entirety came to be an important element of temple and domestic ritual performances and in the practice of meditation. Known generally as *yantras*, these designs have, for centuries, been said to serve as effective visual means to establish the psychological, cosmological, and spiritual foundations for a variety of religious transformations. They are able to do so, because they are understood to delineate in abstract form the powerful forces of creativity and change that drive the universe as a whole; and delineating those energies they are said not only to represent, but also to embody the sacred forces themselves. To draw a yantra is to draw the world as appears to one who sees the essential connections between all forms being in all of the visible and invisible universes. Stella Kramrisch's general definition of yantra would apply to these threshold drawings themselves:

> A Yantra is a geometrical contrivance by which any aspect the Supreme Principle may be bound . . . to any spot for the purpose of worship. It is an artifice in which the ground (*bhumi*) is converted into the extent of the manifested universe.[37]

Fertility and Renewal Symbolism

A culture's praise of female cosmic and theological powers tends to reflect a variety of deep religious sensibilities and hopes centered on the process of the creation and regeneration of life itself. One would expect, therefore, to see such expressions of this sensibility in symbolic themes that suggest birth, growth, and rebirth.

This holds true in the case of threshold designs. For example, the artists make frequent use of vegetation symbolism in their threshold diagrams.[38] One finds representations of *tulsi* grass, the *kadambra* tree and blossoms (*Nauclea kadamba*), the *pipal* tree and leaves (*Ficus religiosa*), *janar* corn (*Zea mays*), the *sola* plant (*Aeschynomeme aspera*, a water plant), and coconuts. Stylized mango leaves appear often in these designs, as in Plate 3, sometimes in association with images of lotus blossoms.

Throughout Indian history, the lotus has been a symbol not only of cosmic unity, but of the fullness of life. A lotus begins its life in the mud at the bottom of a pond, reaches through the water towards the sunlight, and eventually swells on the surface in a burst of harmony and balance. It remains open and alluring all through the day. At darkness, it then folds into itself, only to blossom again at the next light. It is a wonderful symbol of the cosmos as a whole as well as the birth, life, and rebirth of all beings within that cosmos.

These threshold designs present other symbols of fertility, birth, and renewal, too. We have already made reference to images of birds and the snakes, both of which evoke the idea of power of life and, especially, of the possibility of rebirth: the bird is born once as an egg emerging from the body of the hen and again as a chick breaking free of its shell; the snake not only moves easily between the dark, deathly under-worlds and the light, living surface of the ground, but also periodically sheds its skin to become a "new" being. Both animals, at times, symbolize deathless or eternal life: a bird can fly into the immortal heavens above, and by putting its tail into its mouth, a snake forms the circle of infinity (Plates 8, 17, 44, 88, and 89).

Transition Symbolism

The place of transition between two spaces, the threshold symbolizes a person's crossing from the profane to the sacred realm and a deity's crossing from the sacred to the profane world. Such symbols of movement often include visually flowing patterns. For example, serpentine symbolism has long been associated with the inner shifts in consciousness connected with the practice of meditation and contem-plative yoga.[39]

Stella Kramrisch, the noted scholar of Indian art, sees meandering patterns to suggest divine rivers, the life-giving waters of which have their source in heaven and which a devotee must ford in order in order to regain the divine world. Noting that temple doorways often include flowing designs that "enclose the door ascending in an unbroken continuity of swaying creepers, superposed and in panels, each filled with a sinuous pattern," she argues that "all these are sculptural metamorphoses and elabo-rations of the theme of the River-goddesses for it is from their waters that they rise."[40] Kramrisch sees the doorway to be the "structural equivalent" of a natural *tirtha*—that is, a river ford by which one gains access to the other shore.[41] Similar imagery appears in these domestic threshold designs. The sacred transitions of a family's life such as the birth of a child, the emergence of a young person into adulthood, a marriage, or a death are both marked and made safe by sanctifying the symbolic place of transfor-mation; namely, the doorway itself.

Purification and Protection Symbolism

If benign and helpful divine forces are to be welcomed across the threshold and embraced within the home, malignant and dangerous ones are to be turned away. The spirits who bring fear, misfortune, disease, and death to the household or temple must be trapped in a place outside the household or temple; either this or something must be done to confuse them so they become lost and cannot find their way. Goodness and light must be guided into the household; danger and darkness must be turned away. Something must, at one and the same time, both attract the powers of life and yet bewilder the forces of death.

Scholars interested in the history and function of symbols have noted the presence in many world cultures of the labyrinth and the knotted rope as magical and religious images that evoke a variety of motivations and experiences, most of which are connected to the idea of "binding" forces of evil and "loosening" forces of good .[42] One of such functions revolves around the perceived need to protect something valuable from harmful or desacralizing encroachments. In this regard, it is interesting to note that the traditional name for one of the typical kolam designs in Tamil Nadu is known as *Brahma-mudi*, (see, for example, Plates B, 1, and 28); that is to say, "the creator god's knot."

A labyrinth, constructed immediately in front of the threshold, would serve similar purposes. Like a rope tied onto itself in knots, a maze would give entry to those who knew the way through; those who did not would be caught in the snare. Referring to classical temple architecture, George Mitchell has concluded that the threshold is, therefore, "the most vulnerable part of a sacred structure and the most in need of protection from evil forces, real or invisible."[43] The same holds true for domestic space. The threshold keeps evil out and lets goodness in. We see an example in Plate 2 or in VN 2, the latter of which, interestingly, also has suggestions of a deity's footprints leading into the home. One of the Indian words for "maze" or "labyrinth" is *cakravyuha*, which primarily refers to the distribution of soldiers who encircle a particular place in order to guard it from an enemy's intrusions but which also came to refer to any complicated circular design that shields something within or nearby from external dangers. Since this design is understood to be capable of warding off harmful forces, geometrical and circular shapes made of intricately interconnected lines have, for centuries, often been drawn around the area within which sacred rites are to be performed. The labyrinth also purifies that which finds its way through it. Threshold designs are sometimes described as *pavitra* (thus also *pavitu* and *pavita*); that is, as a woven cloth that filters out impurities as sacred substances or forces pass through it. If befuddled demons and evil powers cannot find their way through the protective maze,

then the protected domain remains immune from their danger. Similarly, if benevolent and divine forces are allowed through, then the interior space is strengthened and sanctified. Look at Plates B, 2, 13, 24, and 71 or at VN 13, among others, and you see auspicious and protective filters, mazes, and labyrinths.

Because it is the place of protection and purification, the threshold itself must remain pure and inviolate. Worshippers in a Hindu temple who cross the doorway to the inner sanctum typically do so without touching the floor of the threshold. Similarly, a hostess honors her domestic guests by drawing a threshold design at her doorway; her guests then honor her home through their unwillingness to step on that same design. It is interesting that tradition in India, as elsewhere, holds that a bridegroom is to carry his new bride across the threshold so that her feet do not touch the ground in that powerful place.[44]

Symbolizing protection at the threshold often includes, again, birds and snakes. Of birds, perhaps the most frequently represented in threshold designs is the peacock (see Plates 67 and 89), whose distinguishing eye-like marks on its tail are understood, in traditional India, to ward off the effects of the feared "evil-eye" and to protect people from harmful poisons and other dangerous intrusions into personal and familial space. The peacock's ability to protect an important space from invasion led it to be recognized as the appropriate vehicle by which the god Skanda, the general of the divine army, rode about the celestial kingdom. Other birds figure significantly in Indian religious expression as well. Lord Brahma, who continually brings the world into being, is often associated with or represented by a majestic swan, for example, and the god Vishnu, who pervades and protects the entire universe, rides throughout the cosmos on the mythic bird, Garuda

Snakes have long been regarded in India as embodiments of sacred power and, thus, not only of spiritual transformation, but also of protection. Since at least the Gupta Period (fourth, fifth, and sixth centuries CE), the fashioning of serpentine images on the sills and lintels of doorways to a temple have protected the deities dwelling within the sacred space; similarly, images of a snake help insure the welfare of family members living within the home space (see Plates 8 and 88). Remnants of the worship of the powers embodied by the snake (*naga*) appear today in a variety of settings throughout India. Not surprisingly, many of these practices are similar to those involved in the drawing of threshold designs. One such set of practices takes place during Nagapanchami (the "fifth-day snake festival") celebrated each year, particularly by women, on the fifth day of the waxing moon during the first month of the rainy season.[45] As part of their performance of the Nagapanchami ceremonies, women in Konkan (the coastal region south of Mumbai) use dried cow dung to draw

pictures with snakes on both sides of their doorways. The snake-deities represented by those drawings—Ananta, Shesha, Kaliya, Pingala, and other demigods—are then offered parched grain, flowers, a red lotus, sandalwood, and incense.

Similar Nagapanchami celebrations have taken place all over India for years and still take place today. In Orissa, women participate in the festival by decorating their homes with rice-paste *alpana* designs.[46] In Bihar, "women mark their houses with lines of cowdung, and worship [the divine serpent] Sesh Naga with milk and parched grain." In Garhwal, "the ground is freely smeared with cowdung and mud, and figures of five, seven, or nine serpents are rudely drawn with sandalwood powder or turmeric;" here, these practices "take place both morning and evening, and the night is spent in listening to stories in praise of the Naga."[47] As part of a longer poem entitled "The Festival of Serpents," a twentieth-century Indian poetess has written the following lines to the divine snakes that embody the powers of fertility, health and rebirth:

Guard our helpless lives and guide our patient labours,
And cherish our dear vision like the jewels in your crest;
O spread your hooded watch for the safety of our slumbers,
And soothe the troubled longings that clamour our breasts.[48]

Conclusion

Mysterious, simple, and attractive, the designs that grace the thresholds of traditional Indian sacred present abstract expressions of some of the deepest and most pervading qualities of human nature: of hope for the emergence of light in a world that can seem covered by darkness; of declaring one's autonomy in a world that often seems overwhelming; of the longing to bring new life into a world, despite the constant threat of hardship; of the innate joy of being alive in a world that can be darkened by illness and death; in short, of the human capacity to affirm the value of life itself. I do not wish to overstate myself, therefore, when I say that these folk designs at times not only reflect a kind of unlettered, religious sensibility that celebrates the creative and transformative powers that enliven and sustain the world, but also as, finally, a revelation of the harmony and symmetry of the sacred web of life.

The practice of threshold art shows signs of disappearing in India, particularly in larger cities. Some of this may be due to the increasing effect that medical advances have had on village and family life. These technologies and techniques have come to replace the traditional vrats undertaken by women to protect their homes from danger and disease, thus removing some of the reasons why women would paint these

designs at their thresholds. Recently, some women have begun to create these designs not by writing them with their own fingers but by pouring sifted flower through manufactured tin plates punctured with dots forming typical patterns. This movement toward stylistic rigidity and stereotype in a way contradicts the general idiosyncratic playfulness and mystery that is part of the art's history and charm.

I do hope, though, that, despite the changes in Indian culture moving along the vectors of modernization, the practice of writing these threshold designs will continue. (I smile appreciatively when looking VN 3, in which such a design is written near a set of satellite dishes.) They are fascinating examples of the way in which archaic, symbolic expressions appear in traditional and modern behavior. More importantly, these designs that beautify and sanctify the threshold are also alluring reminders of an important affirmation that I hope we never forget, no matter what culture we live in: The mystery that is life itself is to be protected against harm and celebrated with joy.

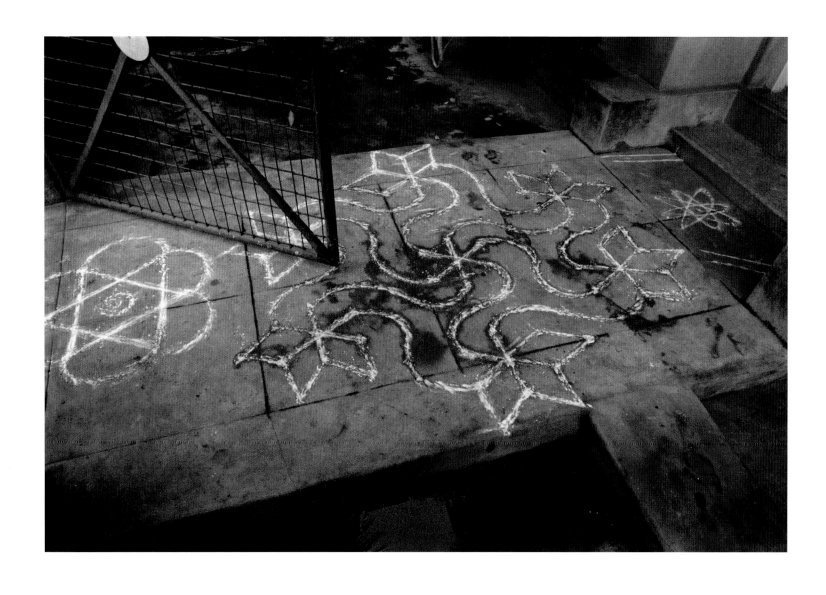

Plate K

Coda

vision in motion

is simultaneous grasp. Simultaneous grasp is creative
performance-feeling, feeling and thinking in relationship
and not as a series of isolated phenomena. It instantaneously
integrates and transmutes single elements into a coherent whole.
This is valid for physical vision as well as for the abstract.

—LASZLO MOHOLY-NAGY, EXCEPT FROM "VISION IN MOTION" (1947)[1]

SINCE THE BEGINNING OF HUMANITY, people have practiced making art and crafts as
a necessity of daily life, as reflections of their culture and souls, and as expressions of
celebration, hope, loss, dreams, challenges, and philosophies. People make art using
the creativity of their being to communicate with others and to reveal what matters to
them deep down in their hearts, minds, and souls.

The action of creating a form of expression is an internally centering process.
When we experience another person's outpouring of images, movements, or sounds
that demonstrates her or his feelings and interests, we share with them that part of
their being that they feel compelled to express. This sharing occurs across time, space,
and cultural differences, by means of performances and exhibitions, presentations on
the street and in multi-media, and collections in museums and libraries. Through art,
especially indigenous art such as women's threshold drawings in India, symbols are
recycled again and again, and numbers, as symbols, are tools that help us create order
in our perceptions of the web of life.

Regarding art, I always return to Rabindranath Tagore, as I did earlier in this book.
Tagore is the famed Bengali polymath and poet who founded the movement known as
Contextual Modernism that reshaped Bengali literature and music and Indian art.
Tagore became the first non-European to win the Nobel Prize in Literature in 1913.
It was Tagore who, in one of his songs (poems), so eloquently wrote:

It is the magic of mathematics, the rhythm which is
in the heart of all creation which moves in the atom
and, in its different measures, fashions gold and lead,
the rose and the thorn, the sun and the planets.

These are the dance steps of numbers in the arena
of time and space, which weave the maya, the patterns
of appearance, the incessant flow of change, that ever
is and is not. It is the rhythm that churns up images
from the vague and makes tangible what is elusive.
This is maya, this is the art in creation, and art
in literature, which is the magic of rhythm.[2]

Time cycles around, and the meanings of symbols change. Knowledge is lost and found again, reclaiming relevancy. It is that spiral of time and the linkages of understanding that form our appreciation, such as that of an indigenous art—threshold diagrams—recorded and interpreted with cameras and presented as a book, in a contemporary world of fractals and computers.

Art is the signature of civilizations.
—Beverly Sills (1985)

PREFACE (Strawn)

1. Martha A. Strawn, *Alligators, Prehistoric Presence in the American South* (Baltimore, MD: The Johns Hopkins University Press, in association with the Center for American Places, 1997).

2. Alan Watts, *The Tao of Philosophy: The Edited Transcripts*, Mark Watts, ed. (Boston, MA: C. E. Tuttle Publishing, 1995), 17–18.

THE VIEW FROM INDIA (Vatsyayan)

1. See, for example, Turner's essay, "Betwixt and Between: The Liminal Period in *Rites de Passage*," in Victor Turner, *The Forest of Symbols: Aspects of Ndembu Ritual* (Ithaca, NY: Cornell University Press, 1967), 93–111.

2. William K. Mahony, "At the Threshold: The Sanctification of Space in Traditional India," in Martha A. Strawn, *Across the THESHOLD of India: Art, Women, and Culture* (Staunton, VA: George F. Thompson Publishing, 2016), 247.

3. Martha A. Strawn, *Across the THRESHOLD of India*, 191.

SARASVATI, THE MUSE (Strawn)

1. This quote is used extensively in conjunction with Kalakshetra, an Indian Centre of International Understanding through the arts. The quote and information about Kalakshetra may be found on a variety of Websites via Google search, such as www.kalakshetra.net (accessed June 14, 2014); see, also, *46th Art Festival 1997–1998 Programme*, (Chennai, India: Kalakshetra Foundation, 1997), 10.

2. Devi is defined by John Stratton Hawley and Donna Marie Wulff in *Devi: Goddesses of India* (Berkeley: University of California Press, 1996) as follows: "Goddess, the most general name for feminine divinity; often used to refer to the wife of Siva (Parvati, Durga, Kali, etc.) but applied to other goddesses as well; or specifically, *the* Goddess, ultimate reality conceived" (318). See, also, Romila Thapar, *Early India: From the Origins to 1800* (Berkeley: University of California Press, 2002), 278 and 485.

3. David Kinsley eloquently describes the attributes and significance of Sarasvati in

Hindu Goddesses: Vision of the Divine Feminine in the Hindu Religious Tradition (Berkeley: University of California Press, 1988), 55–64, especially:

> "A persistent theme in the Hindu tradition is that human destiny
> involves the refinement of nature. Although the ultimate goal of
> the religious quest may be moksa, the complete release from the
> phenomenal world, Hindus affirm that being fully human necessitates
> molding, enhancing, and refining the natural world in order to make
> it habitable for human beings. Such important Hindu ideas as dharma,
> the *samskaras* (life-cycle rituals), and the *varna-jati* (caste) system
> be the most obvious and concrete manifestations of this theme in
> the Hindu tradition. Artistic creation and the accumulated knowledge
> of the sciences, including philosophy, epitomize human culture and
> demonstrate the extraordinary ability of human beings to mold and
> refine the natural world into something beautiful and specially human.
> Sarasvati presides over and inspires this dimension of being human in
> the Hindu tradition"(63).

See, also, Georg Feuerstein, Subhash Kak, and David Frawley, *In Search of the Cradle of Civilization* (Wheaton, IL: The Theosophical Publishing House, 1995), 190–91.

4. More information is available in "Liminality and Communitas," Chapter 3 of Victor Turner's *The Ritual Process: Structure and Anti-Structure* (Ithaca, NY: Cornell University Press, 1969). In Turner's chapter, the term *limen*, as defined by Arnold van Gennep in 1909, is fully explored in relation to its use in anthropology. Van Gennep's use of the phrase "'liminal phase' of *rites de passage*" is cited as "rites which accompany every change of place, state, social position and age." Also, he asserts that all rites of passage are marked by three phases: separation, margin (or *limen* signifying "threshold" in Latin), and aggregation." Turner continues to interpret the concept in the rest of the chapter.

5. Martha A. Strawn, *Alligators, Prehistoric Presence in the American Landscape* (Baltimore, MD: The Johns Hopkins University Press, in association with the Center for American Places, 1997).

6. Klaus K. Klostermaier, *A Survey of Hinduism* (Albany: State University of New York Press, 1994), 163. See, also, Romila Thapar, *Early India* (Berkeley: University of California Press, 2002), 276–77.

7. Ketki S. Shah, *Mehandi Designs* (Ahmadabad, India: Gala Publishers, nd), 75.

8. The following citations are used throughout the texts in this book. Specific pages are cited for each use. Ananda K. Coomaraswamy, *The Dance of Shiva: Fourteen India Essays* (New Delhi, India: Munshiram Manoharlal Publishers, 1982); Ananda K. Coomaraswamy, "Art in Indian Life," in Roger Lipsey, ed., *Traditional Art and Symbolism: Coomaraswamy* (Princeton, NJ: Princeton University Press, 1977); Ananda K. Coomaraswamy, *The Transformation of Nature in Art*, Kapila Vatsyayan, ed. (New Delhi, Indira Gandhi National Centre for the Arts in association with Sterling Publishers, 1995); Pupul Jayakar, *The Earth Mother*, revised and updated edition (New Delhi, India: Penguin Books, 1989); and Stella Kramrisch, *Exploring India's Sacred Art*, Barbara Stoler-Miller, ed. (Philadelphia: University of Pennsylvania Press, 1983).

In Ananda K. Coomaraswamy's essay, "Art in Indian Life," a very clear statement is made regarding the significance of the "Alpana" drawings as outstanding examples of "fine art" within the customary definition of the category. He further describes the diagrams as "an art of almost pure form and almost purely intellectual significance," ibid, 91.

9. For further reading on this topic, refer to Ananda K. Coomaraswamy's essay, "Intellectual Operation," in Lipsey, ibid.

10. *Webster's Encyclopedia Unabridged Dictionary of the English Language* (New York: Portland House, 1989), 731.

11. David Kinsley, *Hindu Goddesses: Visions of the Divine Feminine in the Hindu Religious Tradition* (Berkeley: University of California Press, 1988), 4–5.

12. Ibid.; Miriam Robbins Dexter, *Whence the Goddess: A Source Book* (New York: Pergamon Press, 1990), 75–85; and Pupul Jayakar, *The Earth Mother: Legends, Ritual Arts, and Goddesses of India* (San Francisco, CA: Harper and Row, 1990), 174–206.

13. Karel Werner, "Symbolism in the Vedas and its Conceptualization," in his book, *Symbols in Art and Religion: The Indian and the Comparative Perspectives* (Delhi, India: Motilal Banarsidass Publishers, 1991, 29–35.

14. Ibid.; Feuerstein, Kak, and Frawley, *In Search of the Cradle of Civilization*, 121.

15. I read numerous references regarding the two viewpoints. In each case, I considered the author's bias as stated directly or discerned through a consistent ideological position underlying his/her thesis. I considered the possible sources of biases, such as cultural origin, sex, academic training, and stance. It is also clear to me that there is no real conclusive data supporting either position at this time. So much is unknown about these earliest peoples, including how early their cultures truly existed as civilizations. Each year, the dates move farther back as more discoveries are made, and researchers

rapidly uncover new layers of information. Each new *find* has the potential to reposition our perceptions about the origins of civilization. The best we can do is to remain informed and flexible, changing our body of knowledge and understanding as new information is assimilated.

16. Brian Smith, *Reflections on Resemblance, Ritual and Religion* (New York: Oxford University Press, 1989), 6.

17. Ibid., 13–14.

18. There are around seventy-five festivals and fairs celebrated annually in India. Approximately twenty-five are celebrated throughout the county, including two of the most notable: Diwali (celebrating Laksmi, Goddess of Wealth) and Vasant Panchami (celebrating Sarasvati, Goddess of Literature and Fine Arts). Others that are celebrated more regionally include Pongal (celebrating the harvest and New Year's Day) in Tamil Nadu; Naba Barsha (celebrating New Year's Day) in Bengal; Thironnam or Onam (celebrating the harvest) in Kerala; Makara Sankranti (celebrating the harvest) in Maharashtra, Gujarat, and Karnataka); and Bihag or Rangoli Bihu (celebrating the New Year) in Assam. For a more complete listing of these festivals, see *Festivals and Fairs of India*, produced by the Department of Tourism for the Government of India.

19. I ascertained this understanding through my research experiences interviewing Hindus in the Indian culture, including temple priests.

20. Srimiti Archana, *The Language of Symbols: A Project on South Indian Ritual Decorations of a Semi-permanent Nature* (New Delhi, India: Crafts Council of India, 1985), 4 and 27–28; and Martha A. Strawn, *Field Notes from India* (1989–1990), unpublished.

21. The text in this essay gives a brief distinction between magic and mysticism in order to define a context for description of the threshold diagrams. Further in-depth consideration and comparative analysis of these concepts may be studied in the following sources: Brian R. Clack, *Wittgenstein, Frazer and Religion* (New York: St. Martin's Press, 1999), 6–18; Mircea Eliade, editor-in-chief, *The Encyclopedia of Religion*, Volume 9, "Magic," 81–82, "Theories of Magic," 8–89, "Magic in Primitive Societies," 89–92, "Magic in South Asia," 109–12, and "Magico-Religious Powers," 115–17; Volume 10, "Mysticism," 245–51; and Volume 12, "Religion," 282–92; Sir James George Frazer, Chapter IV, "Magic and Religion," in *The Golden Bough*, Volume I (Abridged Edition) (New York: MacMillan, 1963), 56–69; Bronislaw Malinowski, "Magic and the Kulu," in *Argonauts of the Western Pacific: An Account of Native Enterprise and Adventure in the Archipelagoes of Melanesian New Guinea* (New York: E. P. Dutton, 1950), 392–427; Marcel Mauss, *A General Theory of Magic*, translated from the French by Robert Brain (New

York: W. W. Norton, 1972), 7–24, 40–45, 60–71, and 88–89; Rudolf Otto, *The Kingdom of God and the Son of Man: A Study in the History of Religion*, translated from the Revised German Edition by Floyd V. Filson and Bertram Lee-Woolf (London, UK: Lutterworth Press, 1951), 20–33; Carveth Read, *The Origin of Man and of His Superstitions* (Cambridge, UK: The University Press, 1920), 110–11, 150–53, 193–97, and 219–21; W. H. R. Rivers, *Medicine, Magic, and Religion: The FitzPatrick Lectures Delivered Before the Royal College of Physicians of London in 1915 and 1916* (London, UK: Kegan Paul, Trench, Trubner & Co; and New York: Harcourt, Brace, 1924), 4 and 25–28; and Evelyn Underhill, *Mysticism* (New York: E. P. Dutton, Inc., 1911; reprint 1961), 70–72.

22. Underhill, ibid., 70.

23. Ibid., 71–72.

24. Ibid., 70.

25. Archana, *The Language of Symbols*, 84.

26. Ibid., 28; see, also, the master drawings by the late Barakuru Parameshwar Bayiri in B. P. Bayiri, *Rangavalli: Chitra Kutira Udupi*, 12 Parts (Manipal, India: Manipal Press, 1983).

27. In ancient Indian tradition, *navagriha* refers to the nine planets, which are identified as Moon, Sun, Jupiter, Venus, Mercury, Mars, Saturn, Rahu, and Ketu. Rahu and Ketu are the two dark "eclipse planets," and they correspond to the northern and southern nodes of the moon in Western astronomy. These nodes are the "ascending" and "descending" points on the ecliptic where the planes of the moon's orbit around Earth and Earth's orbit around the sun intersect, creating the planetary shadows that cause eclipses. See Robert Beer, *The Handbook of Tibetan Buddhist Symbols* (Chicago, IL, and London, UK: Serindia Publications, 2003), 190–91

28. Ajit Mookerjee, *Ritual Art of India* (London, UK: Thames and Hudson, 1985), 23.

29. William K. Mahony, "At the Threshold: The Sanctification of Space in Traditional India," in Martha A. Strawn, *Across the THRESHOLD of India: Art, Women, and Culture* (Staunton, VA: George F. Thompson Publishing, 2016), 252–53 and 257.

30. Mookerjee, *Ritual Art of India*, 143; Strawn, *Field Notes* (1989–1990); and Martha A. Strawn, *Interview Notes from India* (1990–1991), unpublished.

31. Archana, *The Language of Symbols*, 73.

1. Ananda Coomaraswamy, *The Dance of Shiva: Fourteen Indian Essays* (New Delhi: India: Munshiram Manoharlal Publishers, 1982), 117–18.

2. Srimiti Archana, *The Language of Symbols: A Project on South Indian Ritual Decorations of a Semi-permanent Nature* (New Delhi, India: Crafts Council of India, 1985), 24.

3. Ram Dhamija, *Image India: Heritage of Indian Art & Crafts* (Delhi, Bombay, Bangalore, and Kanpur, India, and London, UK: Vikas Publications, 1971), 18; and Stella Kramrich, "The Ritual Arts of India," in Thomas M. Evan Gallery, *Aditi: The Living Arts of India* (Washington, DC: Smithsonian Institution Press, 1985), 247; and William K. Mahony, "At the Threshold: The Sanctification of Space in Traditional India," in Martha A. Strawn, *Across the Threshold of India: Art, Women, and Culture* (Staunton, VA: George F. Thompson Publishing, 2016), 244–45; and Martha A. Strawn, *Field Notes from India* (1989–1990), unpublished.

4. Strawn, *Field Notes* (1995, 1998, and 2004).

5. Mahony, "At the Threshold," 242–43.

6. Om Lata Bahadur, *The Book of Hindu Festivals and Ceremonies*, Second Revised and Enlarged Edition (New Delhi, Mumbai, Bangalore, Chennai, Calcutta, Patna, and Kanpur, India, and London, UK: UBS Publishers' Distributors, 1997), 31–38.

7. Archana, *The Language of Symbols*, 13.

8. For a more in-depth description on the evolution of this mandala, see Pupul Jayakar, *The Earth Mother*, Revised and Updated Edition (New Delhi, India: Penguin Books, 1989), 110–16.

9. Heinrich Zimmer, *Artistic Form and Yoga in the Sacred Images of India*, translated by Gerald Chapple and James B. Lawson (Princeton, NJ: Princeton University Press, 1984), 31; and Mircea Eliade, Editor-in-Chief, *The Encyclopedia of Religion*, Volume 9 (New York: MacMillan, 1987), 327–28.

10. Anne Mackenzie Pearson, *"Because It Gives Me Peace of Mind": Ritual Fasts in the Religious Lives of Hindu Women* (Albany: State University of New York Press, 1996), 45–84; and, Pupul Jayakar, *The Earth Mother*, Revised and Updated Edition (New Delhi, India: Penguin Books, 1989), 110–11; also, for more information, read "The Mandalas and Magical Drawings," ibid., 109–16.

11. S. Shankaranarayanan, *Sri Chakra*, Third Edition (Pondicherry, India: Dipti Publications, 1979), 9.

12. Other references may be made to wall drawings; in order to limit the subject to a more tightly defined and well-researched area, however, the wall drawings are a secondary aspect in my visual and academic research.

13. Tapan Mohan Chatterji, *Alpona: Ritual Decoration in Bengal*, with notes by Tarak Chandra Das (Calcutta, India: Orient Longmans, 1948); reprint 1965), 1; and Anonymous (Director, Publications Division), *Alpona* (New Delhi, India: Patiala House, Ministry of Information and Broadcasting Government of India, February 1976; reprint nd).

14. John Stratton Hawley and Donna Marie Wulff, eds., *Devi: Goddesses of India* (Berkeley: University of California Press, 1996), 53–56; and Strawn, *Field Notes* (1990).

15. Archana, *The Language of Symbols*, 27.

16. Ibid.

17. Charles F. Keyes and E. Valentine Daniel, eds., *Karma: An Anthropological Inquiry* (Berkeley: University of California Press (1983), 120–23 and 131–46.

18. Strawn, *Field Notes* (1989–1990).

19. Om Lata Bahadur, *The Book of Hindu Festivals and Ceremonies*, 6–16.

20. Strawn, *Field Notes* (1989–1990).

21. Zimmer, *Artistic Form and Yoga in the Sacred Images of India*, 138.

22. Archana, *The Language of Symbols*, 34.

23. The traditional male attire in India is the *dhoti* and *kurta*. The *dhoti* is a loincloth or *lungi* that is either tied around the waist or tucked between the legs. It is worn with the *kurta* or upper garment, which is a stitched, long-sleeved shirt. Traditional female attire is the *sari*. This is a length of colorful fabric usually about six yards long (5.5 meters), which is tied around the waist with the pleats tucked into an under-skirt. The end-piece or *pallav* is either drawn over the left shoulder or draped over the head. Examples of *dhotis* and *saris* can be found in (no author) "Costumes of India," in Dorling Kindersley, ed., *Eyewitness Travel Guides: India, Mohapatra, Madhulita, Vandana Mohindra, Ranjana Saklani and Aliss Sheth* (London, UK: DK Publishing, 2002), 30–31.

24. Ibid., 37.

25. Ibid., 39

26. Strawn, *Field Notes* (1989–1990).

27. As quoted in Jayakar, *The Earth Mother*, 109–10.

28. Here is the story, as recorded in Strawn, *Field Notes* (1989–1990): King Mahabali fought with the *devas* and *asuras* (gods and angry beings), and the *devas* lost. Maha Vishnu, hearing the prayers of the *devas's* mother, Aditi, came and said, "Don't worry. I will come as Vamana and help you." Vamana appeared as a Brahmin boy.

At this time, King Mahabali was ruler of the whole world. He was generous, and all of his subjects were happy, living in prosperity. There was no cheating, for society had reached a state of perfection. Hearing these conditions, Vamana went to where Mahabali was doing *puja* (praying). Everyone knew, as soon as they saw him, that he was not an ordinary man, because of his shining face. The people treated him with respect, welcoming him and giving him the seat of honor. Vamana met Mahabali and asked for just a small place to stay and for Mahabali's blessing. The following dialogue represents the story Vamana: "I will measure three steps. That is enough for me."

Mahabali laughed and said, "That is not enough. Why don't you ask for a village or a country?" Mahabali then said, "You ask for whatever you want. I will give it to you."

Mahabali's guru, Shukrmaharshi, told him, "Don't say that. Vamana is not an ordinary man. With three steps, he will measure the whole world."

But Mahabali answered, "God gave me all this. If God is trying to take it, I am happy."

Mahabali then asked his wife to bring some water in a special vessel with a spout.

He poured water in Vamana's hand and said, "I am giving you whatever you want."

As soon as Vamana heard those words, he grew huge. With two steps, he measured the whole world. Then, he asked Mahabali where he should take his third step?

Mahabali sat in front of Vamana and bowed his head.

Vamana put his foot on Mahabali's head and pushed him down to *patalam*, the underground world. As this occurred, Vamana told Mahabali, "Once a year, you can come to this world and see your people." And so, once a year during Onam, the people of Kerala celebrate the return of Mahabali.

29. Anonymous (Director, Publications Division), *Festivals and Fairs* (Madras, India: Department of Tourism, Government of India, 1981), 14.

30. Archana, *The Language of Symbols*, 48.

31. Ibid.

32. Strawn, *Field Notes* (1989–1990).

33. Strawn, *Field Notes* (1977).

34. George Feurstein, Subhash Kak, and David Frawley, *In Search of the Cradle of Civilization* (Wheaton, IL: Quest Books; and Madras, India: Adyar, 1995), 190–91.

35. Heinrich Zimmer, *Myths and Symbols in Indian Art and Civilization* (Washington, DC: Bollingen Foundation, 1946; and Princeton, NJ: Princeton University Press, 1974), 190–91.

36. Archana, *The Language of Symbols*, 5.

37. Mahony, "At the Threshold," 246–47. The Aryan Invasion Theory is a scholarly assertion that Vedic Aryans entered India from outside and demolished the Harappan civilization. Feurstein, Kak, and Frawley present seventeen factual arguments against the Aryan Invasion Theory in *In Search of the Cradle of Civilization*, 153–61.

38. Feurstein, Kak, and Frawley, 79–99.

39. Jayakar, *The Earth Mother*, 27–35.

40. Ibid., 34.

41. Ibid., 35.

42. Zimmer, *Myths and Symbols in Indian Art and Civilization*, 190–91.

43. Paul Thomas, *Hindu Religion, Customs, and Manners: Describing the Customs and Manners, Religious, Social and Domestic Life, Arts and Sciences of the Hindus*, Second Revised Indian Edition (Bombay, India: D. B. Taraporivala Sons & Co., nd), 30.

44. Rehana Ghadially, ed., *Women In Indian Society: A Reader* (New Delhi, India, and London, UK: Sage Publications, 1988), 21.

45. Shakunthala Jagannathan, *Hinduism: An Introduction* (Bombay, India: Vakils, Feffer, and Simons, 1984), 46.

46. David Kinsley, *Hindu Goddesses: Visions of the Divine Feminine in the Hindu Religious*

Tradition (Berkeley: University of California Press, 1988), 132–50; and Thomas, *Hindu Religion, Customs, and Manners*, 30.

47. Kinsley, ibid., 55–57.

48. Kinsley, ibid., 58–60.

49. Ibid.; and Pradyumna Karan and Cotton Mather, "Art and Geography: Patterns in the Himalaya," in *Annals of the Association of American Geographers*, Vol. 66, No. 4 (December 1976): 500.

50. Brian Smith, *Reflections on Resemblance, Ritual, and Religion* (New York: Oxford University Press, 1989), 73.

51. Ibid., 173.

52. Joseph Campbell, *Oriental Mythology: The Masks of God* (New York: Penguin Books, 1962; reprint 1988), 160.

53. Riane Eisler, *The Chalice and The Blade: Our History, Our Future* (New York: Harper and Row, 1987), 217.

54. Archana, *The Language of Symbols*, 5.

55. Campbell, *Oriental Mythology*, 160–64.

56. Jayakar, *The Earth Mother*, 34–35.

57. Ghadially, *Women in Indian Society*, 83.

58. Ibid., 88.

59. Ibid., 84–88.

60. Ibid., 88.

61. Ibid.

62. Ibid., 92.

63. Ibid., 93.

64. Ibid., 90.

65. Nancy Martin-Kershaw, "Women, Spirituality, and Social Change in India: Envisioning the Future and Transforming the Present," in *Common Ground*, Vol. 5, No. 1 (May 1990): 12–17.

66. Jayaker, *The Earth Mother*, 22. See, also, Paula M. Cooley, William R. Eakin, and Jay B. McDaniel, *After Patriarchy: Feminist Transformations of the World Religions* (Maryknoll, NY: Orbis Books, 1991), 36–38.

67. S. Shankaranarayanan, *Sri Chakra*, Third Edition (Pondicherry, India: Dipti Publications, 1979), 16.

68. See Narendra Nath Bhattacharyya, *The Indian Mother Goddess*, Second Revised Edition (Columbia, MO: South Asia Books, 1977), 283–86. Note: In the text, subtitled "Rites De Passage," Bhattacharyya discusses the initiation rites as "marking separation from childhood and entrance into manhood or womanhood" (283). These are not birth but rebirth rites, following the death of the pre-existing state, and they are "connected with natural and human fertility, to which the origins of the menstrual and sexual rites and other kindred features, associated with agricultural life, should be traced" (ibid). Bhattacharyya goes on to assert the importance and similarity of female initiation rites: "The rites of the first menstruation are the most invariable and the most strictly observed of all the rites of primitive humanity" (285); "In patriarchal societies, there is a deeply ingrained dread regarding the menstrual blood" (286); and "But this terror attaching to the primitive taboo on the menstruating woman was not, in the most primitive and original form of the conception, the deeply ingrained dread for impurity and unholiness. There are also many instances in which menstrual blood had developed a sanctifying and purifying significance. In the tantras, it is regarded so sacred that it is prescribed as an offering to the great Goddess and her consort" (ibid.). Menstrual blood is of three types: that of a maiden, that of a married woman, and that of a widow. The first is generally preferred.

69. Archana, *The Language of Symbols*, 8.

70. Strawn, *Field Notes* (1989–1990).

71. Bhattacharyya, *The Indian Mother Goddess*, 283.

72. Thomas, *Hindu Religion, Customs and Manners*, 92.

73. Strawn, *Interview Notes from India* (1990–1991).

74. Ajit Mookerjee, *Ritual Art of India* (London, UK: Thames and Hudson, 1985), 92.

75. Strawn, *Field Notes* (1984).

76. Madhu Khanna, *Yantra: The Tantric Symbol of Cosmic Unity*, (London, UK: Thames and Hudson, 1979), 9–11.

77. For example, Smt. Kamaladevi Chattopadhyay devoted her life to work in political, social, and cultural development in India. Her major achievements were in the areas of cooperatives, theater, women's welfare, and handicrafts. She was Chair of the All-India Handicrafts Board for twenty years while she also served as President of the Indian Cooperative Union, giving direction to the rehabilitation of craft, its production and marketing. She was an advocate of the need for and relevance of crafts in modern living, which helped to save them from neglect and ultimate demise. See R. P. Gupta, general editor, *The Arts of Bengal and Eastern India* (London, UK: Crafts Council of West Bengal, 1982), 15. These biographical notes were taken from a catalog for an exhibition (April 23–May 9, 1982) organized by the Crafts Council of West Bengal at the Commonwealth Institute, Kensington High Street, London, UK.

78. Strawn, *Field Notes* (1986 and 1989–1990).

79. Strawn, *Field Notes* (1984, 1986, and 1989–1990).

80. Strawn, *Field Notes* (1984, 1986, and 1989–1990).

81. Strawn, *Field Notes* (1986, 1989, and 1990).

82. Frank Boas, *Primitive Art* (New York: Dover Publications, 1955), 157.

83. Shahrukh Husain, *The Goddess: Creation, Fertility and Abundance, The Sovereignty of Woman, Myths and Archetypes*, Living Wisdom Series (London, UK: Duncan Baird Publishers, 1997), 133.

84. Craig Callender, "Is Time an Illusion?," *Scientific American*, Vol. 302, No. 6 (June 2010): 59–65.

85. I have cited the concepts which refer to "rural ethos" in relation to the threshold diagrams because the practice of making the diagrams evolved from the rural ethos, and is now practiced in residential, community, religious, and familial settings within rural and urban areas. For this reason its influence is widespread.

86. Jayaker, *The Earth Mother*, 26.

87. Thomas, *Hindu Religion, Customs, and Manners*, 142.

88. Marilyn French, *Beyond Power: On Women, Men and Morals* (New York: Ballantine Books, 1985), 341.

89. Ibid.

90. Ibid.

91. The exception to this assertion is that, in particular areas of India such as in the Bengal area and, specifically, in Calcutta, there are men who are devotees of Kali and who, therefore, do not fall into this description. See Elizabeth U. Harding, *Kali: The Black Goddess of Dakshineswar* (York Beach, ME: Nicolas-Hays, 1993), xxxii.

92. George Kubler, *The Shape of Time: Remarks on the History of Things* (New Haven, CT: Yale University Press, 1962), 35.

93. Rabindranath Tagore (1861–1941) established a school called Shantiniketan in West Bengal, which became known as Visa Bharati University. Shantiniketan means "world university" in Bengali. The name reflects Tagore's "one world" philosophy, which is exemplified by his educational goals: fellowship in an all-Indian community, relationships with international representatives, co-educational learning, and the absence of sectarian or any other barriers. These goals are based on Tagore's belief in a mixture of tolerance, rationalism, and universalism. Shanktiniketan became a great place of fusion between the West and the East with students and scholars practicing together in academic, artistic, and scientific disciplines. The school fostered taking the rural arts of India and turning them into sophisticated modern artistic practices to be appreciated the world over. Tagore set a perfect example when he wrote *Gitanjali* (Song Offerings) (London, UK: Chiswick Press, for the India Society, 1912), for which he received a Nobel Prize in 1913, the first non-European to be so honored.

94. Anonymous, *Alpona*, 12.

95. Ibid., 5.

96. Cynthia Ozick, "Women And Creativity: The Demise of the Dancing Dog," in Vivian Gornick and Barbara K. Moran, eds., *Women in Sexist Society: Studies in Power and Powerlessness* (New York: New American Library, 1971), 431–51; and Linda Nochlin, "Why Are There No Great Women Artists?," in ibid., 480–510.

97. To demonstrate that women artists are being recognized and included in visual art historical texts, the following examples are listed: Franz Boas, *Primitive Art* (New York: Dover Publications, 1955), 18; Ann Sutherland Harris, and Linda Nochlin, *Women Artists: 1552–1950* (New York: Alfred A. Knopf and the Los Angeles County Museum of Art, 1984); Lucy R. Lippard, "Feminism and Prehistory," in her book *Overlay: Contemporary Art and the Art of Prehistory* (New York: Pantheon Books, 1983), 41–45; Charlotte Streifer Rubinstein, *American Women Artists from Early Indian Times to the Present* (Boston, MA: G. K. Hall and Avon Books, 1982); and Constance Sullivan, ed., *Women Photographers* (New York: Harry N. Abrams, 1990).

98. Appreciation of the full significance of the practice of threshold drawings, whether by scholars or the general public, does occur in a few publications. Seven examples of scholarly documents were located. Six of the seven researchers are Indians (two women and four men), and the sixth is Stella Kramrisch, an American woman who has spent many years in India and is a foremost Indologist. See Stella Kramrisch, "A Biographical Essay," in Barbara Stoler Miller, ed., *Exploring India's Sacred Art: Selected Writings of Stella Kramrisch* (Philadelphia: University of Pennsylvania Press, 1983), 3–48. Appearances suggest that western male scholars considered the practice relatively insignificant, based on the limited published research. Several other published articles, publications, or references within full texts discuss or make reference to the practice. In each instance, recognition of the integral relationship between the nature of the diagrams, the background of the practice, and its present-day significance would provide a more comprehensive understanding of the subject. The following six texts contain substantial information on threshold drawings in their cultural context: Anonymous, *Alpona*; Archana, *The Language of Symbols*; B. P. Bayiri, *Rangavalli: Part I–Part VIII* (Udipi, India: Chitra Kutira, 1980–1981); Jayakar, *The Earth Mother*; Stella Kramrisch, *Unknown India: Ritual Art in Tribe and Village* (Philadelphia, PA: Philadelphia Museum of Art, 1968); and Ajit Mookerjee, *Ritual Art of India* (London, UK: Thames and Hudson, 1985).

99. Jayakar, *The Earth Mother*, 42.

100. Boas, *Primitive Art*, 78–79; and Anthony Forge, "Schematisation and Meaning," in Peter J. Ucko, ed., *Form in Indigenous Art*, Prehistory and Material Culture Series No. 13. (Canberra, Australia, and London, UK: Gerald Duckworth and Company; and Atlantic Highlands, NJ: Humanities Press, 1977), 30–32.

101. Archana, *The Language of Symbols*.

102. Jayakar, *The Earth Mother*, 117.

103. Polly Schaafsma, *Indian Rock Art of the Southwest* (Santa Fe, NM: School of American Research and Albuquerque, NM: University of New Mexico Press, 1980), 6–23; Alex Patterson, *A Field Guide to Rock Art Symbols of the Greater Southwest* (Boulder, CO: Johnson Books, 1992), x–xii; Fran Barnes, *Canyon Country: Prehistoric Rock Art* (Salt Lake City, UT: Wasatch Publishers 1982), 60–75; LaVan Martineau, *The Rocks Begin To Speak* (Las Vegas, NV: KC Publications, 1976), xxxi–3; and Mark Bahti and Eugene Baatsoslanii Joe, *Navajo Sandpaintings* (Tucson, AZ: Rio Nueva Publishers, 2009), 13.

104. Schaafsma, ibid., 17.

105. Forge, "Schematisation and Meaning," in *Form in Indigenous Art*, 30.

106. Ibid., 30–32.

107. See, for example, Marilyn Houlberg, "Magique Marasa: The Ritual Cosmos of Twins and Other Sacred Children," in Donald J. Cosentino, ed., *Sacred Arts of Haitian Vodou* (Los Angeles: Fowler Museum of Cultural History, University of California, 1995), 267–69; and Tina Girouard, "The Sequin Arts of Vodon," in ibid., 357 and 377.

108. Houlberg, "Magique Marasa," 268.

109. Girouard, "The Sequin Arts of Vodon," 357. Further investigations by Girouard can be reviewed in her book, *Sequin Artists of Haiti* (Cecilia, LA: Girouard Art Projects and Port-au-Prince, Haiti: Haiti Arts, Inc., Martineau, 1994).

110. Zimmer, *Artistic Form and Yoga in the Sacred Images of India*, 134.

111. Boas, *Primitive Art*, 157.

112. Forge, "Schematisation and Meaning," 31.

113. B. N. Goswamy, *Essence of Indian Art* (San Francisco, CA: Asian Art Museum, 1986), 19.

114. Pria Devi, *Notes: "Rasa, One Way of Experiencing"* in *Aditi* (New Delhi, India: The Handicrafts and Handlooms Exports Corporation of India, 1982), 45.

115. K. D. Tripathi, "From Sensuous to Supersensuous: Some Terms of Indian Aesthetics," in Bettina Baumer, ed., *Prakrti: The Integral Vision; Vol. 3: The Agamic Tradition and the Arts*, Kapila Vatsyayan, General Editor (New Delhi, India: Indira Gandhi National Centre for the Arts and D. K. Printworld, 1995), 67–77.

116. Ibid, 21.

117. Sharada Gopal, *Step by Step Indian Cooking* (London, UK: Quarto Publisher Ltd. and Sydney, Australia: MacDonald & Co., 1986), 20–21.

118. Jennifer Harvey Lang, ed., *Larousse Gastronomique: The New American Edition of the World's Greatest Culinary Encyclopedia* (New York: Crown Publishers, 1988), 845.

119. Wassily Kandinsky, *Concerning the Spiritual in Art and Painting in Particular* (New York: George Wittenborn, 1912), originally published as *Über das Geistige in der Kunst* (Munich, Germany: R. Piper & Co., 1912).

120. Roger Lipsey, *An Art of Our Own: The Spiritual In Twentieth Century Art* (Boston, MA: Shambala Publications, 1988), 1; and, Steven R. Holtzman, *Digital Mantras: The Languages of Abstract and Virtual Worlds* (Cambridge, MA: The MIT Press, 1994), 69–84 and 279–93.

121. John Briggs, *Fractals: The Patterns of Chaos: Discovering a New Aesthetic of Art, Science, and Nature* (New York: Simon & Schuster, 1992), 13–34; for specific reference to the construction of *kolam* (with illustration), see 64–65 and 166–81. See, also, S. P. Sabarathininam, "*Agamic* Treatment of *Mahabhutas* in Relation to *Mandalas* and Arts," in Baumer, *Prakrti*, 46–65.

122. Gift Siromoney and Rani Siromoney, *Rosenfeld's Cycle Grammars and Kolam*, unpublished paper (Tambaram, India: Madras Christian College, 1989).

123. Gift Siromoney, "South Indian Kolam Patterns," *Kalakshestra Quarterly*, Vol. 1, No. 1 (nd): 9 and 14.

124. Holtzman, *Digital Mantras*, 290.

125. Ibid.

126. Ibid., 291.

AT THE THRESHOLD: THE SANCTIFICATION OF SPACE IN TRADITIONAL INDIAN LIFE (MAHONY)

1. Vijaya Nagarajan, "Hosting the Divine: The *Kolam* in Tamilnadu," in Nora Fisher, ed., *Mud, Mirror and Thread: Folk Traditions of Rural India* (Middletown, NJ: Grantha Corporation and Ahmedabad, India: Papin Publishing, in association with the Museum of New Mexico Press, 1993), 194. See, also, Stephen Huyler's informative essay in that same volume: "Creating Sacred Spaces: Women's Wall and Floor Decorations in Indian Homes," 172–91.

2. See Eva Marie Gupta, *Brata und Alpana in Bengalen* (Wiesbaden, Germany: Franz Steiner Verlag, 1983), 208.

3. Rupa Gosvamin's *Ujjvalanilamani, Uddpanaprakarana* 19. Sanskrit text in K. Krishnamoorthy, *Studies in Indian Aesthetics and Criticism* (Mysore, India: D. V. K. Murthy, 1979), 67. Unless otherwise noted, all translations in this essay are my own.

4. Nagarajan, "Hosting the Divine," 194.

5. Appreciation is expressed here to I. Job Thomas and to William Harman, for discussing with me several of these meanings of the word *kolam*. I have gained additional assistance from John Layard, "Labyrinth Ritual in South India: Threshold and Tattoo Patterns," *Folklore*, Vol. 48 (1937): 178; and Ralph M. Steinmann's unpublished manuscript, "Kolam: Form, Technique, and Application of a Changing Ritual Folk Art of Tamilnadu" (1989), 2 and 8.

6. The word from which this word derives (*svastika*) is an ancient and honorable one in India, meaning "that which brings welfare."

7. For a reproduction of such a plate, see Bridget and Raymond Allchin, *The Birth of Indian Civilization* (Harmondsworth, UK: Penguin Books, 1968), 312.

8. *RigVeda* 10.110.5.

9. *RigVeda* 1.13.6.

10. See P. K. Gode, "History of the Rangavalli (Ranoli) Art—Between c. A.D. 50 and 1900," *Annals of the Bhandarkar Oriental Research Institute*, Vol. 28 (1948): 226–46; V. Raghavan, "Some Sanskrit Texts on Painting," *Indian Historical Quarterly*, Vol. 9 (1933): 899–911.

11. *Kamasutra*, edited by Kedarnath (Bombay, India: Nirnaya Sagara Press, 1900), 190. Sanskrit text in Gode, "History of Rangavalli," 239–41.

12. Sanskrit text in Gode, 240.

13. Reference in Stella Kramrisch, "Indian Varieties of Art Ritual," in Joseph M. Kitagawa and Charles A. Long, eds., *Myths and Symbols: Studies in Honor of Mircea Eliade* (Chicago, IL: University of Chicago Press, 1969), 40.

14. *Varangacharitam of Shri Jatasinhanandi* 23.15, A. N. Upadhye, ed. (Bombay, India: Manikacandra-Digambar-Jaina Granthamala, 1938), 221. Sanskrit text in Gode, 232.

15. See V. Raghavan, "Some Sanskrit Texts on Painting," 905; Raghavan sees *dhulicitra* as identical to *kolam* designs.

16. See Raghavan, ibid., 905; and Gode, 241.

17. Sanskrit text in Gode, 232.

18. Dried cow dung mixed with clean water rids an area of insects and, most likely, kills microbes. The practice of spreading cow dung on an area to clean it continues to some extent today. An Indian observer of this customer has noted that "water mixed with cow-dung sprinkled or spread over the floors . . . removes pollution." See P. V. Jagadisa Ayyar, *South Indian Customs* (New Delhi, India: Asian Educational Services, 1982), 68–9. See, also, Stephen Huyler, "Creating Sacred Spaces," 174–75. *Lilacharitra*, H. N. Nene, ed. (Nagpur, India: B. G. Sharpe, 1937), 37 and 68; reference in Gode, 227.

19. See *Akashabhairavakalpa*, manuscript number 43 of 1935–1936 at the Bhandarkar Oriental Research Institute (Pune, India), 391; text in Gode, 228.

20. *Akashabhairavakalpa*, 157; text in Gode, 230.

21. *Akashabhairavakalpa*, 55; text in Gode, 230.

22. *Rig Veda* 7.77.1–2.

23. *Rig Veda* 5.80.5.

24. *Rig Veda* 1.113.4, 15–16.

25. Haradatta's commentary on Gautama Sutra 11.20; reference in Kramrisch, "Varieties of Art Ritual," 40.

26. From Cornelia Dimmitt and J. A. B. van Buitenen, *Classical Hindu Mythology: A Reader in the Sanskrit Puranas* (Philadelphia, PA: Temple University Press, 1978), 219–20.

27. See Wendell C. Beane, *Myth, Cult and Symbols in Shakta Hinduism* (Leiden, Germany: E. J. Brill, 1977), 58–61 and 220–27.

28. See *Gobhila Grihya Sutra* 1.3.16; *Manava Grihya Sutra* 2.3.1.2; and *Jaiminiya Grihya Sutra* 1.23.

29. See *Gobhila Grihya Sutra* 1.3.15, 9.8.9; and *Bharadvaja Grihya Sutra* 3.12.

30. See, for example, Mircea Eliade, *The Sacred and the Profane*, translated by Willard R Trask (New York: Harcourt and World, 1959), 20–65.

31. H. Clay Trumbull, *The Threshold Covenant, or, The Beginning of Religious Rites*, Second Edition (New York: Charles Scribner's Sons, 1896), 5.

32. *Manava Dharma Smriti* 4.73.

33. *Apastamba Dharma Sutra* 2.2.1–9.

34. *Rig Veda* 10.130.1–2.

35. *Brihadaranyaka Upanishad* 3.6.

36. *Brihadaranyaka Upanishad* 2.1.20; *Mundaka Upanishad* 1.7; and *Shvetashvatara Upanishad* 6.10.

37. Stella Kramrisch, *The Hindu Temple*, 2 Volumes (Delhi, India: Motilal Banarsidass, 1976), 11.

38. For representative discussion, see N. Annandale, "Plant and Animal Designs in the Mural Decoration of an Oriya Village," *Memoirs of the Asiatic Society of Bengal*, Vol. 8, No. 4 (1984): 239–56.

39. See, for example, the pervasive serpentine symbolism in the *Shat-Chakra-Nirupana*, translated by Arthur Avalon (Sir John Woodruffe), in *The Serpent Power*, Seventh Edition (Madras, India: Ganesh & Co., 1964; New York: Dover, 1974), 317–479.

40. Kramrisch, *The Hindu Temple*, 314.

41. See Kramrisch, *The Hindu Temple*, 315 and 316; she takes authority in a footnote from *Brahmavaivarta Purana* 2.10.48-52.

42. See Giulia Piccaluga, "Knots," translated by Roger DeGaris, in *The Encyclopedia of Religion*, First Edition, Mircea Eliade, Editor-in-Chief, Volume 8 of 16 (New York: Macmillan, 1987), 411–19.

43. George Mitchell, *The Hindu Temple* (New York: Harper and Row, 1977), 76.

44. See *Hiranyakeshi Grihya Sutra* 1.7.6.

45. For translation of the ritual instructions for the Nagapanchami, see J. P. Vogel, *Indian Serpent-Lore: The Nagas in Hindu Legend and Art*, Reprint Edition (Varanasi, India: Indological Book House, 1972), 274.

46. See Sadhu Charan Panda, *Naga Cult in Orissa* (Delhi, India: B.R. Publishing, 1986), 106.

47. Vogel, *Naga Cult in Orissa*, 279.

48. As quoted in Vogel, *Naga Cult in Orissa*, 280.

CODA

1. Laszlo Moholy-Nagy, "Vision in Motion," in his book, *Vision in Motion* (Chicago, IL: Paul Theobald, 1947), 12.

2. Rabindranath Tagore, *A Tagore Reader*, Amiya Chakravarty, ed. (New York: Macmillan, 1961), 263–64.

Sources for the Epigraphs

Page 5 Anonymous. As quoted in (no author) *The Indian Art of Floor Decoration* (Bombay, India: Bombay Printed Grafika, 1974).

Page 19 Rabindranath Tagore, *A Tagore Reader*, Amiya Chakravarty, ed. (New York: Macmillan, 1961), 263–64.

Page 31 Lucy R. Lippard, from a personal email with the author (June 16, 2015).

Page 67 Edward O. Wilson, *Consilience: The Unity of Knowledge* (New York: Alfred A. Knopf, 1998), 239.

Page 131 William T. Latham, on considering the images, from a personal conversation with the author in High Springs, Florida (November 21, 2015).

Page 157 Wim Wenders, as quoted from outside Berlin, Germany, on www.photoquotations.com (accessed December 2, 2015).

Page 175 Frederick Sommer, "The Poetic Logic of Art and Aesthetics," in Frederick Sommer, in collaboration with Stephen Aldrich, *Words*, 2 vols., Volume II (Tucson: University of Arizona Press, in association with the Center for Creative Photography, 1984), 36.

Page 193 Rabindranath Tagore, *A Tagore Reader*, Amiya Chakravarty, ed. (New York: Macmillan, 1961), 234–35.

Page 265 Beverly Sills (New York: NBC TV, May 4, 1985); available online at http://www.quotations.com/art.txt (accessed November 21, 2015).

Selected Bibliography

Anonymous (Director, Publications Division), *Alpona* (New Delhi, India: Patiala House, Ministry of Information and Broadcasting Government of India, February 1976; reprint nd).

Anonymous, *46th Art Festival 1997–1998 Programme*, (Chennai, India: Kalakshetra Foundation, 1997).

Anonymous (Director, Publications Division), *Festivals and Fairs* (Madras, India: Department of Tourism, Government of India, 1981).

Anonymous, *The Indian Art of Floor Decoration* (Bombay, India: Bombay Printed Grafika, 1974).

Srimiti Archana, *The Language of Symbols: A Project on South Indian Ritual Decorations of a Semi-permanent Nature* (New Delhi, India: Crafts Council of India, 1985).

Om Lata Bahadur, *The Book of Hindu Festivals and Ceremonies*, Second Revised and Enlarged Edition (New Delhi, India, and London, UK: UBS Publishers' Distributors, 1997).

F. A. Barnes, *Canyon Country Prehistoric Indians: Their Cultures, Ruins, Artifacts, and Rock Art* (Salt Lake City, UT: Wasatch Publishers, 1979).

Mark Bahti and Eugene Baatsoslanii Joe, *Navajo Sandpaintings* (Tucson, AZ: Rio Nueva Publishers, 2009).

Bettina Baumer, ed., *Prakrti: The Integral Vision; Vol. 3: The Agamic Tradition and the Arts*, Kapila Vatsyayan, general editor (New Delhi, India: Indira Gandhi National Centre for the Arts and D. K. Printworld, 1995).

B. P. Bayiri, *Rangavalli*, Part I, Sixth Edition (Udupi, India: Chitra Kutira, 1980).

_____, *Rangavalli*, Part II, Sixth Edition (Udupi, India: Chitra Kutira, 1980.)

_____, *Rangavalli*, Part III, Fifth Edition (Udupi, India: Chitra Kutira, 1980).

_____, *Rangavalli*, Part IV, Fifth Edition (Udupi, India: Chitra Kutira, 1981).

_____, *Rangavalli*, Part V, Fourth Edition (Udupi, India: Chitra Kutira, 1981).

_____, *Rangavallii*, Part VI, Third Edition (Udupi, India: Chitra Kutira, 1981).

_____, *Rangavalli*, Part VII, Second Edition (Udupi, India: Chitra Kutira, 1981).

_____, *Rangavalli*, Part VIII, First Edition (Udupi, India: Chitra Kutira, 1980).

_____, *Rangavalli*, Part IX, First Edition (Udupi, India: Chitra Kutira, 1983).

Robert Beer, *The Handbook of Tibetan Buddhist Symbols* (Chicago, IL, and London, UK: Serindia Publications, 2003).

Narendra Nath Bhattacharyya, *The Indian Mother Goddess*, Second Revised Edition (Columbia, MO: South Asia Books, 1977).

Enakshi Bhavnani, *Folk and Tribal Designs of India* (Bombay, India: D. B. Taraporevala Sons, 1974).

Franz Boas, "Graphic & Plastic Arts: The Formal Element in Art," in his book, *Primitive Art* (New York: Dover, 1955).

John Briggs, *Fractals: The Patterns of Chaos: Discovering a New Aesthetic of Art, Science, and Nature* (New York: Simon & Schuster, 1992).

Craig Callender, "Is Time an Illusion?," *Scientific American*, Vol. 302, No. 6 (June 2010): 59–65.

Joseph Campbell, *Myths to Live By* (New York: Bantam Books, 1972; reprint 1988).

_____, *Oriental Mythology: The Masks of God* (New York: Penguin Books, 1962; reprint 1988).

Tapan Mohan Chatterji, *Alpona: Ritual Decoration in Bengal*, with notes by Tarak Chandra Das (Calcutta, India: Orient Longmans, 1948; reprint 1965).

Brian R. Clack, *Wittgenstein, Frazer, and Religion* (New York, St. Martin's Press, 1999).

Paula M. Cooley, William R. Eakin, and Jay B. McDaniel, *After Patriarchy: Feminist Transformations of the World Religions* (Maryknoll, NY: Orbis Books, 1991).

Ananda K. Coomaraswamy, *The Dance of Shiva: Fourteen India Essays* (New Delhi, India: Munshiram Manoharlal Publishers, 1982).

_____, "Art in Indian Life," in Roger Lipsey, ed., *Traditional Art and Symbolism: Coomaraswamy* (Princeton, NJ: Princeton University Press, 1977).

_____, *The Transformation of Nature in Art,* Kapila Vatsyayan, ed. (New Delhi, Indira Gandhi National Centre for the Arts in association with Sterling Publishers, 1995).

Donald J. Cosentino, ed., *Sacred Arts of Haitian Vodou* (Los Angeles: Fowler Museum of Cultural History, University of California, 1995).

Pria Devi, *Notes: "Rasa, One Way of Experiencing,"* in (no editor) *Aditi* (New Delhi, India: The Handicrafts and Handlooms Exports Corporation of India, 1982).

Miriam Robbins Dexter, *Whence the Goddess: A Source Book* (New York: Pergamon Press, 1990).

Ram Dhamija, *Image India: Heritage of Indian Art & Crafts* (Delhi, Bombay, Bangalore, and Kanpur, India, and London, UK: Vikas Publications, 1971).

Riane Eisler, *The Chalice and The Blade: Our History, Our Future* (New York: Harper and Row, 1987).

Mircea Eliade, Editor-in-Chief, *The Encyclopedia of Religion*, Volumes 9, 10, and 12 (New York: MacMillan, 1987).

Georg Feuerstein, Subhash Kak, and David Frawley, *In Search of the Cradle of Civilization* (Wheaton, IL: The Theosophical Publishing House, 1995).

Anthony Forge, "Schematisation and Meaning," in Peter J. Ucko, ed., *Form in Indigenous Art*, Prehistory and Material Culture Series No. 13. (Canberra, Australia, and London, UK: Gerald Duckworth and Company; and Atlantic Highlands, NJ: Humanities Press, 1977).

Sir James George Frazer, *The Golden Bough*, Volume I (Abridged Edition) (New York: MacMillan Publishing, 1963).

Marilyn French, *Beyond Power: On Women, Men and Morals* (New York: Ballantine Books, 1985).

Rehana Ghadially, ed., *Women in Indian Society: A Reader* (New Delhi, India, and London, UK: Sage Publications, 1988).

Tina Girouard, *Sequin Artists of Haiti* (Cecilia, LA: Girouard Art Projects; and Port-au-Prince, Haiti: Haiti Arts, Martineau, 1994).

_____, "The Sequin Arts of Vodon," in Donald J. Cosentino, ed., *Sacred Arts of Haitian Vodou* (Los Angeles: Fowler Museum of Cultural History, University of California, 1995), 267–69.

Sharada Gopal, *Step by Step Indian Cooking* (London, UK: Quarto Publisher; and Sydney, Australia: MacDonald & Co., 1986).

Vivian Gornick and Barbara K. Moran, eds., *Women in Sexist Society: Studies in Power and Powerlessness* (New York: New American Library, 1971).

B. N. Goswamy, *Essence of Indian Art* (San Francisco, CA: Asian Art Museum, 1986).

R. P. Gupta, general editor, *The Arts of Bengal and Eastern India* (London, UK: Crafts Council of West Bengal, 1982).

Elizabeth U. Harding, *Kali: The Black Goddess of Dakshineswar* (York Beach, ME: Nicolas-Hays, 1993).

Ann Sutherland Harris and Linda Nochlin, *Women Artists: 1552–1950* (New York: Alfred A. Knopf, in association with the Los Angeles County Museum of Art, 1984).

John Stratton Hawley and Donna Marie Wulff, *Devi: Goddesses of India* (Berkeley: University of California Press, 1996).

Steven R. Holtzman, *Digital Mantras: The Languages of Abstract and Virtual Worlds* (Cambridge, MA: The MIT Press, 1994).

Marilyn Houlberg, "Magique Marasa: The Ritual Cosmos of Twins and Other Sacred Children," in Donald J. Cosentino, ed., *Sacred Arts of Haitian Vodou* (Los Angeles: Fowler Museum of Cultural History, University of California, 1995).

Shahrukh Husain, *The Goddess: Creation, Fertility and Abundance, The Sovereignty of Woman, Myths and Archetypes*, Living Wisdom Series (London, UK: Duncan Baird Publishers, 1997).

Shakunthala Jagannathan, *Hinduism: An Introduction* (Bombay, India: Vakils, Feffer, and Simons, 1984).

Pupul Jayakar, *The Earth Mother*, revised and updated edition (New Delhi, India: Penguin Books, 1989).

Wassily Kandinsky, *Concerning the Spiritual in Art and Painting in Particular* (New York: George Wittenborn, 1912); originally published as *Über das Geistige in der Kunst* (Munich, Germany: R. Piper, 1912).

Pradyumna Karan and Cotton Mather, "Art and Geography: Patterns in the Himalaya," in *Annals of the Association of American Geographers*, Vol. 66, No. 4 (December 1976): 487–512.

Charles F. Keyes and E. Valentine Daniel, editors, *Karma: An Anthropological Inquiry* (Berkeley: University of California Press (1983).

Madhu Khanna, *Yantra: The Tantric Symbol of Cosmic Unity* (London, UK: Thames and Hudson, 1979).

Dorling Kindersley, ed., *Eyewitness Travel Guides: India, Mohapatra, Madhulita, Vandana Mohindra, Ranjana Saklani and Aliss Sheth* (London, UK: DK Publishing, 2002).

David Kinsley, *Hindu Goddesses: Vision of the Divine Feminine in the Hindu Religious Tradition* (Berkeley: University of California Press, 1988).

Klaus K. Klostermaier, *A Survey of Hinduism* (Albany: State University of New York Press, 1994).

Stella Kramrisch, "A Biographical Essay," in Barbara Stoler Miller, ed., *Exploring India's Sacred Art: Selected Writings of Stella Kramrisch* (Philadelphia: University of Pennsylvania Press, 1983).

_____, *Exploring India's Sacred Art*, Barbara Stoler-Miller, ed. (Philadelphia: University of Pennsylvania Press, 1983).

_____, "The Ritual Arts of India," in Thomas M. Evan Gallery, *Aditi: The Living Arts of India* (Washington, DC: Smithsonian Institution Press, 1985).

_____, *Unknown India: Ritual Art in Tribe and Village* (Philadelphia, PA: Philadelphia Museum of Art, 1968).

_____, *Unknown India: Ritual Art in Tribe and Village* (Philadelphia, PA: Philadelphia Museum of Art, 1968).

George Kubler, *The Shape of Time: Remarks on the History of Things* (New Haven, CT: Yale University Press, 1962).

Jennifer Harvey Lang, ed., *Larousse Gastronomique: The New American Edition of the World's Greatest Culinary Encyclopedia* (New York: Crown Publishers, 1988).

Lucy R. Lippard, "Feminism and Prehistory," in her book, *Overlay: Contemporary Art and the Art of Prehistory* (New York: Pantheon Books, 1983).

Roger Lipsey, *An Art of Our Own: The Spiritual In Twentieth Century Art* (Boston, MA: Shambala Publications, 1988).

William K. Mahony, "At the Threshold: The Sanctification of Space in Traditional India," in Martha A. Strawn, *Across the Threshold of India: Art, Women, and Culture* (Staunton, VA: George F. Thompson Publishing, 2016), 241–61.

Bronislaw Malinowski, "Magic and the Kulu," in his *Argonauts of the Western Pacific: An Account of Native Enterprise and Adventure in the Archipelagoes of Melanesian New Guinea* (New York: E. P. Dutton, 1950).

Nancy Martin-Kershaw, "Women, Spirituality, and Social Change in India: Envisioning the Future and Transforming the Present," *Common Ground*, Vol. 5, No. 1 (May 1990): 12–17.

LaVan Martineau, *The Rocks Begin to Speak* (Las Vegas, NV: KC Publications, 1976).

Marcel Mauss, *A General Theory of Magic*, translated from the French by Robert Brain (New York: W. W. Norton, 1972); originally published as *Esquisse d'une Théorie Générale de la Magie* (Paris, France: Presses Universitaires de France, 1902).

Laszlo Moholy-Nagy, "Vision in Motion," in his *Vision in Motion* (Chicago, IL: Paul Theobald, 1947).

Ajit Mookerjee, *Ritual Art of India* (London, UK: Thames and Hudson, 1985).

Linda Nochlin, "Why Are There No Great Women Artists?," in Vivian Gornick and Barbara K. Moran, eds., *Women in Sexist Society: Studies in Power and Powerlessness* (New York: New American Library, 1971).

Rudolf Otto, *The Kingdom of God and the Son of Man: A Study in the History of Religion*, translated from the Revised German Edition by Floyd V. Filson and Bertram Lee-Woolf (London, UK: Lutterworth Press, 1951); originally published as *Reich Gottes und Menschensohn: Ein religionsgeschichtlicher Versuch* (Munchen, Germany: C. H. Beck, 1934).

Cynthia Ozick, "Women and Creativity: The Demise of the Dancing Dog," in Vivian Gornick and Barbara K. Moran, eds., *Women in Sexist Society: Studies in Power and Powerlessness* (New York: New American Library, 1971).

Alex Patterson, *A Field Guide to Rock Art Symbols of the Greater Southwest* (Boulder, CO: Johnson Books, 1992).

Anne Mackenzie Pearson, *"Because It Gives Me Peace of Mind": Ritual Fasts in the Religious Lives of Hindu Women* (Albany: State University of New York Press, 1996).

Carveth Read, *The Origin of Man and of His Superstitions* (Cambridge, UK: The University Press, 1920).

W. H. R. Rivers, *Medicine, Magic, and Religion: The FitzPatrick Lectures Delivered Before the Royal College of Physicians of London in 1915 and 1916* (London, UK: Kegan Paul, Trench, Trubner & Co; and New York: Harcourt, Brace, 1924).

Charlotte Streifer Rubinstein, *American Women Artists from Early Indian Times to the Present* (Boston, MA: G. K. Hall and Avon Books, 1982).

S. P. Sabarathininam, "*Agamic* Treatment of *Mahabhutas* in Relation to *Mandalas* and Arts," in Bettina Baumer, ed., *Prakrti: The Integral Vision; Vol. 3: The Agamic Tradition and the Arts*, Kapila Vatsyayan, general editor (New Delhi, India: Indira Gandhi National Centre for the Arts and D. K. Printworld, 1995).

Jogendra Saksena, *Mandana: A Folk Art of Rajasthan* (New Delhi, India: Crafts Museum, 1985).

Polly Schaafsma, *Indian Rock Art of the Southwest* (Santa Fe, NM: School of American Research; and Albuquerque: University of New Mexico Press, 1980).

Ketki S. Shah, *Mehandi Designs* (Ahmadabad, India: Gala Publishers, nd).

S. Shankaranarayanan, *Sri Chakra*, Third Edition (Pondicherry, India: Dipti Publications, 1979).

Gift Siromoney and Rani Siromoney, *Rosenfeld's Cycle Grammars and Kolam*, an unpublished paper (Tambaram, India: Madras Christian College, 1989).

Gift Siromoney, "South Indian Kolam Patterns," *Kalakshetra Quarterly*, Vol. 1, No. 1 (nd): 9 and 14.

Brian Smith, *Reflections on Resemblance, Ritual and Religion* (New York: Oxford University Press, 1989).

Martha A. Strawn, *Alligators, Prehistoric Presence in the American South* (Baltimore, MD: The Johns Hopkins University Press, in association with the Center for American Places, 1997).

Constance Sullivan, ed., *Women Photographers* (New York: Harry N. Abrams, 1990).

Romila Thapar, *Early India: From the Origins to 1800* (Berkeley: University of California Press, 2002).

Rabindranath Tagore, *A Tagore Reader*, Amiya Chakravarty, ed. (New York: Macmillan, 1961).

Paul Thomas, *Hindu Religion, Customs, and Manners: Describing the Customs and Manners, Religious, Social and Domestic Life, Arts and Sciences of the Hindus*, Second Revised Indian Edition (Bombay, India: D. B. Taraporivala Sons, nd).

K. D. Tripathi, "From Sensuous to Supersensuous: Some Terms of Indian Aesthetics," in Bettina Baumer, ed., *Prakrti: The Integral Vision; Vol. 3: The Agamic Tradition and the Arts*, Kapila Vatsyayan, general editor (New Delhi, India: Indira Gandhi National Centre for the Arts and D. K. Printworld, 1995), 67–77.

Victor Turner, "Betwixt and Between: The Liminal Period in *Rites de Passage*," in his book, *The Forest of Symbols: Aspects of Ndembu Ritual* (Ithaca, NY: Cornell University Press, 1967), 93–111.

_____, *The Ritual Process: Structure and Anti-Structure* (Ithaca, NY: Cornell University Press, 1969).

Peter J. Ucko, ed., *Form in Indigenous Art*, Prehistory and Material Culture Series No. 13. (Canberra, Australia, and London, UK: Gerald Duckworth and Company; and Atlantic Highlands, NJ: Humanities Press, 1977).

Evelyn Underhill, *Mysticism* (New York: E. P. Dutton, 1911; reprint 1961).

Alan Watts, *The Tao of Philosophy: The Edited Transcripts*, Mark Watts, ed. (Boston, MA: C. E. Tuttle Publishing, 1995)

Karel Werner, "Symbolism in the Vedas and its Conceptualization," in his book, *Symbols in Art and Religion: The Indian and the Comparative Perspectives* (Delhi, India: Motilal Banarsidass Publishers, 1991), 29–35.

Heinrich Zimmer, *Artistic Form and Yoga in the Sacred Images of India*, translated by Gerald Chapple and James B. Lawson (Princeton, NJ: Princeton University Press, 1984); originally published as *Kunstform und Yoga im Indischen Kultbild* (Berlin, Germnay: Frankfurter Verlags-Anstalt, 1926).

_____, *Myths and Symbols in Indian Art and Civilization* (Washington, DC: Bollingen Foundation, 1946; and Princeton, NJ: Princeton University Press, 1974).

LIST OF PHOTOGRAPHIC PLATES AND DRAWINGS

Plate A: Woman with Market Basket, Madurai, Tamil Nadu, 1986.

Plate B: Pulli-kolam for Pongal in Madurai, Tamil Nadu, 1990.

Plate C: Sri Chakra and lotus labyrinth diagrams, village near Chennai, Tamil Nadu, 1986.

Plate D: Dancing Shiva, Kailasanatha Temple, Kanchipuram, 2004.

Plate E: Modified Lotus, a *Pongal* diagram from Srirangam in Tamil Nadu, 1986.

Plate F: Pink Sari, in Srirangam, Tamil Nadu, 1986.

Plate G: Light Shaft, in a passageway in Varanasi, Uttar Pradesh, 1986.

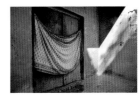

Plate H: Clay Pot Wagon, in Madurai, Tamil Nadu, 2004.

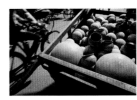

Plate I: Sinking Temple, on the Ganges River in Varanasi, Uttar Pradesh, 1998.

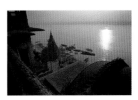

Plate J: Interior, Pink Fort, Jaipur, Rajasthan, 1998.

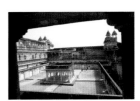

Plate K: Cosmic Lotus, a diagram in a village near Madurai, Tamil Nadu, 1986.

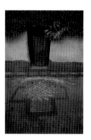

Plate 1: Creator's Knot, a diagram in a village near Mysuru (Mysore), Karnataka, 1977.

Plate 2: Brahma's Knot and Krishna's Feet, a diagram in a village near Simla, Himachal Pradesh, 1990.

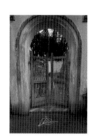

Plate 3: Flower, a diagram in a village near Mysuru, Karnataka, 1977.

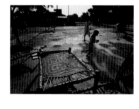

Plate 4: Woven Bed, in Agra, Uttar Pradesh, 1977.

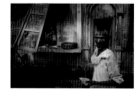

Plate 5: Pan Shop, in Bangalore (Bengaluru), Karnataka, 1977. Here are sold varieties of betel nut, lime, and *catachu* powders, spices, and, occasionally, opium mixed and folded into an edible leaf packet.

Plate 6: Woven Frond Dwelling, in a village near Chennai, Tamil Nadu, 1984.

Plate 7: Silk Weaving, in Kanchipuram, Tamil Nadu, 1990.

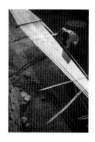

Plate 8: Naga (snake), a diagram in Kanchipuram, Tamil Nadu, 1990.

Plate 9: Lotus, a diagram in Shantiniketan, West Bengal, 1990.

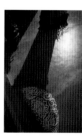

Plate 10: Steam Engine Train, in Orissa, 1986.

Plate 11: Shadows and Jumping Boy, in Agra, Uttar Pradesh, 1977.

Plate 12: Rose, a flower diagram and wall drawing in Tiruchirapelli (Trichy), Tamil Nadu, 1984.

Plate 17: Flying Bird, a diagram in Trivandrum, Tamil Nadu, 1984.

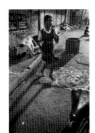

Plate 13: *Pulli Kolam and Swastika*, a diagram and wall drawing in a village near Bangalore, Karnataka, 1984.

Plate 18: Caged Parrot, Krishna's feet and lotus diagram in Shanitniketan, West Bengal, 1990.

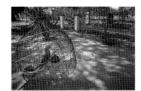

Plate 14: Running Girl at Dawn, a lotus diagram in Madurai, Tamil Nadu, 1990.

Plate 19: Hands and Ribbon, women in Singaperumalkoil, a village near Chennai (Madras), Tamil Nadu, 1984.

Plate 20: Watercourse and atomic symbol diagram in Tiruchirapelli (Trichy), Tamil Nadu, 1984.

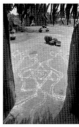

Plate 15: Oil Lamps, a diagram in Madurai, Tamil Nadu, 1990.

Plate 21: Anandhi's Kitchen, with a Sri Chakra diagram, in Chennai, Tamil Nadu, 1990.

Plate 16: Swastika with Oil Lamps, a good-fortune diagram in front of a business in Madurai, Tamil Nadu, 1984.

Plate 22: Sweetshop, in Mysuru, Karnataka, 1977.

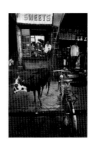

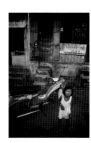

Plate 23: Young Girls, in Mysuru, Karnataka, 1977.

Plate 28: Marthanda Bhawan, *pulli kolam* in front of Marthanda Bhawan, Chennai, Tamil Nadu, 1990.

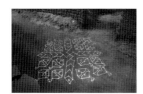

Plate 24: Swastika and Flowing Fish, a diagram in a village near Bangalore, Karnataka, 1984.

Plate 29: Shoes, an atomic symbol diagram in Madurai, Tamil Nadu. 1986.

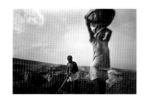

Plate 25: Sand Bearers, on the east bank of the Ganges River in Varanasi, Uttar Pradesh, 1977.

Plate 30: Washing Stone Landscape, a pond in a village near Madurai, Tamil Nadu, 1998.

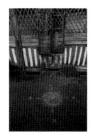

Plate 26: Sun and Star, solar diagrams in Chidumbaram, Tamil Nadu, 1984.

Plate 31: Aiyanar Shrine, bases of an animistic shrine near Mysuru, Karnataka, 1977.

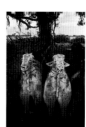

Plate 27: Shrada Ceremony Setting, diagrams for the dead in Chennai, Tamil Nadu, 1990. An inauspicious *kolam* (rice flour diagram in Tamil Nadu) for the Shrada ceremony faces east; cow dung paste (a cleansing substance) is applied to the floor in the form of a circle on the left (south); and a square on the right (north) and *gingily* (black sesame seeds) and *tulsi* leaves (a variety of thyme) are placed on the diagram as offerings to invoke the forebearers and to venerate the gods.

Plate 32: Gate and a Sri Chakra diagram (a mandala of balanced opposite forces, such as female and male energies; a symbol of the human soul as the unified conscious and unconscious being) in Madurai, Tamil Nadu, 1990.

Plate 33: Bullock Cart, a traditional Sri Chakra seated within a lotus diagram and made for an auspicious occasion in Chennai, Tamil Nadu, 1986.

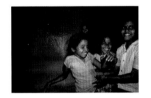

Plate 34: Red Sari, a *Pongal* diagram in Madurai, Tamil Nadu, 1986.

Plate 35: Girls Playing, in front of a wall drawing in a crafts village near Pipli, Orissa, 1986.

Plate 36: Ellora View, Buddhist monks' cells (*viharas* or monasteries) in the Ellora caves near Aurangabad, Maharashtra, 1990.

Plate 37: Pongal Lotus, a stylized lotus diagram in Madurai, Tamil Nadu, 1986.

Plate 38: Fruit Stand, in Varanasi, Uttar Pradesh, 1998.

Plate 39: Frog Boy, in a village near Varanasi, Uttar Pradesh, 1977.

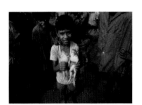

Plate 40: *Navagriha* (nine planets), a diagram in a home in Simla, Himachal Pradesh, 1990. The diagram was made by a Hindu priest for the author on the basis of her birthdate.

Plate 41: Cosmic Order, a diagram (star with eight points) beneath a *puja* (prayer) area beside a kitchen in a home in Subbaratnum, Bangalore, Karnataka, 1990.

Plate 42: Decorations, in a village near Madurai, Tamil Nadu, 1998. The truck and a young bull are decorated for *Jallikattu* (running of the bulls) during the *Pongal* festival.

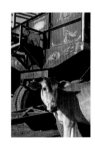

Plate 43: Mickey Mouse, a representational diagram made for the *Pongal* festival in a village near Madurai, Tamil Nadu, 1998.

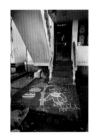

Plate 44: Garuda, a representational bird diagram in a village near Madurai, Tamil Nadu, 1990.

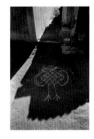

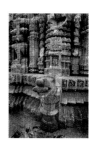

Plate 45: Sun Temple Alligator, an alligator god eating a fish in the Temple of the Sun's compound in Konark, Orissa, 1998. The temple is dedicated to Surya, the sun god.

Plate 51: Girls, in the streets of Varanasi, Uttar Pradesh, 1986.

Plate 52: Post-modern Environs, a modern stylized diagram derived from pattern books in Madurai, Tamil Nadu, 1986.

Plate 46: Tree by the Ganges, a riverside landscape along the Ganges River in Varanasi, Uttar Pradesh, 1998.

Plate 47: Sunrise on the Ganges River, in Varanasi, Uttar Pradesh, 2003.

Plate 53: Pongal Cyclist, riding over a *Pongal* diagram in a village near Madurai, Tamil Nadu, 1990.

Plate 48: Pilgrims on the *Ghats* (steps), along the holy Ganges River in Uttar Pradesh, 2003.

Plate 54: Skirts, in a village near Pipli, Orissa, 1986.

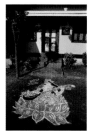
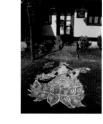

Plate 49: Sarasvati Goddess of the Arts, a modern diagram in Madurai, Tamil Nadu, 1998.

Plate 55: Waterways, in the palm-lined backwaters of Kerala, 1998.

Plate 56: South Indian River, as viewed from a train in southeastern India, 2003.

Plate 50: Men against Red Wall, in the streets of Varanasi, Uttar Pradesh, 1986.

Plate 57: Wall drawing with Window, in a village near Pipli, Orissa, 1986.

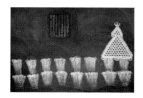

Plate 58: Rooftop Dwelling, in densely settled Varanasi, Uttar Pradesh, 1986.

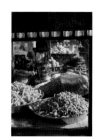

Plate 64: Savories and Sweets, in Varanasi, Uttar Pradesh, 1990.

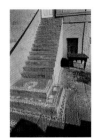

Plate 59: Rajasthani Stairway, with *mandana* diagram (name used in Rajesthan) representing Surya (the sun god) at Mehrangarh (the Majestic Fort), above Jodhpur, Rajasthan, 1990.

Plate 65: Wall Drawings and Grinding Stone, in a village near Pipli, Orissa, 1986.

Plate 60: Indian Construction I, a construction site in Chennai, Tamil Nadu, 1998.

Plate 66: Auspicious Occasion, a diagram in Madurai, Tamil Nadu, 1986.

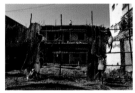

Plate 61: Indian Construction II, a construction site with a "protector" figure on the roof in Chennai, Tamil Nadu, 1998.

Plate 67: Peacock and Tulas. A *Pongal* diagram with *tulas* leaves (*Ocimum tenuiflorum*), or holy basil, in Madurai, Tamil Nadu, 1986.

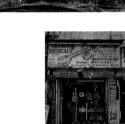

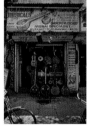

Plate 62 : Veena Shop with *Sri Chakra*, a diagram in front of Chandru Musicals in Chennai, Tamil Nadu, 1998.

Plate 68: Roadside Vender with Cat, south of Chennai, Tamil Nadu, 1986.

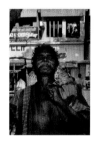

Plate 69: Malapore Produce Stall, near Chennai, Tamil Nadu, 1998.

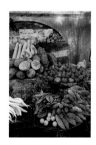

Plate 63: Sarasvati Shrine, to honor Sarasvati during the *Pongal* festival in Calcutta (Kolkata), West Bengal, 1990.

Plate 70: Rooster and Chicken Strut, a New Year strut over auspicious-occasion diagrams in Madurai, Tamil Nadu, 1986.

Plate 76 : Lotus (*Hridaya Kamalam*) diagram with Blue Door, in Thirumazhisai, a village south of Chennai, Tamil Nadu, 1990.

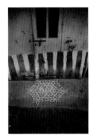

Plate 71: Blooming Lotus, a diagram for an auspicious occasion, with on looking mother and child, in Chennai, Tamil Nadu, 1986.

Plate 77: Blue Entrance, a chowk diagram in Madurai, Tamil Nadu, 1990.

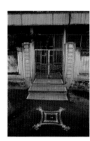

Plate 72: Parrot Gift, for the goddess Kali's son in Varanasi, Uttar Pradesh, 1998.

Plate 78: Meherangarh Landscape, on the mountain of birds (Bhaurcheeria) above Jodhpur, Rajasthan, 1986. Meherangarh (the Majestic Fort) is one of seven wonders of India.

Plate 73: Palm Tree Wall, a wall drawing in Varanasi, Uttar Pradesh, 1986.

Plate 79: Thar Desert Landscape, in Rajasthan, 1998.

Plate 74: Vined Threshold, a lotus diagram at a Subbnaratnam home in Bangalore, Karnataka, 1990.

Plate 80: Oryan Landscape, with a man riding on a bullock cart in Orissa, 1986.

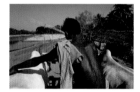

Plate 81: Movie Posters and Rickshaws, in Varanasi, Uttar Pradesh, 1986.

Plate 75: Infinity Diagram, in Chennai, Tamil Nadu, 1986.

Plate 82: Politics and Auspicious Occasions in India, diagrams for an auspicious occasion (*pulli-kolam*) and political wall drawings in Thirumazhisai, south of Chennai, Tamil Nadu, 1990.

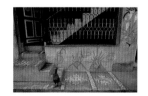

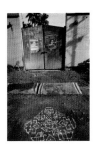

Plate 83: Gandhi Poster on Gate Door, with diagram featuring a pumpkin flower for an auspicious occasion in a village near Madurai, Tamil Nadu, 1990.

Plate 89: Bicycle Boys and Peacock, a *Pongal* diagram, in a village near Madurai, Tamil Nadu, 1990. The peacock is a harbinger of spring.

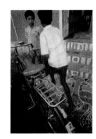

Plate 84: Woman on Rooftop, in Varanasi, Uttar Pradesh, 1986.

Plate 90: Plant Display, with a diagram beneath a showy display of plants in Bangalore, Karnataka, 1990.

Plate 85: Street in Bangalore, Karnataka, 1986.

Plate 91: The Wash, along the Kollidam River in Kancharampettai, a small village near Madurai, Tamil Nadu, 1998.

Plate 86: Rock Bridge over Watercourse, with *Pongal* diagram based on a pattern book in a village near Madurai, Tamil Nadu, 1990.

Plate 92: Himalayan Landscape, from the "toy train" (narrow-gauge train) in route to Darjeeling, West Bengal, 1998.

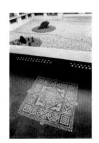

Plate 87: Zen Garden at Shantiniketan, with a stylized diagram in a museum courtyard in Shantiniketan, West Bengal, 1990.

Plate 93: Cosmic Weaving, an auspicious diagram made with a roller stencil in Chennai, Tamil Nadu, 1998.

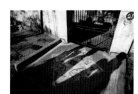

Plate 88: Naga with Shadows and Chickens, fertility diagrams in a village near Madurai, Tamil Nadu, 1990.

Plate 94 : Golden Door, a threshold diagram with a line infinity image on the stoop and an oil lamp diagram just inside the threshold, in Thirumazhi sai, south of Chennai, Tamil Nadu, 1986.

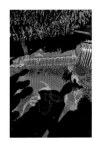

Drawing A: Lotus, a symbol of purity, rebirth, and divinity. Drawing by Jack Colling.

Drawing E: Swastika and Lotus, in which the swastika sends out positive cosmic energy in all directions. Drawing by Jack Colling.

Drawing B: Swastika, a 5,000-year-old symbol representing good fortune and wellbeing; here, it also represents rotations of time and consciousness and the cycle of life in nature. Drawing by Jack Colling.

Drawing F: Sri Chakra, the sacred symbol of unified female and male energy. Drawing by Jack Colling.

Drawing C: Modified Lotus, used for auspicious occasions such as marriages, births, and harvest festivals. Drawing by Jack Colling.

Drawing G: Krishna's Feet and Lotus. Drawing by Jack Colling.

Drawing D: Pulli Kolam, with the patterns of dots established by mathematical formulas. Drawing by Jack Colling.

INDEX

death and rebirth, 198, 200–01, 205, 206, 207, 216, 224, 254–57, 277
equilibrium, 217, 242
eternal life, 257
knotted rope, 258
labyrinth, 198, 246, 256–59; see, also, *cakravyuha*
lotus, 136, 152, 235, 244, 245, 247, 256, 257, 260
snakes (*nagas*), 206, 244, 247, 257, 259, 260
sixteen-point grid-Mother Goddess, 152
Supreme Being, paramount power, *sri chakra*, 22, 198, 214–15, 256
swastika (as cosmic force; movement), 22, 30, *Plates 16* and *24*, 152, *156*, 210–11, 245, 296
vegetation, 256

Tagore, Rabindranath, 200, 279
epigraphs by, 19, 193, 263
Tamil Nadu: see *Indian, states of*
Tanjore, *11* (map), 139
Tantra (Tantric),
Cosmic Unity, 216, 218, 255–57
order, 196,
practice, 236
rituals, 210
ter-kolam diagram, 250
Thar Desert, *11, Plate 79*, 140, 141
threshold, 210
area, 135, 137, 153, 204, 210, 215, 216, 231, 242, 244, 246, 247, 249, 251, 261
concept of, 13, 22, 146–47, 153, 195, 210, 211, 216, 218, 238, 252–54, 257
rituals, 151, 200–01, 204–06, 210, 218, 257
symbolic significance of, 68, 71, 72
threshold diagrams (by region and structure); see, also, *diagrams*
alpona (*alpana*), 196, 200, 205, 227, 234, 245, 260, 269
apna, 245, 252
aripan, 196, 205, 245, 252
athapuvidal, 196, 198–99, 205, 206, 274
cakravyuha, 246, 258
chawka, 205
kolam, 21, 196, 199, 237, 242, 244, 252, 258, 282
Lakshmi, 5, 136, 210, 217, 244, 252
lotus, 136, 152, 235, 244, 245, 247, 256, 257, 260
maha mangala, 250
navagraha, 152–53, 200
pulli-kolam, 152, 196
rangavalli, 196, 199, 248
rangoli, 25, 151, 196, 252
rath-mandala mandala, 250
references in Hindu literatura, 247–48
sarvatobhadra, 198
sathia, 205
sikkal-tamarai, 244
soma rakhna, 252
t'ai chuan, 207
ter-kolam, 250
Trichy: see *Tirucchirapalli*
Thrikkakara Appan, 206
time, 13, 19, 145, 224, 245
cyclic nature of, 13, 154, 198, 222–23, 264
East Indian perception of, 149, 223
mistress of time (Mahakali), 211, 222

trinity of gods, 210
Tiruchirappalli, (also Trichy), 139
transcendence, 136, 236, 238
transcendental consciousness, 151, 236
Turner, Victor, 22, 137

Underhill, Evelyn, 150, 151
United States of America
comparisons with, 141, 212, 230, 232
universalism, 279
universal references, 157, 202, 209, 212, 233, 236, 238, 243, 249, 250, 252
utsava mandala, 205
Uttar Pradesh: see *Indian, states of*

Vadibhasimba, 248
Varanasi (*Banaras* or *Banares*), *11* (map), 21, 135, 136, 143, 223, 233

Varangacharita, 247
Vasant Panchani: see *festivals*
Vastupuja, ceremony, 248
Vatsyayana, 247
vedas
Rig Veda, 22, 247
Vedic prayer, 247–48
tradition of, 249
Vedic culture, 210
pre-Vedic, 149
non-Vedic, 210
practices of, 210
Vedic literature, 249
Vedic Sanskrit, 149
veve, 231
vina: see *musical instruments*
Vishnu, 208, 210, 217
Lakshmi/Vishnu, 217
Vishnudharmottara, Purana, 247
visual ecology, 22, 138–39
visual languages, 230
Vrata (Hindi); Brata (Bengali) rituals, 198, 210, 252,
definition of, 209
utsava mandalas and, 205
Vrata Stoma ceremony, 209

wall drawings/diagrams, 199, 200, 221
waters, 136, 211, 327
Watts, Alan, 14
web of life, 260, 263
Wells, H. G., 223
Wenders, Wim, epigraph by, 157
Wilson, Edward O., epigraph by, 67
women
position of, 212–14, 225–27
power of, 195 206, 207–12, 215, 218–19

Yantras, 149, 152, 198, 205, 207, 218, 236, 246, 256
Yashodhara, 247

Zen gardens, *Plate 78*
Zimmer, Heinrich, 208, 231
myth describing character and deeds of Goddess, 208–209

Drawing G

Acknowledgments

I AM EXTRAORDINARILY GRATEFUL for the support this work has received, from Stella Kramrisch's initial encouragement to pursue this research, through Kapila Vatsyayan's continual inspiring countenance, to my publisher's steadfast support since I first showed him the project in Baltimore nearly three decades ago, to many friends and colleagues who supported this project in meaningful ways. The generosity extended toward the development of this work for nearly forty years is overwhelming. At times, when I thought I would give up, encouragement came in numerous ways. Again, I am very grateful. I believe this is a ship that has sailed with the help of a wonderful crew. If I were to name all those who contributed articles, ideas, sources, artistic support, and encouragement, there would be no room for the rest of the book. There are some, however, who went way beyond generosity and colleagueship.

Over many years the active participation of women celebrating the practice of making threshold diagrams throughout India made this work was possible. Along with my gratitude to those Indian women I am especially indebted to Mrs. K. N. Anandhi, Heather Barrett, Peter C. Bunnell, Jeanne Dutterer, Alida Fish, Ashleigh Frank, Michael Harrison, June Kimmel, Anne Kluttz, Dr. Stella Kramrisch, Gail Larrick, William T. Latham, Dr. William Mahony, William E. Parker, Dustin Peck, John Pfahl, Dr. Premlata Sharma, Dr. Rani Siromoney, David Skolkin, Mark H. Sloan, Mary Ann Smith, Mikki Soroczak, Evon Streetman, William Taylor, George F. Thompson, and Joan Tweedy. Each contributed essential support artistically, editorially, scholarly, technically, or personally. My special appreciation goes to Heather Barrett, who traveled to India with me in 1998, learning firsthand about the threshold diagrams, and, subsequently, provided enormous support for this project. I am especially grateful for the personal and professional encouragement and support given to me by Kamaladevi Chattopadhyay, Dr. Uma Das Gupta, Sharda Nayak, Seetha Srinivasan and her family, and Kapila Vatsyayan. Each helped to make my work in India a series of rich experiences by opening numerous doors of opportunity and insight.

Significant financial support was provided by the Fulbright Foundation, National Endowment for the Arts, North Carolina Arts Council, and University of North Carolina, which allowed for the research time and travel necessary to pursue and complete this project at key points. The Halsey Institute of Contemporary Art at the College of Charleston and Center for the Study of Place were also supportive of the book's development and publication.

I am most grateful to my mother, Marion Gilmore Strawn. She was a very intelligent and strong-willed woman, who introduced me to eastern philosophy and religion and who consistently encouraged my interests. She also fostered my involvement in feminism and, along with my father, Clifford, financially supported my education toward this end.

About the Author

Martha A. Strawn was born in Washington, D.C., in 1945, she grew up in Lake Wales, Florida, and now resides along the Santa Fe River near High Springs, Florida. She attended Mary Baldwin College and received her B.A. in art under Evon Streetman from Florida State University, her Basic Certificate from Brooks Institute of Photography in Santa Barbara, California, and her M.F.A. in art from Ohio University. Strawn is Professor Emerita of Art at the University of North Carolina in Charlotte, where she established the Time Arts program in photography, video, and digital imaging. Strawn also co-founded The Light Factory Contemporary Museum of Photography and Film in Charlotte and has served on other national arts and land/water conservation boards, including the Society for Photographic Education, Friends of Photography, Davidson Land Conservancy, and Center for the Study of Place. She was a Fulbright Fellow in India and the recipient of a National Endowment for the Arts Fellowship.

Throughout her career, Strawn has been recognized for combining aesthetic and scientific interests in visual expressions of the spaces and places that surround us. She coined the term *visual ecology* in reference to her approach to the importance of geography and a sense of place in her photographic work. She works in silver, chromogenic, and digital photographic media. Strawn's photographs have been exhibited and collected internationally in museums of science and art, including the Carnegie Museum of Natural History, Halsey Institute of Contemporary Art at the College of Charleston, Harry Ransom Research Center at the University of Texas at Austin, Indira Gandhi International Centre for Art, Museum of Florida Artists, National Geographic Society Museum, Princeton Art Museum, San Diego Museum of Natural History, Science Museum of Minnesota, Smithsonian Institution, and Southeastern Center for Contemporary Art. Her previous books are *Alligators, Prehistoric Presence in the American Landscape* (The Johns Hopkins University Press, in association with the Center for American Places, 1997) and, with Yi-Fu Tuan, *Religion: From Place to Placelessness* (Center for American Places at Columbia College Chicago, 2009).

Kapila Vatsyayan was, from 1990–2000, the Member-Secretary and, later, the founding Academic Director of the Indira Gandhi National Centre for the Arts. Since 2004, she has been a guiding light of the IIC-Asia Project at the India International Centre and currently serves as its chairperson. She has also served as a member of UNESCO's Executive Board and was a nominated member of the Indian Parliament (Rajya Sabha). She has received more than twenty honors in honor of her scholarship, publications, and exhibitions on Indian Studies, including the B. C. Law Gold Medal of the Asiatic Society and Lifetime Achievement Award from the Government of Delhi.

Mark H. Sloan completed his B.A. in interdisciplinary studies at the University of Richmond and his M.F.A. in art at Virginia Commonwealth University. Since 1994, he has been Director and Senior Curator of the Halsey Institute for Contemporary Art at the College of Charleston. As a curator, he has produced several hundred exhibitions of contemporary art, many of which traveled nationally and internationally, and authored and co-authored fourteen catalogs and books. As an artist, Sloan's work has been exhibited at the American Philosophical Society in Philadelphia; Grand Palais in Paris, France; Harvard Museum of Natural History in Cambridge; High Museum of Art in Atlanta; Photographic Resource Center at Boston University; Southeastern Center for Contemporary Art in Winston-Salem, NC; and United States National Academy of Sciences in Washington, D.C.

William K. Mahony earned his academic degrees from Williams College, Yale University, and the University of Chicago. He joined the faculty of Davidson College in 1982, where he is the Charles A. Dana Professor of Religion. Mahony is also known internationally as a leader of workshops, seminars, and retreats in yoga communities. His books include *Exquisite Love: Reflections on the Spiritual Life based on N rada's Bhakti Stra,* Second Edition (Sarvabhva Press, 2014), and *The Artful Universe: An Introduction to the Vedic Religious Imagination* (State University of New York Press, 1997). He is also an editor and major contributor to the first edition of *The Encyclopedia of Religion*, sixteen volumes (MacMillan Press, 1987).

About the Illustrator

Jack Colling learned the art of pen-and-ink drawing while in high school and community college and photography while a sergeant in the United States Air Force. For fifty-nine years, he lived and worked in central Florida, where his artistry focused on nature, endangered species, and landscapes. His work is in numerous private collections and has been exhibited throughout Florida and Georgia. He currently resides in Blairsville, Georgia.

About the Craft

My photographic technique for this project was very straightforward. I used three Nikon cameras without a tripod, each loaded with a different film: Kodak Tri X, Fuji or Kodak color negative, and Fuji or Kodak transparency films. As the years went by, technology and my printing process changed; thus, the images seen in this book were converted into digital files from their original film for permanence and better reproduction in book form.

By repeatedly returning to India for thirty-seven years, I was also able to present and share pictures I made on previous visits. Having visual demonstrations of what I was doing greatly expanded my ability to communicate my intent and my process with those making the diagrams, and, in turn, this process further encouraged the women's participation in the project. Ultimately, the active participation of these women celebrating the practice of making threshold diagrams all over India made this work possible. To them, I am forever grateful.

About the Book

Across the Threshold of India: Art, Women, and Culture was brought to publication in a limited edition of 1,100 hardbound copies. The text was set in Perpetua, the paper is Lumisilk, 170 gsm weight, and the book was professionally printed and bound by Pristone Pte. Ltd. in Singapore.

Editor and Publisher: George F. Thompson
Editorial and Research Assistants: Mikki Soroczak and Heather Barrett
Manuscript Editors: Ashleigh Frank and Purna Makaram
Book Design and Production: David Skolkin

Special Acknowledgments: The publisher extends special thanks to Peter C. Bunnell, who, as Director of the Princeton University Art Museum, provided the key support to make this book possible. His admiration for and belief in Martha Strawn's photographic art, in particular her work on India, had a profound influence on both the artist and the publisher as they moved forward with this book nearly three decades ago when the publisher was a young editor at the Johns Hopkins University Press.

George F. Thompson Publishing, L.L.C.
217 Oak Ridge Circle
Staunton, VA 24401-3511, U.S.A.
www.gftbooks.com

24 23 22 21 19 18 17 16 1 2 3 4 5

The Library of Congress Preassigned Control Number is 2015956257.

ISBN: 978-1-938086-17-5